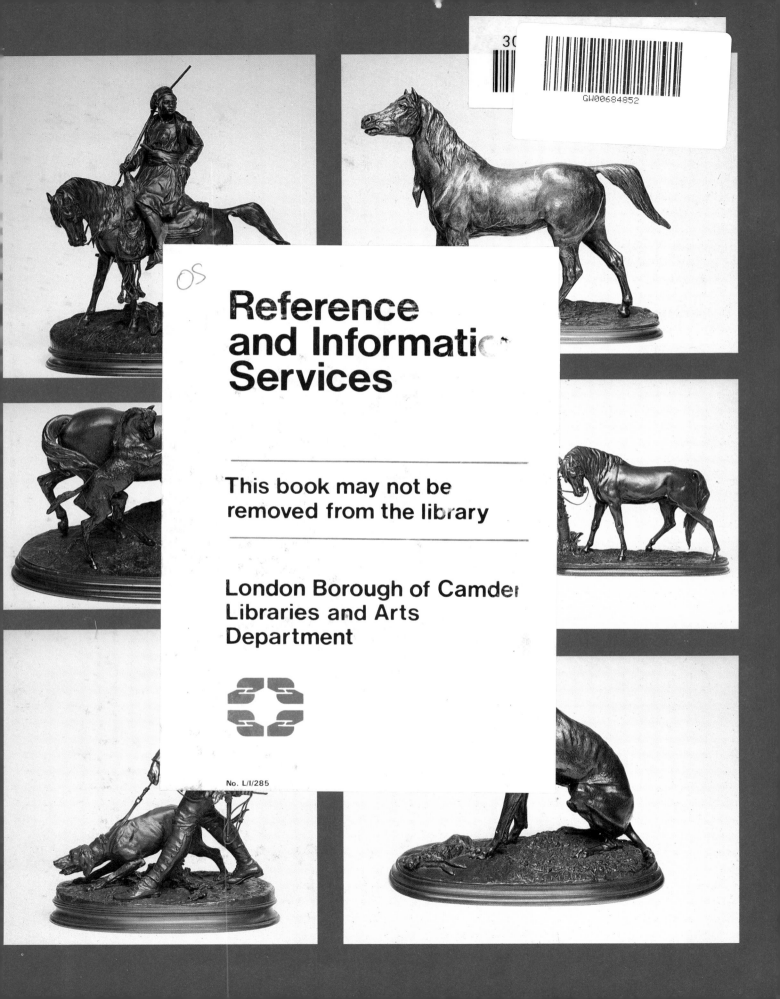

# ANIMALS IN BRONZE
## Reference and Price Guide

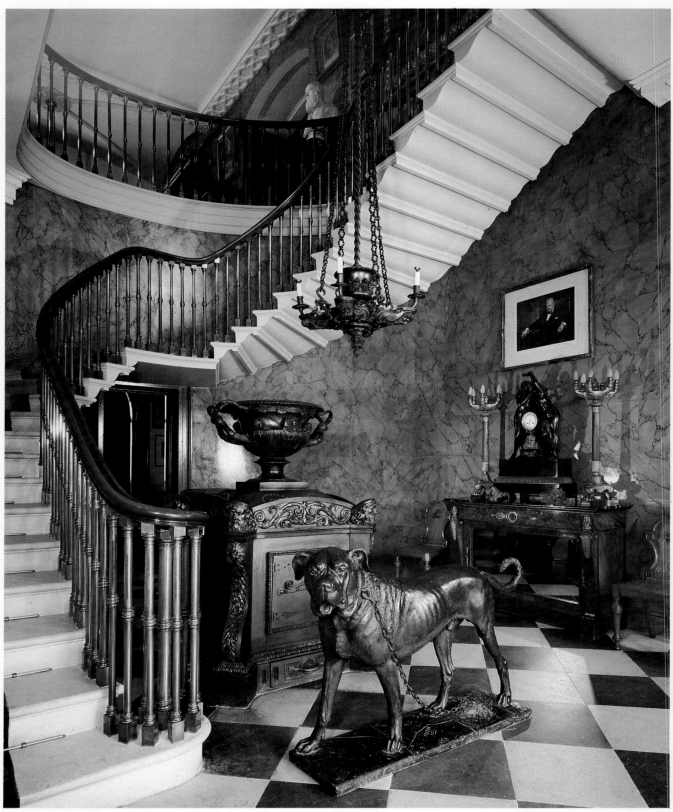

**Plate 1.** A view of the entrance hall of The Argory, Co. Armagh, built c.1820, showing a lifesize mastiff by Fratin, signed and dated. The bronze perfectly complements this grand setting.

# ANIMALS IN BRONZE

Reference and Price Guide

## CHRISTOPHER PAYNE

Antique Collectors' Club

© 1986 Christopher Payne
First published 1986
World Copyright Reserved

ISBN 0 907462 45 6

British Library CIP Data
Payne, Christopher
    Animals in Bronze: reference and price
    guide.
    1. Sculpture — Collectors and
    collecting    2. Bronzes — Collectors
    and collecting    3. Animals in art —
    Collectors and collecting
    I. Title        II. Antique Collectors' Club
    731'.832        NK7906

Published for the Antique Collectors' Club
by the Antique Collectors' Club Ltd.

Designed by John Lewis FSIAD

Printed in England by the Antique Collectors' Club Ltd.,
Woodbridge, Suffolk.

# Antique Collectors' Club

The Antique Collectors' Club was formed in 1966 and now has a five figure membership spread throughout the world. It publishes the only independently run monthly antiques magazine *Antique Collecting* which caters for those collectors who are interested in widening their knowledge of antiques, both by greater awareness of quality and by discussion of the factors which influence the price that is likely to be asked. The Antique Collectors' Club pioneered the provision of information on prices for collectors and the magazine still leads in the provision of detailed articles on a variety of subjects.

It was in response to the enormous demand for information on "what to pay" that the price guide series was introduced in 1968 with the first edition of *The Price Guide to Antique Furniture* (completely revised, 1978), a book which broke new ground by illustrating the more common types of antique furniture, the sort that collectors could buy in shops and at auctions rather than the rare museum pieces which had previously been used (and still to a large extent are used) to make up the limited amount of illustrations in books published by commercial publishers. Many other price guides have followed, all copiously illustrated, and greatly appreciated by collectors for the valuable information they contain, quite apart from prices. The Antique Collectors' Club also publishes other books on antiques, including horology and art reference works, and a full book list is available.

Club membership, which is open to all collectors, costs £12.95 per annum. Members receive free of charge *Antique Collecting,* the Club's magazine (published every month except August), which contains well-illustrated articles dealing with the practical aspects of collecting not normally dealt with by magazines. Prices, features of value, investment potential, fakes and forgeries are all given prominence in the magazine.

Among other facilities available to members are private buying and selling facilities, the longest list of "For Sales" of any antiques magazine, an annual ceramics conference and the opportunity to meet other collectors at their local antique collectors' clubs. There are nearly eighty in Britain and so far a dozen overseas. Members may also buy the Club's publications at special pre-publication prices.

As its motto implies, the Club is an amateur organisation designed to help collectors get the most out of their hobby: it is informal and friendly and gives enormous enjoyment to all concerned.

*For Collectors — By Collectors — About Collecting*

**The Antique Collectors' Club, 5 Church Street, Woodbridge, Suffolk**

# Price Revision List

---

Published annually in February
(the first list will be published in 1987)

The usefulness of a book containing prices rapidly diminishes as market values change.

In order to keep the prices in this book updated, a price revision list will be issued in February each year. This will record the major price changes in the values of the items covered under the various headings in the book.

To ensure you receive the price revision list, complete the pro forma invoice inserted in this book and send it to the address below:

Antique Collectors' Club
5 Church Street, Woodbridge, Suffolk

# Contents

# Colour Illustrations

# Acknowledgements

Very special thanks are due to John Hurman, without whose tuition I would never have mastered the world of animal bronzes and whose encouragement, together with his wife Kate, gave me the essential impetus to write this book.

My thanks are also due to the photographers and staff of the now closed Sotheby's Belgravia, that excellent vehicle for the display and selling of animal bronzes. Also, more latterly to the photographers and co-operative staff of Sotheby's in New Bond Street. Howell Evans always proved to be of tremendous help and my thanks to him. My thanks also to Annette Yarrow and John Elliott, her husband, who took the series of colour illustrations of the casting process, and to Jack and Megon Crofton of the Meridan Bronze Foundry and their employees for so patiently allowing these photographs to be taken. To Aspreys who allowed me to reproduce examples of Annette Yarrow's work. To the Tryon gallery for the work of Jonathan Kenworthy and William Timym.

The advantage to a budding author of an art reference book, the co-operation and beneficence of an institution such as Sotheby's, is incalculable and cannot be underestimated and so my thanks to the being that is Sotheby's, my home for over fifteen years.

# Photographic Acknowledgements

Aspreys (H65-66)

Bonhams

Champin, Lombrail and Gautier, Commissaires-Priseurs, Paris

Christie's

Prudence Cuming Associates (H122)

John Elliott and Annette Yarrow (Figures 1-33; Bi8-9; H67-68)

Malcolm Gale

John Hurman

Institut Royal du Patrimoine Artistique, Brussels (pp.50-61)

Mallet (C89; D46)

Marble Hill Gallery, Twickenham

Felix Marcilhac, Paris (Bi78-79, 81, 83-88; C29, 48-51, 103-105; De46; D17; F1; H70)

National Horseracing Museum, Newmarket (p.270)

National Museum of Wales (Bi89; C5, 61; D125)

Diana Payne

Sladmore Gallery, Bruton Lane

Sotheby's, London, Chester, Torquay, Pulborough, Monaco, Amsterdam, New York and Sotheby's Belgravia, 1971-1982

Tryon Gallery, Cork Street (A8-9; Bi91-94; C55-58; De40-44; D137; E15, 17-18, 24; F4-5; H54, 56, 91, 198, 231)

Rafael Valls

Rowland Ward's of Knightsbridge (C60)

# Note

---

**Sizes:** Unless stated to the contrary, the measurements for the bronzes in this book are by height. Two dimensions represent height by width; three dimensions represent height by width, by depth.

**Prices:** Examples of some contemporary bronzes have been included in this book, but as they do not yet regularly appear in the salerooms, it has not always been possible to give them prices.

For my father
and to
Di, Belinda and Nicholas

# Introduction

The publisher's intention in commissioning this book was to effect a replacement for *Les Animaliers* by Jane Horswell, published by the Antique Collectors' Club in 1971. Printed in the days before spiralling costs, it was possible to devote one page to each bronze illustrated and so concentrate on the detail of each model. This limits the number of bronzes that can be illustrated and so this publication shows several bronzes on each page, thereby supplying a wider range and a more immediate comparison than was possible before. This new edition has deliberately not been given the same title as the previous book as it sets out to show the world of animal bronze sculpture outside the comparatively small, essentially Parisienne world of *Les Animaliers,* starting, as any book on romantic sculpture inevitably will, with the classic work of Barye in the second decade of the nineteenth century and continuing to the present day where we see a refreshing revival of animal bronze sculpture, especially in England and the United States of America. The purist will also notice that on occasion a model made from wood or terracotta has been included, where the example is closely related to contemporary animal bronzes. To those who already have *Les Animaliers* this book seeks to provide a sequel rather than a replacement; to those who have not a copy of the earlier excellent book, it is hoped that here is all the initial information a collector would require.

The present book divides into three main sections; the opening section describes the technicalities of the casting process and gives advice on selecting bronzes for a collection. Then individual bronzes are described and where possible priced (this is impossible of course with the sculptures of animals in the Antwerp Zoo, included because of their influence on animal bronzes of this century). These are roughly divided by species, arranged in alphabetical order, rather than by sculptor. This enables the reader to see how different sculptors approached the same subject and how the treatment of a particular animal gradually changes. The final section contains a biographical index of sculptors and the examples of their work to be found in the book are cross referenced.

Since our ancestors first painted animals on the walls of caves, man has represented the creatures with whom he shares this planet in his art. From generation to generation, and from country to country, different animals may be revered, feared, wild, domesticated, loved or hated; we imbue them with our characteristics, desirable or undesirable, faithfulness, guile, strength, weakness, beauty, ugliness. It is no wonder that collecting animal bronzes has become so popular, and it is hoped that the reader, whether animal lover or collector, will find pleasure in this book.

# The Modelling and
# Casting Process

## Modelling

The original inspiration for every model cast in bronze is usually modelled in one of two basic materials, clay, and, less commonly, in wax. It is normally considered difficult to model directly in wax but those who have mastered the technique find that this medium has infinite flexibility and responds more easily to those precise but necessary deft touches that can make all the difference to the completed work. One of the most charming and fascinating aspects of wax is where, in the finished cast bronze, traces of finger or thumb prints can be found. In this instance the prospective collector feels a definite affinity with the sculptor who worked the wax, especially in the few cases where it is known that the sculptor was in the habit of modelling directly in the wax himself or at least, as is more often the case, working up the wax from the mould before casting.

Modelling in either wax or clay usually requires the use of an armature, formed from wood or metal centre sections with heads and limbs indicated by the attachment of looped wires. This part firm, part flexible grid is then covered in the modelling material, which is slowly but surely built up. The flexibility of the extremities of the armature allow the sculptor to bend the limbs and attitude of the model to suit the requirements of both his orignal conception and the finished bronze. It goes without saying, therefore, that the actual size and scale of the armature must be exactly accurate otherwise there is more than a danger of the finished model appearing out of proportion. The more time and trouble taken over the original scaling, the better the result.

In the case of very small models, French clay can be used without an armature. Its adhesive qualities are better than those of English clay and it keeps its shape more readily. Clay modelling in itself, especially smallwork without the use of an armature, is a skill that can be learnt even by an amateur, the quality of the results alone determining whether or not the modeller has talent. Many of the successful late 19th and early 20th century sculptors in America spent their formative and childhood years modelling clay animals on river banks using the mud they found there, and had no formal training. The process of hand modelling in this way is essentially a process of creativity. Only the creator of the sculpture himself can put the ideas he has formulated into reality, his mind directing the movement of his hands and the subtlety of his fingers directing that essential but slight movement of the clay that makes his work distinctive and unique.

Once the clay model is finished to the sculptor's satisfaction then it must be cast in plaster as the clay model will bend and shrink in a comparatively short time. Here the studio can take over the technical work on behalf of the sculptor. Many sculptors are not

involved with any of the technical work after this stage, either in the studio or in the foundry. A three dimensional model must be piece-moulded in plaster of Paris, whose highly efficient water absorbing qualities mean that the powder will rapidly 'go off' or harden. Several individual layers of the mixture are then put over the model, each one hardening in turn and coalescing with the previous layer, forming a sound bond.

The plaster of Paris is layed on in layers to prevent any shrinking in the clay due to the low, but nevertheless inevitable heat given off by the mixture of water and the calcium sulphate in the plaster. Only the smaller, simpler moulds can be cast in one plaster mould and sectional casting requires the highly skilled placing of numerous shims, today normally made of brass with a complicated arrangement of stops and lock-holes to aid reconstruction of the hardened negative sections. Before modern day techniques were available to braze a rigid framework of brass shims together the caster would insert clay dividing strips.

The hardened plaster mould must then be gently washed out and lubricated with soap or clay water or in some cases oiled to ensure that the completed positive final result parts from the negative sections with ease and without damaging the model. The process of binding the various sections of a piece-mould are somewhat complicated and it is not the intention here to teach the reader how to model and cast but simply to give an understanding of the processes involved. Once the binding is complete a mixture of plaster of Paris is poured into, (in the case of a relatively simple model, one aperture) and carefully shaken to distribute the liquid plaster inside the negative mould before it goes off.

Once the hardening process is completed the negative may be, literally, broken away, eased by the application of a suitable lubricant. This waste-mould, which would not be expected to break off in neat sections, is then thrown away as it has no more use. Obviously, depending on the complications and extremities of the model, a great deal of care and skill must be employed to break away the mould without damaging the newly emerging positive final result. The finished plaster may then require some sanding or more forcible rasping to clean off any impurities or runs, a task ideally performed by the sculptor in person.

The drying out process usually takes a few hours, English plaster taking less time to set than its French equivalent, and the breaking away process also normally takes a considerable amount of time and care. It must be remembered at this stage that any severe damage to the positive would result in disaster as the negative deteriorates as it is removed and the original clay model would have been thrown away

long ago. One process commonly used to facilitate breaking away the waste mould on larger models is the technique of laying on a series of cotton threads on the inside of the negative mould. In the intermediate stages of the plaster hardening, the threads can be pulled through the waste mould outwards. The sections left by this mould will still adhere to the positive but greatly facilitate the removal of the various, now comparatively small 'windows'.

Animal sculpture was not only confined to bronze or plaster. Barye in his early years modelled small animals for the court goldsmith. In England, Roland Ward modelled a life-size fox in silver, weighing 519 ounces. It was commissioned as a testimonial for Sir Bache Cunard of Nevill Holt, Market Harborough, in the heart of Leicestershire hunting country. The *Illustrated London News* of the 17th November 1888 describes the fox as . . . 'representing the attitude just as reynard is drawing across an opening from covert to covert, and on the alert, as though in recognition of some suspicious sound or incident'. A flattering tribute to the sculptor's skills indeed and an indication of the sense of realism achieved by the competent artist.

## Lost Wax Casting

Considered to be the most satisfactory method of casting, although also the most costly, the *cire perdue* method was discovered some 4,000 years ago, and was practised by all ancient cultures reaching its zenith of design and technical skill in ancient Greece. To facilitate the understanding of this process, it is described in a series of colour illustrations (Figure 1-34, pp.22-29) compiled from photographs by John Elliot, photographer husband of the contemporary sculptor Annette Yarrow, carefully illustrating each stage of her work as it is done today with modern materials and techniques and captioned to explain each sucessive stage. Once again, as with sand casting, this is not an attempt to teach the rudiments of actual casting but merely to give the potential or existing collector enough bare facts to enable him or her to establish their own criteria in judging a bronze. This is most important with the comparatively high prices of lost wax bronzes of the 19th and 20th centuries and with the unfortunate plague on the market today of hundreds, possibly even thousands of modern copies, discussed more fully on page pp.42-46.

Certainly the best 'expert' is not necessarily a foundryman, just as the best gourmet is not necessarily himself a cook, but a thorough and complete understanding of the practical nature of bronze sculpture, or

indeed any art or antiques subject, allows the collector to make better use of his own academic knowledge and to develop his own eye.

A brief *resumé* of the *cire perdue* process used in the 19th century is given below. Seemingly complicated at the first reading, it should become clear with reference to the captioned photographs, although they cover the most modern techniques.

The lighter the bronze, the better it is; this general rule is a testimony to the skill of the 19th century foundryman who was able to spend more time preparing his model and core to produce a good thin cast, ideally about 4mm, at a period when time was cheaper than the raw materials. The lost wax process allows highly complicated models to be cast with the extremities, such as a horses legs and ears, cast in the solid but with the principal parts hollow cast with the whole animal or group being cast in one pouring, saving the numerous castings needed to do a similar model by the wet-loam or sand casting method, not even considering the labour needed in the latter method of bolting all these composite parts together.

There are two ways of starting the basic model in preparation for this method of casting. Firstly a gelatine mould of the existing, probably plaster, model is made in the same fashion as described on p.15 for plaster casting and made in two pieces. Next a core is made by coating the inside of the two piece mould with a thin layer of wax at first applied with a brush and then slowly built up more thickly. After washing in alum water this gelatine and wax mould is coated with one of various types of parting agent, often varnish. The inverted mould is then filled with a mixture of plaster of Paris and a suitable binding agent. After setting, the jelly mould is removed and the whole cast is then worked on to reduce the overall size by about 4mm to allow for the thickness of the metal. The core is then varnished again and put in a new gelatine mould previously taken from the plaster model. Melted wax can now be poured in to fill the resultant gap and when almost hard the outer mould is broken away leaving a wax-coated model in the form and, importantly, in the same size as the plaster original. At this stage the sculptor may want to make any necessary repairs and adjustments himself.

The model is now ready for casting and the runners or gates as well as the risers or air vents must be attached in a similar way for the simple type of cast described above as well as for the method below. In both cases the final and most crucial stage is the pouring of the molten bronze which must be done quickly and evenly. Once the pouring starts there is no time for hesitation, the runners must be skillfully placed to allow the metal to flow quickly and above all evenly with a uniform pressure to touch as much of the mould as possible simultaneously.

To model directly in wax is generally considered more difficult but once mastered gives the sculptor more control of the exact nuances of posture in the final bronze. First a skeleton of steel wire or armature is formed and then a rough sculpture is built up in ludo, a refractory material such as fire clay, about 4mm smaller overall than the desired size of the finished bronze. Molten beeswax is then applied by the sculptor to the rough model and sculpted by heated tools, often dentists' tools, which are constantly warmed in the flame of a spirit lamp. When this wax coated model is finished it should be an exact representation of the desired finished model. Lengths of wax, like tapers, are joined by heating the ends to all extremities of the model and then connected back in a loop to the animal. This process is to allow air to escape when the molten bronze is poured in. Then two larger pieces, possibly the size of a candle, are joined to the main body by heat application, one is the sprue, the channel through which the molten metal is poured, and the other the air duct or riser. Then a very delicate process of tapping a number of nails at evenly spaced intervals through the wax into the ludo core, with their heads protruding from the wax by 10-15mm takes place. The piece is now encased in a considerable amount of wet refractory material, known as the investment. This investment is placed in a kiln upside down so that the sprue and the riser are underneath. The whole is then fired at a temperature and in a manner comparable to the manufacture of china. Obviously the consequence of this is that the investment hardens and most importantly the wax is lost during this process. Hence the term *cire perdue*.

The investment or outer casing when cool now contains a perfect negative impression of the desired sculpture. The heads of the nails are embedded in the outer investment and their points into the core. Thus the core is held in suspension with an air gap of approximately 4mm i.e., the desired thickness of the finished bronze, interrupted only by nails. The cooled investment is now buried in sand with only the empty spaces of the sprue and riser visible. Molten bronze is deftly and evenly poured into the sprue until it appears in the riser or air vent. As soon as the molten bronze has solidified the investment is shattered thus exposing the bronze with all the attendant runners nails, riser and sprue attached.

The nails are withdrawn and the sprue, runners and riser cut off, leaving a rough but identifiable model which has to be hand finished.

The bronze is then hand finished removing the core by raking through a hole made in an unobtrusive place such as under the belly of an animal. This rectangular hole might be approximately 25mm x 45mm on a model of a horse or dog of 30cm-35cm high. After raking out, the hole is plugged by brazing in a new piece of bronze. This tell-

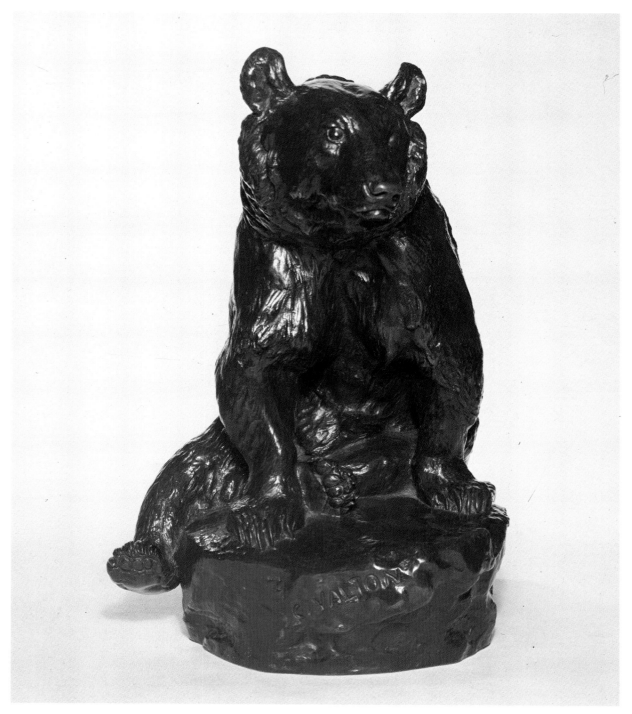

**Plate 2** If there was ever any doubt about Valton's senior position amongst the animaliers of the 19th century then a model of this charm and accuracy, together with the quality of the casting must surely quell them. The whole animal is very finely detailed and a paw is illustrated as B7 on p.70. The animal is most endearingly and sensitively modelled, without the savagery of Barye's work, or the humour of Fratin's. This is a rare cast and it is such a good one that it is difficult to value accurately. Competition would be stiff at auction, and a dealer would have to price it in his shop at a price that would satisfy him that once sold he would not forever regret not finding another one. This possibly is the model of a bear that the sculptor exhibited at the Salon of 1905. His mentor, Barye, had long before allowed a paw to stray off a plinth of a bronze and many had followed this idea but the style of the bear holds some of the master's touch as does the chunky but simple base.

Signed 'C. VALTON' and stamped with the foundry mark
'Colin Paris': 26.5 x 17.5cm (10½ x 7ins.)
rich brown patination, heightened with green,
and rubbed extremities showing a copper red.

*c.1905*                    *£1,800 — £2,600*

tale feature of bronze casting is always worth looking for when judging the age and type of a bronze. The rough bronze has now to be worked on where necessary to obliterate the marks and holes left by the runners, riser, sprue and nails. Various grades of files and cold chisels and emery cloth are used to achieve an even surface. At this stage the foundrymen, or in some cases the sculptor himself, will take this opportunity to chase the finer details that have not come out exactly with the desired precision, for example the mane of a horse may need some attention. The bronze is placed in an acid bath filled with a one to ten solution of sulphuric acid and water and left for approximately twenty four hours. This effectively clears the surface of any heat or scorch marks and dissolves any coke still attached.

'In general terms 19th century ''bronzes'' were made up of pure copper containing from eight to ten percent of tin, but, in fact, the alloys that pass under that denomination are almost infinite' according to G.W. Yapp.[1] Today a mixture of seven parts copper to three parts tin is more likely.

Brass, by contrast in the 19th century was 'two parts of the very best copper and one part of zinc'.

Bronze is much harder than pure copper but the durability can be controlled by the rate of cooling, the faster the cooling, the harder the bronze, a practise understood by the ancient Egyptians and Greeks. The use of tin makes the alloy far more fusible and in France tin, lead and zinc are added.

---

1. G.W. Yapp, *Art Industry Metalwork*, published by Virtue & Co. Ltd., 294 City Road, London, in c.1876.

# Modern Casting Techniques

Modern materials have given the technician an advantage over his counterpart in previous centuries. However the involved, and lengthy process of casting has today one element even more precious than the materials used in constructing the bronze. The time element is today the most expensive of all the processes used, with higher labour costs and rates at the foundry, using expensive equipment. The few sculptors who involve themselves with the stages of casting after the initial modelling have to cost their time even more carefully if they are to see any return at all from their labours. Every hour spent in the foundry is an hour lost in creating new and original ideas.

From the initial sketch the sculptor will make his wire frame or armature from a strong but easily flexible wire. This free standing skeleton is supported on an arm fixed into the workbench or with a weighted base. For smaller models there will be only one point of contact between the model and the supporting arm and for a larger model like a horse there might possibly be two, probably supporting the hind and forequarters. The next stage is to build up the modelling clay on to the armature as described on p.14.

As the clay is built up all finer details such as ears, mane, tail and any tack such as saddle must be worked in. Here wax can often be used as it is far stronger than clay for the fine detail work and keeps its definition better during the next stages. Shellac can now be applied to give overall strength to the model though this is not always necessary. All the details should be incorporated at this stage to give the sculptor a reference for exactly how he wants the finished bronze. It is here that the sculptor will normally sign the model, into the clay which means that he has only to sign once, regardless of the number to be cast. If the base is to be a self base, cast in the same mould, it must be already applied to the feet of the animal. This will usually only apply to the smaller bronzes, in larger models the base is more normally cast separately and bolted, pinned or screwed to the feet of the animal.

By now the model should be resting on the bench, or on a block of wood but still with the arm taking some of the weight. Now the mould will be applied in the form of a fine layer of rubberised material which is often applied in a spray compressor so that the fine liquid can penetrate into every nook and cranny, however small, so that the finished work reflects every minute detail.

The thirty-four captioned colour photographs overleaf continue the modern casting process through to the finished bronze.

# A Colour Guide to Bronze Casting

## The Lost Wax Method

This series of illustrations is intended as a visual guide to each separate stage of modelling and casting. Whereas the text on pp.16-21 goes into detail of 19th and early 20th century techniques, of necessity this modern photographic guide discusses up-to-date methods. Wherever possible the illustrations have been chosen to show one model at each stage of production. The work is a model of a prancing Arab stallion by Annette Yarrow. Photographs by John Elliott.

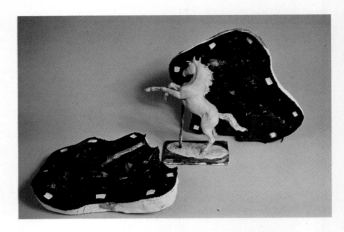

**Figure 2.** The plasticine original is taken out of the mould made from layers of black polysulphide, a material with a lot of flexibility. The overall shape of the horse is preserved by the hardened plaster jacket. Gelatine would have been used instead of polysulphide in the past.

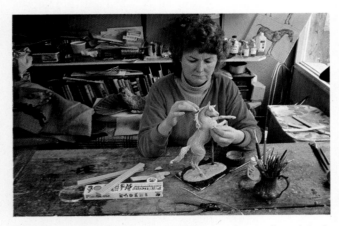

**Figure 1.** Annette putting the finishing touches to the original model, worked up today in ordinary plasticine. An armature inside supports the model, as does wire visible underneath the animal's forelegs. With her own horses in a field outside, immediately visible through the window on her left, Annette's source of inspiration is never far away. Previously a plaster cast would be made from the clay model to be used as a mould for the wax.

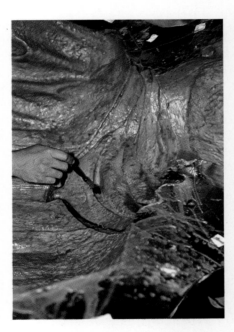

**Figure 3.** The flexibility of the polysulphide is clearly illustrated here. The keys which help bind the halves of the mould together can also be seen helping to form a key for the next stage of slush pouring.

**Figure 4.** Initial layers of hot wax are applied to the black polysulphide layer. The wax is coloured green making it less translucent and consequently easier to work on, see Figure 9. This is in fact a far larger mould, taken from a different model, but the technique used is identical. In fact this size, about 120cm (4ft.) high is about as large as lost wax models can be cast. Larger sizes have to be cast in sand, see Figure 24. The wax layers inside the mould are very thin and soon dry, then the mould is pinned together, leaving a hollow space the size and shape of the desired model. Molten wax is now poured into the upturned mould and quickly poured out again. This is done several times, each layer of wax acting as an adhesive key for the next layer. This is called 'slush casting' and leaves a thin, hollow wax model.

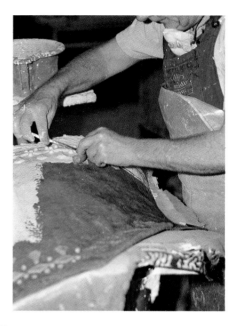

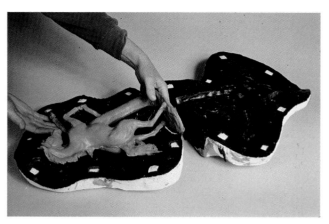

**Figure 6.** The mould is now broken open and the thin wax model carefully lifted out. It should be stressed that at this stage the wax is hollow and consequently very light and fragile. Here Annette is lifting the wax herself, although the pouring would be done by the artisans at the foundry.

**Figure 5.** A minor repair is made to a small detail on a saddle rug which became loose whilst applying the wax. This is for a sand cast of a life-size group of an Arab Horseman by Annette Yarrow, commissioned by the King of Jordan.

## The Wax Model

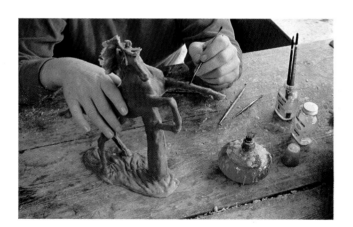

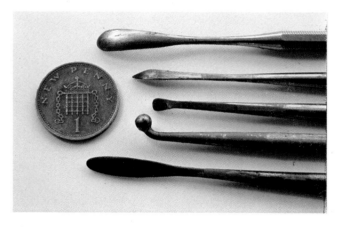

**Figure 7.** The fragile wax model has been taken back to the sculptor's studio where it can be worked on at leisure. The seams that form along the joins of the two halves of the mould are the first part to be worked on and all traces of the seam must be removed so that they do not show up in the bronze cast. Surgical tools are favoured by many sculptors for this process and they are gently heated by the flame of a methylated spirit burner so that they cut quickly and smoothly into the hardened wax. Fine brushes dipped in turpentine are also used to smooth over parts of the softened wax as necessary.

**Figure 8.** Here is a selection of tools specially designed for working on wax, with a new penny to show the scale. The touching up of the wax mould is a highly critical stage for the sculptor as the final outcome of the bronze cast depends on the detail and finish that the sculptor adds to the wax, either to restore the wax to the distinction of detail in the plasticine or to add minute detail. The eyes are a critical point of any animal sculpture and much attention must be paid to them at this stage. Some sculptors have their own specially designed tools; Rembrandt Bugatti (q.v.) designed his own tools which were precision made at his brother Ettore's famous car making factory, opened at Molsheim in 1909.

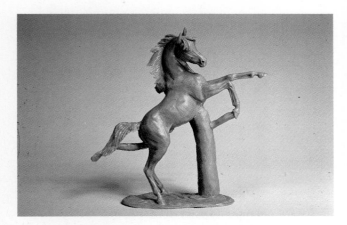

**Figure 9.** The completed wax model, finished to the sculptor's exacting specifications. The model is still hollow with the large support formed by the original model's armature still in place. The wax has been stained green at the first stage to stop the natural transluscence of the material so that the sculptor and foundry worker do not 'see through' the wax when working on it.

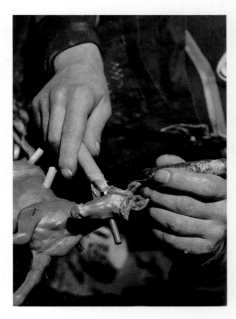

**Figure 10.** Here the skilled work of applying the solid wax runners and risers to the wax is taking place, normally a foundryman's job. The runners form channels for pouring the molten bronze and the risers are essential to allow the gases from the molten bronze to escape.

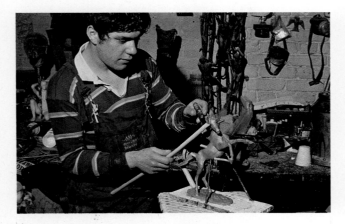

**Figure 11.** The continuation of the same process, melting on the required lengths of undyed wax for the runners and risers. Note that the large centre support has been removed and the model is held up by two wire rods, set at an angle. Also at this stage the supports for the inner core are added, usually in the form of two inch clout nails, pinned into the body of the horse. The grog and plaster core is poured inside the wax and allowed to dry out.

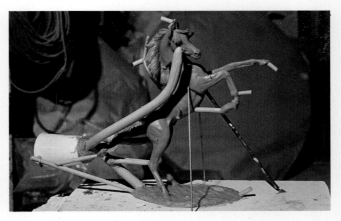

**Figure 12.** The wax model ready to be invested prior to melting out the wax. The complicated series of runners (the thicker tubes) and risers (the thin tubes) clearly visible. The risers have to be thoughtfully placed to allow the gases from the flowing bronze out, thus allowing the molten metal to quickly follow the gas, filling every nook and cranny before the metal rapidly cools. The plastic beaker is an amusing and much favoured ready made device acting as the pouring funnel.

# The Investment

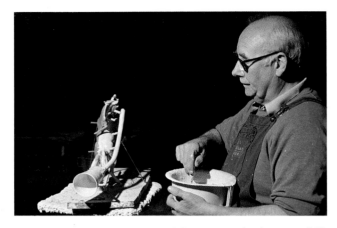

**Figure 13.** The ceramic based investment is then carefully applied by the skilled foundryworker in thin layers painstakingly applied with a soft brush. Here the green of the wax can still just be seen before being completely covered.

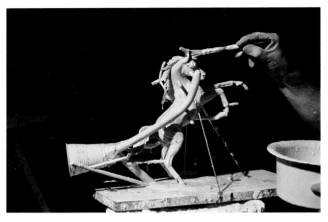

**Figure 14.** A further progression of the same stage, each layer of the investment hardening as it dries out, forming a complete 'protective' shell around the wax. The consistency of investment is often a formula tried and tested by the individual foundries and its composition a closely guarded secret.

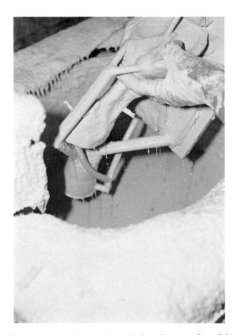

**Figure 15.** Now that the casing is hard enough, although still very thin, it can be dipped in liquid investment to speed up the coating process, thereby saving valuable time. The liquid investment is kept fluid in a revolving drum and one end of a small model such as this can be dipped at a time.

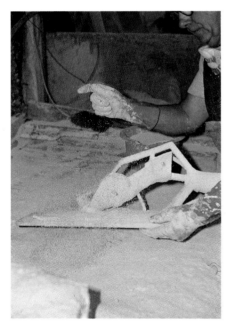

**Figure 16.** After the model is dipped each time it is then liberally coated with a further, rougher investment. This is in the form of a dry powder which is sprinkled over and around the model, the powder adhering to the wet liquid investment. This is a rapid and skilled process as layer upon layer of investment is built up, completely engulphing the original wax model. These laminated layers are built up to approximately 12mm thick before being allowed to thoroughly dry out.

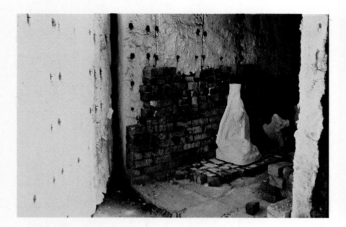

**Figure 17.** The hardened investment cased wax is now placed in the brick lined kiln to melt out the wax model so carefully preserved inside its shell. This is the stage from which the whole process derives its name — the 'lost wax' or '*cire perdue*' stage. The wax is wasted onto the floor of the kiln, melting at the relatively low temperature of approximately 800° centigrade and not therefore harming the very tough investment. It is very important that the wax is *completely* melted out, to avoid a chemical reaction during the pour.

**Figure 18.** The investment casings, by now *completely* devoid of wax and with the inner core supported solely by the iron nails, are bedded into a shutter of sand. The sand is rammed gently around the investment casings and, when sufficient sand has been added to keep the casings firm, carbon dioxide is added, pumped into minute holes in the sand. This instantly hardens the sand making a firm and solid unit.

## The Pour

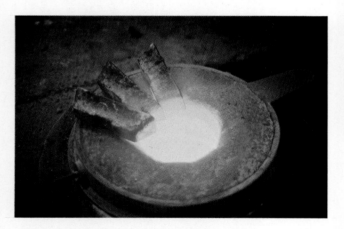

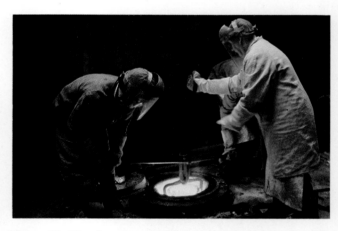

**Figure 20.** Wearing visors and protective clothing against the intense heat, three foundrymen lift out the red hot crucible.

**Figure 19.** Here three ingots of bronze alloy are being pre-heated by the side of a small furnace. At the required time they are put into the crucible and lowered into the furnace and the lid swung over. The bronze ingots melt at approximately 1150° centigrade and at this stage the pour can commence.

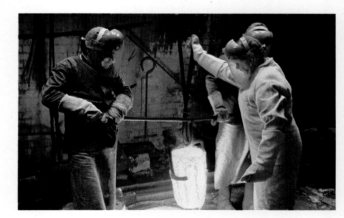

**Figure 21.** The simple lifting tongues grip by force of gravity as the crucible is lifted clear of the furnace and into the pouring ladle.

26

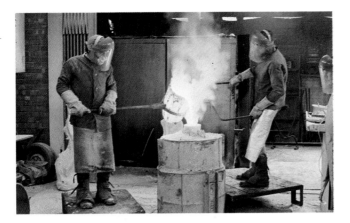

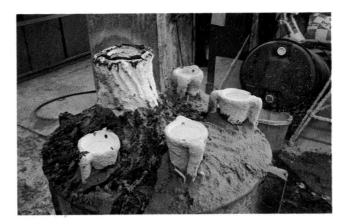

**Figure 22.** The double shank of the pouring tongues or bail allows the exact amount of control for the bronze to be poured into the investment, held firm in its sand clamp within a metal shutter. It is critical at this stage to pour the bronze at exactly the correct speed. Pouring must take place as quickly as possible, keeping the cup full to the brim with the molten metal. A full head of metal will ensure that no dross gets into the pour as oxidised metal will stay around the edge of the cup so that impurities, lighter than the molten metal, will lie on the top of the pour as they must not be allowed to contaminate the bronze. The advantage of speed is that it will not allow air pockets to form. Should this happen the bronze will not flow evenly into the void and this causes problems especially with extremities, particularly the thin legs of animal bronzes.

**Figure 23.** The still red hot bronze cooling in the open neck of the investment. The metal will have reached every part of the hollow casing and must now be left to cool and solidify. There are five casts in this shutter, all having been poured one after the other. The four smaller cases each contain one of Annette Yarrow's rearing horses.

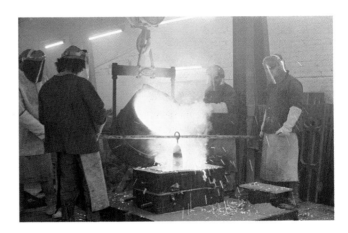

**Figure 24.** For the heavier work models are usually cast in sand and this shows the huge crucible needed for a large pour. It is hoisted out of the furnace by a small crane and swung along a gantry to the sand-filled clamp. The need for protective clothing is clearly illustrated here!

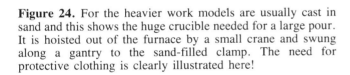

## Finishing and Chasing

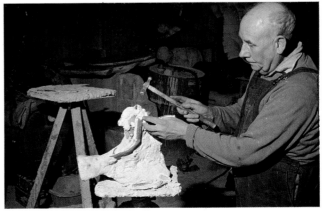

**Figure 25.** The metal cooled, the ceramic investment must now be knocked away from the bronze model inside and its complicated system of runners and vents. One of the two main runners can just be seen in front of the investment.

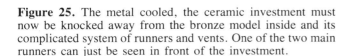

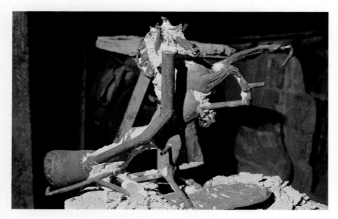

**Figure 26.** As all the investment is broken off, we get a first glimpse of the final model. The runners and risers are still attached and even the disposable cup, used as a funnel for the pour. All the detail that the sculptor worked into the plasticine model and corrected on the wax will be there, down to the smallest line of hair or band of muscle. Now all the attachments must be cut away and today this is done with power tools to save time and expense. The bronze vents are cut as close as possible to the body of the model to save as much of the more laborious hand filing as possible, but at the same time if cut too close the model itself may be damaged or grazed. The tubular pins, clearly visible here, are the pins used to support the inner core after the wax has been melted out and in this instance tubes have been used rather than the less sophisticated clout nails. There are over twenty cuts to be made on this small model and after this is complete, the final stages of finishing may begin.

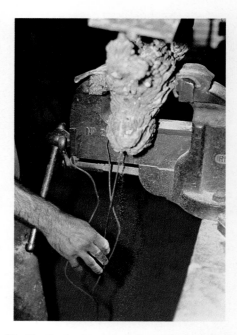

**Figure 27.** Firstly the inner core has to be raked out. It is not possible to leave the core inside as it could affect the bronze at a later date. Should it ever become damp it would have a subsequent effect on the patination. A hole has to be cut into the model and here it has been done at the top of the head but more common practice would be for the hole to be cut under the belly of the animal. This was especially so in the 19th century and most of P.J. Mêne's horse models have a tell-tale rectangle brazed into the stomach to patch up the hole. The more complicated the model, the more time consuming the raking out.

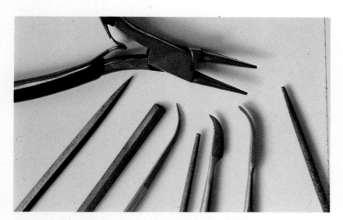

**Figure 28.** A selection of riffler files used for the finishing of the bronze — to smooth off the stumps left from the runners and risers and any bubbles of unwanted bronze detail. Some sculptors do their own finishing, or at least supervise the foundry men themselves so that every detail is exactly how the sculptor intended. Power tools are used to save time and money whenever possible, especially for the cruder work of filing down the stumps left by the pour.

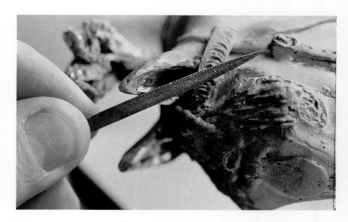

**Figure 29.** Here the minute detail of the horse's mane is being filed to the correct finish and the exact amount of shape being given to the ears. Depending on the type of model and the work put into the original model by the sculptor, there will be a varying amount of filing to be done. Invariably there will be small faults to file out and lines to be emphasised and deepened.

# Patination

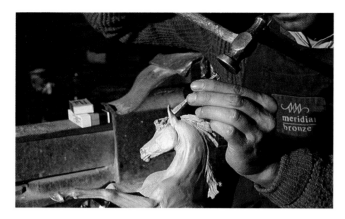

**Figure 30** Lumps by the runners are flattened with a heavy chisel and need a certain amount of force but here the fine detail is being chiselled or chased, giving texture to the surface of the bronze, either the whole surface or selected areas, as required. The model is now ready for the final stage, patination.

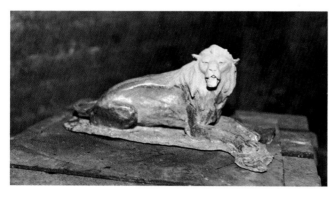

**Figure 32.** This lion, a discarded, faulty cast by another sculptor, was quickly cleaned by the foundry and given a coat of cupric nitrate to produce this bright green colour. It shows a tremendous contrast between the raw bronze and the desired colour which took no longer than a few minutes to achieve. In this simple example the patination is no more than a painting exercise, using heat as a bond. The bronze is still warm to the touch here from the burner and the colour not stable. It eventually dulled slightly but it will be some time before the colour can be considered stable as further oxidisation takes place.

Patination is a process to speed up the natural oxidisation of the raw bronze, controlling the colour as the sculptor directs. It is very difficult to achieve exactly the same colour every time as climatic and atmospheric conditions play a large part in a colouring process in which the actual final shade is somewhat a controlled hit-and-miss affair.

**Figure 34.** Annette Yarrow's bronze of a rearing stallion shows the tremendous detail which may be achieved by the *cire perdue* process.

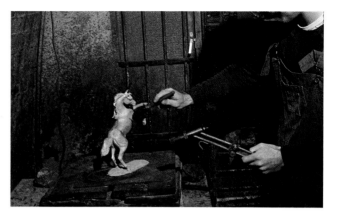

**Figure 31.** The cleaned and finished bronze is placed on a turntable and heated with a blowtorch. Then the correct colour can be achieved by applying the desired acid and alkali to the hot metal, for example the black so popular at the beginning of the 20th century was achieved by applying ammonia. The colours can range from black, though all the hues of brown, greens and blues can also be applied to almost any shade. A stippled or mottled effect can be attained by dabbling the brush on the bronze and many sculptors required one or more layers of colour to achieve the desired combination of colour and effect.

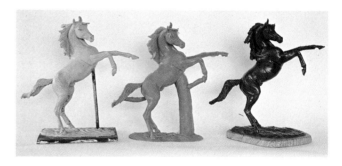

**Figure 33.** Three stages of the making of a bronze.
Left: the plasticine model, worked entirely by the sculptor.
Centre: the hollow wax model, made by the foundry for the sculptor to finish to the required standard.
Right: the finished and patinated bronze.

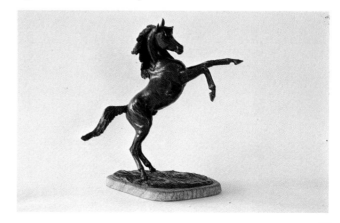

# Sand Casting

One simple way of understanding the sand casting process is to imagine putting ones foot into damp sand on the beach and then pouring molten bronze into the impression. The bronze will very quickly harden and slowly cool and can be lifted out to reveal an exact low relief model of the sole of a foot albeit slightly smaller than the 'mould' due to the shrinkage of the molten metal when cold. Its application is not often seen today but it was in common use for creating features of foundry work in the casting of animal bronzes in the 19th century.

Many animal bronzes were cast in sand by clockmakers who required large numbers of repeat orders during the Louis-Philippe period. The severe Empire clock cases changed with the evolution of the romantic era and the cases became more elaborate, cast in the *Style Troubadour,* a delightfully eclectic mixture of 16th century gothic and 17th century baroque. At first elaborate sand cast figures surmounted the dials but soon animal bronzes, especially horses, became fashionable. These were also cast in sand and extra numbers were cast to be sold separately, to satisfy the growing demand for animal sculpture. Many fitted loosely on the top of clock cases and have become separated over the years. These early sand casts were replaced by the lost wax models as the business of the established sculptors took over, people like Mêne with their own foundry, and Barye and Fratin using outside foundries, like Barbédienne and the Susse Brothers. The early sand casts are easily identified by their varnished patination, smooth finishing and slightly naïve posture, the horses with thin, long faces, akin to the style of the English 'primitive' animal paintings of the same period.

French immigrants, perhaps refugees from the political instability in their own country, brought sand casting techniques to England during the first half of the 19th century. By the 1860s English foundries, notably Elkington & Co., began hand casting, mainly for monumental works, employing English foundrymen who had learnt their skill from the previous generation of French technicians. Large editions of high quality were produced cheaply by this method, employing large numbers of skilled artisans.

A slightly more sophisticated process is the 'closed box' or 'flask' method requiring not only mechanical skills but also a high degree of manual dexterity skill difficult to find today. The connsumate skill, fine balance, technique, and knowledge, combined with what appears to be a certain amount of luck needed for this casting process cannot be learned simply from text books but only by a long and painful process of trial and error. When one realises that the mould will have to include probably at least two or three pieces for the head of a horse, and several for each leg, the body itself cast in two parts, each

requiring its own part moulds, one can appreciate the problems involved. The artist's finished plaster model is laid on its side and an open metal frame or box is placed over it leaving space around all four sides. Fine sand, at the present time usually red Mansfield sand, bound with a small amount of linseed oil is then rammed into the frame to the top over the model. Care must be taken not to ram too hard as the plaster model may break or move within the box thus leaving gaps between some of the edges of the plaster and the sand. A temporary solid is now formed and the frame and model, compacted together, can now be gently lifted and turned over on the workbench. The very thought of this from an amateur point of view is horrifying as one slip, or even the slightest hesitation in turning the open frame will collapse the sand allowing the plaster model to slip and even possibly fall out.

The underside of the plaster model is now exposed and a parting agent of French chalk is liberally sprinkled over the smooth surface of the sand and the model and any empty frame placed over the top, exactly conforming to the size and shape of the first frame. The second frame is then gently rammed with sand, completely encasing the plaster model, and then the two frames or boxes of sand are separated and placed side by side. This will leave the plaster in one section of the frame, the skill of the foundryman determining that it is left in the lower half so that it is not lifted. The plaster pattern is then removed very carefully so that the sand does not kick, leaving a negative impression of the model in each half of the separated box.

Two grooves are then cut by raking away sand from the edge of the impression left by the model, and lead to existing semi-circular holes already formed at either side of the box and this process is repeated on exactly the same place on the other half of the frame. The two prepared frames are then joined together again to form a box or flask, each side with its packed sand coming together with a void in between which exactly takes the form of the plaster pattern and the semi-circular channels or grooves cut in each side of the frames join to make circular channels, one called a 'sprue' into which the molten bronze will be poured and the other an air vent. Once the molten bronze at a temperature of approximately 850⁰ centigrade has been carried with the aid of a shank or bail in its crucible to the completed flask, which by now has been placed on the floor, it is quickly poured into the sprue by the means of a simple sand funnel or collar which has had a finger poked through it to reach the channel of the sprue. The molten metal is poured into the sprue until it fills all the spaces left inside and appears in the air vent. The bronze very quickly cools enough for the frames to be separated, the new casting can then be removed, the runner from the sprue and the riser from the air vent

are then sawn off. This is a comparatively inexpensive method of casting *in the solid,* even today, but nowadays is considered too expensive and time consuming for casting animal models or even figures, the complicated shapes make them very difficult to remove from the sand without causing kicking and disturbing the impression. It is desirable to cast an animal with a hollow interior in order to avoid the excessive use of expensive bronze and to avoid unnecessary weight and the possibility of the mass of metal cracking when cooling. Casting hollow models by the sand method is certainly possible and the photographs clearly show a small model attributed to Theodore Gechter, who favoured this method of casting in the 1830s and 1840s. The technique requires skillful design and planning of all the composite parts, which can be subsequently riveted or, more commonly bolted together.

Hollow casts need to be very carefully prepared and often take a considerable amount of time on the part of the highly skilled moulder. Very careful scaling is needed to make a core that exactly follows the form, if not the fine detail, of the plaster model. This core is supported on an armature which is packed and carefully rammed with sand having been placed in the mother mould. Space has to be cut around the core to allow the bronze to flow so that it can form a skin over the core, picking up the exact form and detail of the negative mother mould as well. The skill needed in cutting away compacted sand to a uniform degree is very great. The core must then be lowered into one half of the frame, carefully supported on an arrangement of gates, vents and the actual supports for the core itself. The other half of the flask or frame is then put into position over the lower half and the core is then firmly in place inside its carefully modelled sand cage. The molten metal is then poured in the flask through the upper gate in the same way as for a simple solid cast. The metal quickly flows, filling all the available gaps between outer sand negative and the inner, slightly smaller positive. The cast model is then finshed in the normal way.

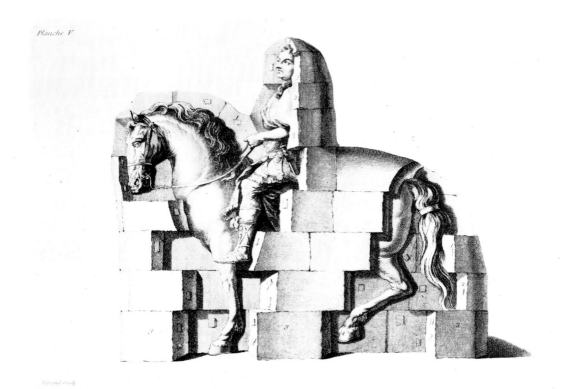

**Figure 35.** A famous engraving of an equestrian group of Louis XIV, illustrating the complexities of sand casting on a large scale. Each block has to be individually shaped and numbered, making a negative shell around the whole group. This necessitates an enormous amount of time and skill but in principle is still the method used for large sand casts today.

**Figures 36 and 37.** Here a large plaster model of a horse is in the initial stages of preparation of the sand mould. Hundreds of small sections or blocks of sand are laboriously formed by gently ramming the sand firm. A highly skilled job, requiring much patience.

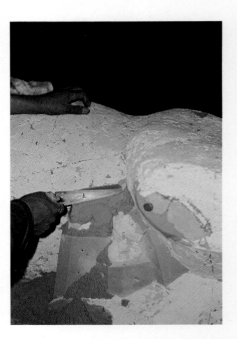

**Figure 38.** A gauze bag containing a parting agent is shaken over blocks of sand that have already been shaped. This helps to separate the sand blocks from the plaster model and the blocks from each other so that the whole sand negative can be easily dismantled, block by block, to remove the plaster. The small holes are inserted into the soft sand with a wire and $CO_2$ is fed in through the holes to solidify the sand, making hard, manageable blocks.

**Figure 39.** The sand above the solid blocks is still soft at this stage and a trowel is used to cut the hand compressed sand into the required shape.

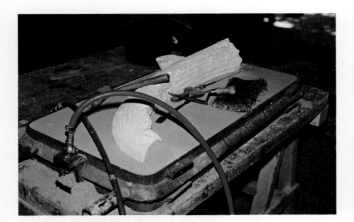

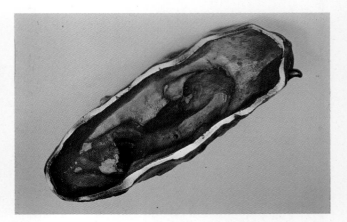

**Figure 40.** This is a section of the tail of the same horse, a model by Elizabeth Frink, with the lower half already embedded in its blocks of sand and held in a fixed pin box. The foundryman is just beginning to build up the sand blocks of the upper section of the exposed tail. The blue hose is for the $CO_2$.

**Figure 41.** The underside of a mid-19th century bronze, looking right into the cast. The thick uneven sides of the base are typical and there is just the correct amount of wear along the bright yellow rim. The yellow is the natural colour of bronze which has been slid along surfaces for the last one hundred years as it has been moved about. In places the cross-hatching from a file used to grind down the uneven rim after casting can be seen. Much of this filing has worn away, leaving a smooth surface but with varying densities of filing still visible. This is a very difficult sign of age to simulate artificially.

34

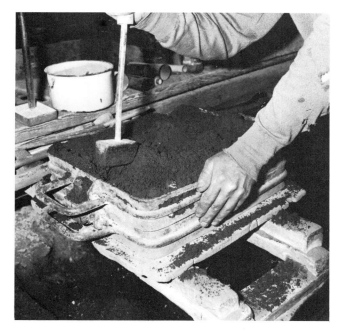

**Figure 42.** Ramming the sand into a loose pin box. If this is done too hard the sand will kick and cause a flaw in the casting. Here the sand is loose and is not carbonated as in figure 40 so great care must be taken when turning the box over to place it on the bottom box, therfore forming a complete mould.

Not all foundries use the latest equipment and power tools. Figures 42-47 illustrate the traditional methods of casting in sand in a foundry handed down over the generations and using skills similarity acquired. Mr. Rees of the B.M.R. Foundry in Battersea casts in iron and bronze, his skills covering the replacement of iron railings to the minute detail of a replacement bronze antler for a 19th century stag.

**Figure 43.** Hundreds of fixed and loose pin boxes are required in a busy foundry. The sand is a silky soft Mansfield sand that has turned black with use.

**Figure 44.** Ladles of various sizes are nostalgically preserved on the wall of the furnace shed although their usefulness was spent generations ago. A large pouring shank or bail, too big for one man to use alone, rests against the wall.

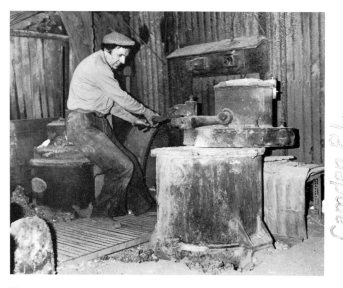

**Figure 45.** Swinging open the furnace lid. Here bronze will be heated to about 850° centigrade. To pour iron it must be considerably hotter at about 950° centigrade.

35

**Figure 46.** The furnace is a very old one, coke fired but now converted to electricity to form the initial heat. The heat is naturally intense and so the shed in which it is housed is kept open down one side.

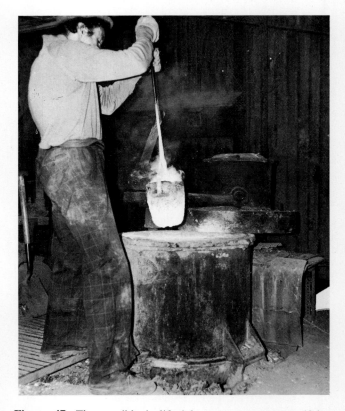

**Figure 47.** The crucible is lifted by one man — a terrifying procedure, especially without protective masks, clothing and boots! The metal will take some time to cool but the pour must be effected as soon as possible so that the metal will flow quickly into the cup of the prepared boxes.

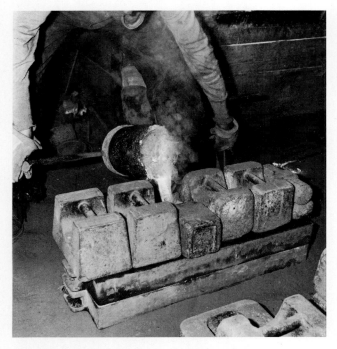

**Figure 48.** The crucible has been transferred into a bail so that it can be easily tipped to control the pour, keeping a good head of bronze in the cup. The two boxes of carefully shaped sand have no top or bottom, each forming one half of the mould, the sand rammed into shape, leaving the desired void inside. This is for a solid cast in this instance so there is no need for a core. The boxes are kept firmly in place by weights weighing well over two hundred pounds.

36

# Substitute Casting Materials

## Spelter

Bronze was an expensive material in the 19th century and two basic substitutes were used, spelter and cast-iron.

Spelter is a mixture of impure zinc alloyed with other soft metals and has a lower melting point to that of bronze. Often termed white metal as a result of its greyish/white colour, it was used extensively in the 19th century for sculpture and for other artefacts commonly made in bronze, for example clock cases. Far softer than bronze, extremities can be bent by hand to some degree and cracking can be detected. It is very difficult to patinate properly. Invented circa 1850, spelter was employed at the Great Exhibition in 1851 for a large equestrian group of an 'Amazon defending Herself against a Tiger' by the German sculptor August Kiss (H165). Generally thought to have been discovered in Berlin, the process was perfected there and another German, Geiss, devised a process for simulating bronze patination on spelter, a process, however, that does not stand the test of time, as discussed under 'Patination' on p.40. Many of Mêne's models were cast in spelter and these are most probably German or English casts. Some of these casts look quite convincing but the models lack life and are often thin and rather sad looking animals. Commonly the patination is a very dull, almost black, the only colour that does not encourage pitting on the surface.

Many spelter casts are by the 'slush casting' method and were popular as cheap souvenirs in the 19th century and still are today, the most common examples being the Eiffel Tower and the Empire State Building. A good example of this technique, electroplated in copper, is illustrated on p.264 as F9. Such a model is cast by working up the rocky outcrop in clay, then a real lizard is carefully mounted in the correct position. A grog solution, made up of two parts china and one part plaster is poured over the model, held by wooden shutters. The grog goes off quite quickly and, after removing the lizard and clay, is fired. The hardened grog negative, looking like the investment of a lost wax model, is then held upside down to receive a pour of spelter. The molten metal cools rapidly at its outer edge and, with skill and fine judgement, the remainder of the partly cooled metal is poured out, leaving a layer of cold spelter about 3mm thick. The investment is then broken away, leaving a simple model in whitish/grey alloy, unpatinated and hollow on the underside.

The lizard, therefore, is probably a *pièce unique*. Slush casts by definition are for economic large scale production and would normally be cast in cast-iron moulds. Costs are saved by the possibility of repetition, cheaper base metals and the lower melting point of spelter, saving on fuel costs and models made by this process do not need a core, which saves an enormous amount of labour.

Generally spelter models are lighter than bronze models of

equivalent size but this is a dangerous rule to use without qualification — to say immediately 'its too heavy for spelter' is a mistake as more often than not the founder (or more properly manufacturer) loaded the bases with plaster of Paris to give them weight and then put baize over the base to cover up their deed. Also spelter models are often given marble or heavy wooden bases to disguise the weight. If the eye cannot pick up the lack-lustre look of a spelter model then touch will soon come to the rescue. Unlike bronze, spelter has virtually no ring and has a very dead feel to it, especially when tapped with a fingernail. It is much warmer to the touch than the very cold feel of bronze. Armed with these facts, spelter should not be difficult to detect but, if all fails and with permission of saleroom or vendor a light scratch with a sharp object inside the underneath of the base will reveal that tell-tale grey gleam, like that of pewter. In fact most of the more difficult cases seen by the author already have one or more scratches made as this 'bronze' has changed hands over the years!

It is perfectly acceptable to collect spelter models although their range is limited to a very few animal models. At the moment, the collector must be content with a very low return on his investment as most people shy away at the very sound of the word, but in the long term they may become more popular.

The Mêne models most often seen in spelter, are the model of 'l'Accolade' and greyhound figures and groups. A good spelter full-size cast of the former can now realise over £500, whereas it would have been almost unsaleable in the early 1970s.

## Cast-Iron

Cast-iron was a comparatively popular substitute for bronze during the 19th century mainly in Great Britain and Russia. There is one rather obvious test that can be made to this ferrous metal and that is to test it with a magnet. If it sticks it is iron! It is quite useful when viewing a large bronze sale to carry a magnet and essential in the early hours at Bermondsey Market!

Another obvious but nevertheless useful point when looking at a suspected cast-iron model is to look for traces of rust, especially underneath the base around the retaining nuts and bolts.

A very similar technique to sand casting is used with the closed box or flask method being employed. In the 19th century French sand was again considered to be very good, mostly silex with small quantities of alumina. German foundries perfected the use of sand from the Harz mountain area. This mixture is porous enough to allow any gases to escape through the sand from the molten metal. Interestingly, the loam used for the core in iron casting was always mainly alumina

mixed with a little silex. The metal was commonly poured while the sand was slightly wet or 'green'. French foundries used three different varieties of sand for fine casting.

In casting iron sculpture in the round, which naturally includes animal casting, then at least three segments of cast are required. Charcoal was often used to stop the sand adhering to the metal as it was poured. In the very large castings the sand was keyed by a complex arrangement of pins and wires to keep the sand together.

The Coakbrookdale Iron Foundry in Staffordshire cast iron animalier works in the latter half of the 19th and at the beginning of the 20th century. Only a few are signed but another factory, the Falkirk Iron Foundry, on the banks of the river Carron near Glasgow, invariably signed their work. Both foundries almost exclusively cast the work of the prolific and enterprising Mêne and this must have been done with the knowledge of the sculptor himself or of his family. Interestingly however the iron Mêne models are never signed, even though in some recorded cases they measure up to be cast from a cast, suggesting that care was taken to erase the signature in the iron cast. The full-size version of Mêne's 'Accolade' in cast-iron illustrated on p.304 was seen by the author (in use as a door stop) in Melbourne, Australia. This may be a one-off case but it leaves the interesting speculation that Coalbrookdale, who cast many thousands of sections of cast-iron railings for use in Australia in the 19th century which were shipped out as ballast in the ships bringing grain back to England, sometimes included items of sophisticated sculpture!

Russian foundries are known to have copied Mêne's work at the end of the 19th and the beginning of the 20th centuries. These incorporate the sculptor's signature but always have a small plaque, inscribed in Cyrillic, usually affixed to the underside of the base.

Cast-iron models can be finished to a high standard but rarely reach the quality of the more tactile bronzes. Detail tends to be softer, as would be expected from a cast, and patination is usually a dull and lifeless black. Prices tend to be approximately a quarter of the bronze equivalent model as a general rule, although the recent emergence of one or two collectors seemingly building up a selection of iron models may, if only temporarily inflate this tendency. Good examples are well worth buying but do not drop them. Cast-iron is very brittle and will shatter easily and, although it can now be repaired by modern methods, it will be at a cost out of proportion to the value of the model. Charcoal made cast-iron is especially brittle.

In general the practice of iron casting developed dramatically in the third quarter of the 19th century, a fact commented on by George Wallis in his report on Bronzes, Art Castings and Repoussé Work at the 1867 Paris Exhibition.

# Cold Casts

With the advent of high quality resins in recent years, the 'cold-cast' 'bronze' has largely taken the place of spelter and cast-iron substitutes. A rubber mould can be easily taken from existing bronze into which is poured the resin mixture with added coloured bronze powder to achieve the desired 'patina'. Green patination is easily achieved by using ammonia. The resin can be heated on a domestic burner and is easy to pour. It flows very quickly and evenly to all corners of the mould, picking up even the minutest detail of the original, and gives a sharp finish. The colour is always an even, usually rich milk chocolate, brown which lacks the lustre or depth of colour of bronze or the gleam of the finely finished and patinated *cire perdue* bronze. Wire wool is rubbed over the proud parts of the cast to give an impression of wear and age, leaving brassy looking highlights which are totally unconvincing to the experienced eye.

Gayrard's Irish Wolfhound, illustrated on p.232, was an unfortunate victim of this process in the 1970s and, at one stage a cold-cast modern copy of this bronze was being brought into Sotheby's almost every week, most of which had been bought at street markets by the uninitiated as 'genuine'. This particular model was often very heavy and one, sent unsolicited to Sotheby's by post, arrived damaged and was found to have a 'core' of lead shot! Again if the purchaser had asked to take off at least part of the baize lining on the base and seen that the cast was solid he would have immediately have been warned of his impending folly.

It is important to point out that there are various manufacturers today producing numerous models in cold-cast material but original models and quite often in sensible limited editions. These are perfectly legitimate and, if they appeal, there is no reason why they should not be collected.

# Patination

The uninitiated will be surprised to see the raw brassy colour of the as yet unfinished bronze which must now be coloured to the desired patination of one or more colours. A highly informative and technical book, *The Colouring, Browning and Patination of Metals* by Richard Hughes and Michael Rowe (Crafts Council 1982), is excellent and technical further reading for anyone wishing to experiment with patination themselves.

There are a number of methods and chemicals which can be used and one of the most popular ones and one that can be eventually attempted by an enthusiastic but skilled amateur is described below. However, it is not recommended that a perfectly coloured horse by Mêne of the mid-19th century should be repatinated purely for

experimental purposes! The bronze is heated a small area at a time with a blow lamp and stippled with a small paint brush with a solution of sulphurated potash or liver of sulphur, the proportion is a piece of a potash about the size of a pea to 5oz. of water. The heat level should be sufficient to evaporate the solution just as the brush touches the bronze. If a chocolate brown colour is preferred, ferric chloride can be used as opposed to the brown/black patination given by potash. The bronze is now left for approximately twenty-four hours in a warm, dry atmosphere and is then brushed and if necessary washed to leech away all corrosive elements. This has obvious importance because if the corrosion erupts at a later date it will be extremely unsightly and will also be an obvious pointer that the bronze has been recently patinated. One would not expect a 19th century bronze to show traces of patination corrosion. The piece is then slightly heated and laquered or, more commonly, a thin coating of beeswax applied, which when cool can be polished to give a high gloss appearance. It will be appreciated that the whole process, to be successful, requires a considerable amount of experience and skill. Bronzes of varying size and of slightly different alloys will react unpredictably to the heat and chemicals. Patinating was said to have been a five to seven year apprenticeship in the 19th century and methods employed were often a closely guarded secret with many brews of exotic and mundane materials used to 'smoke' a patination if the chemical method was not being used. Many old bronzes have had their patination spoilt by over cleaning or neglect, i.e. storing in damp cellars or by being used as garden ornaments, and before adopting the foregoing method it is essential that they be thoroughly cleaned and de-greased in an acid bath and then polished with a mildly abrasive material.

One 19th century method of patination consisted of warming the bronze in the sun or by a fire and running a solution of salammoniac (2 drachms), ½oz. of binoxalate of potash and 14oz. of distilled vinegar over it. The use of a camel hair brush squeezed by the fingers aids the process. To obtain the antique green colour, salammoniac, cream of tartar, salt and hot water were used! The increase or decrease of the amount of salt could vary the hues from blue to yellow.

Colours range from black, through brown and red brown and vary from sculptor to sculptor. Barye preferred dark greens whereas the work of Moigniez or Mêne was sometimes black or silver-plated and, in the case of Moigniez, even gilt. Occasionally the sculptor has achieved a delightful shading of greens and browns by applying colours in layers.

It is interesting to note how frequently the patination of one particular model or group is always a consistent colour, or as consistent as possible, given the fact that atmospheric conditions that

vary from day to day will affect the colouration. The Paris animaliers' models are nearly always the same colour and this is especially so in the case of Pierre-Jules Mêne's work. His 'Chasseur africain', illustrated in colour (Plate 10, p.271) is nearly always a rich brown colour and his 'Jument arabe et son poulain' (Plate 12, p.281) always has a black overtone on rich copper-brown.

Patination is a very important part of the bronze model, the difference between a dull black and a rich brown can make or break the look of an animal and it is the dull blacks of the cast-iron models that amongst other reasons keep their price down. Many of the silvered or gilt-bronze models, so popular with the advent of electroplating in the mid-19th century, have been stripped of their original colouring and re-patinated to suit modern tastes. A re-patinated example will rarely have the same depth of colour as an old bronze as patination takes many years to become stable and even then, the patination is improved by handling, waxing and dusting.

## How Many Were Cast?

Little is known about the numbers of various models originally cast; some were perhaps part of a limited edition, at other times only a few may have been cast if they did not prove popular and sometimes only a single model was cast if for example a wealthy owner required a bronze of his favourite race horse. An instance of this is the model of 'Controversy', sculpted by Sir Edgar Boehm, commissioned by Hannah Rothschild as a gift to Lord Rosebery in 1878, the year of their marriage. It is documented that fifty of the Queen Victoria equestrian groups by Thomas Thornycroft were cast and the artist was said to have taken an active part in the foundry work at the Art Union Foundry on this occasion. It is believed that five reductions of the Gordon monument by Edward Onslow Ford (General Gordon mounted on his camel, illustrated on p.119) were made, one for each of the founder's five sons.

Many of the P.J. Mêne small animal models were cast in considerable numbers due to their popularity and he must have perfected a semi-industrialised method of turning out large numbers. In these cases the earlier casts of the 'run' would be finer casts with a lot more detail and sharpness than the later models, as the detail became worn on the mould. Sometimes the moulds would be worked on as they became worn and this produced a slightly different crispness of that detail which is difficult to spot but can be seen by the sharp eyed collector. However this has the distinct advantage of

allowing many small collectors to be able to afford decorative genuine 19th century bronzes at reasonable prices. As their knowledge and taste develop then perhaps collectors can buy a rarer model by Mêne or a rarer model by a sculptor such as Barye who cast in considerably smaller numbers.

Later 19th century practice by the Foundries Hébrard and Valsuani tended to number casts, at first to forty in any one edition and later to six or, more commonly twelve. Today the popular number for an edition is eleven although cheap recasts are often produced in far larger quantities.

**Figure 49.** A cast by Susse Frères from a Roger Godchaux model, marked 2 out of a limited edition of 5 casts, an uncommon practice until the very end of the 19th century. This has been cast by the *cire perdue* process.

## Later Casts — their morality, manufacture and value

The subject of the copy or, dare it be said, fake, is one of the most difficult to come to terms with and understand. The sculptor himself in most cases only produced the original model, leaving the foundry to cast the actual bronzes. The foundry was perfectly at liberty to continue casting the work and often did so, well after the death of the sculptor, continuing into the 20th century for some of the more popular mid-19th century Paris animalier models. As long as these later casts are so defined and valued accordingly there is nothing wrong with this. The ultimate is of course to collect bronzes that were known to be cast in the sculptor's lifetime and possibly under his supervision but this would restrict the number of collectors and collectable material dramatically. Many Barye models which were sold after his death and subsequently cast, are fine models, valued at only slightly less than the early casts. The frequent *succession* sales after sculptor's deaths allowed the foundries to buy up original models and to continue casting them. When considering the values of these slightly later casts it is often impossible to tell the difference in date and so values are simply judged according to quality and rightly so.

A Paris entrepeneur bought many original Bonheur models in the 1960s from the foundry and had many cast — these are just as good as the 19th century casts and should be valued accordingly. Problems

only arise when modern or later casts are sold as early examples, through ignorance or dishonesty. Many salerooms avoid this problem by simply not dating the cast at all, making the collector decide for himself, not a helpful attitude but at least better than dating the casts irresponsibly. A cast has the same *decorative* value whatever the date; extra points and interest are added for early examples.

The problem is really when a cast is taken from an original cast. In November 1969, Sotheby's held a specialised sale of one collection of eighty animalier bronzes totalling just over £18,000. Mallet of Bourdon House held a selling exhibition of animalier bronzes in 1962. Forty more from one collection were sold at Sotheby's New York in June 1972, a year after Jane Horswell's pioneering book *Bronze Sculpture of Les Animaliers* was published. The subject had become respectable and, what is more, animal bronzes were beginning 'to make money'. (One can rest assured that no forger will take any interest in a subject until the latter condition applies.) The flood gates were opened and a large number of new casts appeared on the market from well-known sources in both London and Paris. The established foundry techniques were still there and the skills were readily employed to produce very good casts indeed, deceiving those without a considerable amount of experience.

Not only is there a lack of detail on a copy, much in the same way that the later models in a long run of casts have worn or less sharp detail, but it is also very difficult for the forger to recreate the carefully applied patination of the 19th century cast. At first sight the modern bronze appears to have a good colour but closer inspection shows the colour is very even, without depth or shading and is often a far too rich milk-chocolate colour. Once one has handled enough old bronzes there is always a newness about a modern copy, especially to the underside of the base. Notably a large percentage of modern copies always seem to be sold with a marble base glued or screwed on, or have the base filled in and a baize-lining glued on so that the underside of the base cannot be inspected, a pointer that should give rise to immediate suspicion until all the relevant criteria have been satisfied. Equally a bronze of poor colour should be treated with suspicion until the collector is satisfied that the colour is just a poor type on a period bronze or an old bronze that has been repatinated, for whatever reason.

But 'a cast from a cast' has one indisputable flaw — quite simply, the size factor. A cast from a cast will always be slightly but significantly smaller than its original mother copy, a rule of thumb is a loss or reduction of about 22mm in 253mm or ⅞in. in 10ins.

A rubber mould is made, in two halves, taken directly from the actual bronze to be copied. A thin layer of wax is brushed onto the

two inner surfaces of the mould, or negatives, a layer up to no more than 2mm thick. The two halves are then put together to form a hollow and molten wax poured in, shaken and then emptied out. This thickens up the 2mm thick wax coating to approximately 4mm and fills the extremities such as the legs, full of solid wax, leaving the centre empty. A core of grog and plaster is put in the resulting cavity whereupon the procedure for casting in the normal way is followed. The reduction in mass by approximately 8.7% is caused by the shrinkage of the wax 'model' or casing when cooling, with further shrinkage when the bronze itself cools. Just as the original bronze is smaller than the model from which it is taken, so a cast taken from a bronze will be smaller than the bronze which is used as 'the model'.

It is quite clear therefore that accurate measuring is essential and really accurate measurements should be taken from known casts in museums and well-established collections. The original sculptors' catalogues are a useful source of information. It is all too easy to stand above a small bronze on a table and measure from a high vantage point, or to measure a larger bronze on the floor, looking down on it, and this can easily result in at least a 10% exaggeration in size in a similiar way to parallax error in a camera viewfinder. It is therefore essential to be at eye level with the top of the bronze and preferable to measure with the aid of a 'T' square or level. Recording of size in the present volume is given by height unless otherwise stated. It is also important to gauge the overall width of the bronze accurately, or the underside of the base. This is an easy, foolproof measurement which should be incorporated in all brochures and catalogues. Even if a marble base has to be removed from a bronze the sharp moulded edges give a very good purchase over which to hook a tape measure.

Most marble and wooden bases on 19th century bronzes were held on by one or more bolts and not glued, and one should be immediately suspicious if the base is firmly glued on. This is a modern practice and covers up a multitude of sins. Old casts have hand cut threads on the bolts that not only retain the base but also hold the legs of the animal to their bronze base. The nuts are also hand cut, erratically square, not the modern hexagonal or octagonal nuts used in less sophisticated more recent casts. But some modern casts now have elaborately made, hand-processed nuts and bolts which makes their detection more difficult.

It is well worth looking at the recasts by the museums who occasionally produce long runs of limited editions of their prize pieces. This has long been an accepted province of the established museums and has been a practice for centuries. The Louvre have cast many Barye models from original models, one of the more recent being his Walking Tiger, modelled in the 1840s and listed in Barye's

first catalogue of 1847. There are over fifteen examples of this cast in museums around the world but as the Louvre own the *modèle* they have issued a modern edition limited to fifty casts available in the United Kingdom. A period cast is illustrated on p.134.

Copying has been a tradition even before the Romans copied Greek models. Thousands of copies of the classic antique bronzes and marbles were cast in the 17th, 18th and 19th centuries and no copyright laws were infringed. The plague of uncertainty that upset the market for animalier bronzes in the 1970s is now over and people have come to terms with later casts and re-casts. Without doubt this uncertainty had an unsettling effect on the prices of the good bronzes which are now beginning to climb out of their depression and hold firm. One must not throw up one's hands in horror if there is a price tremor one year and celebrate if there is a recovery the next. The market has moved upwards considerably over the last ten to fifteen years, and any collector should always be prepared to take the long term view. There is nothing wrong with a later cast as long as it is sold as such, and the collector can learn how to distinguish modern casts masquerading as their 19th century counterparts.

## Prices

The most difficult part of any Price Guide are the prices themselves. Each bronze is an individual object and each has its own unique value on a particular day, whether sold at auction or a gallery.

Today the traditional role of the auctioneer to be an intermediary between vendor and retailer has changed considerably. It is often the case that certain items can realise more at auction than an equivalent model in a shop window. This does not always mean an immediate rush to the lucky dealer, nor is he likely to alter his retail price on the evidence of one good auction figure. Certainly he will point the auction price out to a potential buyer who would be well advised to take the trend at the auction into consideration.

Of course dealers buy at auction and therefore must be allowed a reasonable return on their investment, not only of money but investment of skill and knowledge, their judgment and the enormous overheads of running a business in a large commercial centre.

Prices are stated in this book for almost all models except those whose illustrations have been supplied by museums and similar institutions and some modern examples which do not yet appear regularly in the salerooms. In every case the price is intended as an indication of the value of the actual bronze shown, the bracketed figure encompassing the upper reaches of the possible price, either at

a very good auction, or in the retail trade. Inferior models will fall well below these figures and superior models will realise the top figure and occasionally more. Not everyone will agree with every price but on average they will suit the bronze illustrated. Inevitably these figures will become outdated, some very quickly, some remaining at the same figure for years. The market has picked up enormously in the last two to three years with a surge in prices in the spring of 1985, coinciding with the high value of the dollar. The better models can now achieve prices that begin to compare favourably with paintings of the same period. Barye's work, not surprisingly, provides us with possibly the best example of this belated trend. A single Cheval Turc realised £17,050 at Sotheby's in March 1985. Fashion and demand change as one collector gives up, or another starts buying. If you have found a good bronze that you have been looking for for some time the message is quite simple — buy and enjoy it!

## What Should I Look For?

This is a short summary of points that may be considered the principal features in judging an animal bronze. Learn to trust your own reactions as your experience develops and these points will become instinctive and can then be placed in your own personal order of importance.

i) It must radiate the feeling that it is 'right', a feeling that soon comes with experience.
ii) Look the animal in the eye, the face must look realistic.
iii) Colour: a rich, warm colour, not one that looks as though it could rub off in the hand.
iv) Detail: must be sharp and crisp.
v) Posture: a good sculptor will model with a good, balanced stance.
vi) Weight: 'light is right', 'weight is late'.
vii) The underneath: 'bright is right'.
viii) Is it a known recorded model?
ix) Size: if recorded, undersize models should be investigated.
x) If you feel it is a recast try and see whether the chasing is *in the casting* (which would suggest a recast), or if it is actually worked on the bronze after casting as in a genuine example.

Good hunting!

# Antwerp Zoo

Since the 16th century Antwerp has been a major force in the development of commerce and industry in northern Europe. The centre for the diamond trade, Antwerp brought traders from far afield and great trading ships were attached to this safe and prosperous inland port. The Low Countries reached their zenith in the 17th century, the Dutch control of the seas as a maritime world power and the zeal of her merchantmen in pioneering the eastern trade routes made the whole area financially strong and artistically independent. Fine tapestries, furniture, silver and paintings were produced, backed up by the ever developing diamond trade. The furniture making techniques that were to influence England and subsequently the world waned in the 18th century and the influence of the whole Dutch and Flemish area declined. However, it left a wealthy and still prosperous area which, with the development of the railways in the 19th century, established a firm cultural centre in the town of Antwerp.

The railway and concert hall were in close proximity to the rapidly growing zoo which brought a wide range of exotic animals into the heart of northern Europe just at a time when travel was rapidly developing and the romantic idiom fired the literary and artistic imagination. Just as Barye and Mêne studied their subjects at the Luxemborg Zoo in Paris, painters and sculptors sought inspiration in the zoo at Antwerp. Verboeckhoven, the painter who sculpted in brilliant fashion as a relaxation, was an early visitor to the zoo in the mid-19th century and many others followed his example.

It was Rembrant Bugatti who, moving to Antwerp in 1907, once and for all put the cultural influence of the town on the artistic map. There had been a thriving artristic colony there for some time, where the bohemian way of life was accepted, a way of life that suited Bugatti's temperament ideally.

The zoo was one of the better stocked in the world at that time. There was no shortage of wealth and patrimony in the area and the far ranging African and Asian colonies belonging to the tiny country of Belgium provided a very rich hunting ground for rare and exotic species of mammals, birds and reptiles. The riot of colour, continuous movement and atmosphere of this crowded zoo were an ideal source of inspiration for painters and sculptors. The zoo encouraged artistic interest in its subjects, offering studios in the grounds and complete freedom for all to study the caged animals. The work of the artists and sculptors was frequently exhibited by the Royal Zoological Society, which afforded the lucky ones a living and fostered the artistic ambience in the town. There is no doubt that the international status of the Bugatti family and of Rembrant's status as one of the world's leading animaliers, fostered by his able patron Adrien Hébrard, considerably helped the rise to fame of the zoo as

an artistic centre. Without Bugatti we might only now have been discovering the work of his companion Albéric Collin, or of Arthur Dupon, Josué Dupon, Oscar Jespers or many of the other sculptors and painters who might otherwise have unjustly stayed in provincial backwaters. The illustrator of *The Jungle Book,* Paul Jouve, was also a companion of Bugatti's at the Zoo.

Jaap Kaas, who as a child was fascinated by the zoo, became firmly established as an important animalier sculptor when he returned to Holland at the outbreak of the First World War. He later became Professor of Sculpture and Drawing at the Rotterdam Academy.

The Royal Zoological Society of Belgium founded a biennial Bugatti Prize for Sculpture in 1947. The award is limited to students of animal sculpture at the Higher National Institute of Fine Arts at Antwerp, a thriving academy continuing the work of Barye and Bugatti.

The work of many of the Antwerp sculptors is well represented in the zoo's private collection, which is on display by request and the work of some of these artists is illustrated on pp.50-61 by kind permission of the Belgian Royal Zoological Society, who, with a special fund formed in 1946 started to rebuild the zoo's collection of bronzes, many of which had been taken during the German Occupation to be melted down for the war effort. As it is a museum collection, no attempt has been made to price the sculpture illustrated although it is hoped that the remaining pages of this book will help the reader to establish his or her own ideas about the value of the rarer items. The photographs, taken by the Institut Royal du Patrimoine Artistique for an exhibition at the zoo in 1975, are reproduced by their kindness and co-operation.

The ceiling of the Zoo's Council Chamber, gratuitously painted by Frans Mertens in circa 1949 with a six part scene from the fable of Reinaert the Fox. Starting from the bottom, and reading clockwise the pictures show a. Lamentations for Coppe the Hen. b. Reinaert laughs at Bruno for stealing honey. c. Reinaert confesses to Grimbert the badger. d. Reinaert at the Court of the lion, King Noble. e. The pilgrim Reinaert being shown out by Belyen the ram and Cuwaert the hare. f. King Noble being shown the head of Cuwaert, murdered by Reinaert.

A lifesize figure of a seated cheetah by Collin, which stands outside in the zoological gardens. A magnificent and proud animal, dozing in the sun, its tail curled round its paws like an innocent domestic cat. The constant supply of animal titbits at a zoo inevitably means a large bird population and the subsequent liming of this unlikely perch.

Signed 'Collin' and given by him to the Zoo
116cm (45¾ins.): limed and weathered patination
*c.1910*

An unsigned copy of Pietro Tacca's famous Florentine Boar in the loggia of the New Market first modelled in the early part of the 17th century. This dramatic, rugged cast is well at home with the wide range of 20th century sculpture at the zoo.

133cm (52½ins.): weathered green patination
*Dated 1612*

A dramatic model of a walking leopard, by Collin although there is no record of a signature. It shows a definite move away from the impressionism of Bugatti into the inter-war style of the art deco movement. The smooth lines of the cat's body are given depth by the incising of dramatic, sweeping lines.

79.5cm (31¼ins.): limed and weathered patination
*1920s*

A fine earthenware model of a walking leopard and a snake by Auguste Tremont. The use of earthenware adds an unusual quality to animalier work and the cat is an elegant, stylised animal with a very slinky walk.

Signed 'A. TREMONT': 28cm (11ins.)
*1930s*

There is a distinctly oriental feel about this group by
A.-L. Baggen, helped by the dramatic use of a real ivory tusk.
The tiger is symbolically defending the carcass of the dead
elephant against the snake in an effective and highly individual
group that is well finished and cast.

Founder's mark 'Moyson & Co Anvers'

63cm (24¾ins.):black patination

*c.1900*

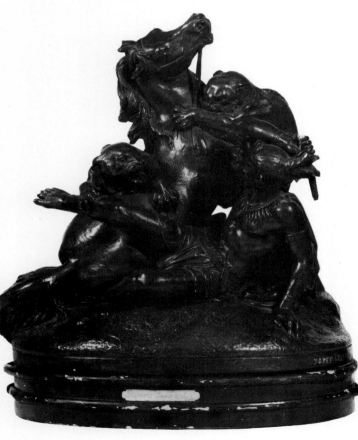

A lively model by Jozef Geefs of a Red Indian and his horse
attacked by a pair of jaguars. This is in fact a plaster model,
coloured to look like a bronze cast and consequently shows all
of the sculptor's intended detailing. This is quite an early
group in style and compares to the style fashionable in Paris
in the third quarter of the 19th century.

Signed 'JOZEF GEEFS': 42cm (16½ins.): bronzed plaster
*c.1860*

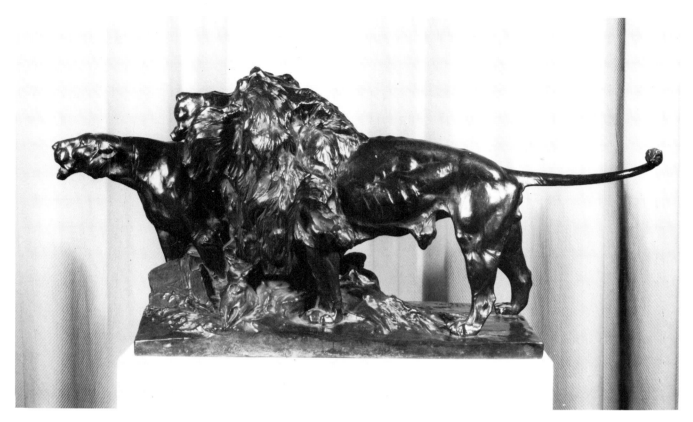

An exciting group of a pair of lions by Josué Dupon combining the dramatic force of Bugatti with an almost Barye-like sense of form and musculature. A most impressive group from a little known and rare sculptor.

<div style="text-align:center">

Signed 'Josué Dupon' and with founder's mark
'A. Van Aerschodt Bruxelles'
49.5cm (19½ins.): rich black patination

</div>

*Dated 1909*

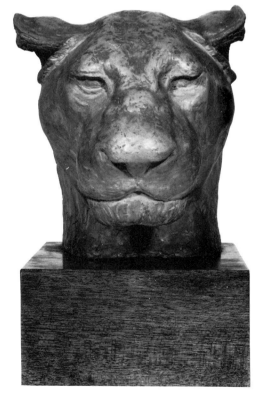

A terracotta model of the head of a lioness by Karel Trompeneers. A good character filled portrait of a lioness called 'Daisy' and given to the Director of the Zoo in 1935.

<div style="text-align:center">

Signed 'K. Trompeneers' and inscribed 'Daisy'
24.5cm (9½ins.)

</div>

*c.1935*

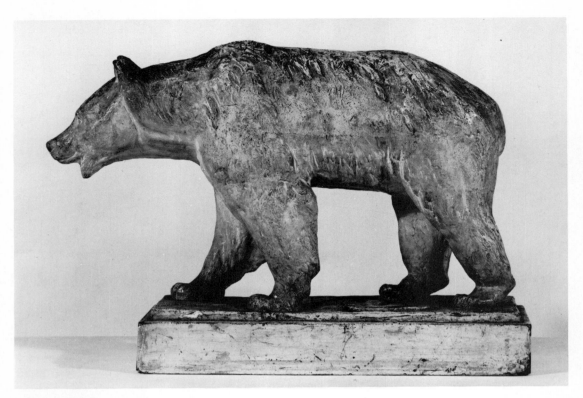

A plaster model of Karel Trompeneers' Brown Bear, given by the sculptor to the zoo. A good, competent model but not very exciting, just a study.

*1930s*                          Signed: 32.2 cm (12¾ ins.)

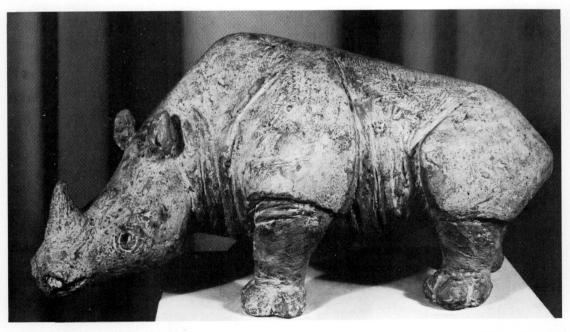

Modern materials have been employed here for this unsigned cement rhinoceros by Oswald Hiery. A perfect material to portray the white rhino in a permanent and stable medium — plaster is always highly susceptible to damage. A very angular model, incorporating both the ideas of Cubism from the beginning of the century and the post war style of Paul Klee.

*1960s*                          39.5cm (15½ ins.)

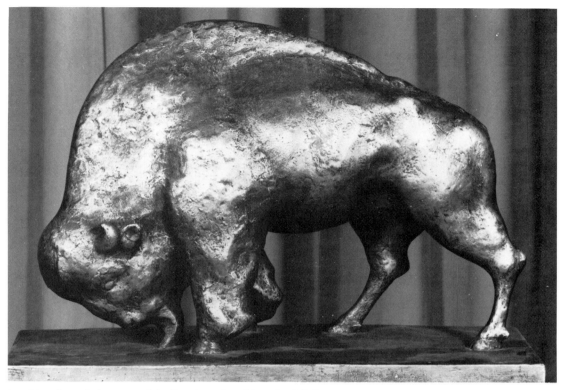

A gold patinated plaster model of an American bison by Olivier Van Dongen. A powerfully modelled animal, worked very loosely, without much attempt at detail or definition. Not an inspired work from an artist who was still developing at the time.
*1960s*       Signed: 40cm (15¾ ins.)

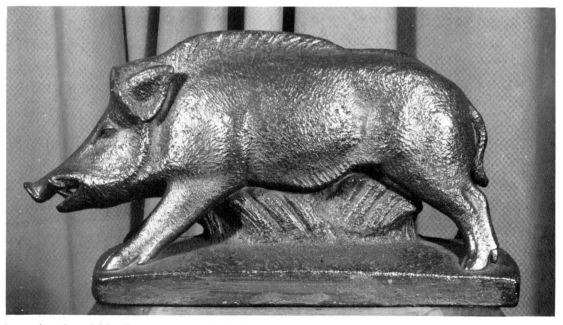

An unsigned model by Tremont, worked this time in terracotta which has been glazed and fired. The style and texture are very similar to that of his leopard on p.51. This sculptor's study of form and movement is in the top rank and his work shows an exciting individuality.
*1930s*`       29cm (11½ins.)

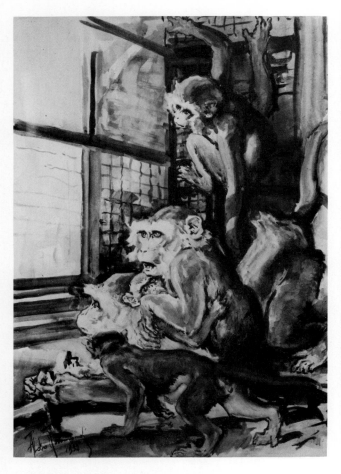

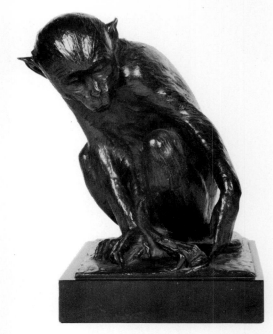

A monkey playing with a frog, a rare and fine model by Frans Jochems, whose work, limited in production, is obviously directly inspired by the Bugatti style and is highly competent. An attractive and amusing group that would appeal to the commercial world were there enough casts to go round!
Signed and with 'Cire Perdue, Bartardy', Brussels seal: rich black patination
*1910-1920*

A watercolour by Aldo Raimondi, born in 1902, of five macaques in a room, looking studiously out of a window. There is a similarity in dimension here with the single monkey in the next illustration.
Signed 'Aldo Raimondi': 100 x 70cm (39½ x 27½ins.)
*Dated 1952*

A wild boar in bronze by Lucien Verlee but unsigned. The stylised primitive form of the animal has the flat, smooth finish of Brancusi's work and the sculptor has sought to delineate the muscles in a watered down style of that used by Collin (p.51). The form is a development of the style of the 1950s but has its roots in Cubism.
22.5 (9ins.)
*1960s*

This highly stylised work of a Bateleur eagle is not immediately recognisable as Collin's work and is much heavier than one would normally expect from him. The detail is also much more roughly textured than normal with bulky feather layers around the neck in a Barye like manner.
Signed with C. Valsuani Cire Perdue seal: 47.5cm. (18¾ins.)
shaded black/green patination
*1920s*

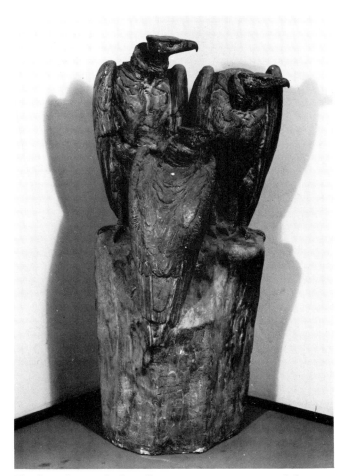

The joy of a zoo is that all creatures are represented there, a fact that appealed to Bugatti, encouraging him to model attractive creatures and the less welcome snakes, lizards and vultures. Frans Jochems, who embodies much of Bugatti's style in his work, continues this idea in this coloured plaster group of three vultures peering ominously from a tree stump.
Signed: 164cm (63ins.): coloured plaster
*Dated '31 (1931)*

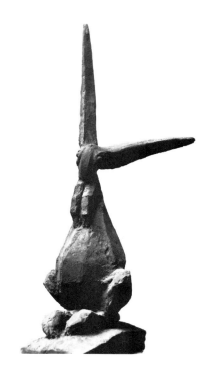

A firm leap into the geometric age of the 20th century with this cheeky model of a hare, with ears pricked, listening alertly, by Oscar Jespers. The angles are dramatically set, especially the left ear of the hare — here the straight and curved contrasting shapes of Sandoz (see p.111) are taken a stage further.
*1930s*

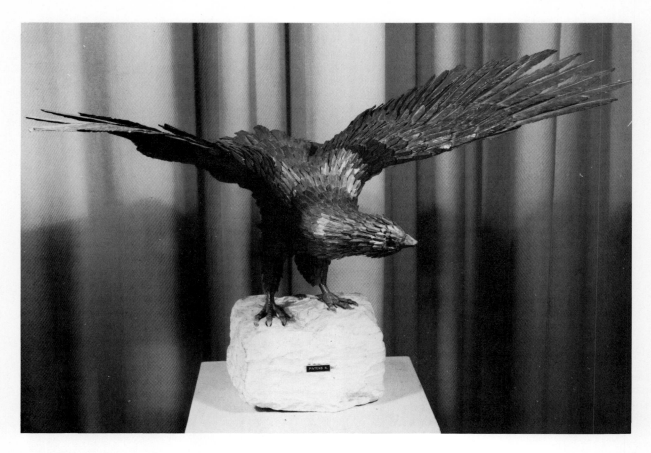

A more recent unsigned bronze eagle, simply titled 'Bird of Prey' by the sculptor Roger Pintens. The highly individual feathering is achieved by applying each individual feather to the main body of the bird in hammered copper, so that this is not a cast at all, but a modern version of *repoussé* work. The copper is unpatinated and so gives a raw red colour to the eagle, which stands on a roughly hewn stone plinth.

46cm high (18ins.): copper red patination
*c.1960*

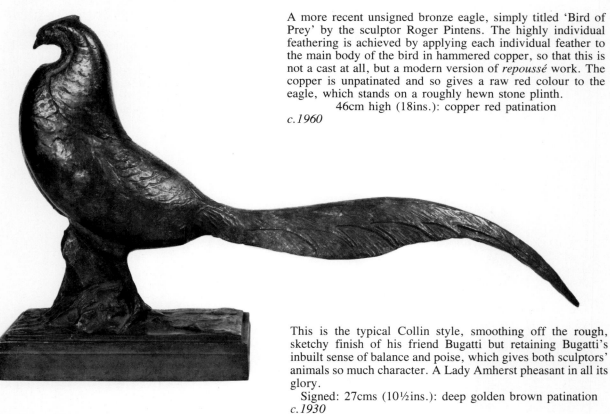

This is the typical Collin style, smoothing off the rough, sketchy finish of his friend Bugatti but retaining Bugatti's inbuilt sense of balance and poise, which gives both sculptors' animals so much character. A Lady Amherst pheasant in all its glory.

Signed: 27cms (10½ins.): deep golden brown patination
*c.1930*

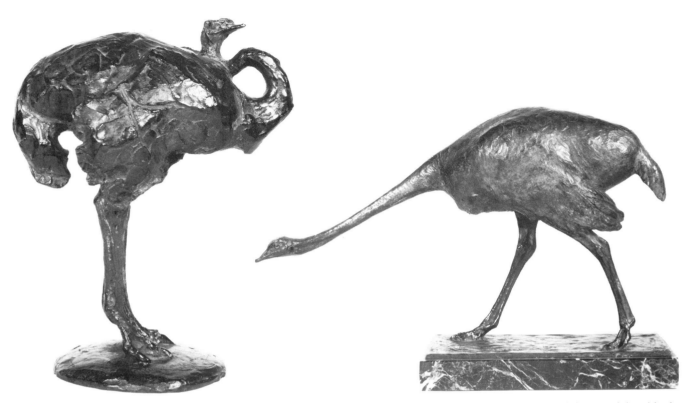

A Collin ostrich, cast by Valsuani and in a style that is very similar to that of Bugatti. The bird is heavier than Bugatti would normally portray, without the same poise but otherwise there is little difference.
Signed 'Albéric Collin' in script and 'C. Valsuani Cire Perdue'
    31cm (12¼ins.): dark grey on black patination
*c.1910*

A Karel Trompeneers model of a walking ostrich with the unmistakable Bugatti influence although the finish is considerably smoother.
Signed 'K. Trompeneers' in script and with Batardy foundry
    signature: 30.5cm (12ins.): green over black patination
*c.1930*

A Collin model in the Bugatti idiom of a running ostrich. The Antwerp School, with an abundant choice of animals, often chose unlikely and ungainly creatures and to model a running ostrich is a brave sculptural feat that pays off well in this example.
    Signed 'Albéric Collin' and 'C. Valsuani Cire Perdue'
        46.5cm (18¼ins.): rich black patination
*c.1910*

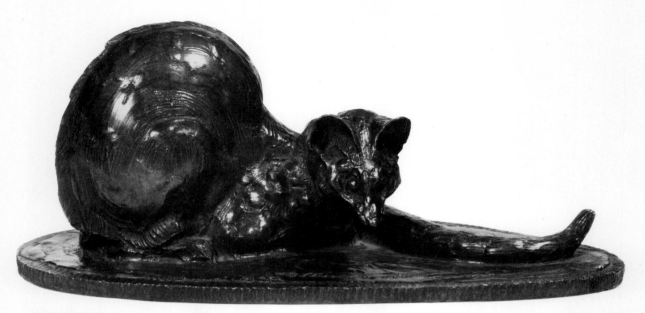

A fine Valsuani lost wax cast of Collin's work — this small model of a genet is both lively and alert and is an unusual animal to model. One wonders how long the animal was able to sit still at any one modelling session! There is a lot of the Bugatti style in this bronze but with a softness of form and lack of drama that gives a very different feel from Bugatti's work.

The arched back of the genet looks like the 'Snail Room' from the Turin Exhibition by Rembrandt's father, Carlo Bugatti.
Signed 'Albéric Collin' in a bold script and with 'C. Valsuani Cire Perdue' seal: 15cm (6ins.)
rich dark brown/black patination
*1920s*

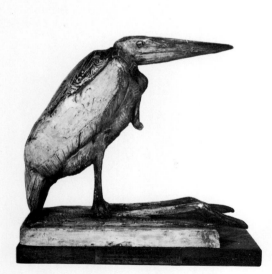

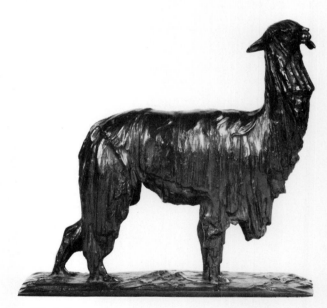

An unlikely cast of a marabout by Bugatti, a subject tackled by Bayre decades earlier. This is not a Hébrard cast and it is unlikely that Bugatti's strict patron would have approved it. Only the one bronze model and a plaster version are known. Quite possibly it is one of the many trial models that Bugatti made in plaster, most of which he threw away before finishing or casting and this one escaped his critical net. The fact that the plaster is not signed adds weight to this theory as all his casts were signed and had the Hébrard seal. A crude, heavy cast but not without character.

28cm (11ins.): green over traces of black patination
*c.1910*

Bugatti's influence is once again evident in this unusual model of an alpaca by Jochems. A proud and fine model, exploiting the possibilities and range of animals at a zoo. The whole treatment of the wool and the simple plinth reflect the Bugatti style, as does the swaggering script signature. Nevertheless it is a good model and deserves as much acclaim as his mentor's work.

Signed 'F. Jochems': 38.5cm (15¼ins.)
rich grey/black patination
*c.1920*

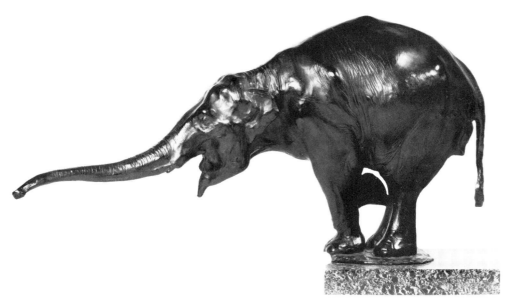

An Indian elephant, unmistakably by Bugatti with his unique sense of poise and balance. Here he has modelled quite simply one of these delightful creatures leaning over the ha-ha at the zoo to take gently a morsel of food from an onlooker. Bugatti must have got to know his animals well and this sensitive model almost conjures up an image of the sculptor sitting studying his model on a fine day at the zoo. He gives the elephant a sense of dignity it would not possess as a circus animal and there is an obvious bond between man and animal.
Signed 'R. Bugatti' in script and 'A.A. Hebrard Cire Perdue':
41.5cm (16¼ins.) black patination
c.1910

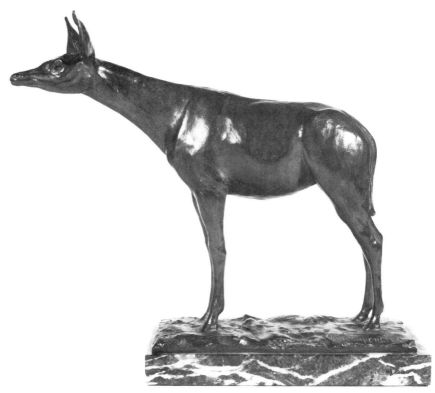

Karel Trompeneers' sculpture has a lot of the Bugatti form about it, especially in his animals' poise and balance but the smooth finish owes more the style of Jochems. However, the overall finish is individual and most attractive. Trompeneer produces highly realistic, inquisitive animals.
Signed 'K. TROMPENEERS' in a dashing script and with Bartardy, Brussels, foundry signature: 33cm (13ins.)
c.1920

# Apes

The use of animals by artists to highlight man's characteristics was not an invention of the romantic period of 19th century art.

The extraordinary paintings of Hieronymus Bosch, the Dutch painter of the late 15th/early 16th century, are amongst the post Reformation examples in which man is represented by distorted animal forms and used to lampoon the follies of the medieval world.

The Teniers, father and son, followed a hundred years later with their representations of monkeys in human poses and situations.

It is likely that the romantics of the 1830s and 1840s were referring to these Teniers cartoons when they created the monkey bronzes on these pages at a time when some features of late 17th century art and architecture were becoming popular.

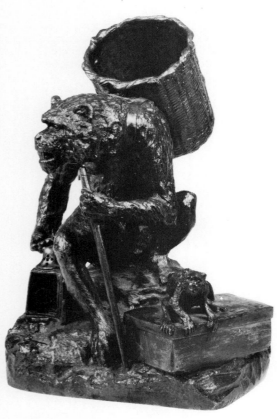
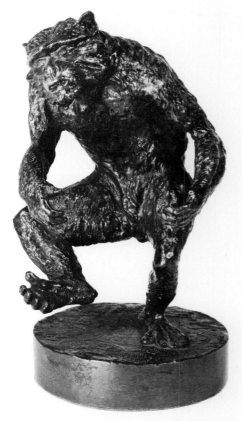

**A1** One of an amusing and ever popular series of performing monkeys and bears by Fratin. This monkey pedlar has his own monkey to attract attention to his wares and the humour of 'man the monkey' is evident in this satirical group. Roughly and, at first glance, unattractively cast, it is typical of this sculptor's inventive and original style, learnt from his master Géricault's painting technique, using lots of impasto and beginning to model an 'impression' rather than a strictly accurate image.

Stamped 'Fratin': 23cm (9ins.)

*c.1850*                    *£1,200 — £1,600*

**A2** Another monkey figure by Fratin showing his individual style. There is little attempt to romanticise the animal which appears to be forlornly dancing to his master's whim before yet another crowd of inquisitive onlookers. Note the very simple and early treatment of the rather roughly finished, sand-cast socle.

Stamped 'Fratin': 18cm (7ins.)

*c.1845*                    *£1,300 — £1,700*

**A3** A very rare satirical bronze group, again by Fratin. The monkey dressed in mid-18th century costume is a knowing connoisseur of the opera and peers with knowledgeable eye through one glass of his spectacles at the pirouetting couple below. Man and his pastimes are 'aped' yet again by the intelligent monkeys. The style is very free and individual leaving little doubt as to the sculptor. Because this model is quite small and has been handled many times, the edges are softening with badly worn patination on the highlights. However a good clean with wax should be enough to restore the bronze's life and lustre and repatination would definitely not be recommended.

Stamped 'Fratin': 19cm (7½ins.)

*c.1845* £450 — £650

**A4** Two small, unsigned monkey groups, this time racing a pair of saddled hunting dogs as fast as they can run. The monkeys, in full jockeys' uniform, are well modelled as are the dogs with their lolling tongues. These must have been on bronze bases originally or on one base as a part of a larger group. There are similarities to both Gayrard and Gechter's work (see A11 and A13) but a firm attribution is difficult. However from the colour and handling of the casting the date would be 1845 to 1850.

Size 10cm approx. (4ins.)

*c.1845-1850* *each* £60 — £110

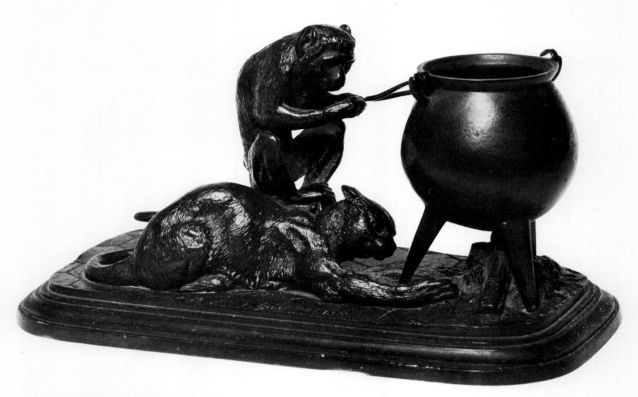

**A5** In an unlikely combination, this monkey chef is aided by a cat who stokes the fire with its paw. This version of teamwork by Isadore Bonheur is an unusual model and has become comparatively rare. This amusing and not very serious sculpture is not even very well modelled for a sculptor who, although not the most exciting, was normally technically highly competent. Nevertheless, it is an attractive small collector's piece and should not prove too expensive.

Signed 'I. BONHEUR': 17.5cm (7ins.): black patination
*c.1870* £320 — £450

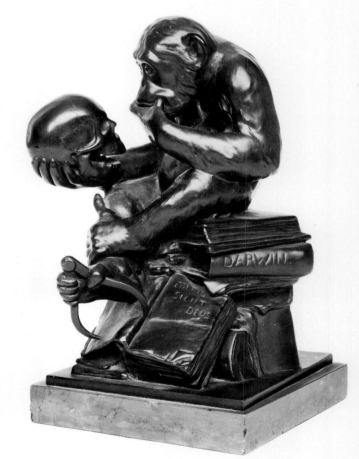

**A6** An ingenious look at man by the Edinburgh sculptor, Gertrude Alice Meredith. The chimpanzee is seated on a pile of Darwin's volumes contemplating a human skull held in his hand and showing superior dexterity by holding a pair of callipers in one foot. The theme of the sculpture is based on a phrase in Genesis 'God made Man in his own image'.

34cm (13½ins.): black patination
*Edinburgh c.1880* £350 — £450

**A7** A very rare terracotta figure of a gorilla preening itself, seated on a bed of huge lilies. This is possibly the model exhibited in plaster at the 1887 Salon and again at the 1889 Exposition Universelle. Terracotta has a most attractive quality, especially when it has become patinated by handling and, although liable to damage (note the right hand side of the base is chipped in this example), is highly desirable and well worth collecting though rarely found. This finely detailed and executed model can be dated by the stylised naturalism of the base and the inclusion of the small snail in the group, all pointing to the style that was to be called art nouveau by the turn of the century. It becomes obvious, therefore, that even in the comparatively narrow field of animal bronzes, a knowledge and sense of style is a distinct advantage.

Signed 'E. FREMIET': 17cm (6¾ ins.)

*1887-1900*                                                      *£450 — £650*

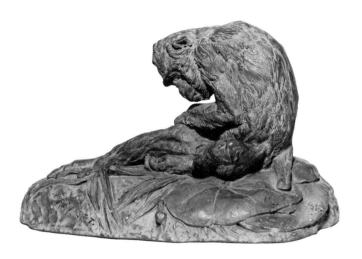

**A8** Baboons are not the most attractive animals and thankfully we are spared the technicolour of the apes by the bronze cast which is extremely well modelled with typical thick daubs of modelling plasticine giving a light and dark effect and that enviable sense of movement. The cast may appear too rough for some tastes and for those used only to the smooth skinned 19th century animals, this style is an acquired taste better viewed after looking at Bugatti's work.

**A9** These baby chimpanzees, huddled together for mutual protection, are by William Timym. Delightfully modelled, their attractive faces are just enough to take the eye away from what would otherwise be a lumpy bronze.

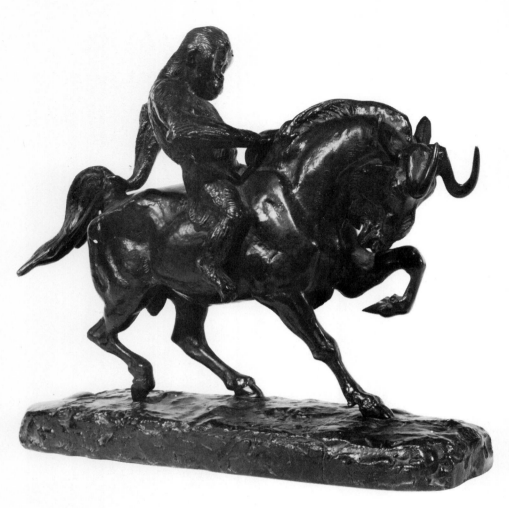

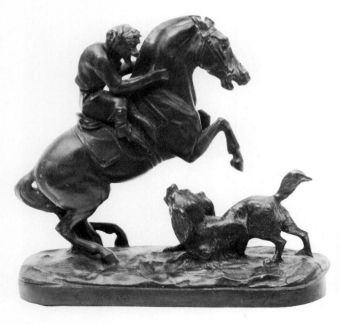

**A10** The height of romantic sculpture by A.-L. Barye but with a conscious sideways glance at the activities of man at the same time. Barye modelled this 'Orang-Outang Riding a Gnu' before the other monkey groups on these pages in about 1840. It is improbable that Gechter and Gayrard (A11 and A13) were 'ribbing' Barye's work though possibly borrowing his inspiration. This work was first modelled c.1840 and was in Barye's 1847 catalogue.

Signed 'BARYE': 23cm (9ins.): rich brown patination
*Probably c.1847* £2,000 — £3,000

**A11** A monkey jockey being startled by a cavalier spaniel; a rare work by Gayrard and very interestingly signed 'Gayrard S' and also 'Boyer', who with Gayrard, cast for A.-L. Barye. The 'S' indicates that Gayrard is the sculptor. Boyer in this instance is most probably the founder. The heavily necked horse is not well sculpted but makes for an interesting and lively group. It is taken from a larger group of The Monkey Steeplechase of 1846 by Gayrard, with the horse shying at a fence rather than the spaniel. Another example has been recorded stamped 'Boyer (B)'.

Signed 'Gayrard S' and 'Boyer'. 11.5cm (4½ins.)
*c.1846* £400 — £600

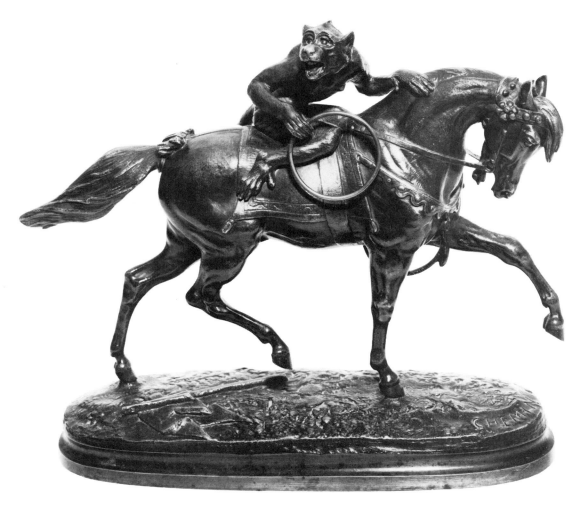

**A12** a model from the third quarter of the 19th century with no intention of a sideways dig at the human race but merely reporting in sculpture an event at the circus which was a very popular form of entertainment in Europe at the time. Joseph-Victor Chemin has modelled the well-trained Arab stallion successfully but there is a disappointing lack of detail in this cast, probably the fault of the original sculpture rather than the result of a worn mould. A good bronze nevertheless, and quite large.

Stamped 'CHEMIN': 30cm (11¾ ins.)
rubbed brown patination
*1851-c.1870*                                            *£900 — £1,200*

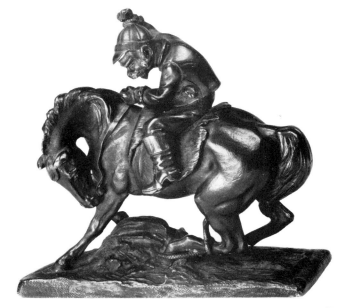

**A13** Another monkey jockey, this time by Gechter, attributable almost by the horse alone and compares favourably with the Gechter models on p. 312. This lively model is full of character and a sweeping sense of realism and movement. The bulging eyes of the horse clearly show its terror with the indifferent monkey whipping the unfortunate animal on as the adder strikes. This model was not signed but others are recorded T. Gechter. The size is consistent with several other examples of this group. It was probably sand cast. This group bears similarities to the work of Gayrard (see A11).

13cm (5ins.): brown and gold brown patination
*c.1848*                                            *£280 — £400*

# Bears

If Barye was the master of lions and Moigniez of birds,
then Fratin must surely be the leading animalier sculptor of bears.
His bears were often highly romanticised and given a Teniers quality
in common with the monkey bronzes of the period.
This vogue is discussed on page 62 at the beginning of the section on Apes.
His anthropomorphic bears are inevitably ragged casts and were for amusement only,
none apparently appearing at the Salon.

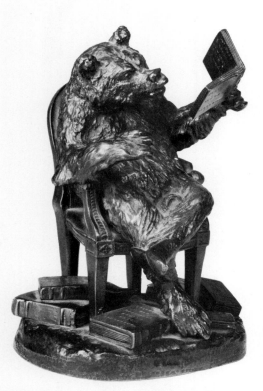

**B1** A fine cast of a learned bear deep into a pile of books, seated casually in a neoclassical armchair in the style of the Louis XVI period. The books all have carefully stamped titles which will have been stamped into the bronze after it was cast by one of the foundry workers. To add to the air of relaxed contentment, Fratin has given the bear one slipper while the other lies discarded underneath the chair. These models normally date to the earlier part of the sculptor's career and this is borne out possibly by the use of Vittoz, a founder who flourished in the 1840s. (Vittoz was normally associated with sand cast clock cases.) This example has lost his elaborate long pipe. An example recorded as 18cm (7¼ins.) suggests a cataloguing error.

Signed 'Fratin' and 'Vittoz Bronzier': 17cm (6¾ins.)
brown black patination

*1840s*                                    *£1,500 — £2,000*

**B2** 'Ours en Liberté' by Fratin, a title which suggests a dig at the deeply troubled political times in France. At least the bear is free, even if after the July 1830 and the 1848 revolutions man was not. The dancing bear celebrates with a bottle held high and a beaker in the other 'hand', wearing a feather in his cap and a scarf around his waist like some revelling football fan. A good model and rare.

Signed 'Fratin': entitled 'Ours en Liberté'
(stamped cold into the bronze)
19.3cm (7¾ins.): brown patination

*1840s*                                    *£1,300 — £1,700*

**B3** A coffee vending bear with a pannier of beans on his back and a coffee mill in his paws ready to grind up his wares if required. This type of street seller must have been a relatively common sight in the larger French towns at the time and Fratin has admirably characterised them in this amusing model. This bear has been given a fig-leaf in common with many bronze figures of humans at the time in the more prudish mid-19th century.

<div style="text-align:center">Signed 'Fratin': 17cm (6¾ins.) approx.<br>dark brown patination</div>

*1840s* £1,000 — £1,500

**B4** One of Fratin's best bear studies and presumably another trade or profession that was a pet hate of the sculptor. A rare group of the 'Dentist Bear', extracting a tooth from another bear who sits in an identical chair to the 'Literary Bear' shown as B1. The victim shrinks into the chair to avoid the pincers and raises a leg in anguish. Fratin so successfully captures a situation that we have all been in and satirises that situation with his amiable tongue-in-cheek humour. The small bag at the 'Dentist's' feet suggests a visiting dentist and the fact that the chairs are the same may possibly mean that Fratin wanted us to see events from the life of the same bear. A cast-iron group is recorded as 14.5cm (5¾ins.).
Signed 'Fratin': 15cm (6ins.): rubbed dark brown patination
*1840s* £1,400 — £1,800
<div style="text-align:center">Cast-iron £500 — £700</div>

**B5** One shudders to think of the treatment Fratin must have had from a nurse to characterise one in such a manner. The bear, wearing a bonnet for identification by the onlooker, brings a beautifully embossed warming pan, stepping lightly as she walks, suggesting the good humour of the well meaning, if a little over large, and strict matron.

<div style="text-align:center">Signed 'Fratin' with a stamp: 17cm (6¾ins.)<br>rubbed medium to dark brown patination</div>

*1840s* £800 — £1,000

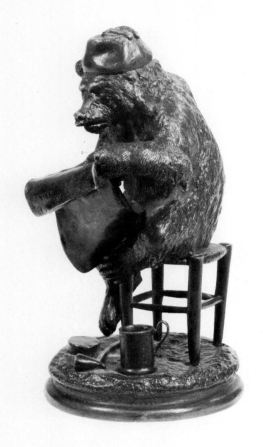

**B6** Not working late into the night to keep the books in order, but reading a copy of *La Patrie,* this bear may well be a tavern keeper with his pipe, tankard and tobacco box at his feet. Again Fratin has given the bear a piece of clothing for identification, in this instance a nightcap. Note that he is sitting on an unsophisticated, rush-seated country chair, unlike the Literary Bear shown as B1.

Signed 'Fratin': 18cm (7¼ins.): brown patination
*1840s*                                                    £900 — £1,200+

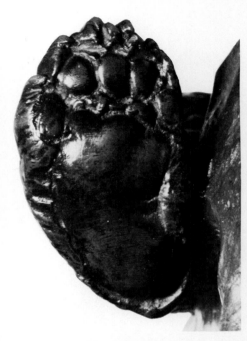

**B7** A detail of a bronze paw from the fine model by Valton illustrated in colour on p.19. Enlarged from its actual size of approximately one centimetre, it shows what a superb cast has been produced with really intimate detail, even to the lines across the pad of the foot which would be unseen by most onlookers.

**B8** In similar vein to B6, this bear by Cain throws a challenge to the onlooker and satirises an aspect of human life. It is unusual for Cain to anthropomorphise his animals, although he often created amusing little farmyard scenes. This bear is a vendor of some as yet unidentified ware, stored in his back pannier and meted out into his conical basket-weave beaker. Cain's Salon début was in the 1840s and possibly this is an early model by him, inspired by Fratin's work, although there is no known record of collaboration between the two. A very well detailed cast and a rare one.

Signed 'Cain': 19cm (7½ins.): rich brown patination
*Probably late 1840s*                                      £600 — £800

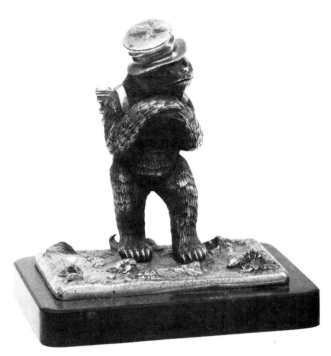

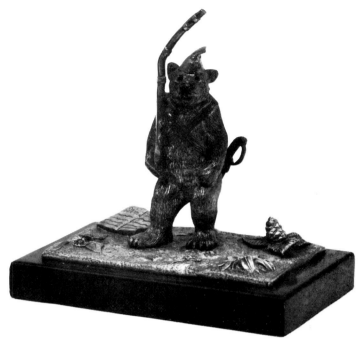

**B9** An extraordinary, silver plated bronze bear dressed as a pedlar. The base is cast in the early naturalistic style of the 1830s and early 1840s. The ragged modelling of the animal's fur is typical of Fratin's work.

<div align="center">13cm (5ins.): silvered patination</div>

*c.1840* £300 — £500

**B10** A companion bronze with the same original silvering. This time we have a bear dressed as a somewhat self-conscious soldier, marching off to war, or more probably, revolution. This comical bronze is rendered all the more ridiculous by the bear's rifle which has become bent over the years.

<div align="center">14cm (5½ins.): silvered patination</div>

*c.1840* £280 — £450

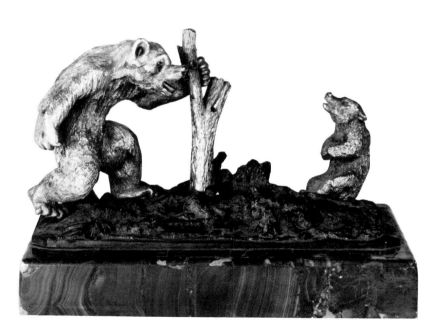

**B11** This is a very rare and unusual bronze group signed by Fratin. As with the previous two models, it is silvered bronze and has been mounted on a plinth veneered in malachite, suggesting that it is in fact a Russian base. Could Fratin possibly have modelled this and the previous two models for the Russian market? The comparatively crude rendering of the group suggest that it is not a sophisticated French cast. A puzzle indeed but a fascinating and amusing bronze, if only for its naïve charm.

Signed 'Fratin' with a very indistinct stamp: 7.5cm (3ins.)

*c.1840* £400 — £600

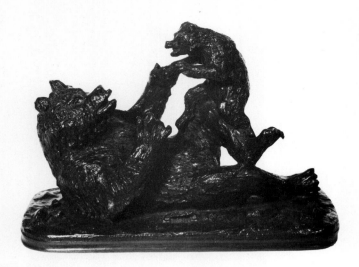

**B12** This model shows the individual style of Fratin to full advantage. The rugged, rather sketchy modelling of the bears' fur is described by Jane Horswell in her book *Les Animaliers* correctly and succinctly as 'the "impasto" technique of this great painter [Géricault — Fratin's teacher] translated by Fratin into his own medium, sculpture'. This is a very good, early cast, once again with anthropomorphic inclinations in this attractive 'domestic' scene — it all seems a little improbable but makes for an amusing, decorative sculpture of the highest quality.

Signed 'FRATIN' with a stamp: 16.5cm (6½ins.)
dark patination

*1840s*                                                    *£700 — £1,000*

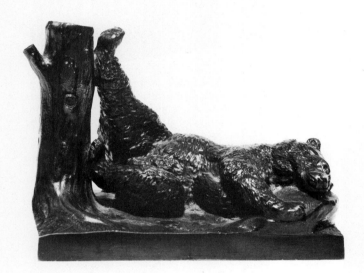

**B13** A very fine cast of a bear by Otto Gradler and presumably cast in Germany. Not an important bronze and very good value for money when compared with the famous and consequently more sought after models by Fratin. Normally the lower one's initial investment the lower will be the return and although this will be true of this model, it is a cheap way to start a collection and is of the very best quality. The copper content is unusually high and gives the bronze a very warm, deep red undercolour and that all-essential tactile quality. Every detail is exquisitely worked.

Signed 'O. Gradler fec.': 10 × 13.5cm (4 × 5¼ins.)
dark brown over deep red/copper patination

*Dated 1888*                                                *£300 — £400*

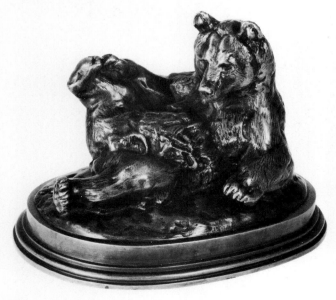

**B14** Barye modelled bears in the first decade of his established career in the 1830s and this popular model was listed in his 1847 catalogue. This is a later cast by Barbedienne and lacks the very fine detail of the early casts which are more like Fratin's work than Barye's with their rugged finish. These casts of the third quarter of the 19th century are far smoother but in a way are more akin to the mellow finish that Barye so often employed. An endearing subject, once again extolling the human characteristics of the animal.

Signed 'Barye' and 'F. Barbedienne Fondeur Paris'
numbered 21466 in ink on the underside
14cm (5½ins.): rubbed dark brown patination

*1870s*                                                    *£800 — £1,000*

**B15** Another amusing Barye model of a bear eating, seated in a tub or hollow in the ground. A Barbedienne cast that has also been seen as a Gold Initial cast and one that may well be an electrotype. It is easy to see how these uncomplicated shapes could be 'cast' as copper electrotypes, with their simple moulds with few difficult corners and no protruding extremities. A good and rare model but it would not sell as well as a lost wax cast as collectors are still wary of electrotype casts, wrongly thinking they may not be genuine.
Signed 'BARYE' and 'F. Barbedienne Fondeur': 12cm
(4¾ins.)
rich black over green patination
*1870s*                                              *£700 — £1,000*

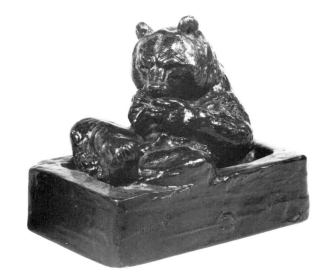

**B16** A similar model of a bear by Gardet to the Valton one illustrated on p.19. Usually Gardet's casts are as good as his fine modelling but the quality of this is poor with very little detail and, compared with the Valton example, very much in an inferior class. The posture and form, however, are of a good standard of sculpture, typical of this talented artist, but the sculpture needs the exquisite detail of the Valton model to save it from becoming lumpy. Gardet was also a sculptor in marble and this subject may well have been primarily intended to be in that medium.
Signed 'G. GARDET' hand written block capitals
stamped 'Siot Decauville Fondeur Paris'
16.5cm (6½ins.): dull black patination.
*c.1900*                                              *£800 — £1,200*

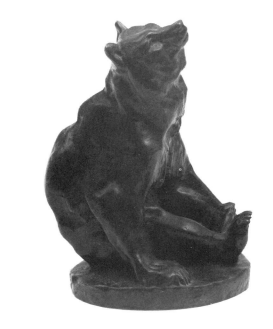

**B17** A delightful model in plaster of a polar bear by Francois Pompon, bringing the bear firmly into the 20th century. The medium is of course, exactly right for a polar bear in colour and in the soft way that Pompon has modelled and sanded the plaster, confirming our impression of these beautiful beasts and belittling their ferocity and strength. It is rare to find plaster models surviving, even from the beginning of the 20th century and it is a fine trophy for the dedicated collector to add to his menagerie. Their fragility does of course have a detrimental effect on the value — a bronze bear may well realise two to three times more than this little model in plaster. This model shows Pompon in one of the earlier phases of his ever changing style and relates to the mood of painters just before the Great War. The bronze version is entitled 'Ours de Cocotiers' and is dated 1918.
10cm (4ins.)
*c.1910*                                              *£750 — £1,000*

**B18** A slightly disappointing bronze group by Mathilde Thomas-Soyer who was capable of much better work and learnt her art under Cain. This model may well be experimental. It is a definite step into the new style of the early 20th century, not only in the use of marble as the base for the animals, but in the angular style that she has used, especially for the bear on its haunches in a style that mixes the techniques of Steinlen and Sandoz.

Signed 'Mathilde Thomas'
(note she is not known to sign with her full name)
17.5 x 28cm (7 x 11ins.)
including the contemporary Belge noir marble base
copper brown patination.

*c.1910*      *£380 — £480*

**B19** An indifferent cast of a bear, made for the mass market and quite probably manufactured in Germany, using the talents of a minor sculptor to model the work that would then be produced in very large numbers, comparatively cheaply, for world consumption. The detail is adequate enough but this can only be considered as a decorative bronze with little investment potential.

21cm (8¼ins.): bronze patination
*Early 20th century*      *£120 — £150*

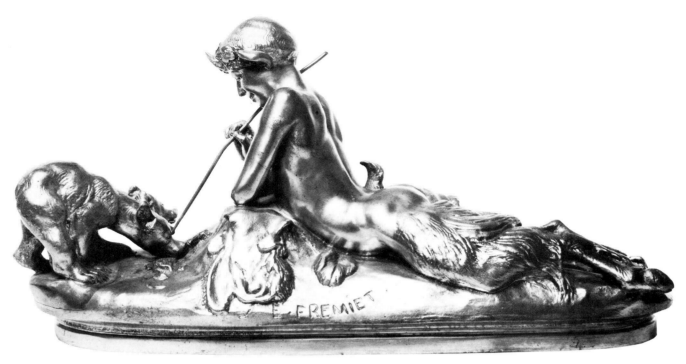

**B20** A common model by Frémiet, clinging tentatively to the definition of an animalier sculpture, a definition that Frémiet himself abhorred as a great deal of his work was monumental and not animalier. This model is seen in patinated bronze, as well as silvered and gilt-bronze. The romantic notion of a satyr youth playing with two bear cubs is not one that appeals to the contemporary collector but they must have been popular at the time.

<div align="center">

Signed 'E. FREMIET': 17.2cm (6¾ins.)
gilt-bronze patination.

</div>

*Probably 1880s*                 £600 — £800

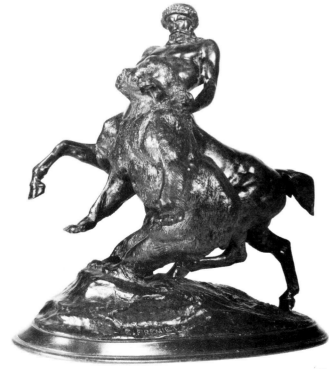

**B21** A masterpiece of Frémiet's work entitled by him 'The Centaur Teree carrying out of his lair a bear taken in the Hemus Mountains'. In the same romantic/classical idiom as the previous model but far more powerful and dramatic. The strength and superiority of the flesh eating centaur is evident as he easily carries off the powerful bear. The plaster version of this group was exhibited at the 1861 Salon and it follows the earlier models by Barye in a similar vein, i.e. the Lapith and Centaur, c.1840, Hercules and the Erymanthean Boar of 1823 — a very early model, and Theseus Fighting the Minotaur of the 1840s. A good model but not very popular today.

Signed 'E. FREMIET': 37cm (14½ins.): green patination
*1860s*                    £1,200 — £1,600

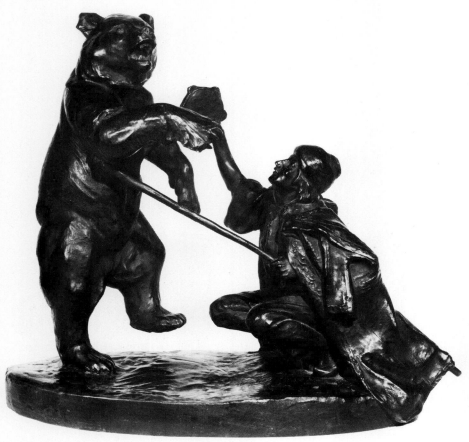

**B22** A decorative group of a performing bear and its attendant. The medieval fascination for these powerful wild creatures brought the distinguished beasts down to the level of street entertainers, a subject which was ideal for the romantic artists of the mid-19th century in their search into history for material. A competent model but unexciting.

Signed 'B. Markup': 42cm (16½ins.)
dark brown to black patination

*1850s* £700 — £1,000

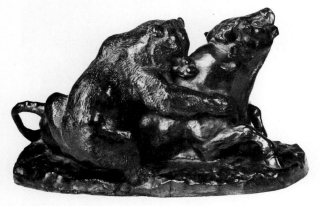

**B23** A dramatic and powerful group of a bear bringing down a bull by Barye. A very rare model and full of the exaggerated musculature which Barye used to such good effect. The detail has been left deliberately vague and gives an impressive feeling of movement in this quite terrifying conflict, awesome to contemplate. As long as the bear can cling on to the bull's back and prevent it rolling over and can avoid those horns, it will surely be able to crush the life out of the bull.

Signed 'Barye': 28 x 14cm (11 x 5½ins.)
brown green patination

*1840s* £1,200 — £1,800

Another violent Barye model shows a bear crushing an owl.
19cm (17½ins.)

£800 — £1,000

# Birds

The outstretched wings of a soaring or alighting bird are a challenge for any sculptor.
Moigniez must surely stand out as the principal 19th century bird sculptor,
certainly in terms of the number of bird groups and models he produced.
However, the few birds modelled by A.-L. Barye are full of a vigour and power
rarely visible in Moigniez' or Mêne's work.

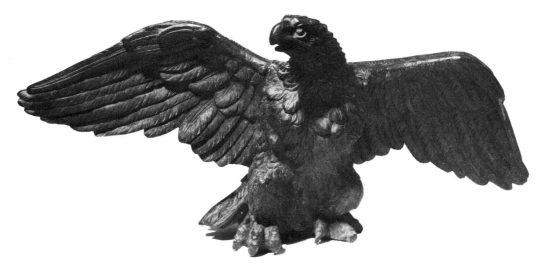

**Bi1** A rare and rather drunken looking eagle from the early 19th century. The outstretched wings are reminiscent of the pose of the American Eagle of the United States and the whole style looks back to the 18th century, especially to the carved eagles on mid-18th century gilt-wood mirrors designed by Thomas Chippendale. This was cast either by or for Vulliamy of London. Benjamin Vulliamy was a clockmaker employed by George III (they both died in 1820), and his son continued as Court Clockmaker. They produced clocks in the Louis XVI manner and were responsible for some very fine castings in ormolu and presumably this eagle was cast in bronze by the same workshops.

Signed 'Pub'd by Vulliamy London May 12 1810'
23.5cm (9¼ ins.)

*1810*                                                    *£400 — £600*

**Bi2** A good group of an eagle standing guard over its prey and warning off any would be attackers. The dead heron looks almost unreal in its relaxed pose of death. The head of the eagle is turned to the left in this model but others, inexplicably, are recorded with heads turned to the right.

Signed 'Barye': 30cm (11¾ ins.)

*c.1855*                                              *£1,000 — £1,450*

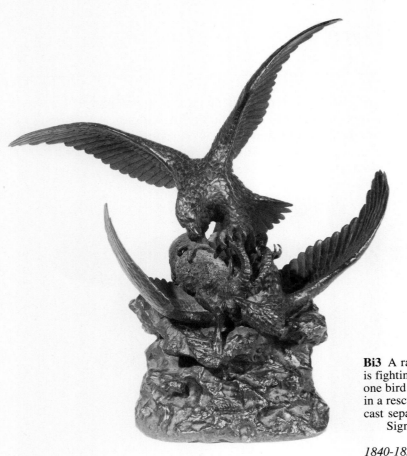

**Bi3** A rare and complicated group by Fratin. A pair of eagles is fighting a fully grown antelope which has managed to down one bird while the other alights savagely on the animal's back in a rescue bid. Each bird, the antelope and the base would be cast separately in this instance and pinned together.

Signed 'FRATIN' with normal 'N': 49cm (19¼ins.) black patination

*1840-1850*                    *£550 — £850*

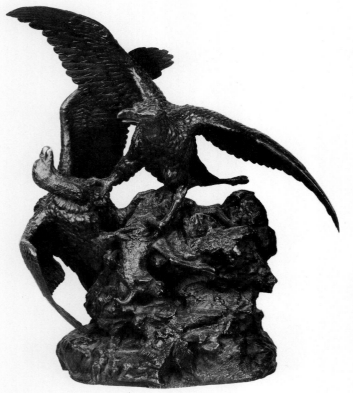

**Bi4** A 'companion' group, this time an eagle ferociously defends its prey of a mountain goat against a marauding vulture. A very good cast indeed, equal in quality to Bi3 but a better colour and it has been regularly dusted. The hair, feathers and skin, as well as the fine detail of the moss on the rocks, are exceptionally fine.

Signed 'FRATIN' with normal 'N', and 'Daubree Editeur' approx. 35cm (13¼ins.) high

*1840-1850*                    *£450 — £750*

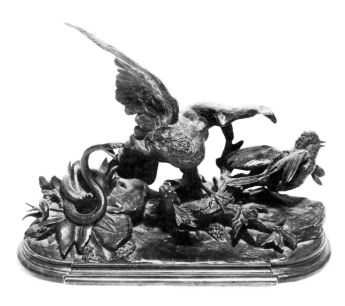

**Bi5** Signed 'J. MOIGNIEZ': 27.4cm (9¾ ins.)
dark rubbed brown patination

*c. 1860*                                          *£350 — £500*

**Bi6** Signed 'J. MOIGNIEZ': 25.4cm (10ins.)
rich dark brown patination

*c. 1865*                                          *£280 — £450*

**Bi5, 6, 7** Three versions of the same hawk all by Moigniez, the first two signed J. Moignez and the third not signed, nor attributed in a provincial catalogue but without question a Moigniez model. The first two are comparatively well known variations. In one the hawk is fighting for the terrified escaping sparrow against a coiled snake who was after the same prey. It makes for a complicated, slightly awkward group, showing how difficult it is even for the most talented sculptor to capture a snake in bronze. Bi6 is a better model, concentrating on the bird only, but yet still on an over-fussy 'naturalistic' base so popular at the time. The breakfront bases appear to be identical in size but with differing additions. The naturalistic use of ivy leaves in Bi7 suggests that this bronze is more or less contemporary with the other two.

**Bi7** Unsigned, but from the Moigniez stable
36cm (14¼ ins.) high: rubbed brown patination

*c. 1865*                                          *£200 — £400*

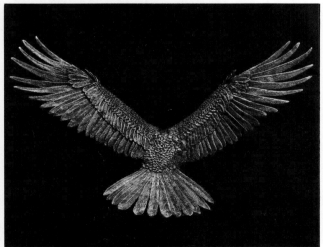

**Bi8** Two views of a magnificent bronze eagle by Annette Yarrow, photographed by her husband John Elliott. This contemporary sculptor has only, in the 1980s, started to sculpt birds, a subject in which she seems to excel. Although the handsome bird is a little awkwardly perched without a proper base, the balance is very good indeed and great care has been taken to achieve a realistic head and talons. The feathering must have taken a very long time to achieve. On a comparatively large model feathers need to be well detailed and here the artist has modelled each individual feather directly in the wax and overlaid them to dramatic effect.

*Modelled in 1982          a private commission for Asprey's*

**Bi9** Here is a similar bronze by Annette Yarrow *in situ* on its intended base. The life size golden eagle is magnificently perched on a globe to represent man's domination of the air. This was commissioned for the Army Air Corps Centre at Middle Wallop.
*Erected 1982*

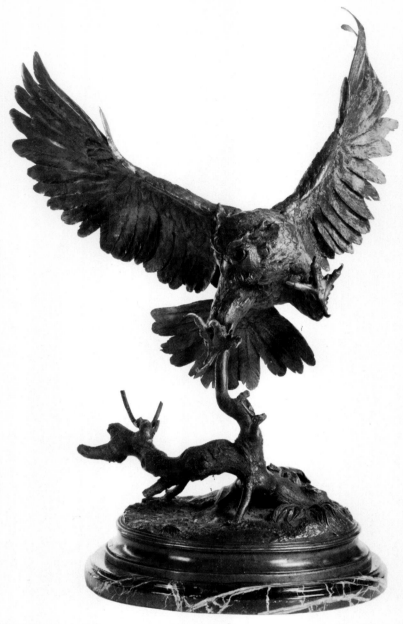

**Bi10** A quite magnificent study of an owl alighting, bearing Moigniez' signature. A rare and apparently unrecorded study, although since this was offered for sale in March 1983 another cast has been seen in America. It is really a masterpiece in sculpture and must surely be the best bird study in the animalier world, by the accepted doyen of bird sculpture. Many have attempted the concept of a bird swooping on to its prey but to achieve such a large model, with wings outstretched, supported only by one comparatively slender bough is quite incredible. The detail of the cast is exceptional but with one overriding worry — the owl and socle were cast in lost wax but there is considerable pitting, especially on the back of the wings. Normally in the 19th century a socle would be sand cast. Also the plinth is irregular and appears to be cast with a bump, which is not something acquired when being moved at some time in its one hundred and twenty years. The cast has a very fresh waxy feel to it and a very even patination with little life to the colour or depth of colour. The marble socle is obviously new, not in itself important but another suspicious pointer. Opinions were divided as to the authenticity of this model — an experienced dealer was the underbidder at the auction at £1,700. Is such a rare cast only worth so little, and not at least £3,000 or £4,000? One can't help feeling that the total purchase price at auction of almost £1,900 was its mere decorative value and was not a price for an unrecorded rarity. Until a model turns up slightly oversize, without any suspicious pointers we will never be sure but one can't help feeling the collecting world was not willing to take a chance this time and would rather pass the chance by than get caught!

Signed 'J. Moigniez': 84cm (33ins.)

flat greyish brown patination

*Modern, probably cast in the United States of America*

*£2,000 — £3,000*

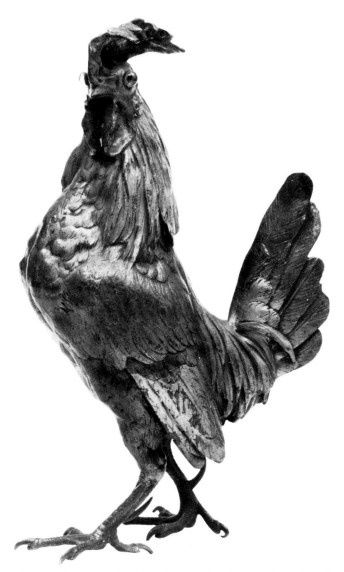

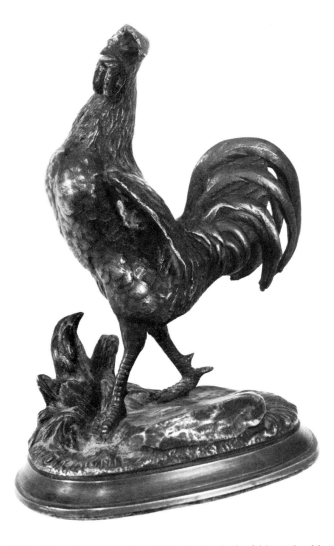

**Bi11** A Viennese cold-painted bronze hen in a similar style and pose to the next model of a rooster by Moigniez. This figure must have originally been intended to have been on a base. It is included here to show the contrasts and similarities between French models and later Viennese casts (discussed on pp. 391-393).

    With 'Berman seal' and 'Geschutz': 30.5cm (12ins.)
*c.1900*                £230 — £350

**Bi12** A bantam rooster by Moigniez typical of his style; his animals often look rather emaciated. It does not compare very favourably with the fine model by Mêne in the Walters Art Gallery, Baltimore, illustrated in *Les Animaliers*, p. 114. This example is a contemporary cast but probably from a much used mould and the detail is not very precise. However, not a cast commonly seen on the market today. Sometimes seen as a pair with a hen.

<div align="center">

Signed 'J. MOIGNIEZ': 14.6cm (5¾ins.)

gold and brown patination

</div>

*c.1870*                £200 — £300

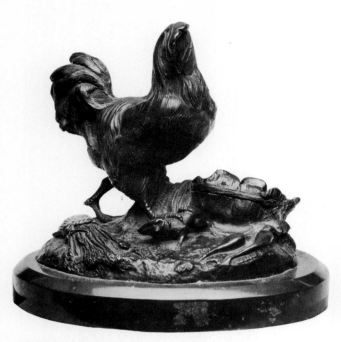

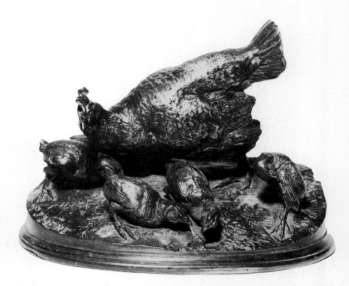

**Bi13** A rather charming farmyard scene by Arson. The sculptor has captured something rarely seen by most of us; a cockerel has caught a small rat in its talons and there appears little chance of escape. Both animals, no doubt, were interested in the same forgotten corner of the yard with an old bucket and two discarded or fallen parsnips as well as a sheaf of barley. Loosely modelled with none of the fine detail of the mid-19th century groups. Supplied with a red marble base, as are most of these small groups.

Signed 'Arson': 11cm (4¼ins.) high, excluding base
mid-brown patination

*c.1870* £220 — £300

**Bi14** Another farmyard scene so loved by the well-to-do middle class town dwellers of the mid-19th century. This group by Mêne of a hen and her chicks feeding, is one of a certainly large edition cast by his own foundry. The sculptor has accurately portrayed the feeling of the mother hen while the chicks confidently feed and preen. The smell of the yard is almost there and the feeling of warm sunlight. Normally with this group one should be able to see the other foot of the hen who, in this case, has been slightly squashed down. It could be bent upwards but this should be done by a proper restorer with the hen unbolted from the base; any attempt to bend the hen in situ will almost certainly result in the fracture of the other leg. The bump on this base is an obvious knock, unlike that of Bi10.

Signed 'P.J. MENE': 10.5 x 14cm (4 x 5½ins.)
rubbed dark brown patination, the hen quite badly rubbed
*c.1845 — 1850* £400 — £600

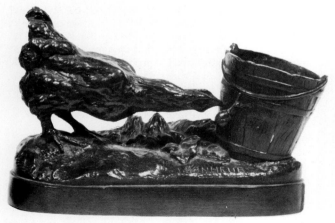

**Bi15** Isadore Bonheur modelled a companion piece to this hen investigating a snail crawling along a bucket — a goose drinking from what appears to be an identical bucket. Both are charming and rare models and show Bonheur's work in a new and amusing light akin to the farmyard scenes of Cain.

Signed 'I. BONHEUR': approx. 7cm (2¾ins.)
rich dark brown patination

*1880s* £400 — £500

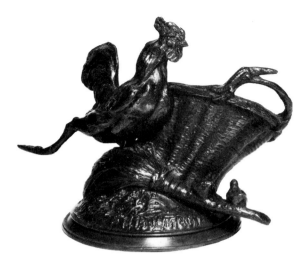

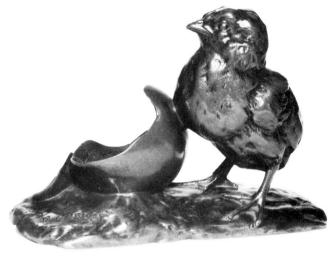

**Bi16** An amusing small model, one again capturing, as in a photograph, a farmyard scene unfamiliar to most of us. A very angry looking hen chases a lizard on to the handle of a large basket while her chicks perch contentedly on the handle of a broomstick. The sculptor has condensed several frames into one scene with plenty of movement. Not a particularly crisp cast.

Signed 'F. PAUTROT': 9.5 x 7.8cm (3¾ x 3ins.)
dull rubbed brown patination

*c.1870* £220 — £380

**Bi17** The Chicken and the Egg. An unusual and very endearing model by Gardet, cast by Barbedienne. The rather misleading 'wear' that appears in the photograph is in fact wear of the patination which retains traces of its original complete gilding. This somewhat symbolic bronze has a definite 'later' feel in both the composition and the rather smooth texture and deliberate lack of detail. It is unfortunate that the highly experienced foundry had to join the small bird to its egg for purely technical support.

Signed 'G. GARDET' and 'F. Barbedienne'
10.5 x 14.8cm (4 x 5¾ins.)
rich light brown patination with traces of gilding

*c.1900* £250 — £400

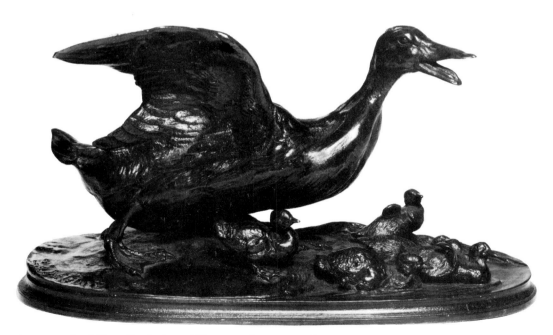

**Bi18** A charming group by Mêne of a duck waddling proudly along to the water's edge with her brood of five chicks. In this example there is nothing posed and the movement appears totally natural. A well-detailed cast.

Signed 'P.J. Mene' and numbered 33 on the underside
8.3 x 15.5cm (3¼ x 6ins.)
rich copper red/brown patination but a little rubbed

*c.1850-1860* £440 — £600+

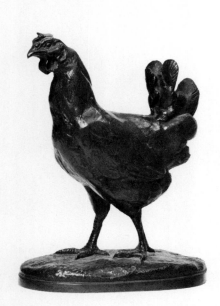

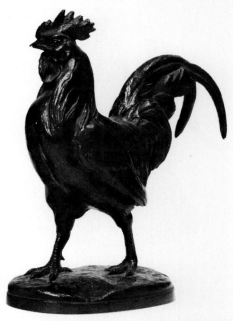

**Bi19** A good pair of bronzes of a hen and rooster. These two models by Valton are not often seen and are quite rare as a pair. A very competent sculptor who has not concentrated on fine detail on these small models but given the feathering a bold flowing sweep to heighten the dramatic effect. In a way the fine sculptural technique is a little lost on such mundane creatures — with apologies to poultry farmers!

Signed 'VALTON': 14 and 16cm (5½ and 6½ins.)
*c.1900*

*hen £150 — £200*
*cock £180 — £230*

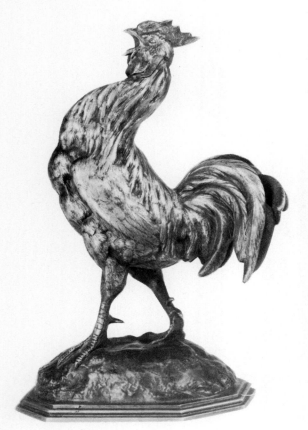

**Bi20** A strongly patriotic French theme of a strutting, crowing cockerel by Barye. A very purposeful animal, well modelled and detailed but not intricate. Not in listings of Barye's works, it is possibly an unlikely model for him except for the overriding romantic nationalistic feeling probably inspired by the 1848 revolution and the political uncertainties of the time.

Signed 'Barye': 21cm (8¼ins.): gilt-bronze patination
*c.1860*
*£350 — £480*

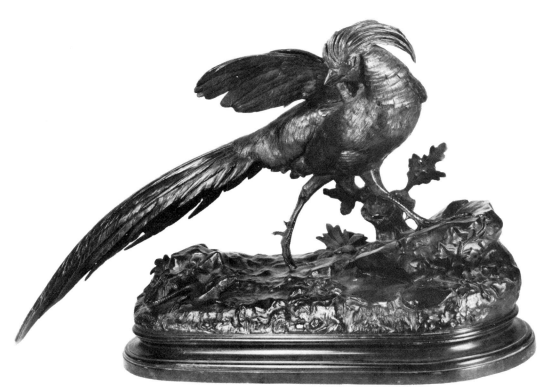

**Bi21** A golden pheasant by Moigniez of exceptional detail and realism. The detail on this model seems to be good on all the casts made of it. A rare bronze that was possibly made in a comparatively small edition, or at least small by the commercial standards of the time. Again Moigniez cannot resist the triangle theory and gives the bird the superior position with one foot on a rock. The bird is caught between a 'pose for the camera' and worrying about the danger of the snake at its feet.
Signed 'J. Moigniez': 42 x 71cm (16½ x 28ins.)
*1860s*                                         *£1,200 — £1,800*

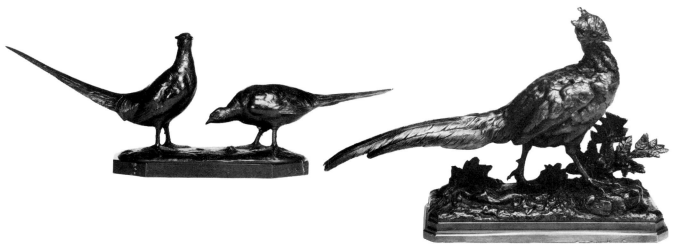

**Bi22** A well-detailed brace of pheasants by Professor Poertzel. The sculptural form however, is a little stiff. The sculptor has ably captured the guard stance of the cock while the female forages. The base is later c.1920.
Signed 'Prof. Poertzel': 30cm (11¾ ins.)
*c.1900*                              *£500 — £700*

**Bi23** A good quality, early model by an underrated animalier, Trodoux. The feathering is excellent and the inquisitive stance with ears cocked is somewhat endearing, reminiscent of a curious cat. The base is nicely detailed although let down by the common problem of the flabby fern.
Signed 'Trodoux': 20cm (8ins.) high
light and dark red/brown patination
*c.1870*                              *£500 — £800*

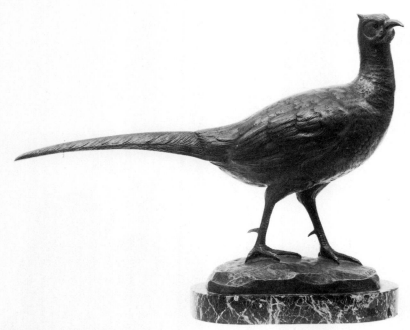

**Bi24** A somewhat stiff and solid looking pheasant in a less romantic style than the animaliers of the mid-19th century. The whole effect is anticipating the angular geometric features of the art deco period in the 1920s. Even the base is severely cut, without the moulding of most earlier bases and in the green verde antico that was popular in the early part of the 20th century. There is a lot of superficial detail but it is not undercut in any way giving the feathers a flat look.

Signed 'I. GALLO': 32.5cm (12¾ins.)
light brown patination

*c.1910* £250 — £400

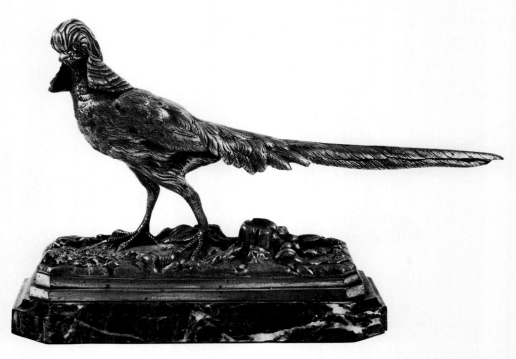

**Bi25** A very well cast figure of a cock pheasant strutting with an attentive ear to some distraction giving him a quizzical look. Unfortunately the eyes are rather exaggerated and the 'rings' in the bird's pupils make him appear rather comical. A great deal of attention has been given to the feathering and also to the excellent base. The base in this case was cast with the bird and not bolted on later. Compare the verde antico marble base with the later model, Bi24. This is moulded to soften the line (as is the base) and has much wider veins of white in it, both early features.

Signed 'Trodoux': 16.5cm (6½ins.): gilt patination
*c.1880* £350 — £600

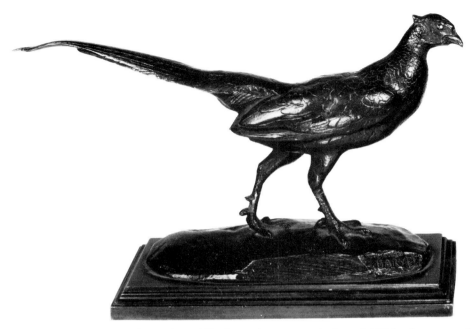

**Bi26** A Barye golden pheasant, strutting rather stiffly for such a competent and original sculptor. In fairness the balance of the model has been lost by the badly bent tail and the broken right leg. Both features could be almost invisibly restored by a competent restorer although any heat applied might destroy local patination. Quite well detailed but with none of the angularity of Bi24, the romantic theme of Barye's work clearly showing here. Another numbered cast with oval base is recorded as 12.5 x 19.5cm (5 x 7¾ins.).
Signed 'Barye' and stamped 'BARYE 20': 10cm (4ins.)
*c.1855*                                                                      *£400 — £600*

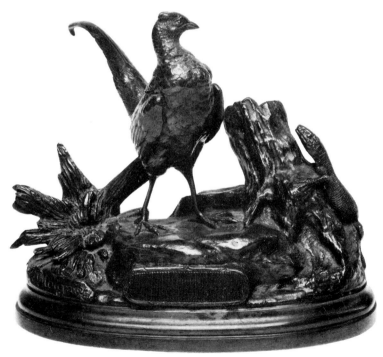

**Bi27** A typical Moigniez group. Here, at this angle the pheasant is almost lost in the rough undergrowth and the long sweep of its tail is essential to the composition. The bird is frightened by a lizard hiding behind the tree stump. The foliage, pose and detailing are typical of Moigniez. A good colour and nice quality cast. Note the oval plaque for presentation which is carefully outlined in knotted branches.
Signed 'J. Moigniez': 14.5cm (5¾ins.)
rich golden-brown patination
*c.1870*                                                                      *£350 — £450*

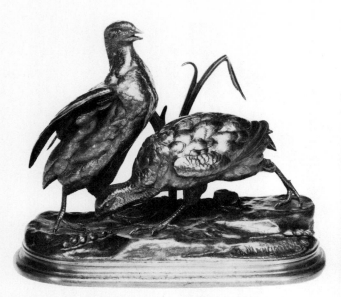

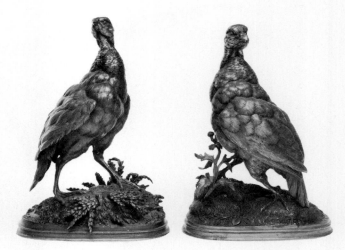

**Bi28** A nice quality group of a brace of partridge feeding. This model is very similar to one exhibited in silvered bronze by Moigniez at the 1865 Salon, illustrated in *Les Animaliers*, page 219, but is a simpler, less complicated cast. It is unusual to find these models, large or small, with their foliage intact, especially when it is as vulnerable as the standing corn in this model. The feathers are realistic and there is a good feeling that the birds are in their natural habitat and not posed as the hen bird stretches her neck for the fallen ear of corn.

<div align="center">

Signed 'J. Moigniez': 19cm (7½ins.)

gilt-brown patination

</div>

*c.1860* £600 —£800

**Bi29** A very fine brace of partridge by Pautrot. The pose and especially the detailing are of the very best quality which reached its height in the 1860s. The wing, body and neck feathering is totally realistic with excellent detailing in the base. Only the foliage, as is so often the case, is a little weak and appears almost superfluous. Moigniez produced a similar model to the left hand one at about the same time (illustrated in *Les Animaliers*, page 231), but it has his familiar emaciated feel which is certainly not evident in the plump birds illustrated here! A much underrated sculptor.

Signed 'F. PAUTROT' (one with an almost totally obliterated
<div align="center">

'F' in the casting): 35.5cm (14ins.) approximately

deep golden brown patination

</div>

*1860s* £2,000 — £3,000

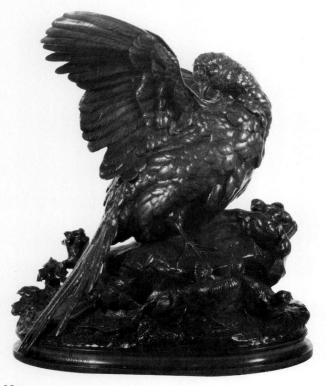

**Bi30** Another good bronze by Arson, also an under-appreciated sculptor. A little complicated possibly but a good family group, the proud hen pheasant preening herself while five chicks frolic at her feet. Her wings have been cast separately and brazed on, which heightens the realism of the feathers, cleverly aided by the ruffled breast feathers which she must only just have preened. The triangular line favoured by painters has been used in the composition to great effect.

<div align="center">

Signed 'ARSON' and 'Société des Bronzes'

43cm (17ins.) high: red/brown patination

</div>

*Late 1860s* £500 — £850

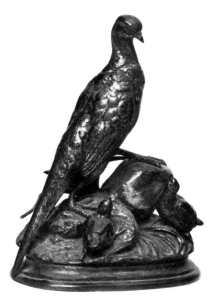

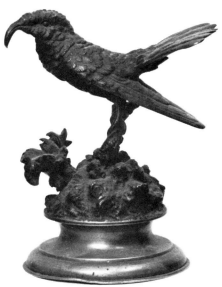

**Bi31** A Moigniez pheasant and her two chicks. Once again there is a proud, romanticised vision of motherhood. The rather awkward stance of the hen with one foot on a rock gives the painter's double triangle, with the point of one at her head and that of the second covering the peak of the rock. A familiar variation of a theme by Moigniez who is surely the best bird sculptor of his time.
Signed 'J. Moigniez': 10cm (4ins.) high: parcel-gilt patination
*c.1865*                                                    *£250 — £350*

**Bi32** A very unusual subject by Pautrot of a sunbird, making a welcome change from the somewhat stereotyped theme of posed game birds. Perched cheekily on a fallen branch, the bird is full of life and the eyes in particular have been realistically modelled. Their piercing and unblinking gaze gives the impression that the bird would fly off at the slightest disturbance. The socle is unusual in that it is round and very tall, but suits the model well. The model is signed 'Pautrot' with no initial letter and so there may be some debate as to whether it is by Ferdinand or Jules. The exceptional quality of the work points to Ferdinand. The style of the base also indicates the period at which Ferdinand was working, namely the 1860s, rather than the 1870s from which Jules' work dates.
Signed 'Pautrot': 12.5cm (5ins.)
*1860s*                                                    *£400 — £500*

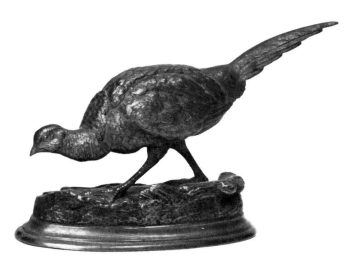

**Bi33** Another pheasant by Moigniez and an ideal dining room bronze. The detail in the feathers is a little worn and is typical of casts readily available today. This sculptor's style is easily recognisable, even down to the particular type of comparatively deep, moulded base which differs from most other animaliers.
Signed 'J. Moigniez': 18cm (7ins.) long
*1860s*                                                    *£330 — £500*

91

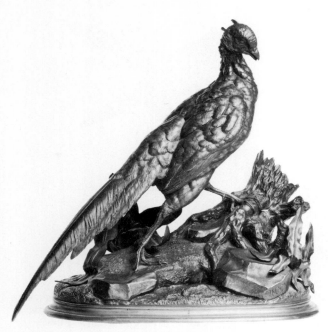

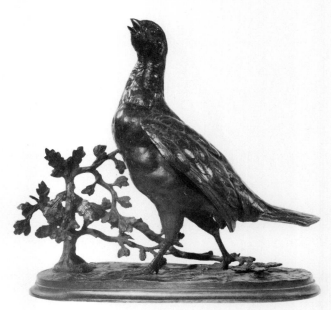

**Bi34** A very fine and large cock pheasant, again by the master of bird sculpture, Moigniez. The bird stands with one foot around a tree stump behind which can be seen a frightened weasel in the undergrowth. This cock pheasant was exhibited in bronze at the 1864 Salon and is a very superior cast and composition.

Signed 'J. MOIGNIEZ': 53cm (21ins.)
rich medium brown patination

*c.1870* £1,200 — £1,800
*Also seen in a size of 33.5cm (13¼ins.) with a companion hen pheasant 35cm (13¾ins.) the pair £1,500 — £2,000*

**Bi35** The bird in this model by Moigniez has almost a Barye-like quality, especially in the rounded lightly detailed body. This is an unusually flat and uncomplicated base for Moigniez which suggests an early period. Also the 'foliage' is very naïve indeed. It looks like a miniature or bonsai oak tree and as such is totally out of proportion to the bird. The naturalistic form of the tree is also an indication of an early date and it is quite possible that this was an early, somewhat experimental model. It has little of his rather complicated assurance of the 1860s and 1870s.

Signed 'J. Moigniez': 27cm (10½ins.)
light black patination

*Late 1850s* £400 — £600

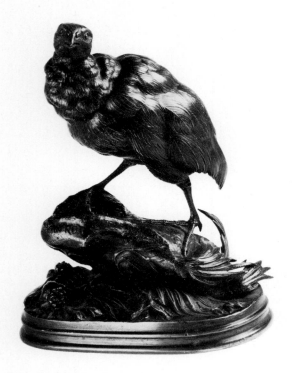

**Bi36** An uncommon, small figure of a partridge perched on a rock by Pautrot probably Ferdinand (see Bi32). Modelled very much in the Moigniez idiom and probably intended as the right hand model of a pair. A good, alert bird and a nice cast.

Signed 'PAUTROT': 23cm (9ins.)
slightly rubbed dark brown patination

*c.1860s* £400 — £500

92

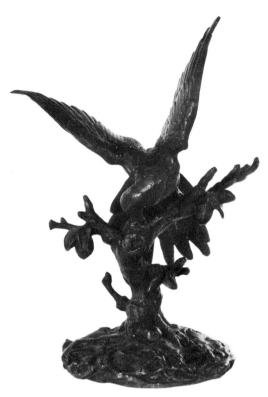

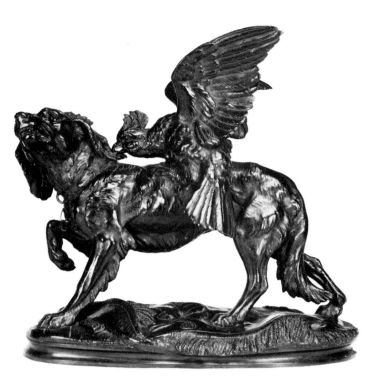

**Bi37** A parrot by Barye rarely seen on today's market. The inquisitive bird is captured in the act of alighting in a tree, its head turned towards an unseen insect. The balance of the bird's wings makes the sculpture come alive giving it a very powerful realism that was never experienced before Barye and rarely after him. There is a certain softness of form that characterises his work which is clearly seen here.

Signed 'Barye' and stamped Barye, numbered 1 on the front
21.5cm (8½ins.) high

*c.1840*                                                            *£850 — £1,200*

**Bi38** The humour of Arson's work is evident in this cast. The poor spaniel is being tormented by the angry parrot or parakeet and is having his ear severely nipped! This unusual and rather exotic combination of animals was very popular amongst mid-19th century animaliers. Both animals appear to have broken their chains and the parrot has gone into full attack. Both are well detailed but the bird is certainly better modelled and, as with the Barye bronze shown as Bi37, the sculptor has made a good use of the bird's wings to achieve balance. The ruffled, heavily tasselled carpet would have been popular in the mid-19th century which would help anyone who was uncertain to date the bronze, or at least to date the original model.

Signed 'Arson': 52cm (20½ins.) high
rich brown patination

*c.1865*                                                            *£800 — £1,200*

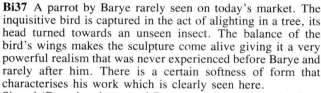

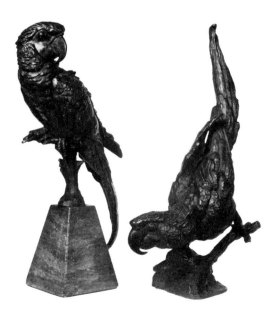

**Bi39** This highly decorative pair of large parrots will appeal to a wider market of buyers rather than the more limited field of animalier collectors. They fit very well into the decorative theme of the 1920s. They are well cast but without any pretence at small detail, their modelling and poses are realistic, and they balance well together as a pair.

35.5cm (14ins): dark brown patination

*c.1920*                                                            *£2,000 — £3,000*

The number of sculptors producing small still-lifes is an indication as to their popularity, especially in the mid-19th century and most of the successful animaliers produced them. The love of allegorical naturalism was very popular in dining rooms and was used in all art forms of the period.

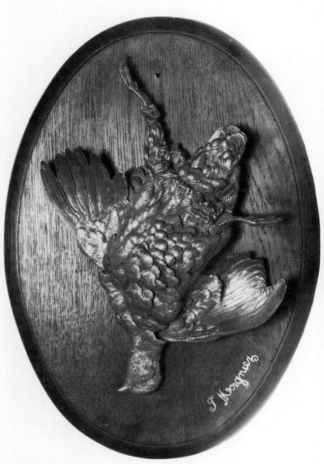 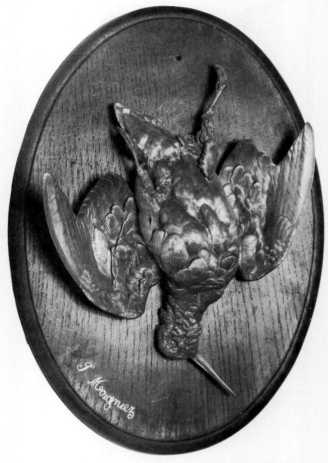

**Bi40** A pair of still-life studies of a woodcock and snipe by Moigniez. There is no reason to suspect the authenticity of the models but the oak bases are obviously recent replacements and quite possibly the casts were originally supplied with similar mounts. Oak would be very much in keeping with the feeling of the time, a wood indigenous to the French forests (rather than a more 'sophisticated' imported wood from the Carribean), and the type of copse in which game would be found. The applied brass 'signatures' are obviously false in a crude attempt to reproduce the sculptor's signature. The birds are very well modelled and almost certainly early casts now with a silvered patination. Silvered bronze or electroplated subjects were popular at the time and especially so with Moigniez.

37cm (14½ins.) long overall

*c.1865* *the pair £250 — £400*

**Bi41** A sparrow by Comoléra that must have been cast in very large numbers as paper-weights. Seen frequently on market stalls, it is a difficult bronze to sell but very useful for keeping the cat on its toes!

Signed 'Comoléra' and stamped 'Susse Fres. D and MM'

13cm (5ins.) long: worn gilt patination

*c.1850* *£45 — £75*

**Bi42** A highly realistic model of a dead sandpiper by Cain. The small bird seems to have expired after breaking its right leg, a common enough sight for any nature rambler. Four flies and a beetle cautiously approach the bird and the thought of its subsequently decomposition is enough to put off all but the most dedicated collector! However this model is cast with the typical sensitivity of Cain who excells in small detail — the broken stem of bell-flowers cast into the base of the bronze is typical of him and also is a guide to the approximate date of the model as they are cast in the naturalistic way that typified plant forms in the period around 1840-70.

Signed 'A. Cain': 30cm (11¾ins.) wide
*c.1850* £90 — £150

**Bi43** Mêne also produced still-life subjects but in this example not very successfully. Dated 1850, this cast was produced in large numbers and this example possibly dates from some years later. There is little fine detail on this model, which is spoilt by the amateurish naturalistically carved beechwood contemporary base.

Signed 'P J MENE 1850': 3.3 x 10.3.cm. (1¼ x 4ins.)
*c.1865-1870* £65 — £110

**Bi44** A fine bronze plaque by Mêne of a dead hare and pheasant hanging up with game bags. The sculptor has used all his powers of line and incredible detail in this group, from leather work to feathering, incorporating the faultless realism that typifies the period. A rare cast and not everyone's choice but a must for anyone forming a representative collection.

Signed 'P.J. MENE' in unusual script: 16cm (6¼ins.) wide
*c.1850* £200 — £300

95

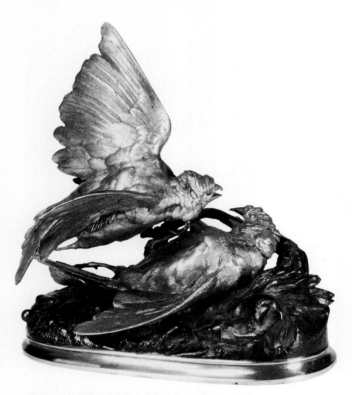

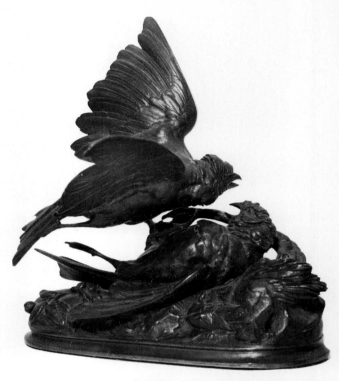

**Bi45** A parcel-gilt bronze group of two fighting sparrows by Comoléra. The birds are gilt as is the base with a deep/brown patination to the naturalistic ground. The two tone effect serves to heighten the three-dimensional image, making what would be normally a fairly complicated and fussy group far less so, allowing the eye to see quickly the principal subjects of the group. The birds are fighting, it seems, to the death and the squawking and scuffling can almost be heard and the feathers be seen to fly!

Signed 'COMOLÉRA': 20cm (8ins.)
*c.1860*                                              £400 — £600

Although an aid sculpturally and very popular at the time of casting, parcel-gilding puts off most collectors. Unfortunately someone will probably buy No. 45 'cheaply' and repatinate it in hues of brown to suit modern taste. As this happens more and more and fashions, as they surely will, change, the partly-gilt bronze will become a most sought-after rarity!

**Bi46** The same group as Bi45, without the gilding. There is virtually no difference between the two except for the signature and that this one is slightly less crisp.

Signed 'Comoléra': 20cm (8ins.)
*c.1860*                                              £320 — £450

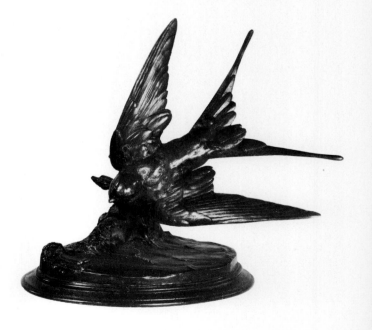

**Bi47** A rare model of a swallow in flight by Comoléra. This sculptor seems to vary the amount of intended detail from model to model and, judging from the very few casts of this model seen, it appears that it was intended to be somewhat sketchy, as the quality of the cast is very good. He has created a vivid impression of the swallow swooping at speed to the edge of a pond to pick up the unfortunate water beetle which can just be seen on the front left of the base.

Signed 'P. Comoléra' and 'Susse Fres': 17cm (6¾ins)
brown patination
*c.1860*                                              £500 — £800

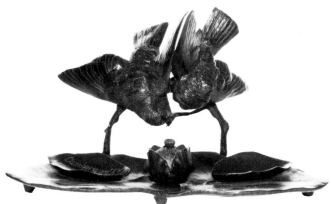

**Bi48** Signed 'Cumberworth' in script: 15.5 x 23.5 (6 x 9¼ins)
dark brown patination

*Early 1840s*                                    *£200 — £300*

**Bi49** Signed 'Cumberworth' in script: 17.5 x 28cm (7 x 11ins.)
dark brown patination

*Early 1840s*                                    *£250 — £350*

**Bi48 and Bi49** A rare 'pair' of bronze models of reed warblers by Cumberworth. It is difficult to realise that these are comparitively early models and many people would quite undertstandably feel that they were more possibly c.1900 than the earlier animalier period. However, it is important to train the eye to distinguish between the heavy, rather languid foliage that is the hallmark of the art nouveau period around 1900 and the abundant naturalism that characterised the direct allusion to nature in the middle of the 19th century, on both sides of the channel. Both pairs of these charming birds are fighting playfully on flowering lily leaves and a feeling of spring is in the air. Both are intended as desk pieces and Bi49 looks as though it may have originally be designed for use as an inkwell.

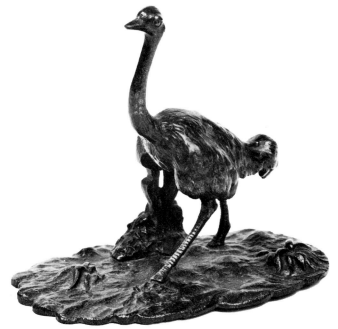

**Bi50** A cast-iron model of an ostrich, both poorly modelled and equally poorly cast. Some cast-iron models can be very highly detailed to incredible standards of workmanship. The model has been cast in three parts, bird, base and 'supporting' tree and would have been cast in sand. Very difficult to date, especially without a signature.

17cm (6¾ins.) approx.

*c.1860-1890*                                    *£70 — £110*

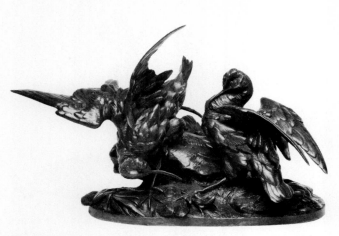

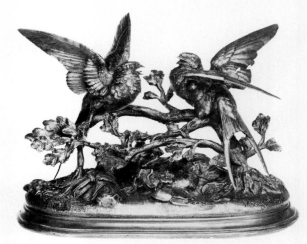

**Bi51** A highly competent group by the little known sculptor, Hippolyte Heizler. The two snipe, hunting in tandem, have succeeded in flushing out an unfortunate frog, caught by its back legs by the foot of the right hand bird. Very well detailed although a little complicated as a group but full of lively movement. The sculptor has chosen a very difficult stance for the left hand bird with its wings outstretched, stepping down from a rock, and it only just comes off.

Signed 'Heizler': 21cm (8¼ins.) high
rich light brown and red patination

*c.1850-1870*                                            *£400 — £600*

**Bi52** Moigniez' mastery of his subject is clearly seen in this group of two swallows jostling for position on a branch. The height of the branch above the ground has allowed for a gap in the centre of the group essential to an unfussy composition. The base is exceptionally well detailed although the oak leaves are a little heavy. Leaves seem to be one of the sculptor's most difficult tasks during this mid-19th century period.

Signed 'J. Moigniez': 17cm (6¾ins.)
dark brown patination

*c.1865*                                                  *£500 — £700*

Accurate measurement of these small, well-handled groups of birds is very difficult as they often become bent, as in many cases the birds are supported by their fragile legs only, or possibly with the help of the tail feathers. Ideally each bronze should be measured from top to bottom and then across the base, which gives a firm and unchanging reading.

**Bi53** An amusing group of two corn sparrows and a mouse confronting each other by an ill-defined stand of barley. This is a rare group by Moigniez and has a lot of the feelings of Mêne's work in it. It is not particularly accomplished and may possibly be an early work. It is certainly a fairly worn cast and the unusual upper case signature is extremely ill-defined.

Signed 'J. MOIGNIEZ': 11.5cm (4½ins.): black patination
*Probably late 1850s*                                    *£450 — £600*

**Bi54** Two fighting sparrows, again by Moigniez. A well detailed cast that is too crowded by the complicated undergrowth and tangled foliage at the edge of a pond. The water's edge can just be made out on the left and there is the rather nice touch of a shell in the right foreground. Another cast, recorded as 12cm (4¾ins.) high, had the taller bird slightly bent.

Signed 'J. Moigniez': 12.5cm (5ins.)
*1867 Paris Exhibition model*                            *£400 — £700*

**Bi55** A Moigniez sandpiper lifting its right leg as it stalks around a large clump of foliage in search of a tit-bit on the pond's edge. An early well-detailed cast and a very bold attempt at subject movement that just and only just, comes off.

Signed 'J. Moigniez': 25.5cm (10ins.): rich brown patination

*1860s*                                                                                       *£550 — £900*

**Bi56** This illustration is taken from a somewhat uncompromising angle which has the advantage of showing the very good detailing of the feathers and the base. A difficult subject to photograph and consequently to judge two dimensionally. The sculptor invariably conceives his models in the round and in this case it is essential to see the model from all sides to appreciate the feeling of panic as the animal spies its unknown predator. The branch on which the bird is precariously perched is rather dashingly conceived with part of it trailing well over the side of the base. Naturalism was certainly the order of the day but to carry asymmetry to this extent in the 1860s must have been quite a bold conception.

Signed 'F. PAUTROT': 20cm (8ins.)
golden brown patination

*1861-1870*                                      *£500 — £700*

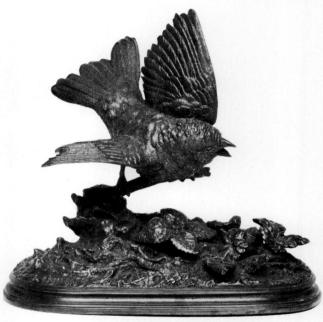

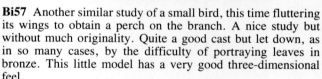

**Bi57** Another similar study of a small bird, this time fluttering its wings to obtain a perch on the branch. A nice study but without much originality. Quite a good cast but let down, as in so many cases, by the difficulty of portraying leaves in bronze. This little model has a very good three-dimensional feel.

Signed 'F. PAUTROT': 18.5 x 19.5cm (7¼ x 7¾ins.)
parcel-gilt brown patination

*1861-1870*                                      *£400 — £600*

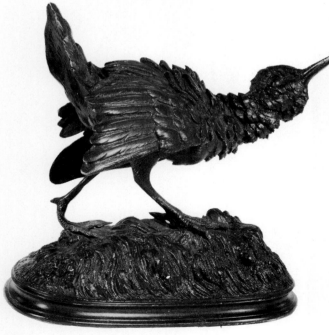

**Bi58** An unusual model of a ruff, a subject also used by Moigniez. As would be expected with this highly competent sculptor, there is plenty of detail in the finish of the cast and although the bird looks a little awkward in its pose, he has captured the typical movement of this quick moving rather nervous little creature.

Signed 'F. PAUTROT': 15cm (6ins.)

*1861-1870*                                      *£500 — £700*

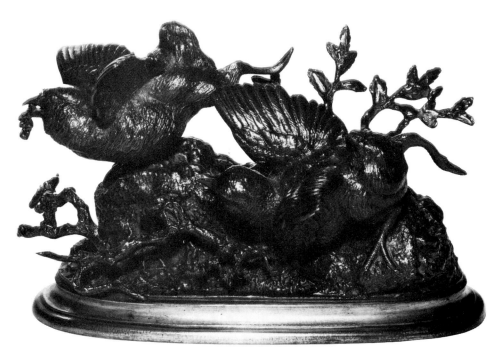

**Bi59** A complicated but rare model of two grouse chicks nesting, both fluttering their wings as they scurry along the ground. Once again Pautrot has used the branches in his model to help balance the sculptural effect and this gives a very good impression of uneven terrain with years of fallen twigs and branches in an undisturbed copse. The base is gilt-bronze which is only occasionally seen but serves to lighten the whole effect of the model, putting it on a pedestal, rather than simply allowing the model to dissolve into the base in an often unhappy liaison. It is a technique that Pautrot used comparatively frequently and to very good effect.

Signed 'F. Pautrot': 12 x 18cm (4¾ x 7ins.)
good rich dark brown patination with gilt base
*1861-1870*                                              *£550 — £800*

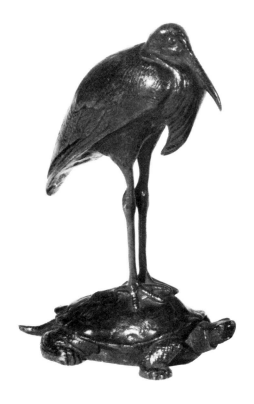

**Bi60** Once again Barye romanticises in his combination of animals as we saw with his ape riding a gnu on page 66. Barye also produced an identical model of the turtle by itself, approximately 10cm (4ins.) long. This smaller version is equally rare and an amusing piece for a collector to acquire. It is listed no. 1 in Barye's catalogue of 1847. Most casts are very good indeed. This one was not signed but the turtle has been recorded by Horswell as 'stamped Barye'.

8 x 5.5cm (3⅛ x 2⅛ins.): deep rich brown patination
*1825-1850*                                              *£350 — £550*

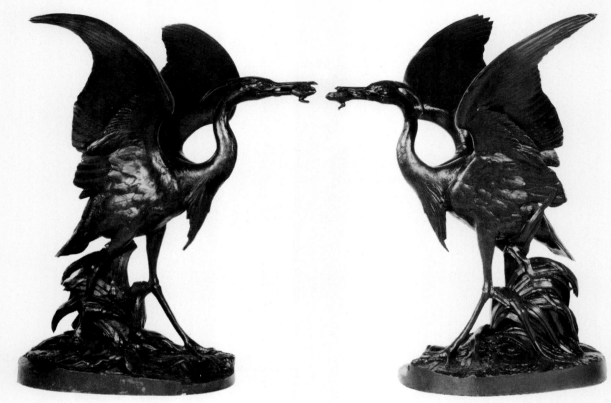

**Bi61** A pair of herons by Jacquemart, or more correctly two identical bronzes of the same subject; the cast is reversed to show each side and is more usually two variations of the same animal or a male and female. Quite a good impression of impending movement is given as the large bird steps out flapping its wings, having just caught a frog. As was popular in representations of water birds, there is a slight indication of a pond or a lake which can be clearly seen cut away into the base on the left hand bronze at the front.

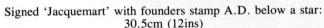

Signed 'Jacquemart' with founders stamp A.D. below a star:
30.5cm (12ins)
*c.1870*                                    *each £450 — £750*

Moigniez modelled a similar subject of an egret with head inclined.
Signed Moigniez: 53.5cm (21ins.): brown patination
*c.1870*                                    *£1,400 — £1,900*

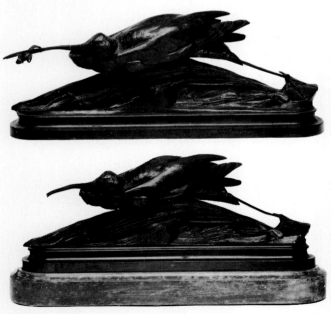

**Bi62 and Bi63** The sculptor Cain has captured the exact moment at which a stalking heron has caught a wriggling frog in its bill whilst another frog, caught in the reeds which have been flattened by the weight of the bird, struggles to get free and escape. These two examples of the same model differ in quality and condition. Bi62 (left above) is not such a good cast but at least is complete. Bi63 (left below), a better cast, would need at least £150 spending on it to recast a frog and repair the heron's bill. The purist would require the outstretched left leg to be repaired as well as the dew-claw straightening. Other very slight variations in the cast can be seen, noticeably the shell, in Bi62, and the rock in Bi63 just to the left of the rock held by the bird's left foot. More interesting is the fact that the former appears to be cast all in one with its moulded base and the latter has been bolted together. Other variations have been recorded with gilt-bronze bases in a style similar to that used by Pautrot (Bi59).
Signed 'CAIN' in hand written capitals: 15 x 39cm (6 x 15¼ins.)
Both rubbed brown/black patination
*c.1860*                                    *Bi62 £550 — £900*
                                           *Bi63 £350 — £850*

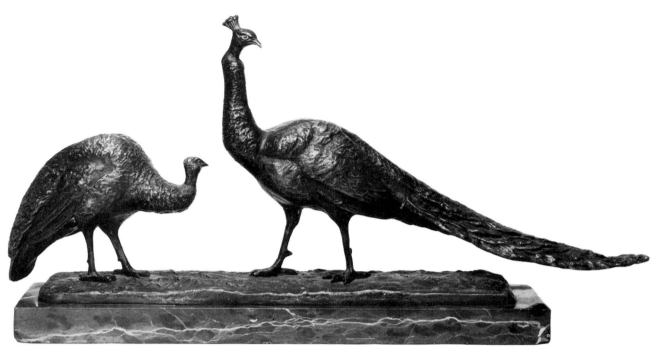

**Bi64** A pair of peacocks by Buchelberger. The somewhat heavy style hardly flatters these proud birds. The conception of balance is about the only good thing about this badly modelled bronze. The red griotte marble base is contemporary.

Signed 'Buchelberger': 26cm (10¼ins.)
dark brown/black patination

*1930s*

£500 — £700

**Bi65** A lively group of a turkey cock with two admirers by Guido Couria Paoli. A loosely worked group in a quasi-Impressionist manner and well modelled. Although an unusual subject, it is not a very successful bronze as it comes over as a black mass.
Signed 'Guido Couria Paoli' in script: 28 x 18cm (11 x 7ins.)
light black patination

*c.1910*

£450 — £650

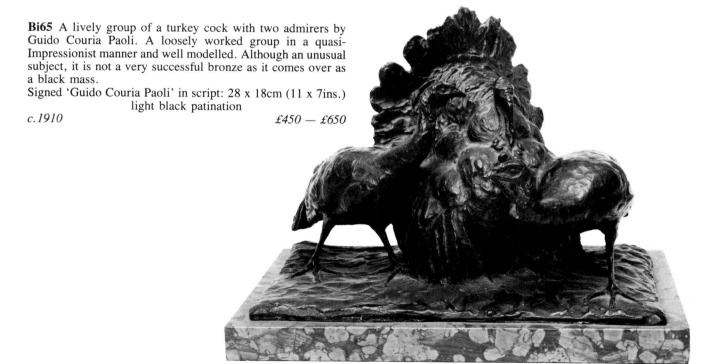

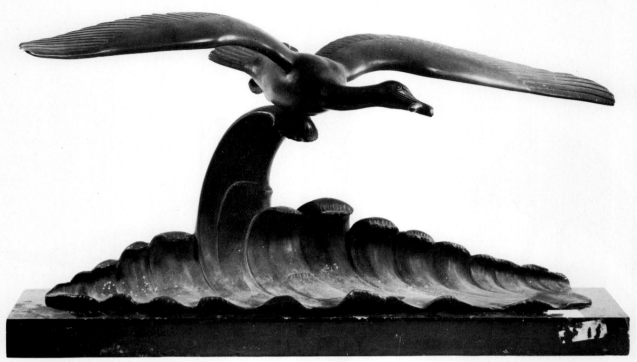

The bird groups on this page clearly show a different style of bronze which developed just before the First World War and came to fruition in the 1920s, heralding the 'art deco' style. The balance of all these models is self assured and the geometry simplified. No longer is it felt necessary to overdecorate the model, or to add clumsy and unnecessary foliage or branches. Significantly, in many of the examples, the bases are of marble and are an integral part of the design.

**Bi66** A bronze group of a seagull flying over the water with a small fish in its beak. As with Bi68, the sculptor and founder have collaborated in a bold style of support for the birds. Technical improvements, impossible in the previous century, have allowed the sculptor to obtain more visual impact.

Signed 'L. Gilbert': 44cm (17¼ins.): dull black patination
*c.1925* £200 — £400

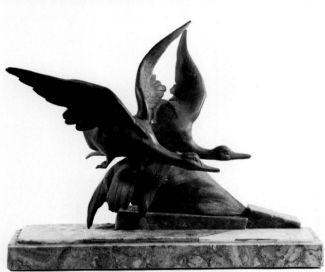

**Bi67** This group, very much in the same manner, is unsigned and cast in white metal, or spelter. The material would normally realise less at auction than bronze but with little known and purely decorative works such as these, this rule is not precise. The frozen frame action of the pair of mallards is highly competent but not particularly successful as sculpture.

44cm (17¼ins.): dark dull-grey patination
*c.1925* £200 — £300

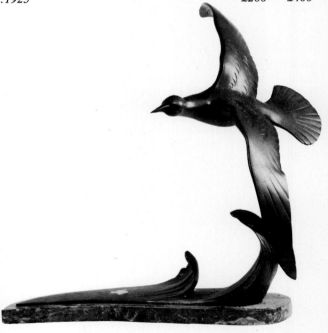

**Bi68** Another unsigned example, this time in bronze. Not as dramatic as the gull above but a good study nevertheless. These models are still very reasonably priced.

46cm (18ins.): dull black patination
*c.1925* £200 — £350

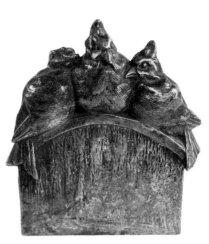

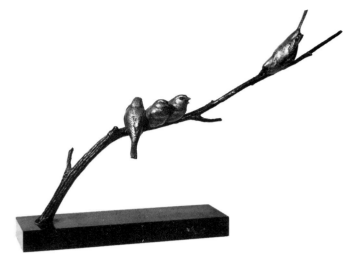

**Bi69** The cosy detail of these sparrows sitting on a rooftop by Deroche is in a style that looks back to the 19th century and is not particularly innovative apart from the roof, which shows the start of a breakaway from traditional forms.

Signed 'Deroche': 17cm (6¾ins.): dark gold patination
c.1910                                                    £120 — £180

**Bi70** A Becquerel parcel-gilt bronze group and well balanced like his model below. A highly aesthetic piece very much in keeping with the contemporary 'art deco' background.

Signed 'Becquerel': cold painted gilt bronze
c.1920                                                    £400 — £700

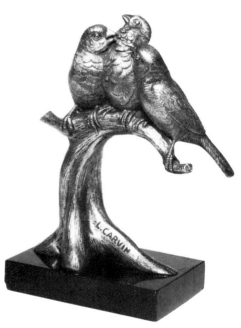

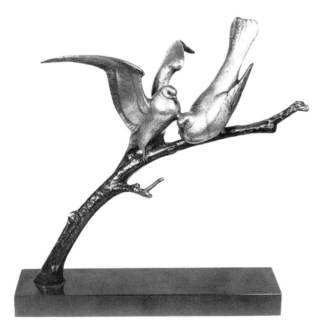

**Bi71** Once again the sweep of the tree is used to heighten the sculptural effect and the signature of Louis Carvin can clearly be seen. The central bird seems to have two attendants to preen its feathers although the rather bulbous eyes make them look somewhat aggressive and possibly they are all jostling for position! There has been a lot of hand finishing but done in a sketchy way rather than paying too much attention to fine detail. The Belgian black marble plinth has become a little chipped which always spoils the good finish of these bronzes.

Signed 'L. CARVIN' and numbered 2: 19cm (7½ins.)
gilt-bronze patination
c.1925                                                    £300 — £450

**Bi72** Becquerel has achieved near perfect balance in this model between the sweep of the branch and the juxtaposition of the alighting bird's wings on the left and the bird on the right tilting its tail at the moment of settling to attain its balance. Here there is plenty of assurance in the strength of materials in the bronze arm of the tree and there is a definite feeling of almost Japanese aestheticism in the composition. The birds and branch have been cold painted in gilt and brown rather than chemically patinated and this has been done to a very high standard indeed for this technique. The base is slate which can chip very easily but in this case is, like the bronze, in perfect condition.

Signed 'Becquerel': 33cm (13ins.): cold painted
c.1920                                                    £600 — £900

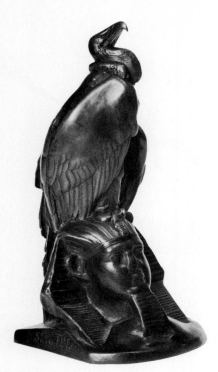

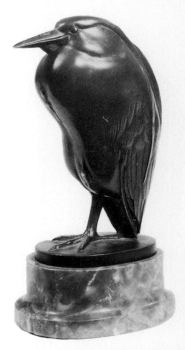

**Bi73** A strange composition by Cain of a vulture perched on the Sphinx. A cast seen quite commonly suggesting great popularity at the time it was made, but one that is very difficult indeed to sell today. The French especially were heavily influenced by the romance of North Africa but this Egyptian scene appears to owe its origin more to the brief Napoleonic conquest in the late 18th century rather than to later 19th century 'Orientalism'. Often seen on a self-tapering red griotte marble base. This example is a very poor cast. The model is listed in the combined catalogue of Mêne and Cain issued from 19 rue de l'Entrepôt, entitled 'no. 10: Vautour sur tête de sphinx' and measuring 50 x 22 x 20cm (19¾ x 8¾ x 8ins.).

Signed 'Cain' and founder's mark 'Susse Frs. Edrs'.
16.5cm (6½ins.)

*c.1870 but probably modelled in the 1860s*     *£150 — £300*

**Bi74** A night heron by the sculptor Gerhard. Standing watchfully on one leg, it immediately conveys the style peculiar to the Austro-German school that developed during the last decade of the 19th century. Black patination, and a somewhat heavy look with smooth rounded corners, are typical features which, once understood, are easily recognised. The Mexican onyx oval plinth is typical of the period c.1910-35.

Signed 'Gerhard' entitled 'Schliepstein': 19cm (7½ins.)
light black patination

*c.1920*                                                   *£220 — £350*

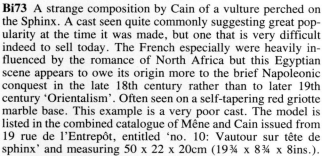

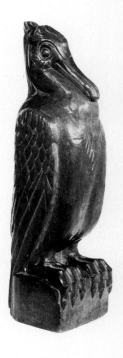

**Bi75** A wooden carving of a pelican. The bird has an almost tongue-in-cheek look about it but this may be the way the sculptor has carved it in a stiff and formal way. An ideal subject for a newel post, it unfortunately looks as though it has been carved from a rectangular block of wood and has none of the feeling of roundness that a bronze would have. Wood must be carved from a given shape inwards and a bronze, when modelled first in clay or wax, has no form to start with and has to be built up from nothing outwards, producing, normally, a more complete effect.

*1925-1950*                                               *£300 — £500*

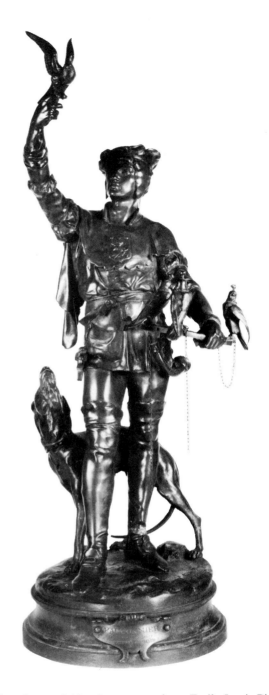

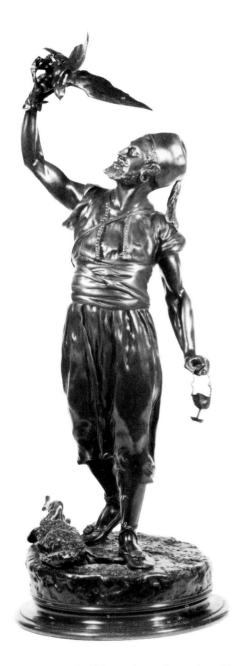

**Bi76** A fine model by the genre sculptor Emile-Louis Picault, who was exhibiting in the Paris salons from 1863 to 1909. He is not listed in the index of sculptors as he is not generally considered an animalier. However, he was an exceptional and very popular sculptor and his modelling of the four falcons and the hunting dog are as good as those modelled by many animal specialists. Combined with the exquisitely modelled figure of a huntsman in splendid eclectic costume he provides a typical 19th century romantic view of the joys and simple pastimes of days of yore.

Signed 'E. Picault': 86.5cm (34ins.)

*c.1870*                                                    £2,500 — £4,000

**Bi77** Also in the rue de l'Entrepôt catalogue but this time by Cain's father-in-law, Pierre-Jules Mêne, entitled 'no. 11: Fauconnier arabe à pied'. This model has suffered over the years; the falcon has been bent and damaged which spoils the whole line of the model. It could be repaired. The bird should be standing with both legs outstretched, legs that will be delicate to bend or replace. A dead hare lies at the hunter's feet as a gesture of the bird's success. A wax and subsequently a bronze version were exhibited at the Salon in 1873-74 and the bronze at the Universelle Exposition of 1878. The catalogue size is 65cm (25½ins.) high, base 22cm (8¾ins.).

Signed 'P.J. Mêne': 61cm (24ins.)
even mid-brown patination

*c.1873-1874*                                              £1,200 — £1,800

Bugatti's individual style is instantly recognisable and highly individual.
His follower and companion, Albéric Collin,
was never able to quite capture the strange genius
that Bugatti had at the end of his fingertips.
No imitators have captured the pose of their animals in the same geometric but fluid manner.

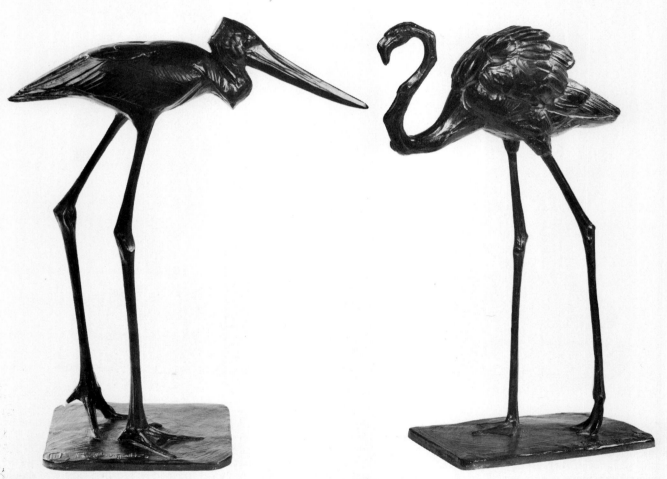

**Bi78** The walking heron 'L'Echassier' or wader. This is a fine example of the sculptor's unique ability to capture movement. A cast of this model was made in silver by Hébrard, size 35cm (13¾ins.) high and a base size of 12 x 15cm (4¾ x 6ins.)
Signed 'R. Bugatti' with AA Hébrard cire perdue seal and numbered 9
35 x 17cm (13¾ x 6¾ins.):black patination
*c.1910*                                    *£2,500 — £3,500*

**Bi79** A rose flamingo, with its neck drawn back as its struts quizzically by the onlooker. The tall elegant thin legs are well proportioned to the bird's body and there is none of the feeling of heaviness that the sculptor shows in Bi80 and Bi81. A silver version of this model was cast by Hébrard, 34.5cm (13½ins.) high, with a base size of 17.5 x 11cm (7 x 4¼ins.).
Signed 'Rembrandt Bugatti' with A.A. Hébrard seal
*c.1910*                                    *£2,500 — £3,500*

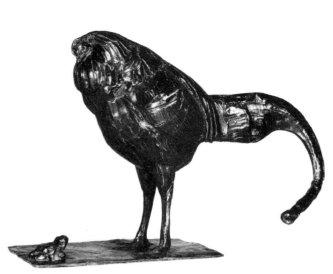

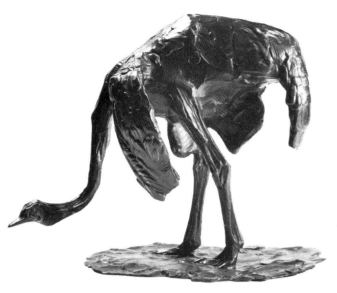

**Bi80** A mighty confrontation between a rooster and a frog. The bird has puffed its chest out to the tiny frog and is determined not to be the one to back away. The massive wall of bronze in the bird's chest is almost too much, especially with the heavy, almost lion like tail. The previous model was full of fine detail but in this example the sculptor has concentrated on the feathery effect of the rooster by using his fingers to work up the clay in bold strokes.

Signed 'R. Bugatti':
Stamped 'Cire Perdue A.A. Hebrard and M.'
25.5cm (10ins.): rubbed brown/black patination
*c.1910* £3,000 — £4,000

**Bi81** A stooping ostrich with the awkwardness and ungainly balance of the bird emphasised by the sculptor. Its pathetic wings are a record of the bird's size and evolution as a land animal and dependence on its long and powerful legs as a means of transport and escape.

Signed 'R. Bugatti' with seal: approx. 30cm (12ins.)
*c.1910* £1,500 — £2,500

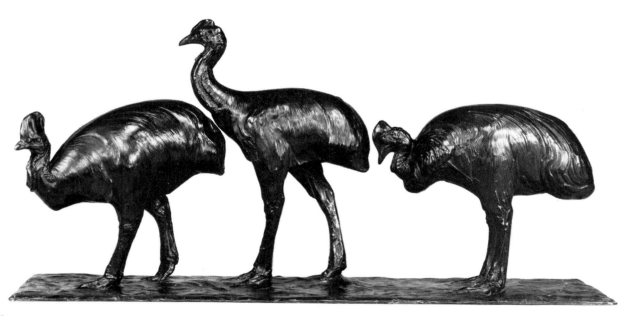

**Bi82** A marvellous group of three cassowaries walking in single file, and intermittently pecking, in a way that Bugatti managed so very well. At first a rather odd subject but a realistic one that the sculptor may well have seen at the Antwerp Zoo. These long groups of his need a large viewing space to be successful but are highly decorative. A very fine and well-detailed cast.

Signed 'R. Bugatti' and stamped 'Cire Perdue A. Hebrard', numbered 7.
42.5cm (16¾ins.): dark brown patination
*c.1910* £15,000 — £20,000

109

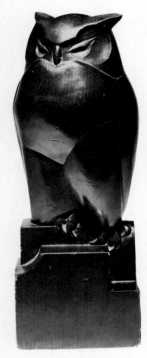

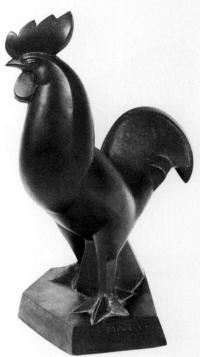

**Bi83** A wooden owl by Francis Pompon in a sleepy almost belligerent posture that is full of confidence. The sculptor has used deep sweeping cuts to model the animal in marked contrast to the softness of the fruitwood chosen as his material. The angular pedestal the bird sits on is a useful date guide.

Signed 'F. Pompon': 33cm (13ins.)

*c.1910* £1,500 — £2,500

**Bi84** A bronze rooster by Jan and Joel Martel, twin brothers who worked on a range of sculpture together. Once again they have used deep, sweeping cuts to give the surface an angular rounded feel. A somewhat self-conscious animal but very patriotic.

Signed 'J. MARTEL': light black patination

*1920s* £800 — £1,500

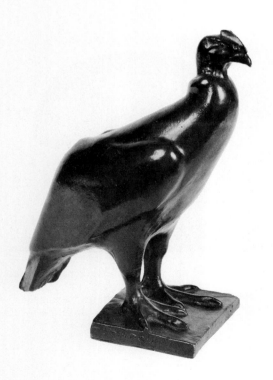

**Bi85** Pompon once again in a less angular mood with a considerable amount of realism in this large bodied bird. The small base and overhanging tail give the model a very good sense of balance. An interesting small detail is the way the sculptor has intentionally cut off the nail of the bird's right toe at an angle in line with the flat base.

Signed 'POMPON' slightly slanted: black patination

*c.1900* £1,000 — £1,500

110

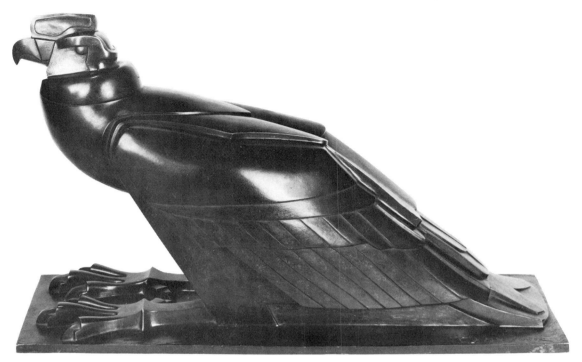

**Bi86** The full impact of the Aztec culture has been incorporated into this bronze condor by Sandoz. This fine sculptor of many moods has caught the full geometric flavour of the 1920s in this proud animal but using rounded surfaces in the same way that Pompon does in the owl shown as Bi83.
Signed 'Ed. M. Sandoz': no size available
brown/black patination

*1920s* £1,800 — £2,800

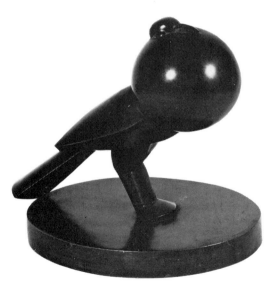

**Bi87** Bela Voros has captured the puffed up bill of this billing dove in a way that reflects absolutely the style and period of her age. The sense of balance between the unusually wide circular base and the little bird's puffed up throat at full stretch makes for a very desirable item of sculpture which, as with most of the bronzes on this and the previous page, will appeal more to the art deco market than to those who collect animal bronzes for their own sake.

black patination

*c.1930* £1,000 — £1,500

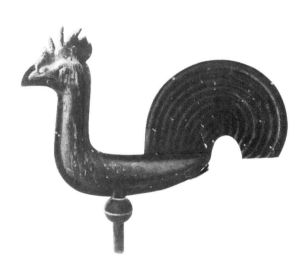

**Bi88** A traditional weather vane by Pompon but in his own ever-changing and far ranging personal style. The practical sweep of the tail is emphasised by the stylised feathering and smooth body of the bird.

*c.1910* £500 — £900

111

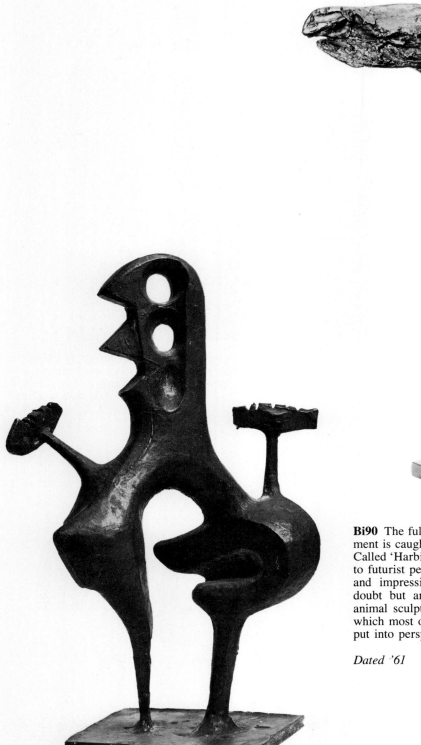

**Bi90** The full effect of the first half of 20th century development is caught in this strange bird by Dame Elizabeth Frink. Called 'Harbinger Bird IV' and modelled in 1961 it uses cubist to futurist persuasions and is a strange mixture of geometric and impressionistic techniques. Not everybody's taste no doubt but an interesting sideshow in the development of animal sculpture in that period of the 1950s and early '60s which most of us are only now beginning to understand and put into perspective.

Signed 'Frink': 49cm (19¼ins.)

*Dated '61*                          *£1,500 — £2,200*

**Bi89** Almost unrecognisable to the uninitiated onlooker, this cock by Bernard Meadows reflects absolutely the style of painting popular at the time of this sculpture, the style of Klee and Miro. In contrast to his surrealist works this pierced bronze creates a stark skyline.

*By permission of the National Museum of Wales*

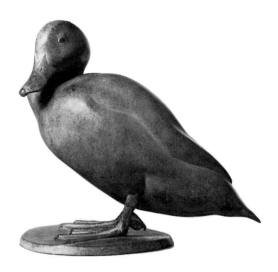

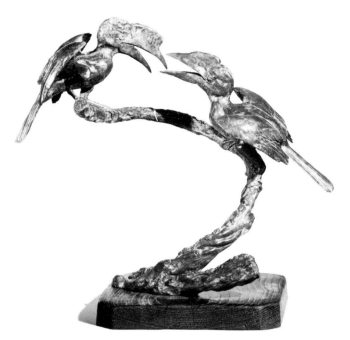

**Bi91** The work of Adrian Sorrell, which is reminiscent of ancient Chinese bronzes in its colour sense, is a firm favourite of the author's so an unbiased viewpoint becomes difficult. The sculptor uses very smooth surfaces and his patination is not just an afterthought but an important part of the conception of the model. The obviously modern birds he creates have an extraordinary timelessness about them that will surely make them very sought after by generations to come. They appeal as much to the bird lover as to the decorator, another important 'marketing' factor. Made in a limited edition of twelve.

    Signed 'Sorrell' with Morris Singer foundry mark
25.5 x 30.5cm (10 x 12ins.): soft Chinese green patination
*1977*                                       *£1,000*

**Bi92** This pair of jostling hornbills by Terence Mathews is a tribute to the firm yet malleable bronze alloys used since the turn of the century. He has perched his birds on a curving un-supported branch in the popular style of the 1920s and 1930s seen on p.104. An oak plinth has been used to give an air of naturalism. Made in a limited edition of five.
Signed 'T. Mathews': 48.2 x 30.5 x 30.5cm (19 x 12 x 12ins.)
                dark green and black patination
*c.1975*

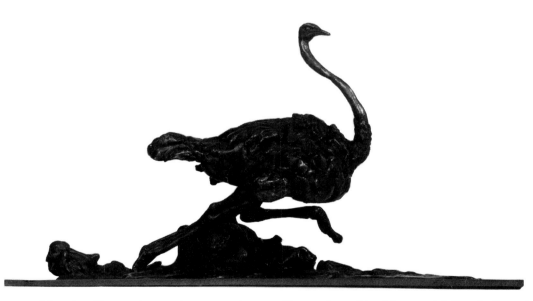

**Bi93** The bronzes of Jonathan Kenworthy are always popular as he injects a sense of realism into his work which gives life and vigour to his animals. This ostrich running at a gallop is in stark contrast to the one by Bugatti illustrated as Bi81. Possibly this marks the difference between a sculptor like Kenworthy, taking his material directly from the open plains of Africa, and Bugatti's disconsolate view of the same species in a zoo. Here the long base, coincidentally a popular choice of Bugatti's, aids the sense of the animal's speed.

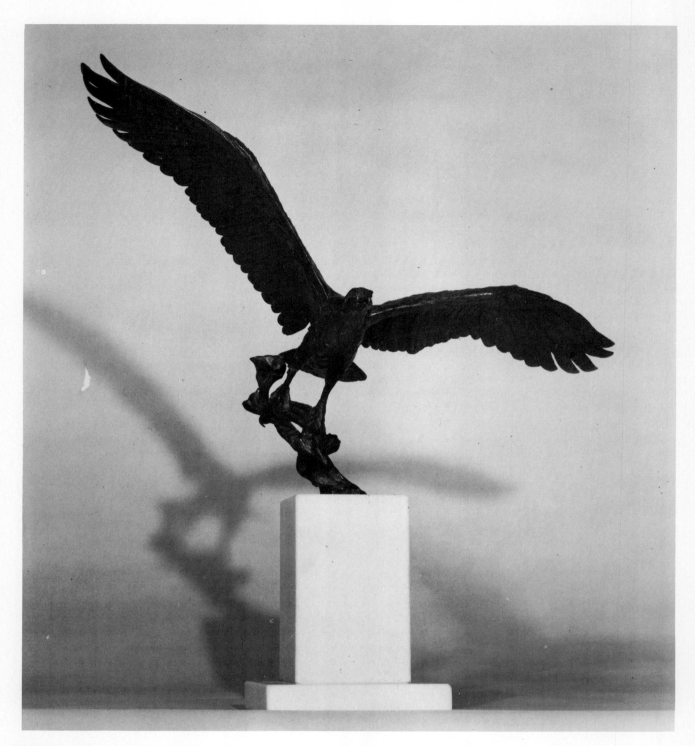

**Bi94** This swooping fish eagle is another fine example of Kenworthy's work. The eagle, always a dramatic bird whether in flight or simply perched, is a wonderful subject for the sculptor. This model may be compared with that of another contemporary artist, Annette Yarrow, on p.81.

The Anatidae or duck family are commonly used in sculpture; the ducks usually figure for their natural charm and are a perfect target for the romantic animalier who simply wishes to capture a farmyard scene. The goose is the perfect foil for artist and sculptor as its aggression towards man is well known and amusing events can be portrayed in harmless fun. The swan has been used from time immemorial, most particularly in the many portrayals, both in painting and sculpture, of the god Zeus and Leda, the daughter of the king of Aetolia.

**Bi95** An unlikely combination of a young toddler riding on the back of a very angry goose by E. Dinée. Possibly the sculptor had the idea of Leda and the swan in mind. Nevertheless a good, lively and decorative bronze group that will always be popular.
Signed 'Dinée': 37cm (14½ins.): rubbed brown patination
c.1890                                                        £450 — £750

**Bi96** Leda and the Swan by Jules Desbois, a genre sculptor who also created some animalier models. This subject certainly cannot be considered animalier with its background in ancient Greek mythology but it portrays a subject repeated many times in the 19th century. This is a very powerful model, brilliantly executed with the full impact of Rodin clearly influencing this model. The casting is equally good and sensitive by a fine foundry.
Signed 'J. Desbois'
and founder's mark A.A. Hebrard Cire Perdue:
37cm (14½ins.)
c.1900                                        £500 — £1,000

**Bi97** An amusing model by Seifert of a satyr stealing two goslings. The young Greek wood god has certainly taken his life in his hands in exciting the anger of the ferocious goose.
Signed 'V. Seifert': 24 cm (9½ins.)
c.1890                                                        £400 — £600

# Camels

The camel has from time immemorial been a most important beast of burden and transport
in the Arab world from the eastern Mediterranean to the Gibraltar Straits.
It was an unfamiliar creature to most Europeans until introduced by the great zoos
of the 19th century, although they had been introduced for practical purposes
into southern Italy as far back as the 16th century.
From Napolean's short conquest of the Nile the camel became an animal suitable for sculpture,
and the Emperor was portrayed riding a camel by several sculptors,
especially towards the end of the 19th century.
The exotic nature of these animals from another continent,
albeit the nearest part of the African mainland, was a perfect foil
for the romantic 19th century taste and love of the Oriental.
Whole rooms were decorated in an Arabic style, many artists painted Arab scenes
and Arab cameleers, and sculptors carried this image into three-dimensional representation.
As an object of study, the camel by itself was not modelled very often
and is quite difficult to find without a rider.
Barye modelled four camels in his career, one ridden by an Arab, Frémiet exhibited one in wax at the
1847 Salon and two in plaster at the Exposition Universelle of 1855,
Isadore Bonheur showed this unusual subject for him in bronze
at the 1868 Salon, certainly a very rare figure.
Apart from these few examples, the camel is normally part of a group,
carrying a soldier or huntsman.

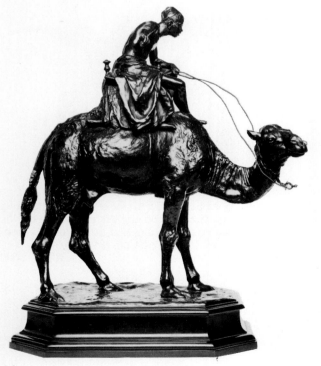

**Cam1** A fine group of a North African negro boy pointing out the way to his obstinate mount. Every detail is perfect in this very well modelled group which is in fact copper coated, a term used in saleroom parlance to describe the electroplated plaster figures popular towards the end of the 19th century. A plaster model is used in an acid bath and, by means of an electrical current, copper from an immersed copper plate flows on to the surface of the plaster. It can well be imagined that the 'liquid' copper will search out every detail in the plaster however fine and however intricate. Whatever the sculptor can achieve in his original model, provided the plaster cast is accurate, will be accurately repeated by this process. The thin layer of copper over plaster is obviously very vulnerable to damage and knocks, and this should be the only reason for a collector to be wary of these fine groups or figures. Traditionally they have been less collected than their hollow bronze cousins but it is important to remember that the sculptor probably had as much to do with the casting in either case and certainly each had exactly the same amount of involvement in creating the original model. In the last ten years there has been a considerable improvement in what is termed the decorative market and these copper-coated groups are bought mainly for visual merit and, to some extent, the bigger the better.

72cm (28½ins.): rich copper red/brown patination
*c.1900*        *£2,200 — £3,000*

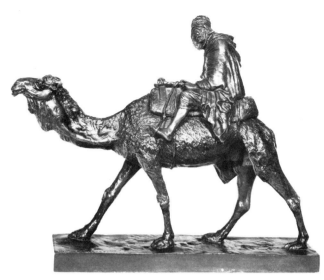

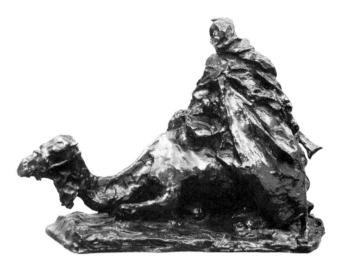

**Cam2** A well cast group by Lazerges. The slow deliberate pace of the camel and the wistful stare of the elderly Arab rider who has obviously spent all his life in the saddle, provide a dramatic sense of realism in this group. The whole scene is a familiar one to anyone who has travelled in the Near East or North Africa and the sculptor here has almost created a tourist 'snapshot'. To the travelled onlooker in the 19th century this group would have conjured up a dramatic sense of the exotic.

Signed 'PAUL LAZERGES': 34 x 34cm (13½ x 13½ins.)
rubbed brown patination

*c.1880-1900*                                    *£1,200 — £1,800*

**Cam3** A very fine and dramatic group by Troubetzkoy. Few bronzes are successful when they include recumbent figures, especially in animal groups and it is a brave sculptor who tries. With most animals, unless the animal is standing, walking or running, all the onlooker can see either in reality or from a photograph is a rather dark blob with little definition of form. There is a great difference between seeing under the animal and through its legs and looking at an impenetrable mass of bronze. Here Troubetzkoy's group works very well indeed and he has overcome the problem, more obviously so when the group can be seen in the round. Almost extreme in its impressionism, the onlooker is left with the image of a swaddled Arab figure, completely covered up against the engulfing sand-storm, alighting from the camel which obediently and willingly lies down to avoid the worst of the sand.

Signed 'Paul Troubetzkoy': 28cm (11ins.)
rich, chocolate brown patination

*c.1910*                                    *£3,000 — £4,000*

**Cam4** As with Cam1 this group is not exactly as it seems from the photograph. Made of spelter it is patinated to resemble bronze and, as with the copper-coated group, it required as much thought and effort from the sculptor, in this case Emile Guillemin (1841-1907) a genre sculptor exhibiting from 1870 to the turn of the century. This is a particularly good example of a spelter group in good condition, and it has not pitted as is usually the case with this material. At first glance, until one were fully cognisant with the 'look' of spelter, it would be very difficult to tell apart from bronze. A highly decorative group that is bound to sell well despite its inferior substance.

Signed (indistinctly) '. . .le Guillemin': 44.5cm (17½ins.)
good even mid-brown patination

*1890s*                                    *£1,000 — £2,000*

117

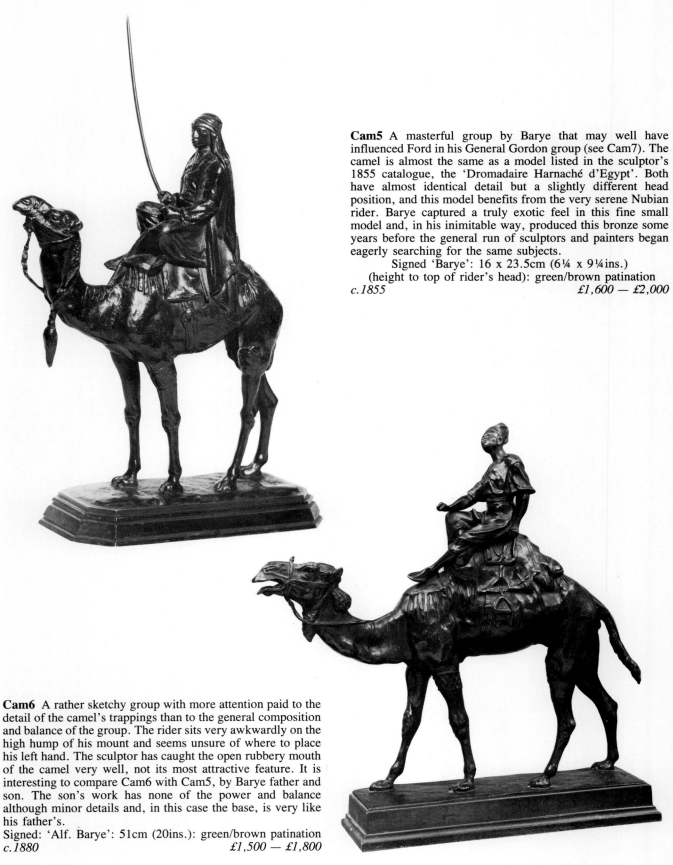

**Cam5** A masterful group by Barye that may well have influenced Ford in his General Gordon group (see Cam7). The camel is almost the same as a model listed in the sculptor's 1855 catalogue, the 'Dromadaire Harnaché d'Egypt'. Both have almost identical detail but a slightly different head position, and this model benefits from the very serene Nubian rider. Barye captured a truly exotic feel in this fine small model and, in his inimitable way, produced this bronze some years before the general run of sculptors and painters began eagerly searching for the same subjects.

Signed 'Barye': 16 x 23.5cm (6¼ x 9¼ins.)
(height to top of rider's head): green/brown patination
*c.1855*                                              *£1,600 — £2,000*

**Cam6** A rather sketchy group with more attention paid to the detail of the camel's trappings than to the general composition and balance of the group. The rider sits very awkwardly on the high hump of his mount and seems unsure of where to place his left hand. The sculptor has caught the open rubbery mouth of the camel very well, not its most attractive feature. It is interesting to compare Cam6 with Cam5, by Barye father and son. The son's work has none of the power and balance although minor details and, in this case the base, is very like his father's.

Signed: 'Alf. Barye': 51cm (20ins.): green/brown patination
*c.1880*                                              *£1,500 — £1,800*

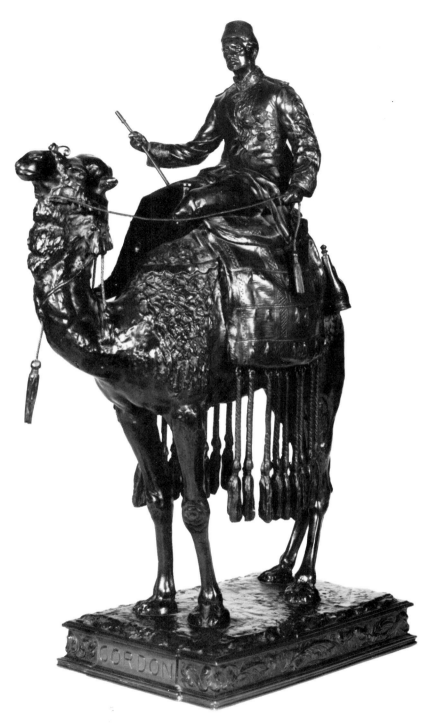

**Cam7** A very rare bronze group of General Gordon by the English sculptor Edward Onslow Ford (1852-1901). Like Guillemin he was not an animalier but covered a wide range of genre subjects. This model is cast to the very highest standards as a scale reduction of the Gordon Monuments erected in 1890 at Khartoum and now at Chatham. This size was thought to have been cast only five times, once for each of the sculptor's sons. The corded and tasselled reins are complete, as are the articulated tassels hanging from the saddle. There is tremendous power in the portrait of Gordon and even the camel looks proud with his head pulled back. A very rare group, and one for animal bronze collectors and historians alike. Ford was one of the individual English sculptors who worked at the end of the 19th century in the wake of Rodin and Gilbert, and many English New School collectors would also be interested in such a rare model. Competition therefore would be from several sides.

Signed 'E.O. Ford R.A.': 60 x 29cm (23¼ x 11½ins.)
black patination

*c.1890*        *£10,000 — £15,000*

**Cam8** A fairly accomplished group of that popular subject, Napoleon directing operations in the Nile Delta. The young general is haughtily pointing something out to a subordinate from atop his patient camel. The sculptor, Jacquemart was an animalier for the major part of his career and also executed several monumental commissions, including one in Cairo. He modelled a camel driver of Asia Minor in 1877, and a Nubian dromedary two years later, having travelled extensively in the Near and Middle East. He was familiar with the decorative effect of precious metals because of his collaboration with the Christofle firm, and it does not seem surprising to see this group in a very bright gilt-bronze. Not a popular colour today in the animalier world but one that will appeal to the Eastern market buyers.

Signed 'A. JACQUEMART' and 'F. Barbedienne Fondeur'
numbered 43 on the underside
26cm (10¼ ins.): gilt-bronze patination
*c.1875-1880*                    *£1,000 — £1,500*

**Cam9** A bronze and alabaster group of poor quality both sculpturally and in the casting. The camel looks like a cartoon character with its 'Pink Panther' legs, arched hump back and ill-proportioned head and neck. The soft alabaster group of father and son which would have been easy to carve, is very fragile; the father's outstretched right arm and hand have both been broken, something that will be difficult to repair satisfactorily. Few animal bronzes work well when mounted directly on to a different material, which in this case is the popular early 20th century verde antico.

<div align="center">

Entitled 'MIRAGGIO': 42.5cm (16¾ins.)

dark bronze patination

</div>

*c.1920*  £600 — £800

**Cam10** A seemingly unrecorded camel group by the animalier Valton, whose only other camel figure is of bronze and marble exhibited at the Salon in 1896. This dromedary with its bearded nomadic rider is a very good cast with a certain lightness of form and touch that one does not normally associate with this sculptor's work, although he had a wide and interesting repertoire. A good size for the subject, and one that views very well in the round. If anything the rider looks a little too large for his mount.

<div align="center">

Signed 'C. VALTON': 35.5cm (14ins.)

rich brown/black patination

</div>

*c.1890*  £1,500 — £2,600

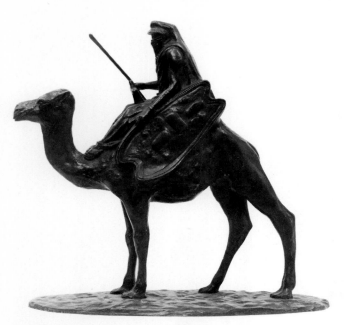

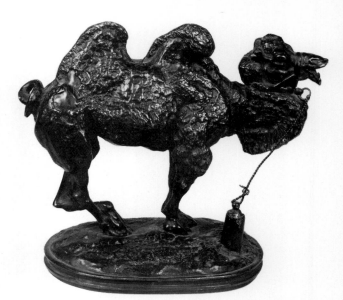

**Cam11** The proportions are inadequate on this model which simply looks lumpy. The keen expression on the face of the camel is hardly realistic, and the intended dramatic effect of the masked rider falls completely flat. Interestingly the sculptor has made an unusual attempt to create the impression of sand on the base, which is quite effective but unfortunately the base does not marry up well with the feet of the camel.

Signed 'J. Charles': 42cm (16½ins.)
light brown patination

*c.1910* £400 — £600

**Cam12** Delabrierre uses the same post as to tie a horse in his cast for this rare bronze figure of a camel with two humps. One cannot help feeling that the sculptor must have seen his subject at a circus, tied up waiting to go into the ring. Note how the camel is characteristically resting one back leg entwined with the other. A well detailed and not unattractive model which although anatomically correct, seems out of proportion, and this will keep its price down in comparison with other rare models.

Signed 'DELABRIERRE': 29cm (11½ins.)
very dark brown patination

*c.1849* £1,000 — £1,600

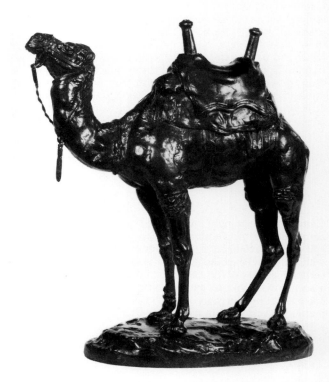

**Cam13** Barye's harnessed Egyptian dromedary from his 1855 catalogue. A similar model to the mounted group Cam5, it is a powerfully modelled and very regal animal illustrating the sculptor's own individual style. This cast which lacks definition and surface detail is not a particularly good example.

Signed 'Barye' and stamped BARYE
24.6 x 18.9cm (9¾ x 7½ins.)
dull dark red brown patination

*c.1855* £1,500 — £2,500

122

**Cam14** One of a very fine pair of seated dromedaries, a bold and in this case highly successful attempt to portray an animal in a recumbent pose. The modelling and cast are excellent and typical in style and finish of French late 18th century bronzes that were made until approximately the 1820s. They fit in completely with the style and decoration of post-Royalist France and are possibly inspired by the Nile conquests. Very sophisticated and highly decorative objects they are not so much something to be sought after by an animalier collector but a decorator or better quality antique furniture shop.

15 x 25cm (6 x 9¾ins.): rich copper brown patination
*c.1800*                                    *the pair £4,000 — £6,000*

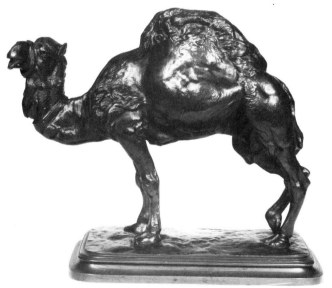

**Cam15** Frémiet's Egyptian dromedary, the one modelled in wax for the 1847 Salon. A rare and very good model. The sculptor has caught perfectly the pose and character of the animal. A very elegant piece of sculpture which will probably be admired and hotly competed for by a wide range of buyers. One cast is recorded with the top two bars of the E in the signature missing.

Signed 'E. Frémiet': 29 x 26.4cm (11½ x 10½ins.)
red/brown patination
*c.1850-1860*                              *£2,000 — £2,500*

# The Cat Family

If bird models are the province of Moigniez,
then the cat family must surely be that of Barye.
It would not be easy to select his best models as all are so very good and original
but his most famous must be the Walking Lions and Tigers.
The *Lion qui marche* started life as a plaque
on the Column of the Fourteenth of July in the Place de la Bastille, erected in 1836.
A symbol of national pride to the French and the hallmark of Empire for the British,
these lion figures were immensely popular and consequently produced in large numbers,
with some of the best examples, like so much of Barye's work,
in museums in the United States of America.

**C1** The lion is in its traditional majestic pose but with an extraordinary look on its face, one almost of astonishment. The hollow, rock-like triangular base is an often used shape and gives animals a raised, defiant posture. This unsigned model is quite well cast with a considerable amount of rough modelling in the clay by the sculptor. A similar cast to C1 and C3 was modelled by Maurice Fauvre.

30.5cm (12ins.): dark brown patination

*c.1900* £800 — £1,500

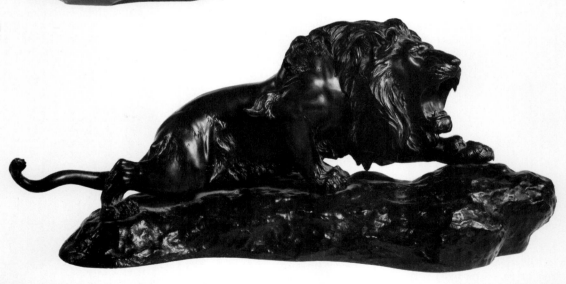

**C2** There is a distinct feel of a Japanese cast when one looks closely at this crouching, snarling lion. The base is very similar to the others on this and subsequent pages but the detailing of the lion's coat is of a very different style. Whilst there is a lot of detail, it is only on the long hair and the claws, leaving the flatter parts of the pelt untouched which is a very Japanese feature. The small nicks above the shoulders and on the thighs are also typical of Japanese detailing. There is a high copper content in the bronze, another Japanese feature. On inspection it proved impossible to identify the origins of the cast; there was neither a European signature nor a Japanese seal or character mark on the underbelly. Possibly it is an exceptional Japanese example, made for the European market and made to appear European rather than an obvious export.

26.7cm (10½ins.): dark brown patination

*c.1900* £700 — £1,100

124

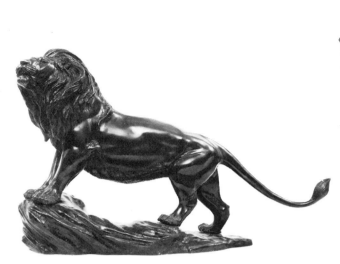

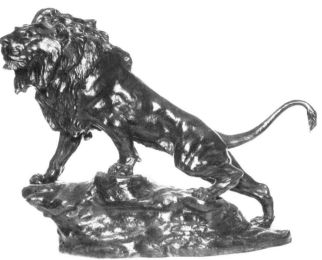

C3 Once again there is something of the Japanese style as in C2 with the same smooth skin. The model looks somewhat uncomfortable on what looks at first glance like a Japanese wooden base which has been simply cast in bronze. The model meets the base in a way that suggests that possibly they did not originally belong together. Inspection proved disappointingly inconclusive, with no signature, but a possible answer is that the lion is in fact Japanese and had become detached from its original wooden base and a European foundry cast a bronze base to 'fit' and match the style of the Oriental.

29cm (11½ins.): brown/black patination

*c.1900*                                                           *£400 — £700*

C4 Thomas-François Cartier modelled many lions throughout his career and this is typical of his better work. This proud, and defiant animal has plenty of surface detail. It is a pity that he put such a good model on a base that conveniently has a pad for each of the lion's paws making the whole piece seem less realistic.

Signed 'T. CARTIER': 34 x 48cm (13½ x 19ins.)

rich, rubbed green patination

*c.1920*                                                          *£700 — £1,000*

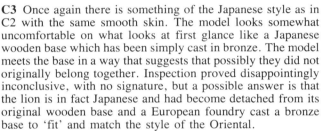

The lion in a proud posture became very much more popular at the turn of the 19th and 20th centuries and certainly appealed to the British. Possibly the huge influx of Japanese export bronzes at this time inspired French and English sculptors to compete with this hitherto little known source of production.

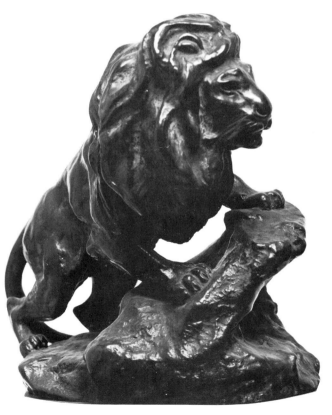

C5 Rowland Ward's rare models of lions are well cast and detailed but in this case the stance is a little weak and his heavily maned lion looks a little self-conscious. The idea of a slope to lift the animal's head has been taken to its extreme. The design follows general principles of painting by creating two triangles, one over the lion's head, the other over the peak of the rock. By permission of the National Museum of Wales.
*c.1900*

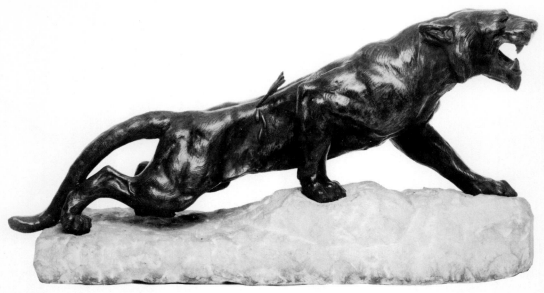

**C6** The period between 1910-20 produced many animal bronzes on a marble or granite base suggesting a rocky outcrop and this example by Bartelier is typical. Many were unsigned although the marble was usually soft enough to work easily as in this instance. The hunter must have loosed off his arrow from very close range to sink it so far into the animal's back and it slinks across the base in agony. The huge droplets of blood are rather unrealistic, the sculptor being a better modeller of musculature and form than of added detail.

The concept of the mountain lion (also known as a puma or cougar) wounded by an arrow delivered by the American Indian fascinated sculptors in the inter-war period of the 20th century, in the era of the gun. Subjects such as these had good export potential.

Signed 'BARTELIER' in the marble: 20.3cm (8ins.)
rich brown patination
*c.1920*                                                    *£500 — £700*

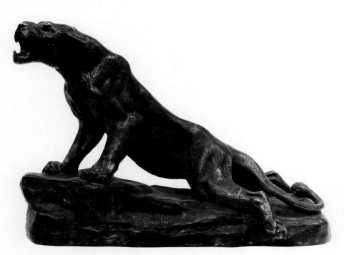

**C7** Carvin has attempted the same subject as that of C6 with what looks more like a bullet wound in the animal's flank rendering its back legs useless as it tries to drag itself along the ground, roaring defiantly with what strength it has left. The mouth is a little crudely modelled but otherwise it is a well sculptured subject although not a very popular one today.

Signed 'L. CARVIN': 30.5cm (12ins.)
mid-brown patination

*c.1920*                                                    *£500 — £700*

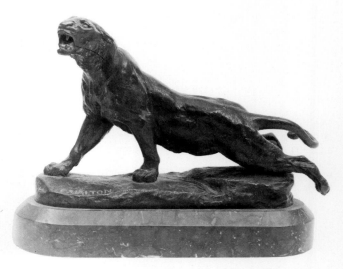

**C8** A very similar theme, this time by Valton. The number of 'wounded lion' models shows how popular they must have been, no doubt stirred by the freedom and expanse of the United States where cougars had to be hunted to preserve life and stock. The normally very competent Valton has failed where Carvin succeeded, although the lion is better detailed and generally well modelled the rear trailing haunches are not quite as realistic.

Signed 'C. VALTON': 33cm (13ins.): dull brown patination
*c.1910*                                                    *£500 — £700*

**C9** A wounded lion with its powerless haunches partly hanging over the granite plinth is a theme that was often used by sculptors. The animal roars in pain. Not a very preposessing bronze but big and decorative.
40.6cm (16ins.): matt black patination

*c.1910*                                                                     *£500 — £800*

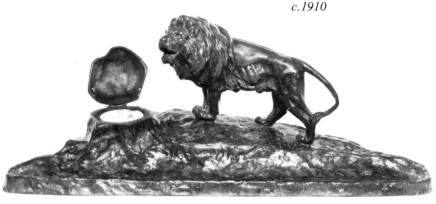

**C10** Good and indifferent sculptor's models were sometimes subjected to the ignominy of becoming part of a desk set and lions were a popular subject for inkwells. This model by Kucharzyk looks most extraordinary perched by the open inkwell. A really good model mounted in this way would probably have been taken off years ago and the indifferent ones such as this are very difficult to sell. As with this example they do become very worn as they are often handled but this in some cases can make the patination more attractive.
Signed 'Kucharzyk': 47cm wide (18½ins.)
rubbed dark brown patination

*c.1900*                                                                     *£110 — £160*

**C11** The Belgian foundries have always produced good casts and this one by Bouré is no exception. Unfortunately the facial expression leaves a lot to be desired and spoils what is otherwise a very good model. There is an enormous amount of power in the animal as it prepares to spring and the textured skin allows light to play on the body, creating the impression of movement.
Signed 'Ant. Felix Boure': 20cm (8ins.) approx.
dark brown patination

*Dated 1873*                                                          *£500 — £700*

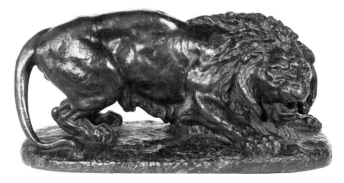

127

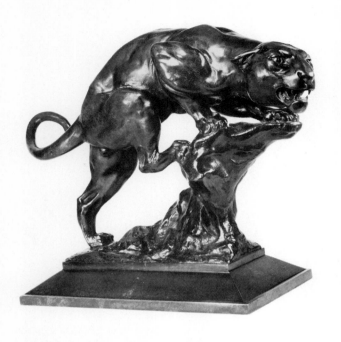

**C12** An exceptional bronze jaguar by Gardet and probably some twenty years earlier than the model by Becquerel (C14). These two 20th century animals are far more sophisticated than their 19th century colleagues and it is not until one goes right back to Barye that there is any serious competition. The whole posture of this bronze is new, alive and exciting with huge reserves of power in the crouched animal and an almost Barye-like texture and muscle structure. The rock, although an unlikely shape, seems more realistic than the slabs of stone of other models, its twisting form has almost as much life in it as the animal. A very rare subject, it sold in 1972 at auction for a modest £260 and is now worth far more. Drouot sculpted a similar group.

Signed 'G. Gardet': 33cm (13ins.)
green black patination

*c.1900*                                      *£1,000 — £1,600+*

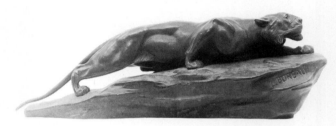

**C13** A stalking tiger by Léon Bureau, the slender body of the tiger is accentuated by the sloping rock and is well modelled, albeit in a stylised manner typical of the early part of the 20th century. The face however, lets the model down completely, the serious expression must have been modelled from a stuffed tiger's head as it has none of the life and expression of a real animal, let alone one like this which is concentrating on its prey.

Signed 'L. BUREAU': 15.2cm (6ins.)
green/brown patination

*c.1900*                                      *£400 — £600*

**C14** A very powerful and fine model by Becquerel. The tiger lazily sharpens its claws on a conveniently angled tree and a huge amount of latent power is inbuilt in this sensitive model. Everyone has seen domestic cats in this ritual, usually on loose covers, and there is something fascinating about these huge beasts in such an innocent feline posture. The detail is excellent with the striped markings in the skin accentuated by a slightly uneven bronze surface, a technique that the contemporary sculptor, Jonathan Kenworthy has made good use of. The contemporary sandwich marble base is a very effective period complement to the bronze.

Signed 'A.V. BECQUEREL' (the initials monogrammed with two foundry seals LN and JL Paris): 44.5 x 58cm (17½ x 22¾ ins.)
dark brown over black patination

*c.1920*                                      *£800 — £1,200*

**C15** This excellent model by the English sculptor, John Macallan Swan, is full of power and vigour but, once again, learning from the style of Barye, not from the realists of the generation before. This panther is about to spring on an unsuspecting enemy and once again, texture has been used to allow the light to play on the animal's muscles to give the very effective feeling of movement. The lack of detail in the face of this model does not matter as it is in keeping with the whole style of the bronze. He has learnt well from his Paris tutors, Barye and Frémiet, and his models are sure to become more appreciated in this country.

<div align="center">Signed 'J.M. Swan': 22cm (8¾ ins.)<br>rich chocolate-brown patination</div>

*Dated 1891* £850 — £1,300+

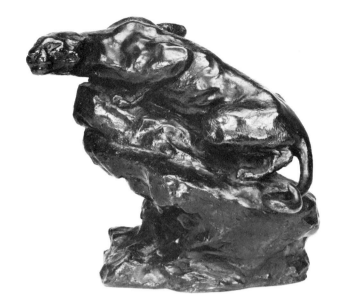

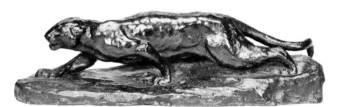

**C16** Another fine model by Swan with an identical face. The slinking panther is saved from becoming a mass of bronze by the effect of light on its tensed body. Interestingly he has reversed the triangular sloping rock base and for once the animal is stalking its prey downhill. It is interesting to note the difference in price of the two Swan bronzes, as always the crouching animal that represents little or a very flat silhouette is far less expensive and would have been considerably cheaper to cast.

<div align="center">Signed 'Swan' (indistinctly): 11cm (4¼ ins.)<br>rich black/green patination</div>

*1890s* £400 — £600

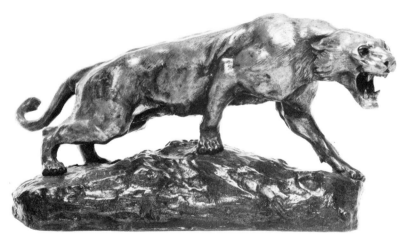

**C17** Here the unrecorded sculptor has used the idea of a dual patination to give the model definition, with a gilt tiger and 'earthy' green base. A poor model however, but a commercial bronze in its time and only just good enough to be a popular decorative model today. Something must be wrong with the animal's right forepaw which is turned at an uncomfortable angle. If an animal has an odd or uncomfortable posture it may be difficult for the collector, who must live in harmony with his purchase, to accept, and a sculptor must decide if he is to model the truth or use artistic licence to create an overall impression.

<div align="center">Parcel-gilt and green patination</div>

*c.1910* £400 — £600

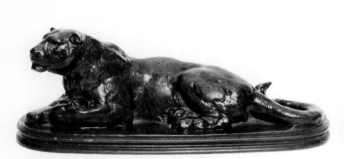

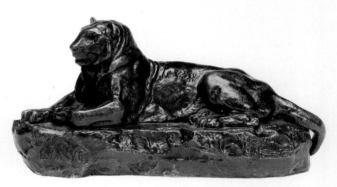

**C18** The 'Panther of India' by Barye, in this instance a Gold Initial cast by the firm of Barbédienne. It has never been established for certain whether they were special editions made by Barbedienne after the sculptor's death in 1875. They are all without exception very good casts, of an even standard, which suggest possibly that they were all made at about the same time and, therefore, may well have been cast after Barye's death. Without being as good as the very early Barye casts, they are as good as generally found on the market today and are always very popular, selling at a premium.
Signed 'Barye' with gold initial F.B. and F. Barbédienne signature, numbered 11 on the underside: 18.5cm (7¼ins.) wide
*Modelled 1850s*
*Cast 1870s* £500 — £1,000

**C19** The more famous model with the accentuated thick neck of the Panther of India, with an earlier style of base to the previous model. The casts vary a great deal for this popular model and there are many late 19th and early 20th century casts from the original models, as well as more recent casts from casts and these latter should really be avoided. A fine model, this cast of average quality.
Signed 'BARYE': 13.5 x 26.5cm (5¼ x 10½ins.)
dark green/black patination
*1850s* £700 — £1,200
*(The finest casts will retail from £1,200 upwards)*

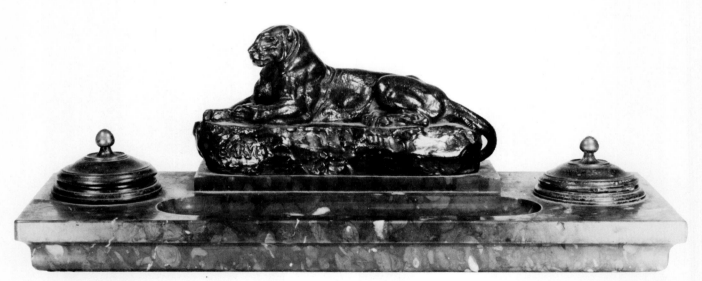

**C20** A good Barbédienne cast of the same model as C19 subjected to the ignominy of an inkwell. It is slightly smaller than the previous example (by 3 to 3.5cm) and one presumes specially cast for the inkwell. The Barbédienne firm made many fine bronze groups and candelabra and commonly used this particular type of red griotte marble (of which they obviously had a large supply) for the bases. The whole set, therefore, would have been made by them. The style is typical

of the 1860s and most unlikely to have been made after 1880. The inkwell would make little or no difference to current value, most dealers and collectors would rather not have the base at all.
Signed 'BARYE' and 'F. Barbedienne Fondeur' (on the bronze):
the bronze 10cm (4ins.) high: dark green patination
*1860-1880* £500 — £800

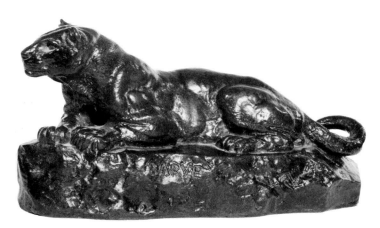

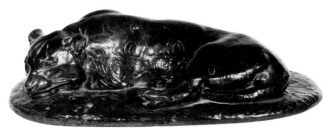

**C21** A companion model to C19 entitled 'Panthère de Tunis' in Barye's 1855 catalogue. The position of the forepaws is different from the previous model and the head inclined forward losing the 'thick neck' of the Panther of India. Another fine model where the casts vary tremendously. An 8cm (3¼ins.) cast has also been recorded.

<div align="center">

Signed 'BARYE': 12.5cm (5ins.)

rich green and black patination

</div>

*1850s* £700 — £1,200

8cm cast £500 — £800

**C22** A sleeping panther by Barye, listed in his first catalogue of 1847. Never an easy model to view and, in this instance a very loosely detailed cast with an unusual flat base. The animal's spots have been accentuated by deep stylised lines which are most effective.

<div align="center">

Signed 'BARYE': 20.3cm (8ins.) wide

green/black patination

</div>

*1850-1870* £500 — £700

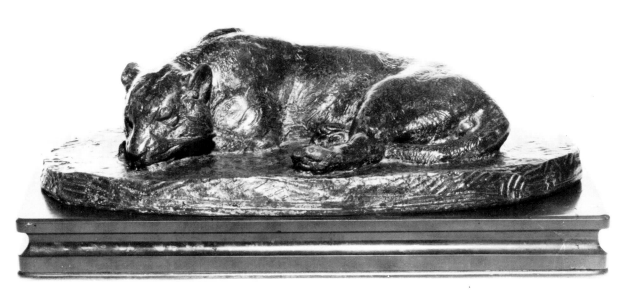

**C23** An exceptionally finely detailed Barbédienne Gold Initial cast of the previous model. The detail is quite incredible, almost as if the sculptor has modelled directly in bronze which, of course, is not possible. The reason for the exquisite detail is that it is an electrotype model, cast with liquid copper directly on to the plaster model in an acid bath. This process has picked up every single tiny detail of the artist's intention. Unfortunately, due mainly to lack of knowledge of the subject,

people shy away from these models but they are just as good as the sculptor's original and are more detailed than their bronze counterparts.

<div align="center">

Signed 'BARYE' with 'F.B.' gold initial

31.2cm (12¼ins.) wide (not including the plinth)

rich brown green patination

</div>

*1850-1870* £800 — £1,200

**C24** A fine model of a lioness by Maurice Prost, cast by the Susse brothers. Prost first exhibited in 1922 and this must be one of his earlier models as it continues the style that Gardet and Swan, amongst others, carried over from Barye into the 20th century. Later his style reflected the art deco movement much more closely in a very flattened and geometric manner. Some will prefer the earlier style, some the later and they will sell to two completely different markets. Generally speaking his art deco models of comparable size and quality to one of his earlier style will realise only about a third of the price.

Signed 'M. Prost' and with founder's signature
'Susse Fres. Edit Paris cire perdue'
21cm (8¼ins.): rich black/brown patination
*1920s*                                      £1,200 — £1,800

**C25** Another panther, this time by Masson but taken directly from his master's style. The Barye influence can be clearly seen, even down to the detail of the spots. There is a closeness also to the work of John Swan, another of Barye's pupils (see C15 and C16). A very good model which, with its overhanging features, does not appear so lumpy as many recumbent figures.

Signed 'C. Masson': 11.3 x 22.2cm (4½ins. x 8¾ins.)
green patination
*c.1890*                                          £400 — £600

**C26** In a style that closely reflects his senior contemporary Barye, this lioness by Delabrierre is a good attractive model and may well be his Javanese Panther, exhibited in plaster at the 1857 Salon. The animal sits well on its base with just enough light passing under the body to avoid a dark mass of bronze. A powerful animal and full of character.

Signed 'E. DELABRIERRE': 18cm (7ins.)
rubbed brown patination
*c.1860*                                      £2,000 — £2,500

132

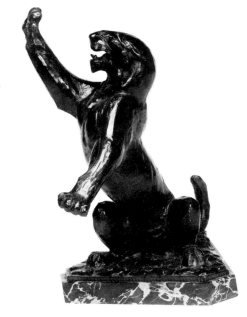

**C27** An eerie looking panther, unsigned but in the style of Steinlen in an almost dog-like posture. The smooth bald head and muscled breast contrast with the very long front legs in a stylised model that, to most eyes, is not particularly attractive. The size is too large for most to deal with satisfactorily but it would be very good in a decorative scheme. Beware! This model is still cast today in Florence.
100cm (39½ins.): dull green patination
*c.1930* £1,500 — £2,000

**C28** A bronze figure of a panther, the powerful animal seated on its haunches with one paw clawing the air on a yellow mottled black marble base.
Signed 'R. de Meester de B':
founder's mark Batardy Cire Perdue Bruxelles:
Inscribed 'Epreuve d'Artiste Cire Perdue No. 11/11:
44.5cm (17½ins.)
*c.1950* £2,000 — £3,000

**C29** A fine seated panther by Rembrant Bugatti. His feline models are amongst his best but it is invariably difficult to distinguish which animal they represent as essentially he concentrates on capturing the characteristics of the cat family rather than a panther, a lion or a domestic cat. The movements are often identical and he plays on this theme very well, modelling their lithe, agile bodies very competently and eroding the danger of a powerful wild cat.
Signed 'R. Bugatti' and with Hébrard Cire Perdue seal
black patination
*c.1910* £2,000 — £3,000

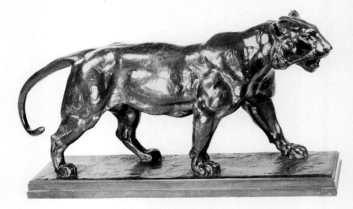

**C30** The 'Lion qui Marche' in full relief, adapted from the column in the Place de la Bastille. Casts vary in crispness, some being sharper than others. The illustration chosen is only an average cast in terms of what was available at the time but is considered a good cast in terms of present day availability. Like many, it is made by Barbédienne and very difficult to date accurately. Listed in the first catalogue of 1847, most would date after this time into the 1880s. A very few may predate the catalogue and, if so, would be expected to realise at least half as much again as this example.

Signed 'BARYE' and 'F. Barbedienne'
39.5 x 23cm (15½ x 9ins.): rubbed green patination
*1850-1870*                                  *£1,200 — £1,800*

**C31** The tiger as a companion model to the previous lion, and although not as famous, is both very popular and arguably a better model, more powerfully worked and more dramatic. The price is higher than that of a comparable lion because it appears on the market less often. If sold as a pair, the lion and tiger would probably realise the sum of the value of each bronze as one does not need the other to complete the sculpture and each was modelled with a separate identity, the accepted 'plus a third for a pair' not applying. The striping of the tiger's skin is very subtly managed and both the base of the lion and the tiger have a crazed pattern that creates the feeling of hard dry sunbaked earth.

Signed 'BARYE': 21.5 x 39.5cm (8½ x 15½ins.)
rich black green patination
*1850-1870*                                  *£1,500 — £1,800*

A model of this bronze has recently been recast by the Louvre Museum, 21 x 39cm (8¼ x 15¼ins.), with a limited edition in the United Kingdom of 50 casts, at a cost of £450 each.

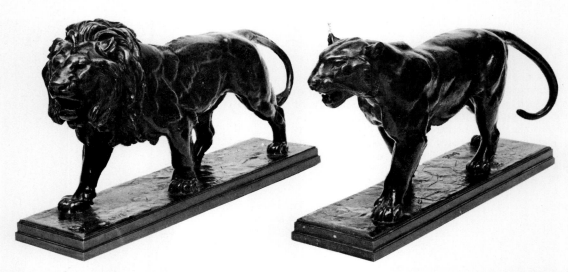

**C32** The pair of proud, defiant animals striding out together, each a well detailed cast but of a very slightly larger size than is commonly recorded. These were sold in a large country house sale as a pair and were thought to have been bought together in Paris in the third quarter of the 19th century by the vendor's forebears and in this instance it would be a shame to split them up. They are not as valuable as the earlier size.

Signed 'BARYE'
41cm (16¼ins.): rubbed brown patination
*c.1870*                                  *the pair £2,000 — £3,000*

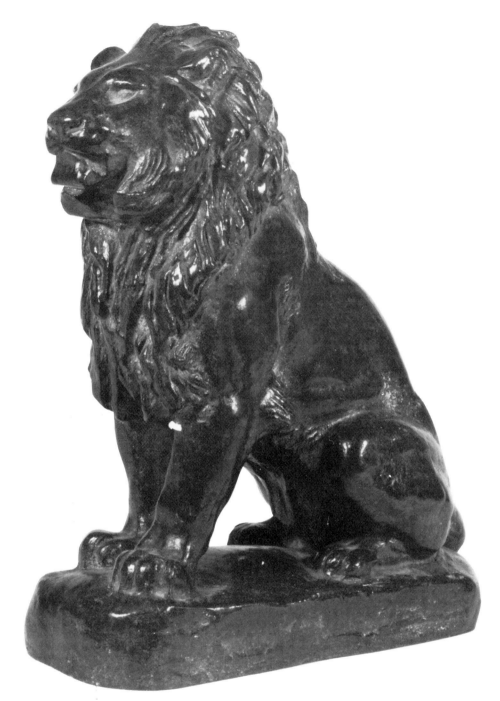

**C33** This model is listed in Barye's first catalogue of 1847 and was exhibited in bronze in the Salon of that year, having been commissioned for the Tuileries Gardens the year before. A good model, most casts are well detailed but a little lacking in life — an unusually monumental posture for Barye but still with his unique curvature of the pelt over powerful muscles at which he was so good.

Signed 'Barye' : 18cm (7ins.): dark brown patination
*c.1850 (but possibly slightly later)*                    *£1,000 — £1,500*

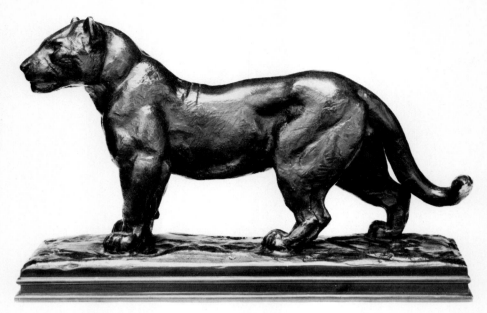

**C34** Four views of an exceptionally fine model of a panther by Barye, and one of the finest casts he produced. The model needless to say, is very powerful both in its dramatic content and in the underlying feeling of strength in the muscles of the alert panther, so lithe yet so strong. The general detail is intentionally smooth with traces of sketchiness, especially at the back of the rear legs, that suggest the early smoulderings of an impressionist technique. On the top of the base one can quite clearly see finger and thumbprints which can only be the prints of the sculptor himself as he used his bare hands to work up the model before casting. Here one has a direct and almost unique sense of being with the sculptor himself. The underside of the base shows the eveness of the outside of the plinth with slight roughness on the inside as well as a mixture of file marks along the bottom edge when smoothed off by the foundry. There are myriad scratches around these filing marks

where the base has been slid along various surfaces over the years. Cast in two pieces as it must be, the slight indentations for the feet can clearly be seen. These were not bolted on with nuts as in the middle period of the 19th century but very carefully brazed around a bronze retaining pin secured into the pad of the foot. A very much neater arrangement and one in keeping with Barye's feeling of uninterrupted smoothness for the model as a whole. Listed in the first catalogue of 1847 the later models would be worth comparatively less than the illustrated example, around £1,000 to £1,500. A Barbedienne cast is in the collection of the Victoria and Albert Museum. This example is a most valuable and rare numbered cast.

Signed 'BARYE' and stamped with the Barye stamp and numbered 6: 18cm (7ins.) wide

*Dated 1840*                                          *£1,500 — £3,000*

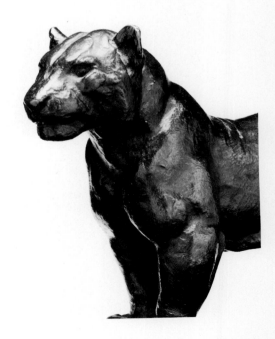

**C35** This is a rare and exceptional example of Christophe Fratin's mastery of his chosen vocation. The walking tiger, probably the model recorded as exhibited at the 1858 Salon and so a late model in his career, has none of the underlying power of the Barye animals but is cast with fine detail and plenty of character. The sculptor has simply modelled an animal as he saw it with its own personality but without the romantisicm of Barye.

Signed 'Fratin': 28cm (11ins.): dark green patination
(an unusual colour for Fratin)

*c.1860* £1,000 — £1,500

**C36** Modelled by Fratin again, this delightful panther, in an almost domestic cat-like posture, appears to be keeping a wary eye on the sculptor. There is more of the underlying strength of Barye's work here although the animal looks somehow foreshortened. Mêne also modelled a similar panther. A very finely cast and detailed model and another rare example of early animalier work at its best.

Signed 'Fratin' with stamp: 10cm (4ins.)
green patination (see above)

*Late 1850s* £800 — £1,200

137

Plaques are a generally underrated form of sculpture, only the very best casts realise good prices and even these are often less than a quarter of the price of the equivalent bronze freestanding figure. A very popular medium in the early part of the 19th century which had generally died out by the 1850s, it is now an undervalued one.

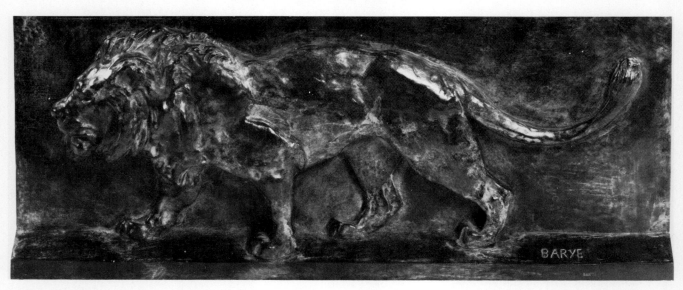

**C37** A stamped and numbered Barye plaque of the Lion of the column of the 14th July. A very loosely modelled lion that gives an extraordinarily good impression of a three-dimensional view and one that is halfway between a plaque and a half model. A very fine cast but one for the animalier collector rather than the casual admirer.

Signed 'BARYE' and with the Barye stamp

*c.1840* £500 — £800

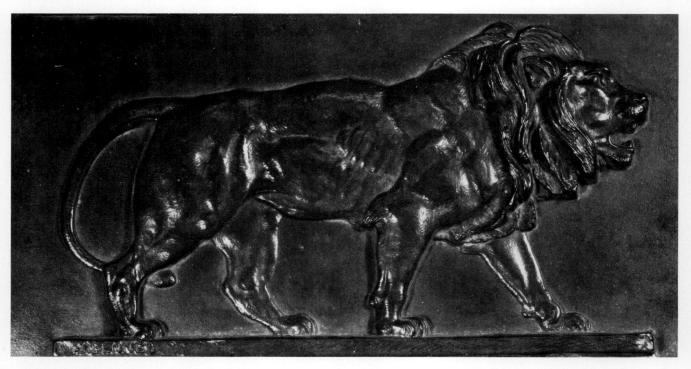

**C38** Directly inspired by the Barye 'Lion qui Marche' from the column of the 14th July shown as C37 this is a fine cast and model by a little known sculptor J. Bennes. It has a pair of a striding lionesses and both are very well modelled and detailed.

Signed 'J. BENNES': 7 x 15cm (2¾ x 6ins.)
black rich patination

*Mid-19th century* the pair £200 — £400

138

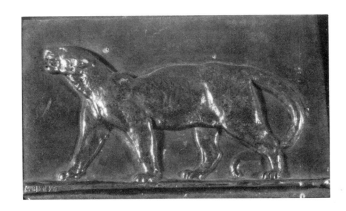

**C39** A small, very early Barye plaque of a walking leopard. A finely modelled and detailed plaque of great power and character. This would be a very good example with which to start a collection as they are still very reasonably priced. There is a companion plaque of a walking panther, every bit as good as its pair, which would command a similar price.

Signed 'A. BARYE': 7.5 x 13.5cm (3 x 5¼ins.)
*c.1840*                                    *£200 — £300*

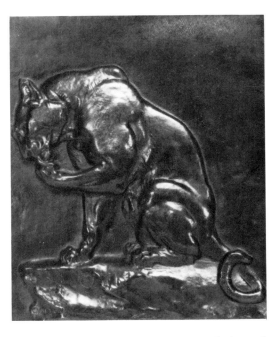

**C40** A companion bronze to the walking leopard, with the same power and ferocity — a truly magnificent leopard.
Signed 'A. BARYE': 7.5 x 13.5cm (3 x 5¼ins.)
dark green/black patination
*c.1840*                                    *£200 — £300*

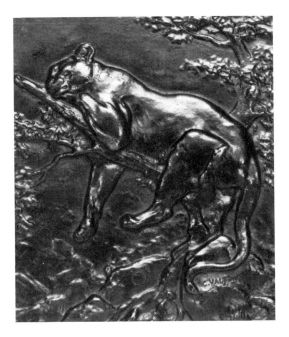

**C41** A fine pair of plaques of lions in realistic settings by Barye's pupil Valton, one cleaning its paws, the other asleep in a tree. These highly skilled two-dimensional works are underrated.

Signed 'C. VALTON': 12cm (4¾ ins.)
dark rich brown patination
*c.1900*                          *the pair £400 — £600*

139

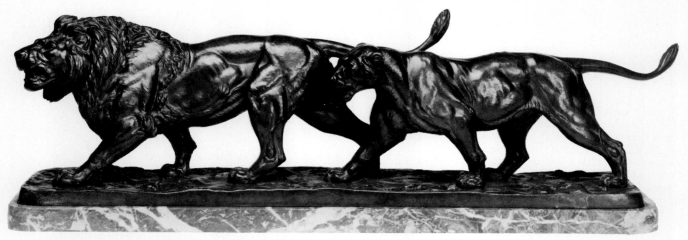

**C42** A good group by Delabrierre, inspired no doubt by the master's pair of walking lion and leopard. There is a feeling about the positioning of the two animals in line that anticipates the style of the 1920 and 1930s bronzes and at first glance the flat, almost slab sided animals have a later appearance. A powerful and well detailed example but not up to the standard of Barye.

Signed 'Delabrierre' (normally he signed E. Delabrierre)
27cm (10½ins.) including marble plinth
rich brown patination

*c.1880*                                                      £550 — £850

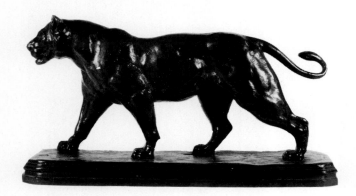

**C43** A much better Delabrierre model and very similar to the lioness in the previous example but not in fact the same model. A well detailed cast again with lots of underlying power and another rare model. This could be either the Royal Bengal Tiger exhibited at the 1857 Salon or the Bengal Tiger of 1864.
Signed 'E. Delabrierre': 11.5 x 20cm (4½ x 8ins.)
rubbed green patination

*1860s*                                                    £700 — £1,000

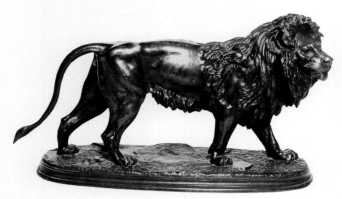

**C44** Moigniez was certainly a far better sculptor of birds than of lions as this and the pair shown as C47 prove. In a way he has captured the animal as they often are, especially in the wild, slightly lean and often mangy, without the full bodied smoothness that Barye builds into his animal. Generally the more romantic image is more successful and this model falls short of most people's requirements in a bronze. (This model is not listed in the sculptor's Salon exhibits and probably would have been refused entry.)
Signed 'J. Moigniez': 20 x 32.5cm (8 x 12¾ins.)
slightly rubbed brown/black patination
*Probably c. 1860*                                         £450 — £600

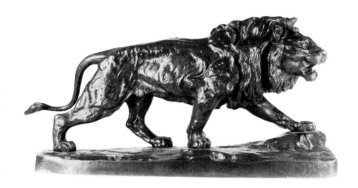

**C45** A good and very large lion from a little known sculptor P*** Thomas, very confidently modelled with plenty of power in the general limbs. Perhaps the face is a little 'dead-pan' but nevertheless a detailed and decorative model.
Signed 'P. Thomas' with founder's signature
'Ch. Gautier Bronzier'
70cm (27½ins.) wide: even mid-brown patination
*1880s* £1,000 — £1,500

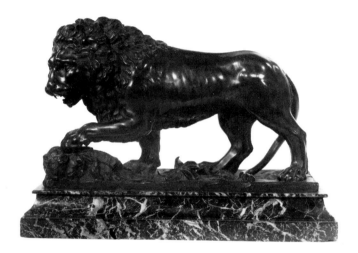

**C46** A German cast inspired by ancient Greece. In many respects the original classical style is little changed. The body is a little fuller and possibly more rounded but the treatment of the mane and face is more in keeping with the style of the 17th century rather than that of the 19th. The base is typical of Paris animal bronzes of the 1840s with its token of naturalistic foliage. Although unadventurous, this is nevertheless a very fine, thin and light cast and a very decorative one, especially on the handsome verde antico plinth which was added later.
35cm (13¾ins.) wide: black patination
*Mid-19th century* £600 — £900

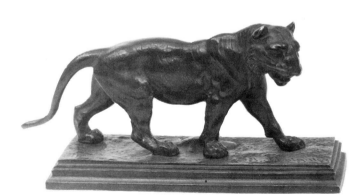

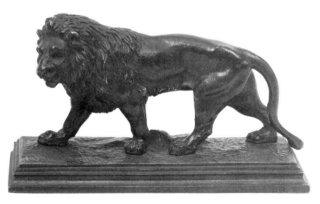

**C47** A pair of lions by Moigniez, the lion is similar to C44. Both are rather naïve and, although there is a certain amount of detail, they are not even very well cast. Each animal sits uneasily on its flat base. It is difficult to believe that the genius of bird sculpture also made these prosaic beasts.

Signed 'J. Moigniez': 7.5cm (3ins)
dull brown patination
*1860s* £300 — £500

141

C48-C51 show the poise and grace of the big cats and illustrate
Bugatti's consummate knowledge of these graceful creatures. In each example
the sculptor captures the beasts' more endearing qualities and reduces them to gentle pets
whilst still each model retains that innate strength and instant source of power
that so typifies the feline world. All the casts are by Hébrard
and signed by the sculptor but exact sizes were not recorded.
All were probably cast in the first decade of this century.

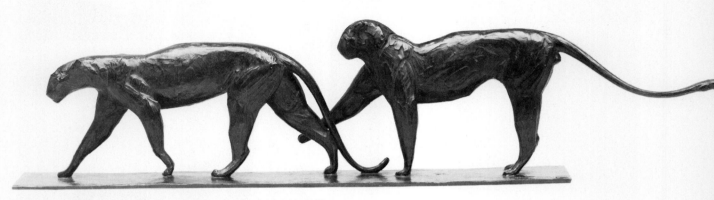

**C48** Possibly these are the same panthers illustrated in C49,
the male following his mate and playfully cuffing her leg as
they walk off. Note that the male has his back legs together so
possibly he is restraining his mate as she starts to walk off.

Signed 'R. Bugatti'

*c.1900-1910*                    *£4,000 — £6,000+*

**C49** The male panther marks out his territory. Thus Bugatti
captures an essential part of a cat's life in a graceful movement
and lift of the tail. His mate ignores the whole thing with an
air of dignity.

Signed 'R. Bugatti'

*c.1900-1910*                    *£4,000 — £6,000+*

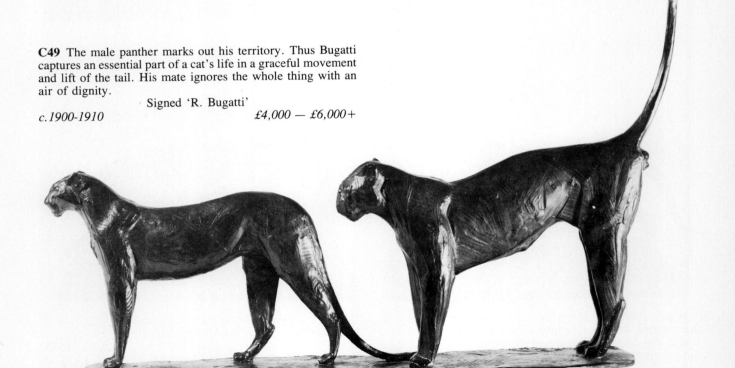

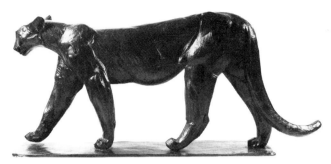

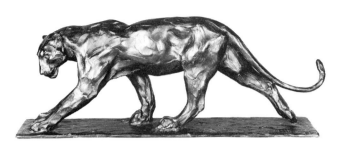

**C50** Power and grace again combine in a style imitated by Albéric Collin and in the paintings of Paul Jouvre. There is a spring in the step of the lioness as she walks with a jaunty, confident air. Could she be carrying a litter?

Signed 'R. Bugatti'

*c.1900-1910*                                    *£3,000 — £4,000*

**C51** A well-defined and very powerful walking lioness becomes a study in muscle and structure, prized for both the able representation of a large cat and for its realism. The working of the artist's fingers in the original clay are clearly visible; in fact little else but the fingers have been used in the modelling.

Signed 'R. Bugatti'

*c.1900-1910*                                    *£3,000 — £4,000*

**C52** An excellent bronze cast by I*** Robert of a prowling lioness. Inspired by the work of Bugatti, but a half generation later, this model moves away from impressionism into the range of the art deco style but still keeps that essential quality of body form and musculature that was such a feature at the turn of the century. The stylised way the rear leg 'drops' down is typical of the new, angular style just appearing on the horizon.

Signed 'I. Robert': black patination

*c.1920*                                          *£550 — £900*

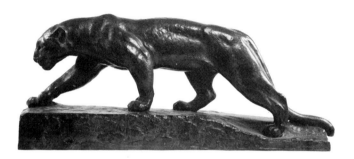

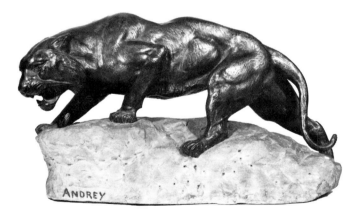

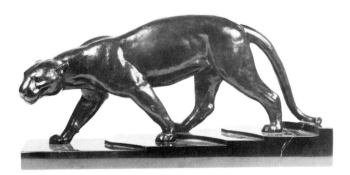

**C53** Andrey has attempted the same posture for the back leg as in the previous model but has achieved none of the subtlety. This indeed powerfully modelled tiger is roughly textured but somewhat lacking in movement. The base is of white Carrara marble.

Signed 'ANDREY': 35cm (13¾ ins.) wide approx.

gilt-bronze patination

*c.1925*                                          *£450 — £700*

**C54** A far better bronze in a stylised manner but lacking the first rule of animal sculpture — does it have an attractive face? The face is comparatively sympathetic but very dull and forlorn looking. The idea of the animal walking down several steps is a good one and again typical of the period. (Think of contemporary musicals.) It is mounted on a sandwich grey and black slate plinth.

20cm (8ins.): black patination

*c.1930*                                          *£400 — £600*

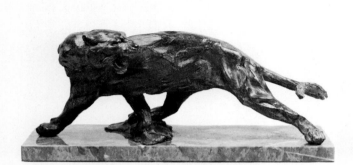

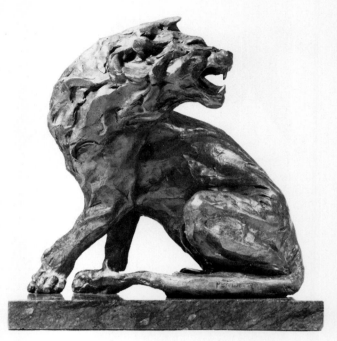

**C55** A ferocious, snarling leopard by Jonathan Kenworthy. Working in an Impressionist style but far more sketchily than Bugatti, he uses quick flicks of the fingers in the modelling clay to reflect the litheness of the animal and indicate something of its speed of movement and reaction. Who or whatever the cat was warning off would surely take heed. Many of this sculptor's bronzes are mounted on marble bases, some acting as a base for the animal itself, others purely as a decorative feature. It is interesting to note that the present day marble bases are almost invariably thinner than the pre-war and 19th century examples. The green coloured bases are very different in graining to the Italian verde antico bases and are currently mined in Greece, usually on the island of Tinos.

**C56** The same turning, snarling pose is given to this lion by Kenworthy. The seated posture is possibly not quite as dramatic, but the same dashes of the fingers give a feeling of the lightning speed of the King of the Jungle.
Signed 'KENWORTHY'

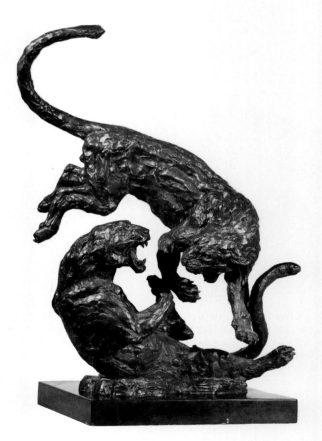

**C57** A dramatic rendition of two fighting leopards by William Timym. The sculptor uses a very chunky palette which conveys, as with Kenworthy, the impression of speed but is also meant to portray the dappled effect of the spotted leopard.

144

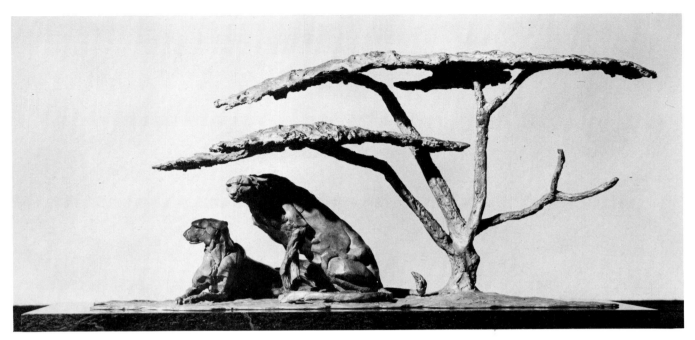

**C58** Incredibly Kenworthy has here been able to capture the feeling of the intense afternoon heat on an open African plain. The more powerful beasts rule the plain and also have first choice of the best shelter under the wide umbrella of the acacia tree. Certainly the photographer has made a special effort to place his lights just where the sun would have been and it would be great fun to light the subjects in a similar manner at home. The sun in fact appears to be on the decline and the two sleepy hunters are gazing out along the plain in search of their next meal. Here the sculptor has applied large blobs of clay to simulate the folds of relaxed skin on the cats and using the same technique has captured exactly the inquisitive but confident proud face of the cheetah, obeying the first rule of the good animal sculptor.

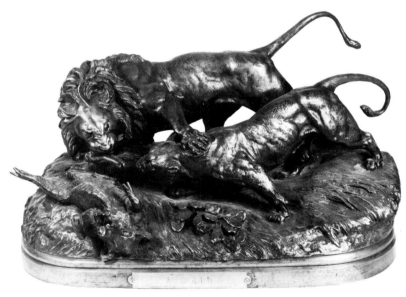

**C59** If Barye was the finest sculptor of lions, Auguste Cain, the sculptor of this group, must surely rank second. The power and realism of his models have few rivals. In the generation after Barye his work takes realism to new heights, without Barye's romantic overtones, but with some superlative models, especially the monumental ones like this model for the Tuileries Gardens. Here a lion and a lioness are fighting over a wild boar, its hind leg being crushed in the lions' jaws. The lion pushes away his mate (with unsheathed claws), digging deeply into her neck. The onlooker may shy at such bestiality but let him imagine trying to take food away from the average domestic cat, and he may expect to be cuffed or at least hissed at. Magnify that cat to the size of a lion and the realism of this bronze becomes more acceptable. Listed in the Mêne and Cain catalogue as 37 x 63 x 31cm (14½ x 24¾ x 12¼ins.).

Signed 'A. CAIN' 37cm (14½ins.) wide

slightly worn patination

*1860s* £1,200 — £1,800

145

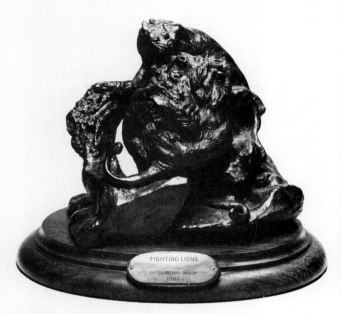

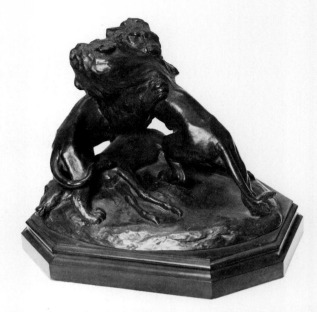

**C60** A male lion attacked by two lionesses in a fearsome fight to the finish is the subject of this swirling bronze by Rowland Ward. It is a rare, if not unique model, in almost pristine condition. The sculptor has built up a motion of movement and interwoven fighting bodies. The tree stump is sculpturally necessary to give the model a sense of proportion, otherwise it would be an unidentifiable mass of bronze. A good model but not his best work.

Signed 'Rowland Ward FECIT': 30.5cm (12ins.) approx.
black patination

*Dated 1907*                                         *£1,200 — £1,800*

**C61** These two lions fighting over an antelope are the work of Arthur Walker, a London sculptor whose work spanned a forty year period around the turn of the century. A well cast model but sculpturally not very convincing. The muscles lack the power and conviction that French sculptors would build into such a fierce battle. The manes are a weak pastiche of the work of Bugatti and suggest a date between 1900 and 1910. The details of the animals' faces, however, are excellent. The English are quite capable of spoiling their models by adding heavy wooden bases and this and the Ward lions in C60 suffer from this. National Museum of Wales.

Signed 'A.G. Walker': black patination

*c.1910*

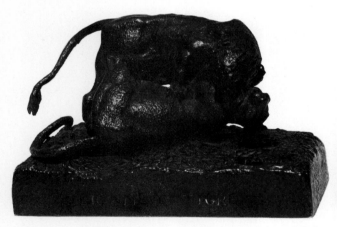

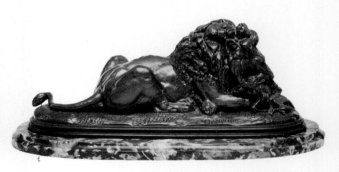

**C62** An exceptionally fine cast of a lioness and tiger fighting certainly to the death. The sculptor, Fauque, has made it difficult to see which species is which as he has not given the tiger any stripes but it appears that the broader faced animal which should be the tiger has the upper hand as he bears down on the lioness' throat. The simple, deep-sided base is very effective and in a style loved by Fratin in the period c.1840.

Signed 'Fauque': 19cm (7½ins.) wide
very dark brown patination

*c.1850*                                         *£300 — £500*

**C63** A wild animal eating its hard won prey gives no quarter and has little or no sensitivity in its eating habits, a characteristic that the sculptor must instantly display to make his subject credible. Here, Delabrierre's huge lion tears into the back of a tiny doe as though it were compulsively eating a biscuit. This model is most probably the sculptor's 'Lion and Roedeer' exhibited in plaster at the Salon in 1867.

Signed 'E. DELABRIERRE': 15cm (6ins.)
rubbed to light brown patination

*c.1870*                                         *£400 — £600*

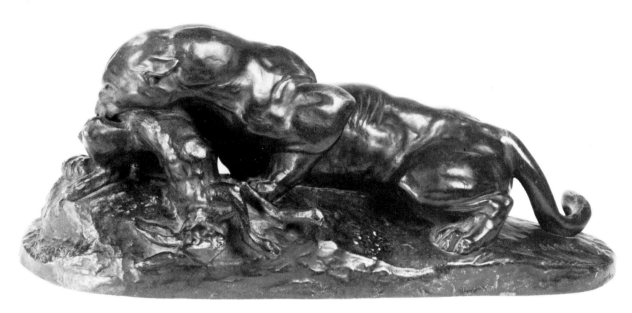

**C64** Barye's sensational 1850 exhibit at the Salon, his first entry for ten years and a triumph in romantic sculpture. The original plaster is in the Louvre and is an incredible work of art. Even the squeamish can see that here Barye has created a group which as a work of art is a *tour de force* in the world of sculpture. Entitled 'Jaguar devouring a Hare', it is possibly one of his best models. This is a Barbédienne cast.

Signed 'BARYE': 40.5cm (16ins.) long
rubbed green/black patination
*c.1880 (this model)*          £1,000 — £1,500
*Mid-19th century*             £2,000 — £3,000

**C65** One of Barye's most striking models of a tiger devouring an antelope, an early group, modelled in the 1830s and listed in the first catalogue of 1847. Once again the sculptor employs strong emotions as the immensely powerful cat easily overcomes the screaming antelope. The moulded plinth is unusual and helps to date the cast to the 1850s or slightly later. A very good cast. A version is recorded as being only 26.5cm (10½ins.) high (although the accuracy of this measurement cannot be verified), and there is another with a paper label on the underside 'Le Solville 25 rue de Paris'.

Signed 'BARYE': 36cm (14¼ins.): dark green patination
*1850s*                        £2,000 — £4,000

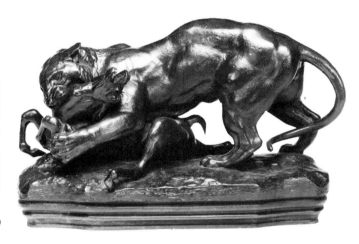

**C66** Another Gold Initial and well-detailed cast by Barbédienne from the Barye model of a lioness devouring a gazelle. It is powerfully modelled with a very strong image of brute force and innocence combined. Barye has apparently accentuated the muscles in the foreleg holding the helpless animal.

Signed 'Barye' and 'F. Barbedienne Fondeur'
with F.B. gold initials: 14cm (5½ins.)
rich black patination
*c.1850*                       £1,000 — £1,500

147

**C67** This panther gnawing on a bone almosts melts into its base. So sketchy is the model by Bugatti that the cat's skin appears to be hung on the backbone like a tent giving the animal a gaunt unrealistic feel but at the same time giving a certain impression of movement in this completely relaxed carnivore as he eats undisturbed. Bugatti's simple bases complement the models and never interfere with their composition. There is no foundry mark, which is unusual.

Signed 'R. Bugatti': 74cm (29ins.) long: green patination
*1900-1910* £1,500 — £2,500

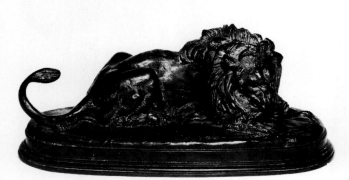

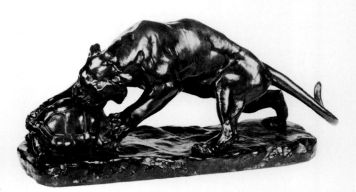

**C68** Another Barye model, this time of a lion eating a hind. Seeing this model it becomes clear from where, some thirty years later, Delabrierre draws his inspiration (see C63). A very good model indeed with considerably more fine detail than one is accustomed to in Barye's work. The whole body of the lion is full of vigour from head to tail and there is an enormous amount of latent power especially in the back legs. Modelled in 1837 and in Barye's 1847 catalogue.

Signed 'BARYE' and 'F. BARBEDIENNE FONDEUR'and with F.B. gold initials: 28cm (11ins.) long
dull green patination

*c.1850* £1,000 — £1,500

**C69** A most impressive model from Georges Gardet taking a leaf out of Barye's book. Barye clearly influenced his work although they were never master and pupil, according to existing records. Gardet later worked with Frémiet and a little of this sculptor's very early style of the late 1840s can be detected in this tiger biting hard into the shell of a turtle. The flick of the tail is characteristic of Barye's style as well as the smooth skin of the tiger giving a wonderful lighting effect. Another version is numbered 448K.

Signed 'GARDET' with founder's mark 'Siot Paris' and numbered 436A: 46cm (18ins.) long: green patination
*c.1900* £1,200 — £1,800

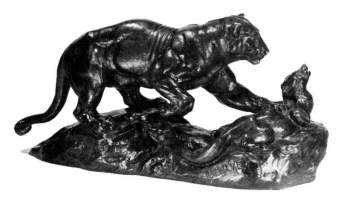

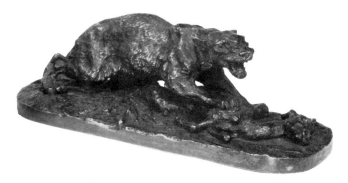

**C70** A rare Barye model of a panther pouncing on a civet cat, squashing the smaller animal on to the ground in one easy pounce. The civet would be a threat to many animals but has more than met its match this time. Possibly the panther has not hunted the civet for food but has found it in the panther's territory. Although listed in the later 1855 catalogue this is in the style of the previous decade. The panther is very powerfully modelled in keeping with Barye's style with accentuated skin folds and muscles. A very difficult model to capture successfully but one that has worked well.

Signed 'BARYE': 23cm (9ins.): green/brown patination
*Late 1850s*                    £1,400 — £1,800

**C71** A rare and interesting small bronze group stamped P.J. Mêne and possibly the 'Panther of Constantine and Gazelle' listed in the Salon records for 1841. The base is typical of an early Mêne base. Cruel subjects were rarely attempted by him and after his initial success in the early 1840s, he concentrated on the more romantic, gentler themes. The finish owes more to the style of Fratin and suggests again an early attempt by Mêne who was still searching for his own individuality. This bronze would be sought after by those trying to form a representative portfolio of the sculptor's work but a slightly uncomfortable composition that would not generally be popular.

Stamped 'P.J. Mêne'
(the stamp is a rare and probably early form of signature)
19cm (7½ins.) wide: dark brown patination
*c.1841*                         £400 — £700

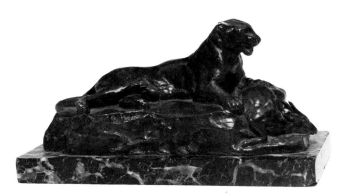

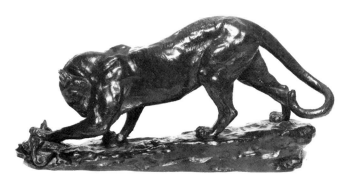

**C72** A very proud study of a panther lying over its kill of a Muntjac deer. There is a great similarity to the Panther of India (C18 and C19) and the Panther of Tunis (C21) by Barye but the nonchalant air the sculptor has built into the face and posture of this animal is much more realistic. A well-detailed cast in very good condition with an unusual and effective 'step' at the right giving the recumbent cat added height. Number A78 in the Barye catalogue.

Signed 'Barye': 11 x 21cm (4¼ x 8¼ins.)
*c.1840*                         £800 — £1,200

**C73** Morris Harding may well have seen the above model by Barye (C70) or seen the wax and plaster models in the Louvre. The inspiration is obvious and in some ways the copy is an even better model than the original. The cat is most probably a tiger and the animal's longer body makes for a more elegant model, whereas in the Barye version the body looks a little foreshortened. The tiger appears uncertain as to what to do next with the lizard he has trapped under his massive paw and we may imagine that he will probably play with it.

Signed 'MORRIS HARDING': 26 x 50cm (10¼ x 19¾ins.)
worn green/brown patination
*Dated 1912*                     £1,200 — £1,800+

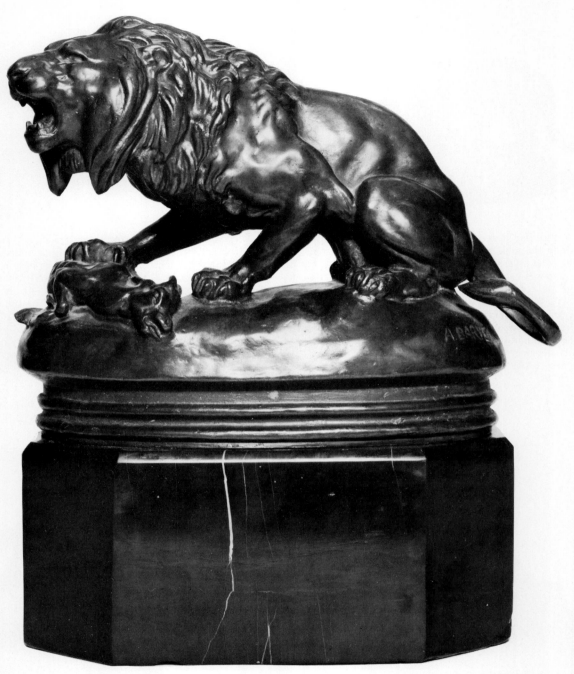

**C74** An interesting but not very good cast of a lion with its paw holding down an antelope by Alfred Barye, the son of Antoine-Louis. This type of poorly postured model gave the son a poor name as a sculptor, with none of the genius of his father although occasionally he could be very good. Cast in Portugal, the finish is very smooth and almost without detail except for the pitting in some areas. Alfred has used some of his father's style in portraying the muscles as in the moulded base. The black marble base may be contemporary.
Signed 'A. BARYE' and stamped 'Cera Perdica A.ct d'Abreu Lisboa': 18.5cm (7¼ins.) excluding base
*1900-1920* £400 — £700

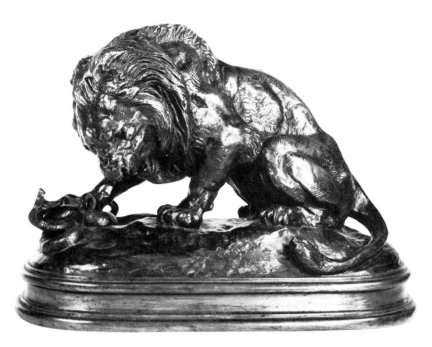

**C75** The inspiration for the previous model is clearly seen in this group of a lion crushing a serpent with its paw by Barye Senior. This is a particularly good cast of a famous model and would be sought after by a wide range of collectors, well outside the normal band of devotees. This is the sort of good quality bronze bought by dealers and galleries world wide and not just by the specialist gallery. The original plaster was modelled in 1832 and a version cast by Ganon, formerly in the Jardins des Tuileries, is now in the Salle de Barye at the Louvre.

Signed 'Barye' and numbered 8: 25.5cm (10ins.)
rich copper brown patination
*c.1840* £2,500 — £3,500

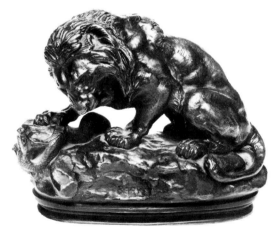

**C76** A more common version of the previous bronze which was itself listed in the first 1847 catalogue and may indeed have been the version modelled again for the catalogue, rather than the previous example for the 1832 Salon. There are several differences, notably the moulded base which always indicates a later date and the variation in the rockwork. The most immediate difference is in the placing of the bold signature right in the centre front of the base — a sensible commercial instinct!

Signed 'BARYE' 20 x 15.5cm (8 x 6ins.)
green/black patination
*1860-1880* £500 — £1,000

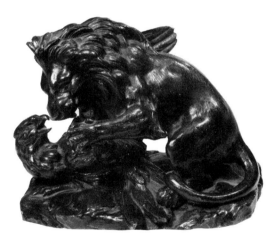

**C77** A lion clawing at an eagle signed 'Barye' with an unusual handwritten joined script signature. This unrecorded model does not have the verve and style that one has become to expect of Barye Senior. One explanation is that it may be a model by Alfred Barye with his earlier signature before he started to put his initial before his surname. This photograph was taken some years ago and the bronze was not personally inspected. The signature appears to be in the cast but may prove to be a completely false one, engraved into the cold metal. Certainly the inspiration is Barye's.

Signed 'Barye' and 'B.DT': 14cm (5½ins.)
black patination
*1850-1870* £800 — £1,000

151

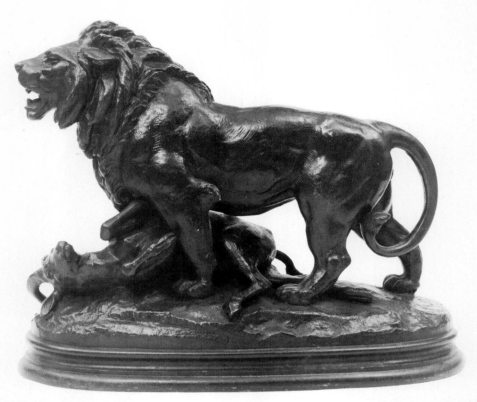

**C78** This magnificent Barye model of a lion standing with pride over its recent kill of an ibex is well finished and detailed. The subject matter is so well conceived that it hardly offends even the most sensitive nature and such a good bronze will always sell well. The founder's stamp of Graech-Morly is very rare.

Signed 'Barye' stamped G.M.: 39.5cm (15½ins.)
rich brown patination

*c.1850* £2,500 — £3,500+

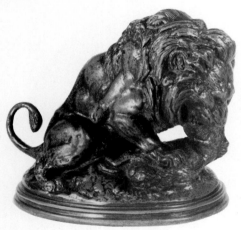

**C79** A well handled and slightly worn cast of a lion eating a boar. The animal is very powerfully modelled by Delabrierre but has none of the drama of the Barye models nor the feline grace of the Bugatti versions. There is quite a lot of detail in the casting and this is a relatively good cast but the patination has been worn almost completely off as it is a small, easily manipulated model and may have been used as a desk weight. Signed 'E. Delabrierre': 15cm (6ins.): worn green patination
*Probably 1850s* £450 — £600

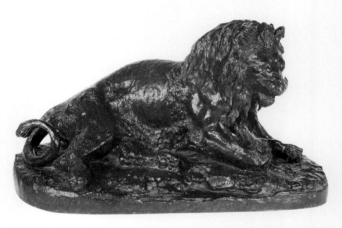

**C80** Fratin's distinctive style is instantly recognised in this moody lion toying nonchalantly with a baby alligator in its paw. His roughly finished bronzes are a complete contrast to his contemporary Barye. A good model but difficult to see well in a photograph and too lumpy to be popular. The casting and detailing are superb which will be a bonus for collectors. Not as well modelled as 'Lion eating an Antelope', with the cat tearing at the small animal's flank.

Signed 'FRATIN': 28cm (11ins.)
light to mid-brown patination

*c.1840* £800 — £1,200

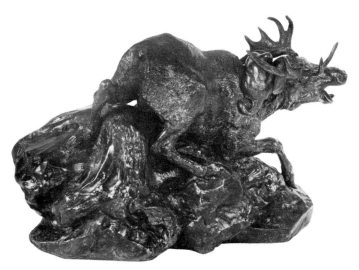

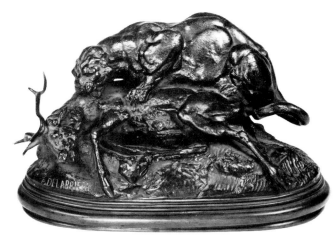

**C81** Somehow an animal actually pulling down another is even more violent than the subsequent act of a hunter eating its prey. This fine model by Barye of an elk being attacked by a lynx was exhibited in plaster at the Salon as early as 1834 and is a very rare cast. Listed in Barye's first catalogue of 1847, it would have had much appeal at the time and would have been considered a good subject for the dining room. The falling stag has stumbled over a tree trunk on a very complicated but very realistic rocky base as the tiny cat sinks its sharp teeth into the neck of the huge beast. Although Barye's smooth angularity of form is evident here, he has concentrated on the detail of the elk's skin.

Signed 'Barye': numbered 10: 23cm (9ins.)

*1840s* £1,500 — £2,000

**C82** A superb model of a panther finishing off its kill of a dead stag by Delabrierre. Again the inspiration is from Barye as is the general style. The subject is particularly macabre and not a very commercial one, albeit a fine piece of work. A really good Barye model, however violent, will always sell if it is a good cast, but one from the lesser known stables, even from a sculptor as good as Delabrierre will only appeal to the dedicated animalier collector. A powerful model.

Signed 'E. DELABRIERRE': 20cm (8ins.)
rubbed mid- to dark brown patination

*c.1870* £700 — £1,000

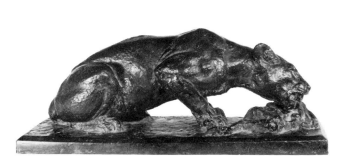

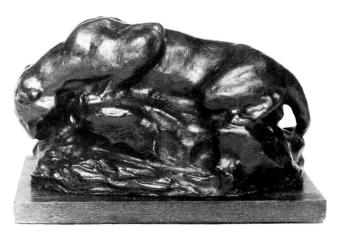

**C83** A well detailed Susse Frères cast of a lioness licking at the remains of a carcass, by Pierre Dandelot. A very good lost wax cast and an unlikely subject for the inter-war period at a time when a lioness drinking would be very much more commercial. This sculptor's bronzes are not often seen on the market and he is not very sought after but they would seem to be good investment as they are extremely competent.

Signed 'P. Dandelot' and 'Susse Frères Cire Perdue'
21cm (8¼ins.) wide: dark brown patination

*c.1830* £350 — £500

**C84** A rare English animalier subject by John Macallan Swan and a very good model, albeit rather indifferently finished and a little pitted. The model combines the even texture of Barye and the seeds of Impressionism. There is something of the sensitivity which Frémiet, his master, incorporated into his models. An appealing subject and a popular sculptor, especially in England, but there is always something lacking from this sculptor's work that makes his models a hit and miss affair.

Signed 'J.M. Swan': 15cm (6ins.): rich brown patination

*c.1890* £800 — £1,200

**C85** This lion and ostrich and the following bronze are possibly the most magnificent models by Auguste Cain. Life-size versions stand in the Tuileries Gardens and until one has seen them it is difficult to really appreciate the reductions. Standing amongst the trees and shrubs of the gardens they have an air of reality, albeit in foreign vegetation. The power and natural pride of the lions is very expressive in the larger versions and it is not difficult to imagine many Parisians and visitors to Paris ordering reductions from the original foundry of Barbédienne or the subsequent foundry of Susse Frères. The detail of the large models is every bit as good as in these reductions which were first modelled in 1868 and enjoyed continuing popularity.

Signed 'A. CAIN' and 'Susse Fres Edrs Paris'
63 x 83cm (24¾ x 33ins.)
rubbed green patination with traces of gilding
*1890s*                                    £1,500 — £2,500

**C86** The patination of the life-size versions of this model in the Tuileries is a superb heavily weathered green with rich dark brown patches where thousands of onlookers have touched the bronze and worn away the weathering. A richly conceived and exotic bronze, the tigress holds up a peacock for her greedy young cubs who eagerly snatch at the prey. This and the previous bronze are quite large reductions and it is clear from the patination that they have obviously been in a garden, which would no doubt please the original intention of the sculptor. A purchaser could continue to keep the bronzes in a garden (provided they are secure) or have them cleaned or even repatinated. Placing bronzes in a garden for the first time will alter the patination achieved by the foundry. This bronze was listed in the combined Mêne and Cain catalogue from 19 rue de L'Entrepôt as two sizes, the smaller being 43 x 63 x 20cm (17 x 24¾ x 8ins.) the other as below. First modelled in 1868, this is a later cast.

Signed 'A. Cain' and 'Susse Fres Edrs Paris'

62 x 102cm (24½ x 40ins.)

rubbed weathered green patination

*1890s*                                                            £1,500 — £2,500

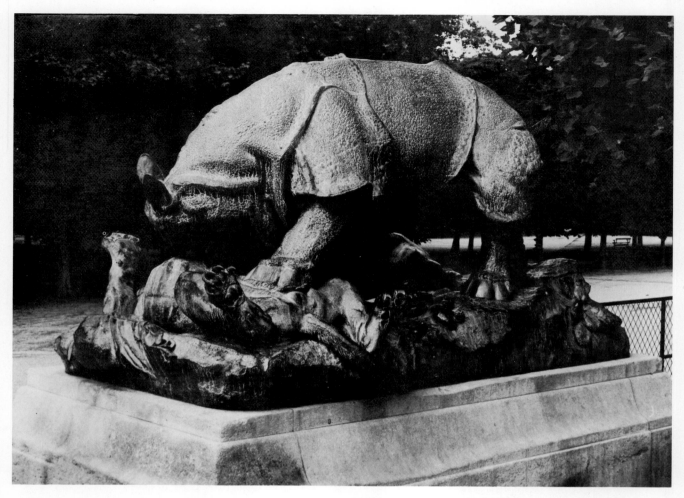

**C87** Another magnificent model by Cain of a rhinoceros attacking two large cats. This life-size bronze is in the Tuileries gardens alongside the main entrance from the Rue de Rivoli. It is a superb cast, full of life and vigour as the three powerful animals fight to the death. The technical achievements in casting such a large fine bronze are considerable and it is impossible to place a value on this unique model.
*c.1884*

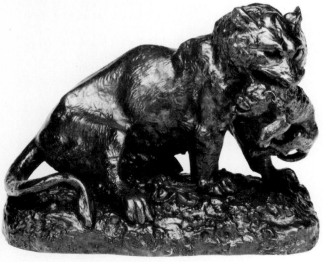

**C88** A very fine cast of a lioness carrying a cub in her mouth. Although unsigned, it is attributed to Fratin because it is characteristic of his sensitive style, his technique in both the loosely modelled form of the lioness and the almost careless detail of the finish. If one studies the form of the bronze although somewhat ungainly and untrue, at the same time it gives a very natural everyday impression. This paradox is typical of Fratin and makes him difficult to understand as a sculptor but his followers are legion.

14.5cm (5¾ins.): light and dark red/brown patination
*1840-1860*                                          *£550 — £800*

156

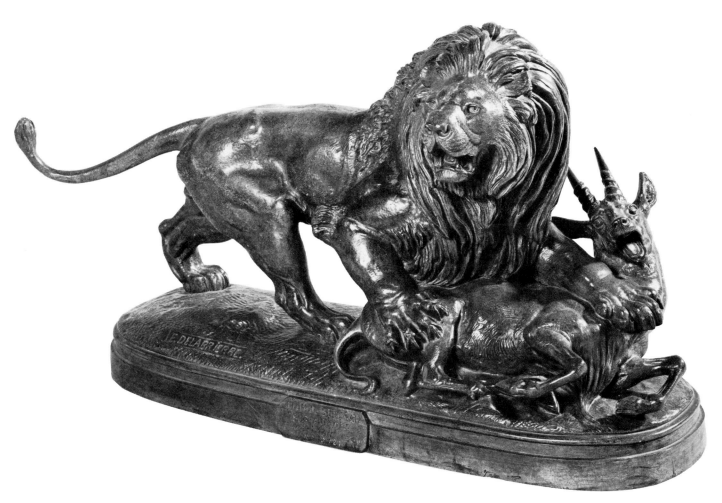

**C89** A magnificent, proud model of a lion looking up at some disturbance as it is about to apply the *coup de grâce* to a screaming antelope. This model was exhibited at the Salon in 1866 and though Barye's influence can be clearly seen it lacks the subtlety of Barye's work. Here the lion's legs are too fat, as is the body of the antelope. The pose is too stiff, almost as if Delabrierre was modelling it from a taxidermist's model.

Signed 'E. DELABRIERRE' within a reserve titled 'Lion du Senegal sur antelope' Exposition 1866 No.2721

71 x 47 x 28cm (28 x 18½ x 11ins.): green patination
*c.1866*                                                £4,500 — £5,500

**C90** From a soft mouth to a vice-like grip, this lion is strutting back to a shady place to devour the recently caught roedeer. An excellent early Fratin model full of power and detail and a cast that typifies his work. There are few of these very crisp Fratin casts available on the market today and they are subsequently very much sought after. This is good enough to be a Quesnel cast of a model made in 1836 and a Salon entry.

Stamped 'FRATIN': 35cm (13¾ins.): rich brown patination
*c.1836*                                                £1,500 — £2,000

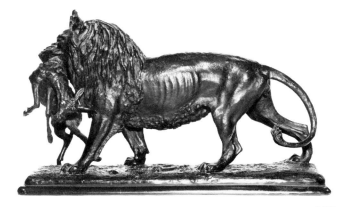

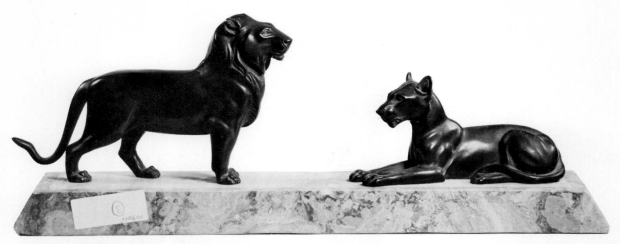

**C91** One of the worst available examples of an animal bronze group. A most uninspired piece of sculpture in every respect, especially the modelling. The attempt made to capture the new 'angular' style of the 1920s has resulted in a pseudo-Egyptian manner, no doubt unintentionally inspired by the opening of Tutankhamun's tomb in 1924. It is possibly of German origin and is mounted on a contemporary brown fossilised marble plinth.
*c.1930* £120 — £180

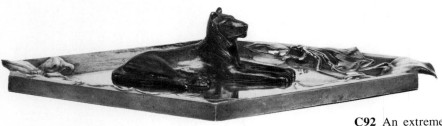

**C92** An extremely poor seated lion incongruously mounted on a lily pond. Closer inspection shows that the qualities of the bronze tray and the lion are very different and therefore it may be presumed that this unlikely pair did not originally belong together.
*The tray c.1905* £50 — £80

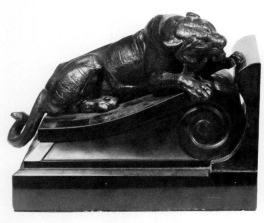
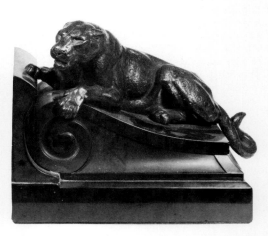

**C93** An uninspired pair of bronze and Belgian black slate bookends. The animals look very weak on their unrelenting architectural stands. The left hand cat has the markings of a tiger and the right hand of a leopard. A good sculptor designing this imaginative pair of bronzes would normally be expected to model the animals to suit their bases and complement them, but there is no such sympathy here. The great Paris and other French monumental animals for buildings have a much greater feeling of synergy than this pair of useful bookends. Ideal for the complete animalier collector.
20cm (8ins.): black patination
*c.1910* £180 — £260

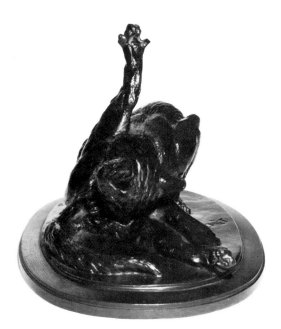

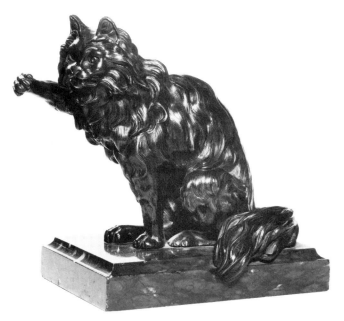

**C94** The first example of the domestic cat family, all of which are, not surprisingly, popular amongst animalier and occasional collectors. There are far fewer bronze models of cats than cat owners and good models can quite often realise more than the normally accepted value, especially in a good, well attended auction. This is a very fine model by Frémiet and a typically sensitive model, capturing the true nature of the animal, a feat he was so very good at. The cat is cleaning itself in a time honoured manner, indifferent to sculptor and on-looker alike. A well detailed cast but somewhat sketchy in overall form as intended by the sculptor. A charming title for the bronze was suggested as 'Cat playing the Fiddle'! The long outstretched leg is cast separately.

Signed 'FREMIET' and numbered 1 with an unidentified
foundry mark (?) of a Y within a circle
14 x 20.5cm (5½ x 8ins.): very dark brown patination
*1845-1850*                                              *£800 — £1,200*

**C95** This is based on a very popular 18th century model by P.P. Thomire, said to have been made for Marie Antoinette (probably one of her favourite pets). The subject is in sharp contrast to the other bronzes on these pages and shows the change in attitudes and style that the 19th century sculptors brought to their work. The pair to this bronze is a lion-cut poodle. Both mounted on red marble bases and with patination typical of the period.

20cm (8ins.): red tinted laquer patination
*Late 18th/early 19th century*          *Cat £1,500 — £2,000*
                                        *Poodle £1,500 — £2,000*

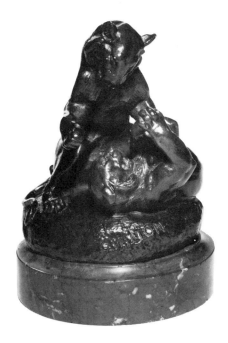

**C96** Valton was a very competent, wide ranging sculptor and this rare model by him of two tigers playing is one of his best and most sensitive subjects. He has reduced the magnificent beasts to playful cats as they romp together with claws sheathed. Two influences are seen here — the form and texture of the animals is very Barye in style but the sensitivity is that of his other mentor, Frémiet. This ideal combination of tutors may well be the reason that Valton is such a very good sculptor though still underappreciated. The contemporary base is made of red griotte marble.

Signed 'C. VALTON': 11.5cm (4½ins.) without base
rich dark brown patination
*Dated 1879*                                              *£500 — £750*

159

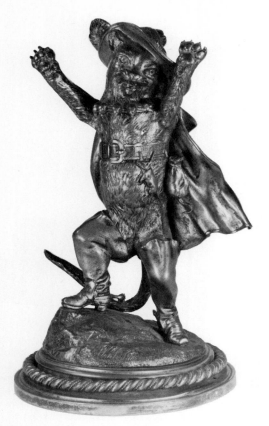

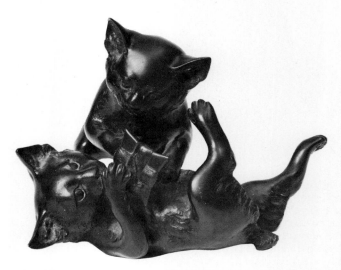

**C97** This unsigned model may well be English. It appears to be a model of Puss in Boots, no doubt inspired by the popular pantomime. Puss has a mouse and a rat slung from his belt, with a cloak collar studded with birds' heads! In fact it is an inkwell, the head hinged at the neck. It is quite an early model with a rope-twist border to the socle found on contemporary English and French furniture.

23cm (9ins.): gilt patination

*c.1860*                                                           *£400 — £500*

**C98** Two frolicking kittens make an ideal subject in bronze but unfortunately this example is neither very well modelled nor well cast. Almost certainly this unsigned cast is of Japanese manufacture, made for the European market at the end of the 19th century.

16cm (6¼ins.): black patination

*1880-1900*                                                       *£200 — £250*

**C99** A charming portrait of a leopard in playful mood, more akin to our image of its domestic cousins. This bronze is recorded as being unsigned but has a lengthy inscription dedicated to two friends killed in 1917. There is a certain naïvety about the modelling but the feel and inspiration are pure Bugatti.

20cm (8ins.): flat brown patination

*c.1917*                                                           *£700 — £1,000*

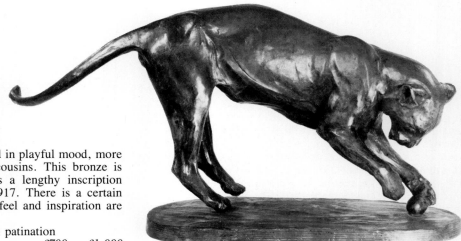

160

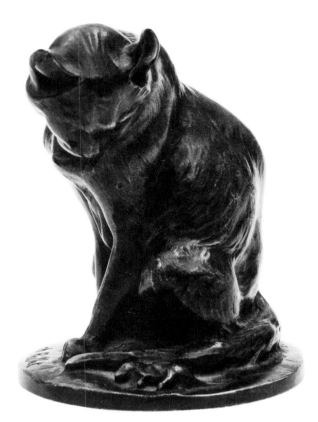

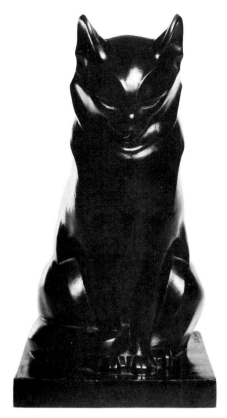

**C100** A loosely worked model by Charles Paillet whose best casts are normally those of his dogs. This a perfectly genuine cast, in the Frémiet style but the lack of detail will leave it open to criticism. The cat has obviously been ignoring its prey and is just in the act of looking round as if surprised to see it there.

Signed 'Ch. Paillet': 9cm (3½ins.) approx.
black patination

*c.1900*                                                          *£220 — £300*

**C101** A favourite animal in a heavily stylised manner that is possibly an acquired taste but one that becomes addictive. Clearly influenced by Pompon, it is a very attractive study in a typical feline posture with the tail curled around a forepaw. The face and body of the cat have been 'sliced' in a geometric style using contrasting angles and curves.

Signed 'Ed. M. Sandoz' and
'Susse Frs Edtrs Cire Perdue Paris'
42cm (16½ins.): black patination

*c.1920*                                                      *£2,500 — £2,800*

**C102** An unsigned small bronze cat of a friendly and attractive disposition and popular with a wide range of buyers simply because of the subject matter. More likely to be found in a curio shop than in a specialised animalier shop. An average cast — there must have been a very large edition to satisfy a big market.

*c.1900*                                                          *£100 — £120*

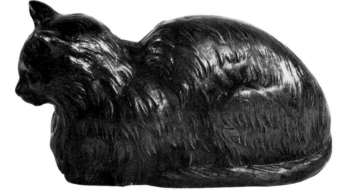

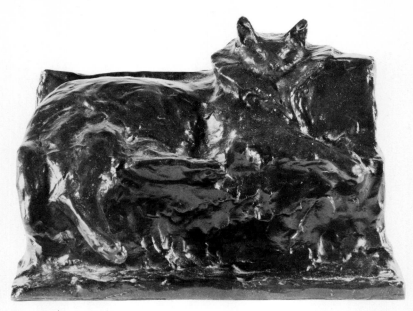

**C103** A very proud sleeping cat by the master sculptor of the domestic cat, Théophile-Alexandre Steinlen who was always able to capture the character of these elegant and independent creatures. Even asleep the cat is confident and assured in its manner. This is highly impressionistic in technique and similar in style to that favoured by Prince Paul Troubetskoy.
Signed 'Steinlen' and 'Cire Perdue A.A. Hebrard'
black patination
*c.1910*                    *£2,200 — £3,000*

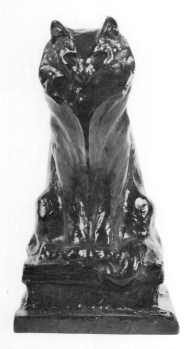

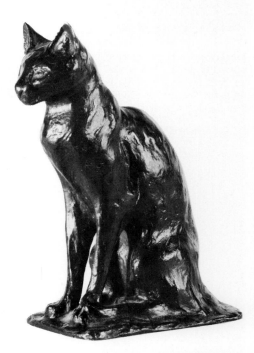

**C104** Another Steinlen and a magnificent model of an Angora which while in an impressionistic manner, anticipates the geometric style of the period immediately after the Great War. It is interesting to compare it with the Sandoz model shown as C101. The Steinlen example can almost be taken as a transitional model between impressionism and art deco.
Signed 'Steinlen' with A.A. Hébrard Cire Perdue seal numbered 5: 24 x 14.5cm (9½ x 5¾ins.): black patination
*c.1910*                    *£2,500 — £3,000*

**C105** A good Hébrard cast of another Steinlen cat, less exciting and less stylised than his previous models but still attractive and sure to be a popular model. The sculptor has modelled his animal on the ancient Egyptian cat, *mau*. These cats have an eerie appearance and are an acquired taste. Steinlen in this and the previous model, has not bothered about the hind legs very much and the fur of the animal's back falls in an unlikely sweep out towards the edge of the base.
Signed 'Steinlen' with Hébrard seal: black patination
*c.1910*                    *£2,200 — £3,000*

162

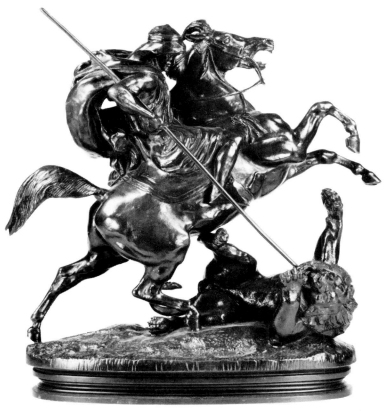

**C106** A variation of Barye's 1830s model of 'Two Arab Horsemen Killing a Lion' and listed in his 1847 catalogue. This subject usually has two horsemen, the second horse and rider entangled on the ground under the hooves of the other horse, straddling the upturned body of the lion. Although a good bronze it has none of the superb finish of 'The Five Hunts' commissioned from Barye by the Duc d'Orléans for his *surtout de table*. The base suggests that it is a post- catalogue cast.

    Signed 'Barye': 38cm (15ins.): medium brown patination
*c.1850*                                        *£2,000 — £3,000*
       *Earlier cast with the two horsemen £3,000 — £4,000*

**C107** A lion trying in vain to reach the cool and calm figure of an Assyrian who stands defiantly with his short sword bared. An extremely unusual bronze composition that has little credibility. A very good cast and well modelled although the figure may be a little too tall for absolute realism but it does emphasise the story line.

    81cm (32ins.): deep brown patination
*c.1890*                                        *£1,000 — £1,500*

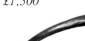

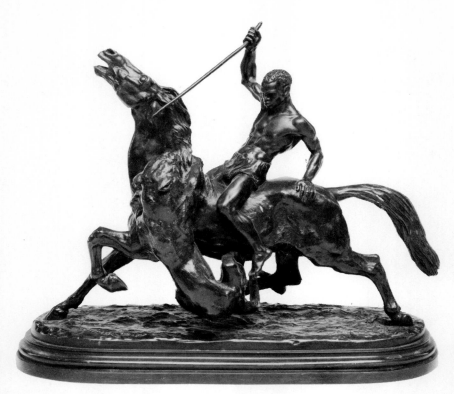

**C108** This fine and very rare group was used by Isadore Bonheur for his début at the Salon in 1848, and was exhibited in plaster with a painting of the same subject by the sculptor/artist. The horse gives a Barye like scream as the lion claws into his neck and underbelly and as the negro rider stabs wildly at the attacking lion. The lion is dragging the horse down with its weight and this has made the proportions of the horse uncomfortable.

Signed 'I. Bonheur': 29.2 x 33.5cm (11½ x 13¼ins.)
rubbed black/brown patination

*c.1848* £1,200 — £1,800

**C109** There is an air of the 18th century about this cupid walking alongside a humbled lion. It is a finely detailed and well executed cast although the modelling is a little naïve and bears none of the romanticism of the work of Barye and his successors. Its sources still come from the classical style. An attractive model however and a good decorative subject of love triumphing over strength. The idea of an upholstered base was one used for the model of dogs attributed to Barye illustrated as D73. Probably Italian.

20 x 32.5cm (7⅞ x 12¾ins.)
rubbed copper red brown patination

*1830s* £250 — £450

164

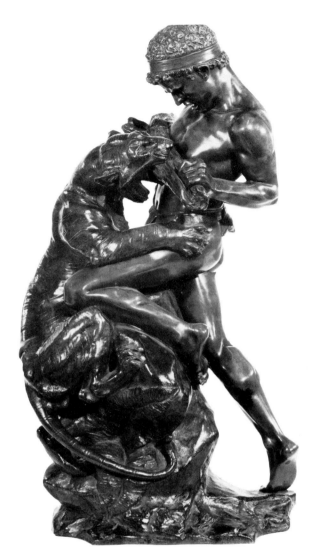

**C111** The medium of terracotta is a very fine one for sculpture with its own special qualities. Jean-Baptiste Clésinger, known as Auguste, born in Besancon 1814, died 1883, made many such models from the original and they have a very direct affinity with the sculptor and an appealing texture of their own. The subject is an interpretation of Greek and early Persian originals, possibly inspired by the Homeric 'Hymn to Dionysus'. This is a typical late classical subject and is included here as a contrast to the work of Clésinger's animalier contemporaries who were, after all, working on a new and as yet unestablished style.

Signed 'J. CLESINGER': 41cm (16ins.)
*c.1850*                                    *£1,000 — £1,500*

**C110** The natives of North Africa were a constant source of inspiration for French artists and sculptors in the closing years of the 19th century. This fine model and cast is by Edouard Drouot who exhibited his genre sculpture from the 1890s. He is not usually considered an animalier. Here he has captured this fight between two unlikely rivals with realism. All that stands between the cat and the human is a log that is being forced down the animal's throat.
Signed 'E. Drouot': 66cm (26ins.): rich mid-brown patination
*c.1900*                                    *£2,000 — £3,000*

**C112** A naked witch seated on her broomstick resting on a cloud beneath which bats are flying. A romantic model by the normally classical English sculptor, Edith C. Maryon. Her work is well represented at the Liverpool Art Gallery. She worked at the turn of the century and in this example seems influenced by the English New School. The cat is an extraordinary extra and is modelled in a Fratin manner.
Signed 'Edith C. Maryon': 37cm (14½ins.): black patination
*Dated 1904*                                *£1,000 — £1,500*

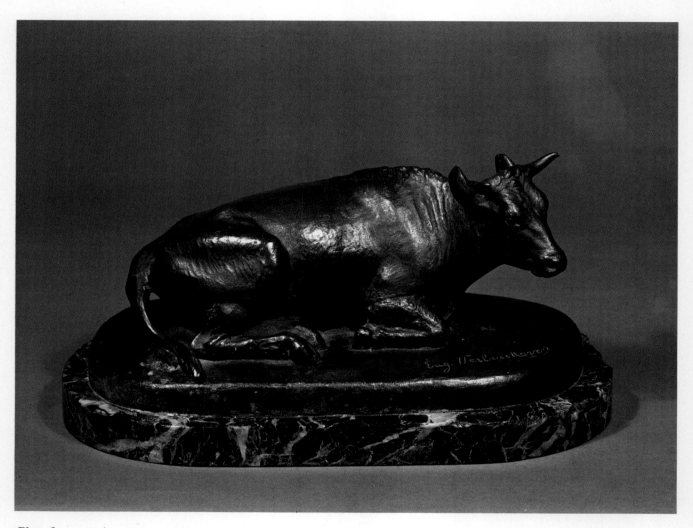

**Plate 3**

A good and rare cast of a recumbent cow by the Flemish animalier and part time sculptor Eugène Verboeckhoven. This highly talented painter worked for a time with the English artist Thomas Sidney Cooper. For relaxation he modelled animals which also helped his study of them for his paintings, achieving an accurate feeling for their three-dimensional proportions which he realistically portrayed onto board and canvas. His paintings and his models are a little unadventurous but, for an 'amateur' sculptor he certainly produced a bronze of exceptional quality, texture and finish. The founder has made an excellent job of both casting and patination.

Signed 'Eug. Verboeckhoven': rich black over brown patination
*c.1840* £1,000 — £1,500

# Cattle

This group needs the sure hand of a highly skilled sculptor
to bring out the best in the animal.
The Bonheurs' bulls and cows are magnificent animals
as are, inevitably, the rare Bayre examples.
Fratin is competent but unusually static
whereas Mêne's work varies from very good to indifferent
and Moigniez produced somewhat scrawny, uninspired creatures.

**Catl 1** A very fine cast-iron group by Mêne. A well proportioned and unusual model from a sculptor whose better bronzes and, more especially, bronze groups, possibly came closest to the style of animal paintings of Eugène Verboeckhoven and Thomas Sidney Cooper. A complete picture is recorded here with the young peasant girl steadying the cow while the bull calf licks the salt on her hand. Originally there must have been a rope between the cow's horns and the stump in the foreground. The girl is particularly well modelled with a subtle emphasis in the twist of her body.

Signed 'P.J. Mêne': 14.5cm (5¾ins.)
*c.1860*                                    *in iron £500 — £800*
                                          *in bronze £1,200 — £1,600*

**Catl 2** A good bronze figure of a cow in a rather majestic pose, swishing its tail. The alert animal is exceptionally well built and may possibly be a commission model of a prize winning beast at an agricultural fair. The stepped moulded Belge noir slate plinth is contemporary.

Signed 'Isadore Bonheur': 25.5cm (10ins.) high
rich dark brown patination
*Late 1870s*                                    *£850 — £1,250*

**Catl 3** A large and rare group by Delabrierre, each of the three animals is nicely modelled but the composition is somewhat lacking in balance. It is interesting to compare with the Bonheur group, Catl 12.

Signed 'E. Delabrierre': 33cm (13ins.) rich dark brown patination

*c.1860*

*£2,000 — £3,000*

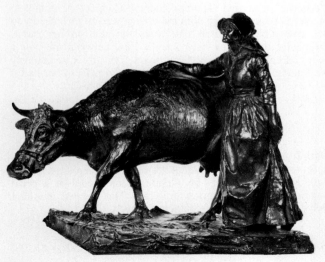

**Catl 4** A very fine and rare cast of a peasant girl walking a cow back from milking by Dressler. This is a superb example of lost-wax casting in a quasi-impressionist style. There is tremendous harmony between the girl and her charge as she walks dreamily at the slow, waddling pace of the cow. One can almost feel the heat of a summer's day.

Signed 'Dressler': 30cm (11¾ins.) approx.

*c.1910*

*£1,100 — £1,600*

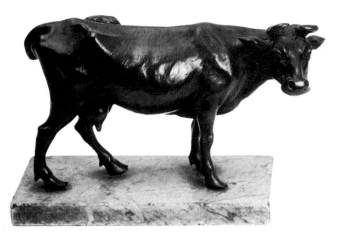

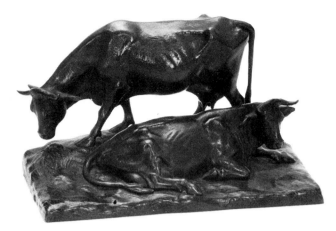

**Catl 5** An indifferent small model of a cow, cast in the solid. The back legs and the horns have been bent, the former giving the animal a very unsteady look on its contemporary worn marble plinth. Certainly the animal is instantly recognisable as a cow but the sultry pose and pitted casting do not make it a very desirable item.

11cm (4¼ins.): black patination

*c.1910* £80 — £120

**Catl 6** An earlier cast but again a very indifferent one. How difficult it seems for all sculptors to model the legs of animals successfully and the minor sculptors who imitate the best of the animalier school hardly succeed at all. The idea of this small group is a good one and may have worked better on a larger scale.

Signed indistinctly 'E. de Sabroue': 12cm (4¾ins.)
rubbed black/brown patination

*Mid-19th century* £180 — £260

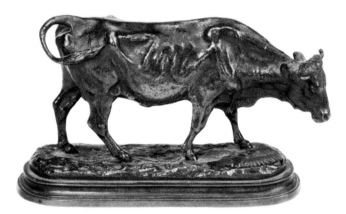

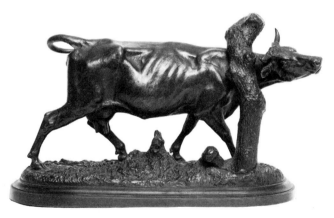

**Catl 7** A small model of a cow by Isadore Bonheur. Being a small cast it has been constantly handled and become very worn but is well detailed, if unadventurous.

Signed 'I. BONHEUR' Stamped Peyrol

*c.1870* £300 — £400

**Catl 8** An amusing subject of a cow scratching its neck on the bark of a tree by Isadore Bonheur. Almost invariably the 19th century sculptor made us imagine the tree and only provided the stump in his model. By the 20th century, the advent of elecricity allowed the sculptor attempting a similar group to include the whole tree, making use of the leaves and upper branches to form a fixed lampshade. This is a very well modelled and detailed cast, of the standard one expects from this family of sculptors. Early years of training as painters for both the Bonheurs heightens their three dimensional effect in bronze.

Signed 'I. Bonheur': 32cm (12½ins.)
rubbed dark brown patination

*c.1875* £600 — £900

169

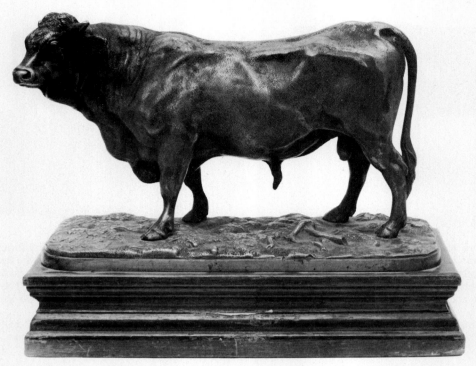

**Catl 9** A highly detailed and textured bull by Mêne. This model was first exhibited at the Salon in 1845 and must have been produced by Mêne in quite large quantities. This very simple base without any moulding as seen on later models is an early one of three different versions. The fold of the skin and the lines of fine hair on the hide are exceptionally well done and for pure detail must be one of Mêne's best models. The nose is a little too rubbed here and the feet have become bent and do not sit very satisfactorily on the grassy base. This could be remedied quite easily by a restorer and would be well worth doing. (A cast-iron version of this model was seen recently, by coincidence the base was the same width as the height of the model.)

Signed 'P.J. Mêne' 23.5cm (9¼ins.)
brown/black patination

c.1845                                       £1,000 — £1,500
                              *cast-iron version £200 — £300*

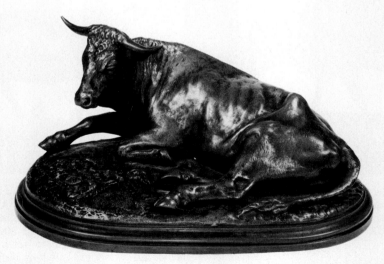

**Catl 10** Recumbent figures are not normally as popular as standing ones but when they have the sculptural pose and quality as this example by Rosa Bonheur they enter a hotly contested collecting league. This cast was made in some quantity but is not often seen on the market these days. This example is a little worn but nevertheless there is a lot of fine textured detail in this cast. The folds of skin over the protruding hip bone are especially good, but is the extended right foreleg slightly too short and thick?

Signed 'Rosa B': 14cm (5½ins.)
heavily rubbed very dark brown patination

c.1860                                          £800 — £1,100

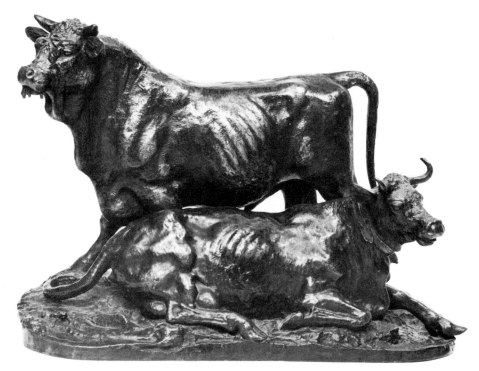

**Catl 11** A well modelled and fairly large group of a bull and his cow by Fratin. The textural quality of this sculptor's bronzes is very evident in this example, the interplay of light on the rippling hide of the two animals in itself gives an impression of movement in a way that few other sculptors could achieve. There is so much life here that one almost expects a flank to twitch or an eye to blink. While the cow rests, the bull is chewing a mouthful of grass which heightens the feeling of contentment in this group. Unfortunately the grass in his mouth looks more like spaghetti!

Signed 'Fratin' (indistinctly): 41cm (16ins.) wide
rubbed parcel-gilt patination

*1835-1850*                                                              £800 — £1,200

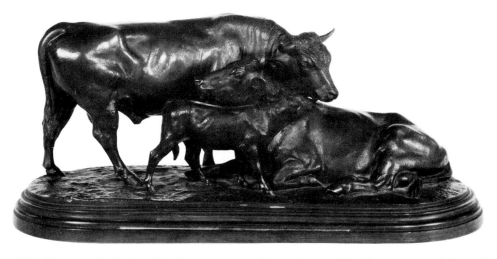

**Catl 12** A very good family group by Isadore Bonheur, cast by his uncle by marriage, Hippolyte Peyrol. It was possibly intended as a companion group to his Bull and Cow, both standing (illustrated in *Les Animaliers,* p.202). The composition works very well with the triangular focus of attention firmly in the middle of the group, encompassing their three heads. An intimate study, pleasing to the sentiments of the era but possibly almost too much for today's less romantic tastes. If the cow had been standing this group would be commercially more desirable.

Signed 'I. Bonheur' and with Peyrol founder's stamp
37.5cm (14¾ins.) wide: even mid-brown patination

*c.1870*                                                              £2,000 — £3,000

171

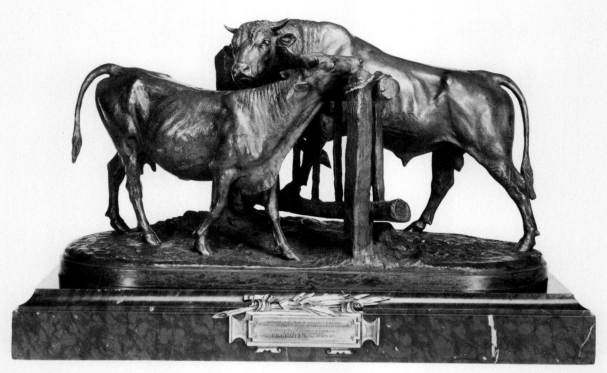

**Catl 13** Two almost identical casts of a bull and a cow separated by a rustic gate. This model is a combination of different models by Isadore, who produced a similar version without the dividing gate. The casts are similar in detail but vary a great deal in patination, the presentation one above has been stripped at some time, while the other is very black. For Bonheur an ideal patination would be a mid-brown, halfway between these two extremes. The presentation plaque is a prize from the French Ministry of Agriculture and dated 1889, probably some twenty years after the group was first modelled. The red (griotte) marble plinth is typical of the period and often seen on clock garnitures. The group below is a Peyrol cast.

Signed 'I. Bonheur': both 29 x 53.5cm (11½ x 21ins.)
*1880s*                          *either version £2,000 — £3,000*
                    *(Slightly more with an ideal patination)*

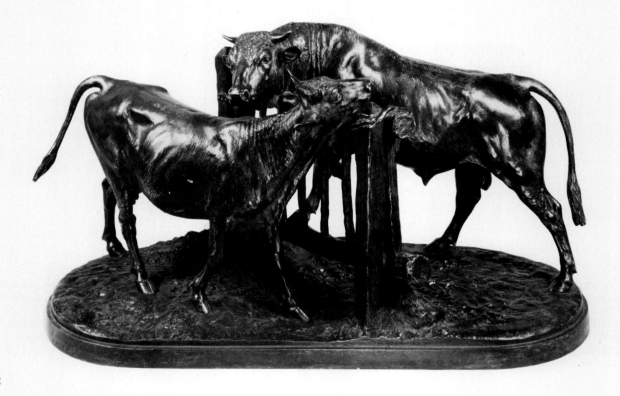

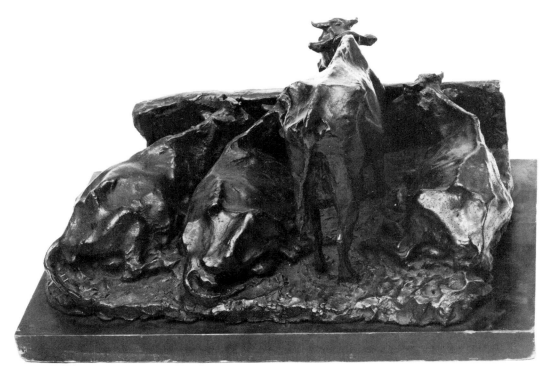

**Catl 14** A very rare group by Paul, Prince Petrovitch Troubetzkoy. An exceptionally good lost-wax cast of four cows by a byre wall. Not, however a very commercial cast but an interesting one in this very good aristocratic sculptor's career. A homely scene that is relieved by the fact that one of the cows, at least is standing, giving the model some height and perspective. It is a good example of a wealthy sculptor creating a bronze for his own pleasure and artistic development rather than to please others. There is a lot of light movement on the angular flanks of the bony animals.

Signed 'P. Troubetzkoy': 23 x 50cm (9 x 19¾ins.)
thick black even patination

*c.1910* £1,000 — £2,000

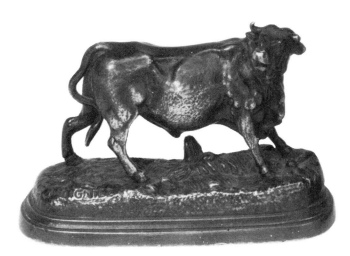

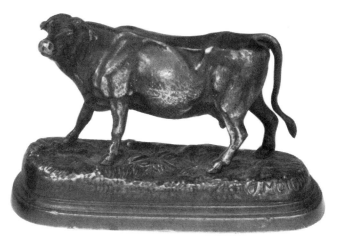

**Catl 15** A pair of very poor casts of a bull and a cow by Moigniez. These same animals have been seen together on one base in a 6.5cm (2½ins.) example and another approximately 20cm (8ins.). All versions are remarkably unsuccessful and most recorded examples appear to be from the same poor quality casts. Inevitably, these small bronzes are bent and damaged over the years and a general service would help.

Signed 'J. MOIGNIEZ': 6.5cm (2½ins.)
rubbed black patination

*c.1880* £200 — £400

173

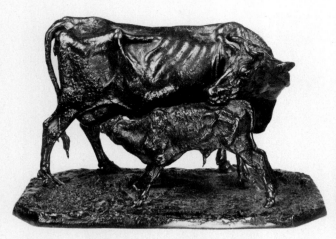

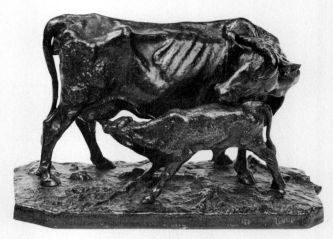

**Catl 16** A very fine group by Mêne of a cow suckling its calf. A cast with incredible detail and an exceptionally good textural quality normally expected to be seen on Fratin's work. Presumably intended as the left-hand half to a pair, complemented by a bull possibly the one shown as Catl 9. A difficult cast to better. This realised £420 at auction in 1973.

Signed 'P.J. MÊNE': 21.5 x 36cm (8½ x 14¼ins.)
rich very dark brown patination

*1840s*                                                    *£1,000 — £1,500*

**Catl 17** A cast-iron model of the same subject and what a contrast! It has lost all power and detail. Cast-iron is perfectly collectable and a very reasonable way to start but the tactile quality of the bronze version is a very seductive force. These casts are always presumed to be English, normally Coalbrookdale, but the French were highly skilled at iron casting as well, and to date there is no certain way to tell. Bearing the very faintest of signatures: 22cm (8¾ins.) wide
black patination

*1880s*                                                    *£100 — £160*

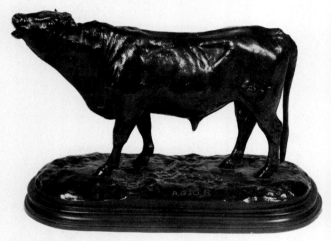

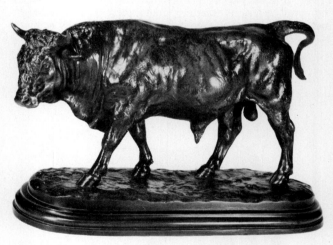

**Catl 18** A good model of a bellowing bull by Rosa Bonheur. Unfortunately the cataloguer over a decade ago did not record whether or not there was a Peyrol founder's stamp. Almost certainly there was but it is always so very small and indistinct on the back of the bronze, that it is very often overlooked. The actual size of a Peyrol stamp is under one centimetre wide and no more than two millimetres high, so oversight can be understood, but it must be stressed that anyone looking at a bronze by either of the Bonheurs must look closely for a Peyrol stamp and, if not successful, then must look again.

Signed 'Rosa B' in script
(some with a capital R, others in lower case)
15cm (6ins.): rich dark brown patination

*c.1840*                                                    *£1,000 — £1,400*

**Catl 19** Another bull by the same artist, which is very powerfully modelled and possibly a more desirable pose. Seven versions of this cast have been recorded at Sotheby's, two in the same sale in April 1976 and two in the same sale in November 1981.

Signed 'Rosa B': 28cm (11ins.)

*c.1845*                                                    *£1,200 — £1,600*
*Peyrol version recorded as 18cm (7ins.) £800 — £1,200*

174

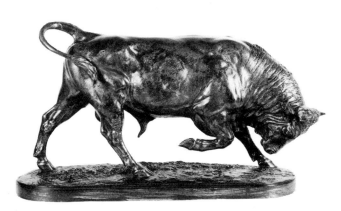

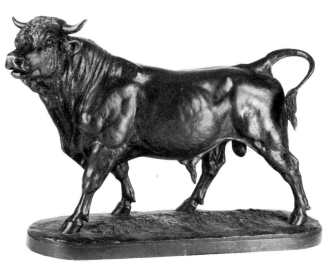

**Catl 20** A magnificent charging bull by Isadore Bonheur and a very rare model. There is a wealth of very fine detail in the hide, every single area has been painstakingly incised to give the accurate effect of the texture of the skin. This example has a very worn patination which only serves to heighten the play of light over the surface of the bronze. An imposing and popular model. It was exhibited at the Salon of 1865 with its companion bull (right), and they were ordered for the Sultan's Palace in Constantinople.

Signed 'I. BONHEUR': 34cm (13¼ins.)
rubbed brown black patination
*c.1865* £3,000 — £4,000

**Catl 21** The companion figure to Catl 20 standing 4.5cm taller but in this particular example not such a very highly detailed cast. Not quite as popular individually but still a very majestic figure.

Signed 'I. Bonheur': stamped Peyrol: 38.5cm (15¼ins.)
rich mid-chocolate brown patination
*c.1865* £3,000 — £4,000

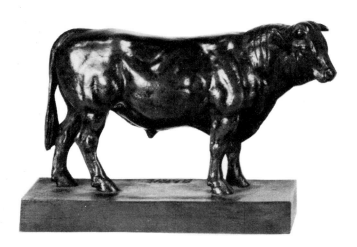

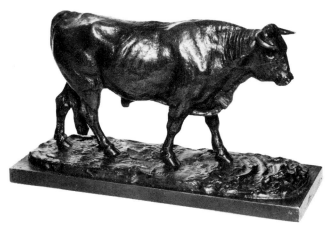

**Catl 22** A rare miniature model of a bull by Barye. A good realistic model but a little lifeless for an enjoyable piece of sculpture. The absolutely plain rectangular base is a common feature of Barye's work, drawing the eye to the subject itself without unnecessary frills.

Signed 'BARYE': 9.5cm (3¾ins.)
dark brown patination
*c.1850* £600 — £900

**Catl 23** A fine model of a bull by Germain Demay, a pupil of Barye, who helped him prepare his casts. This figure compares closely with the previous model, as would any two models by sculptors of the same school at the same time. However, the Demay version lacks some of the assured solidity of the Barye cast and he does not have the master's ability to round off the body of his animals. Certainly Demay has produced a better detailed cast but where the pupil has had to be precise, the master has sketched an impression in a manner far ahead of his time. Nevertheless, a good model, with a very distinctive and unusual type of base.

Signed 'DEMAY': 14.1 x 24.2cm (5½ x 9½ins.)
rich dark red patination
*1845-1850* £550 — £800

175

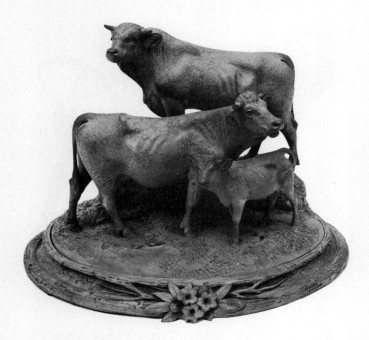

**Catl 24** A carved walnut group by J. Baud, an unrecorded sculptor. Produced either in Southern Germany or Austria it is typical of provincial carving in a style favoured by the animaliers of mid-19th century Paris. An intricate model to carve and well done in an amateur way, it is quite probable that this type of group was in fact made by peasants or people in farming communities during the long winter evenings. Somewhat reminiscent of an over decorated breadboard!

Signed 'J. Baud': 25.5cm (10ins.)

*Late 19th century*                                    *£250 — £350*

**Catl 25** The exotic influence of the Orient was ever present in 18th and 19th century European art. This plaque, presumably modelled from animals at a zoo, has had the silhouette of a Malay temple cast into the background. Not a very good cast although this sculptor's textural quality is still in evidence.

Signed 'Christophe Fratin' (stamped): 33.5cm (13¼ins.) wide
black patination

*c.1840*                                    *£220 — £360*

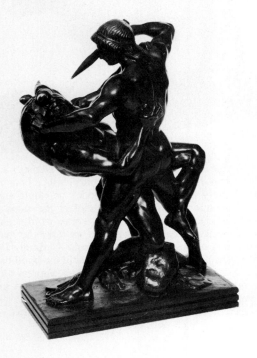

**Catl 26** There is almost a feeling of art deco in this very powerful model of Theseus Slaying the Minotaur, but this was modelled almost one hundred years prior to the art deco period by Barye. Certainly the overtones and influences of this group are classical but the way the sculptor rounds off his proportions is an inspiration well ahead of his time. Not a true animalier subject but a very popular model indeed by Barye and sculpturally very important.

Signed 'Barye': F. Barbedienne Fondeur Paris
46cm x 29.5cm x 16cm (18⅛ x 11⅝ x 6¼ins.)
rich brown patination

*c.1870*                                    *£2,800 — £4,800*

176

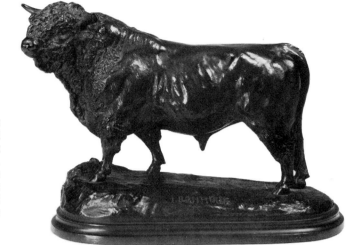

**Catl 27** A good, but unusual model of an Aberdeen Angus bull by Isadore Bonheur. This popular breed was exported widely abroad and, although his sister Rosa painted in Scotland there is no evidence that Isadore modelled there. Possibly he saw drawings of these magnificent bulls by his sister or he simply modelled them at an agricultural show in France. As always quality of casts varies and the hide detail in this model is usually slightly vague with more emphasis on the thick black curly hair around the face, chest and thighs.

    Signed 'I. BONHEUR': 16.5 x 23cm (6½ x 9ins.)
dark brown patination but seen with green brown patination
*c.1860-1880*                           *£1,500 — £2,500*

**Catl 28** A model of a steer from the contemporary school in the United States known as the Western Bronzes School, which concentrates on cowboy subjects. This could make a pair with H 234.

    Signed 'E. W. Bascomb': rich dark brown patination
*c.1970*                                  *£700 — £900*

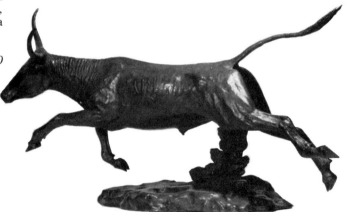

**Catl 29** A very fine and well modelled group recording a desperate struggle between a bear and a bull by Isadore Bonheur. The outcome of such a battle of giants is too gruesome to contemplate and the sculptor has all too well captured the full violence of nature. Fox hunting would seem comparatively mild after witnessing such a battle. It is difficult to imagine that Bonheur actually saw this conflict, although we will never know. The power of the bull is clearly seen but the bear needs to be viewed from the other side to fully appreciate its contribution to the fight.

          Signed 'Isadore Bonheur'
(a recorded variation of his signature but not common)
22.2 x 37.5cm (8¾ x 14ins.): rubbed rich mid-brown patination
*c.1870*                          *£1,000 — £1,500*

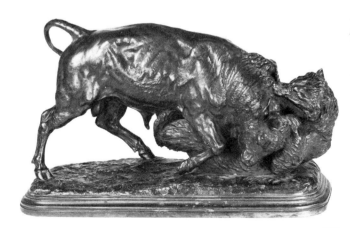

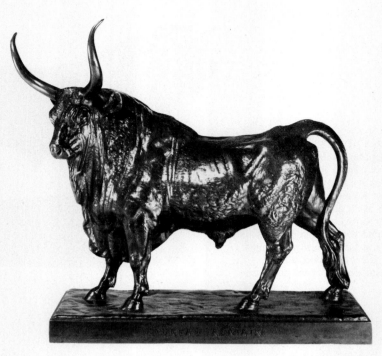

**Catl 30** A well modelled cast of a somewhat ponderous bull by Clesinger. Not a very popular subject but an interesting model all the same. There is an attempt at the textural quality that Fratin employed (see below) but it has not worked nearly so effectively. There is merely the feeling of a sculptor putting a species of animal on record here, rather than trying to capture the mood of the animal. The simple base, normally very effective dramatically, only serves to heighten this. A half size reduction of the marble version, it was listed in the 1867 Barbedienne catalogue.

Signed 'J. Clesinger': stamped 'F. Barbedienne Fondeur': titled 'TAUREAU ROMAIN':33cm (13ins.): brown patination
*Dated Rome 1858*                                    *£1,000 — £1,500*

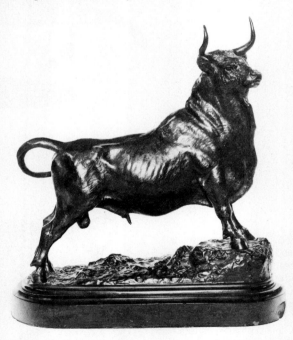

**Catl 31** A very proud and majestic model of a bull by Fratin, almost monumental in its pose, with the dramatic effect heightened by standing the animal with its forelegs on a raised clump of earth. A well detailed cast but certainly not with the exceptional detail that Fratin produced with regularity. This is a very large model, almost too big for modern tastes for such an animal, and not the type of bull that appeals very much to the English.

Signed 'Fratin': 40.8cm (not including Belgian slate plinth)
rubbed light and dark brown patination
*1845-1865*                                         *£1,400 — £1,800*

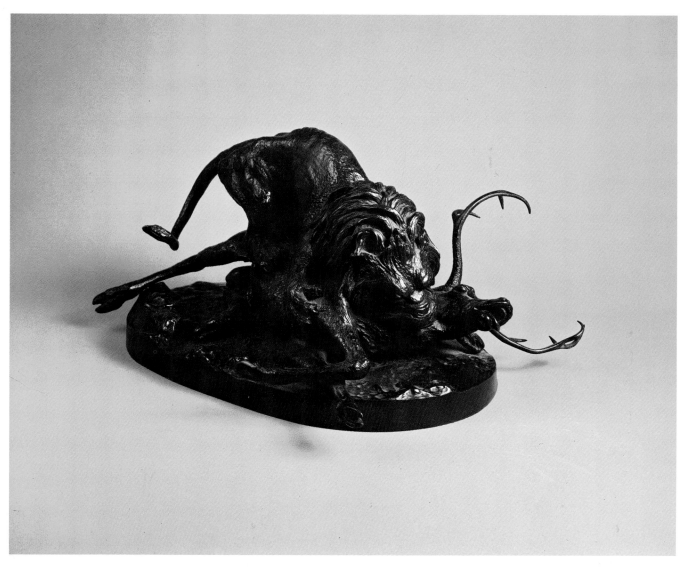

**Plate 4**

An exceptional model by Fratin of a lion killing a stag. The powerful lion has its whole weight on the unfortunate stag which has collapsed in the most complete and dramatic way. Although not an appealing subject, Fratin has captured this scene most vividly and presumably from his imagination and not from personal visual experience on safari. He has dramatised the event in a Barye like manner, with the triumph of strength over innocence brilliantly conceived. Anatomically there are the normal Fratin idiosyncracies, the well detailed paws could belong to many of his species, but the detail in the superb casting is most exceptional, even down to the gruesome feature of the lions claws puckering the skin of the stag before actually ripping it. This is presumably the model of a lion bringing down a stag that was refused entry to the Salon in 1839 and possibly there were few cast as a result. It compares in style with 'Lion with kill' successfully exhibited at the Salon in 1835 by Fratin and it is difficult to see, with today's eyes why the model illustrated should be rejected.

Signed 'Fratin': 19cm (7½ins): rich brown patination
*c.1840*                                                    *£1,000 — £1,500*

183

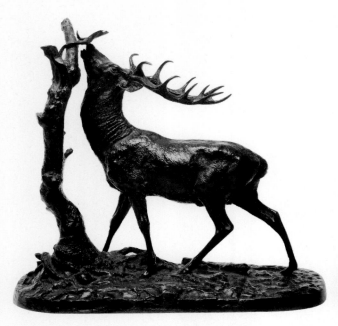

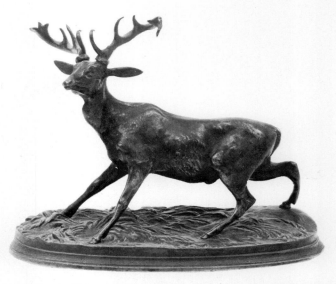

**De4** A well detailed cast of 'The Browsing Stag' by Mêne. This is a very common bronze, but one that appears to have escaped the eye of the copyist. Certainly the many variations available of this model have kept prices to a modest level, making it not worth copying. All the models are similar in detail but the sizes range from 13cm to 37cm for the bronze with two sizes seen in cast-iron, presumed to be Coalbrookdale models. Most casts are well detailed but it is a somewhat awkward bronze to view and consequently not very popular.

Signed 'P.J. Mêne': 37cm (14½ins.)
black to dark brown patination
*1840s* £1,000 — £1,500

*N.B. There are many casts that are dated up to sixty years later than this example and the price could slide down to £500 — £800 for the later casts.*

**De5** An indifferent cast by Mêne, now in poor condition and not very well detailed. The stag's massive antlers have been bent and the legs slightly squashed down. The stance is intended to give the impression of an alert animal about to take off at the first smell of danger, hence the spring in the legs. The flat, uninteresting base is typical of Mêne's earlier 1840s models, appearing uncomfortable and naïve compared with his and other sculptors' styles of the 1860s.

Signed 'P.J. MENE': rubbed brown patination
11.5cm (4½ins.)
*Modelled 1840s but possibly cast twenty years later*
£300 — £500

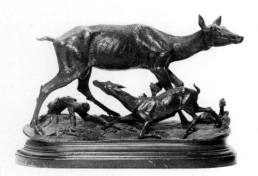

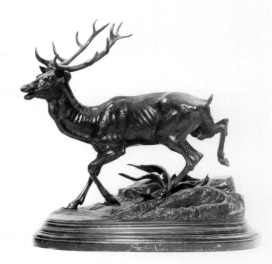

**De6** A good small matched pair of bronzes by Moigniez which create the sentimental feeling of the perfect family group popular with the public during the third quarter of the nineteenth century. The helplessness of the young doe on its spindly legs as it is about to suckle, is countered by the powerful stag always on the lookout for danger. Well modelled and finished casts are certainly becoming difficult to find, especially in pairs.

Both signed 'J. MOIGNIEZ'
brown/black patination
stag 31 x 30.5cm (12¼ x 12ins.)
doe 22.2 x 28cm (8¾ x 11ins.)
*c.1870*                    *Doe £400 — £600*
                           *Stag £500 — £800*

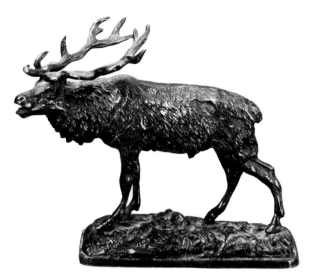

**De7** A small Austrian model of a barking stag by Winder. The body which is cast in the solid is well modelled with plenty of good detail on the fur. Small models that rely on the legs of the animal for support rather than a tree or branch often suffer damage particularly to the legs. The legs and antlers of this model have been bent back into position several times, leaving cracks which eventually will give way.

Signed 'Rud. Winder': 12 x 10.5cm (4¾ x 4ins.)
rubbed, mid-brown patination

*1870s*                                         £80 — £140

**De8** A German cast, by Duroidze of Berlin. Compared with the previous Viennese cast, this is very heavy in both detail and modelling and awkwardly placed on the sloping base. It is typical of German bronzes which lack the sensitivity associated with French animal bronzes.

Signed 'Duroidze, Berlin': 35.5cm (14ins.)
*c.1900*                                         £430 — £550

**De9** A delightful and rare group by I. Bonheur of running and leaping gazelles. A well detailed cast and one where the sculptor has captured the spirit of these delightful animals. The use of foliage aids the flow of form and is not merely a technical afterthought. The group was exhibited at the Salon of 1853.

Signed 'I. Bonheur' and with Peyrol founder's stamp
11.5cm (4½ins.)
slightly rubbed medium dark brown patination
*c.1853*                                         £800 — £1,200

185

**De10** This popular small model of a muntjak, captures the extremely quick movement of these small, flighty animals. A beautifully detailed cast, well finished and of good colour, this type of small bronze by Mêne was very popular in its time and is still popular today, as possibly the best examples of the commercial animaliers' art. The simple base is an indication as to the possible date.

Signed 'P.J. MÊNE' entitled 'CERF MUNTJAC'
19cm (7½ins.) wide: deep, rich brown patination
*1840s*                                        £350 — £550

**De11** A leaping chamois by Mêne that, although a rather surly looking animal employs a great deal of movement and liveliness. It is a pity he decided to give the animal just one central support to heighten the effect of the animal's leap. How much better this impression is achieved by Bonheur in De9. Until the late 1850s Mêne models are liable to be let down by their bases, especially where a sense of movement is to be conveyed: a sad failing for such a competent and important sculptor.

Signed 'P.J. MÊNE' and dated 1850
22 x 30cm (8¾ x 11¾ins.): black/brown patination
*c.1850*                                        £550 — £800

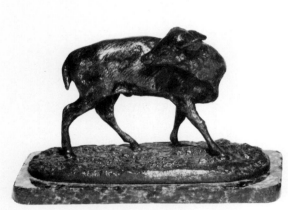

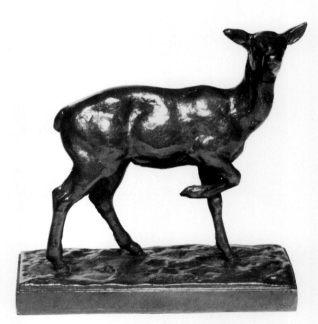

**De12** A charming and rare baby deer by Mêne, which is a well detailed cast but has a loose feel about the general finish. These tiny models must have been made in large numbers but comparatively few seem to have survived. The green serpentine marble base is probably contemporary.

Signed 'P.J. MÊNE': 5.8 x 8cm (2¼ x 3¼ins.)
rubbed gilt patination

*c.1850*                                        £200 — £400

**De13** Another rare small model this time by Barye. The alert doe is poised to listen having caught an unfamiliar scent. It is a beautifully modelled animal, full of the sensitivity that makes this sculptor's work so important and highly romantic. A good commercial and very popular model not often seen on the market and therefore competition would be stiff.

Signed 'BARYE': 9 x 9cm (3½ x 3½ins.)
light copper/red brown patination

*1840s*                                        £450 — £700

186

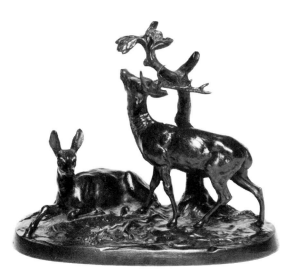

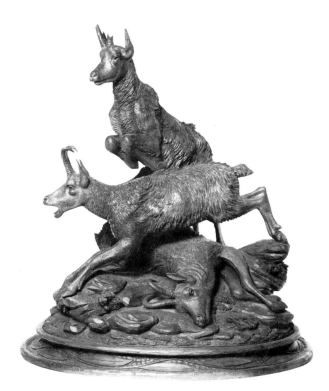

**De14** A cast-iron group of a stag and hind after a model by Mêne inspired by his 1843 model of the 'Cerf à la Branche'. The lack of life of cast-iron models can be detected even in a photograph. The evenness of the black patination and slight lack of detail together with a flatness of surface are all hallmarks that can soon be spotted once the collector has seen and handled a few cast-iron models. This group would be nice to find in bronze.

Signed 'MENE': 11.5 x 13.9cm (4½ x 5½ins.)
black patination

*Probably 1870s*                                      *£110 — £180*
                        *A good cast in bronze £400 — £600*

**De15** A German or Austrian group of chamois in carved walnut. A lively model typical of the Bavarian carved hunting scenes that closely reflect the styles of the Paris animaliers but also have their traditions firmly in the 17th century engravings and marquetry of the area. The bucks are leaping all over the place at the sight of their dead companion. Although a little stiff and awkward this type of group has become very popular since the mid-1970s and can often make as much, if not more than comparative animal bronzes, albeit selling to a different, mainly Italian market. Normally unsigned.

Signed 'H. Muggler': 37cm (14½ins.) approx.
*c.1890*                                              *£400 — £650*

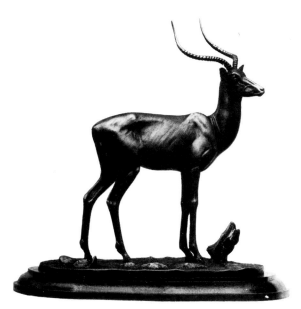

**De16** A well detailed small model of a springbok by a young contemporary artist working in Southern Africa, whose style is very much in the idiom of the 19th century but with that unmistakable modern finish in a high copper/red colour. A good, distinguished cast.
*c.1980*                                              *£450 — £600*

**De17** A good small plaque by Barye of a running deer, which would look uncomfortable in a three-dimensional bronze of the period where casting techniques required a support such as a tree stump. Barye here is anticipating the advent of the camera in the study of motion, and the work of Eardweard Muybridge in America.

Signed 'BARYE': 9 x 15cm (3½ x 6ins.)
rich dark brown patination

*Dated 1831*                                          *£150 — £200*

187

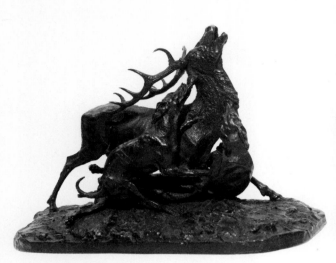

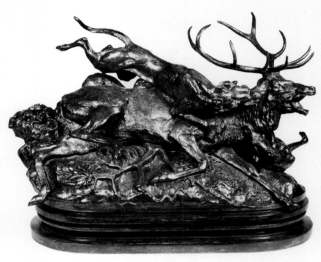

**De18** A well detailed model of the 'Chasse au Cerf' by Mêne. This appeared later as no. 21 in his catalogue but with a different measurement possibly accounted for by a moulded plinth. Here Mêne has mastered a complicated group without spoiling it by too much foliage. A fairly grisly subject for today's tastes, but a fine cast such as this will always be saleable amongst true collectors of the school.
Signed 'P.J. MÊNE' and dated 1844: 28 x 40cm (11 x 15¾ins.)
deep black/brown patination

*c.1844*            *£1,500 — £2,500*

**De19** An important group by Barye listed in his 1847 catalogue under the long title 'Un Cerf Dix-cors Terrassé par Deux Lévriers d'Ecosse'. A very powerfully modelled group showing the full strength of the early style of Barye with incredible detail and movement. A difficult group to date as it was first modelled in the early 1830s, possibly without the multiple moulded base, but appeared in the 1847 catalogue.
Signed 'Barye': 43 x 54cm (17 x 21¼ins.)
good rich green/brown patination

*1840s*            *£2,000 — £4,000*

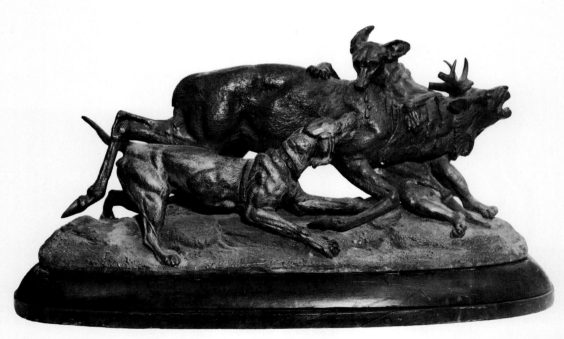

**De20** An unsigned group of two dogs bringing down a stag, detailed even to the drops of blood running down the stag's shoulder. The inspiration for the group appears to be drawn from De18 but this lacks life and the dogs especially are very poorly modelled. The antlers are missing and will cost up to £150 to replace if they have to be modelled from scratch.

However if a mould of an antler could be taken from another model this would reduce the cost by about £100.
47 x 96cm (18½ x 37¾ins.) excluding wooden plinth
greyish mid-brown patination

*c.1850-1870*            *£1,000 — £2,000*

**De21** Two identical stags to form a pair, each rearing rather unrealistically in a very stiff pose. The modelling of the animals is very accomplished and there is much good detail in the casting. The brown onyx plinths are indicative of the models' late date. Note one has a foot missing, which could cost about £50 to replace.

Signed 'BORMANN' stamped 'B.K.': 26.8cm (10½ins.) overall
rich dark brown patination

*c.1920*                          *each £400 — £500*

**De22** A well modelled braying stag with a mass of fine detail on the fur. Stiff and posed it is typical of the run-of-the-mill sculptors of the third quarter of the 19th century.

Signed 'J.E Masson': 55cm (21½ins.)
rubbed mid-brown patination

*c.1870*                         *£1,000 — £1,500*
*A similar Barye model with right foreleg raised,*
*cast by Susse Frères 51cm (20ins.) £1,200 — £1,800*

**De23** A pair of deer by Mêne in a similar style to De14. Both animals are alert and the whole cast is well detailed without being exceptional. The thin, oval moulded base has one or two irregularities that characterise Mêne's early work.

Signed 'P.J. Mene': 18.5cm (7¼ins.) wide
rubbed mid-brown patination

*1840s*                                                    £550 — £800

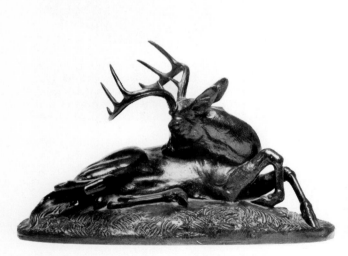

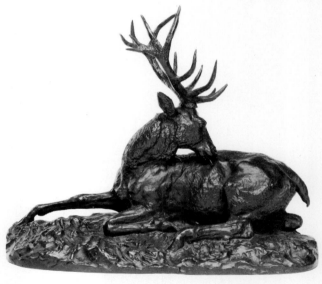

**De24** A rare and charming model by Barye entitled 'Cerf de Verginie couché', number A117 in the Barye catalogue. It is in a similar style to a pair of early models by Fratin (see De25). Barye here creates a sensitive, well rounded, model with an extraordinary sense of naturalism whereas Fratin's model has an 18th century formality. No attempt has been made to beautify nature as the sculptor has captured exactly what he saw, regardless of laid down rules of shape or form. Legs akimbo, the stag is oblivious to the outside world.

Signed 'Barye' and numbered 1
26 x 41cm (10¼ x 16¼ins.): mid-brown patination
*c.1840*                                              £1,400 — £2,000

**De25** Compared to De24 this version by Fratin seems very stiff, but is a very finely modelled and cast bronze. Once one can forget the posed feel of the stag then the quality of this early cast can be appreciated. All the details are well executed and the very rich patination given an extra sense of texture, and a tactile quality present in some of Fratin's early work. The balance of this model is better when seen with its companion bronze stag, who, in a similar position, is scratching his ear with a hind leg.

Signed 'FRATIN': 37 x 30.8cm (14½ x 12⅛ins.)
rich black patination

*c.1835*                                                £700 — £1,000
*Fratin also modelled a similar stag,*
*with head raised, 22.5cm (8¾ins.) £380 — £550*

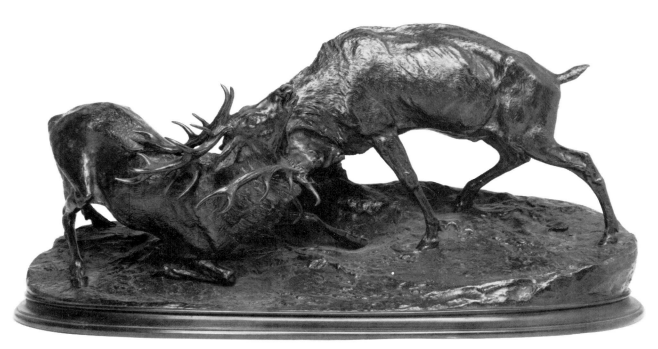

**De26** These battling stags by Mêne may not have immediate appeal to today's tastes, but they would have been very much *à la mode* when first exhibited in wax at the Salon in 1833, and the model later appeared as no. 116 in the catalogue where the casts proved popular due no doubt to the powerful modelling and exquisite detail. They now command a high price, despite the subject matter, showing that the exceptional will always sell well. The moulded oval plinth on this example probably means that it was made some thirty years after the Salon exhibition.

Signed 'P.J. Mêne': 28 x 59cm (11 x 23¼ins.)
dark brown patination

*c.1860*                                                £2,000 — £3,000

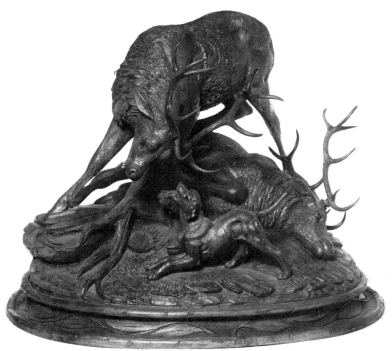

**De27** Another German or Austrian group in carved walnut by the same sculptor as De15. The stags are well carved but the small yapping dog is unconvincing and is unlikely to have brought down the dead stag without considerable assistance. Not such a good balance as De15 and consequently less costly.

Signed 'H. Muggler': 37cm (14½ins.) approx.
*c.1890*                                                £380 — £520

191

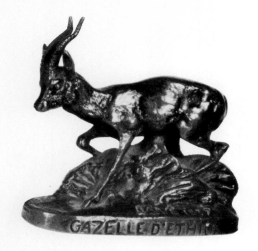

**De28** Barye's miniature 'Gazelle d'Ethiope', a popular endearing model rarely found today. This appears in both the 1847 and 1855 Barye Catalogue although first modelled in 1837. Although not as good as some available casts, because of its charm and comparative rarity it could realise as much as a better cast given a lively market at the time.
Signed 'BARYE' titled 'GAZELLE D'ETHIOPE'
9 x 11cm (3½ x 5ins.): rubbed brown patination
*Dated 1837 but possibly c.1855*          *£400 — £600*

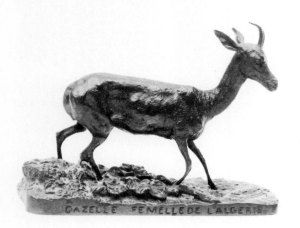

**De29** A Mêne model of the 'Gazelle Femelle de l'Algerie'. A good model but often found in poor condition as the horns and the very thin legs are highly susceptible to breakages. The base is a typical early Mêne shape, with flat sides.
Signed 'P.J. Mêne'
titled 'GAZELLE FEMELLE DE L'ALGERIE'
11cm (4¼ins.): rich mid-brown patination
*1840s*          *£300 — £600*

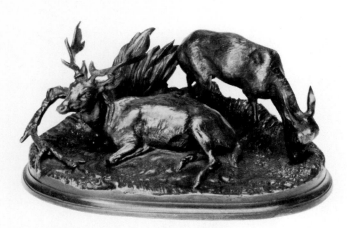

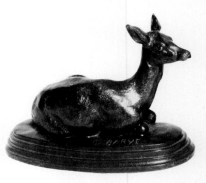

**De30** A small group by Mêne of a stag and hind in a similar style to his larger version of a pair of roe deer exhibited in wax at the 1859 Salon. A sensitive model where, for once, the base seems to work well and complement rather than complicate the group.
Signed 'P.J. Mêne': 8cm (3¾ins.)
brown/black patination
*c.1860*          *£400 — £600*

**De31** A tiny cast of a doe by Barye. A well cast sensitively portrayed good quality model of an attractive subject.
Signed 'BARYE': 7cm (2¾ins.)
green/light brown patination
*c.1850*          *£250 — £450*
*There is another Barye version of a doe resting its head,*
*4 x 15cm (1¾ x 6ins.) £600 — £800*

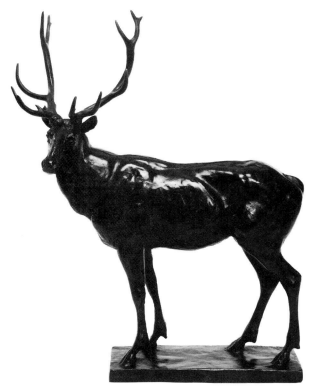

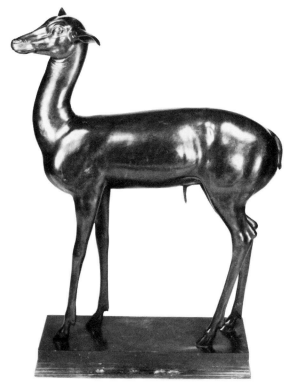

**De32** A very handsome model of a stag by Louis Tuaillon, a German sculptor whose origins are evident in the style of his sculpture. This model is heavily worked with a black patination but still conveys great sensitivity in a mixture of realist and impressionist styles combined with the overriding simplicity that became the hallmark of the Germans in the first few years of the 20th century.
Signed 'L. TUAILLON': 23 x 50 x 18cm (9 x 19¾ x 7ins.)
brown/black patination
*c.1910*                                                    *£600 — £900*

**De33** In complete contrast to De32 is this model of a roe deer taken after the antique model in marble in the Naples Museum, and much reproduced in recent years; buyers should satisfy themselves of the age of such a bronze. There is nothing against buying a modern cast for decorative purposes, provided a decorative price is paid. 19th century copies will realise slightly more than modern examples, if for no other reason than that the patination would be better.
This example 94cm (37ins.): mid chocolate brown patination
*c.1900*                                        *£1,500 — £2,500*
*A modern cast of the same size, usually distinguished by an even shiny black patination £650 — £1,200*

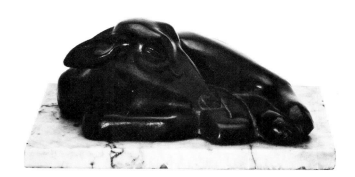

**De34** When a highly competent sculptor chooses an endearing animal subject then it is surely going to be much sought after in gallery and saleroom. When that sculptor was also a genius and modelled for only five years of his short life the price is certain to be high. The demand for these small models by Gaudier-Brzeska is always keen. To sell really well they must come with a good provenance, especially his small marble models which are comparatively easily copied and not always signed. This sleeping fawn in bronze has a very geometric feeling to it, anticipating the sweep of cubism that would have distorted this type of small, somewhat sentimental bronze out of recognition.
Unsigned, but a reliable provenance: 25.5cm (10ins.) long
black patination
*c.1913*                                        *£3,000 — £4,500*

193

The bronzes on pp.194 and 195 show the concept of the animal bronze as seen through the Art Deco eyes of the inter war period. Human figures were introduced, normally naked females, and a romantic, somewhat sweet image was presented. Their concept was wholesome, sweeping away the undercurrents of suggestiveness that were commonplace in the sculpture of the previous generation during the 'belle époque'.

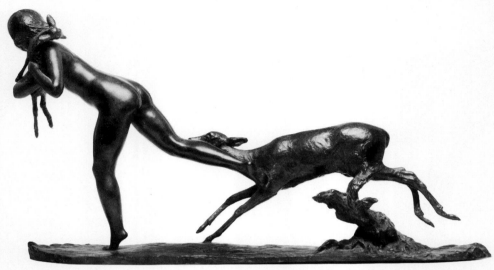

**De35** Presumably the young girl with the well-rounded bottom is not stealing the fawn from its mother? That would certainly not be in keeping with the sentiments of the 1920s. The helpless young animal is being carried through the woods in a game with its parent in an idyllic scene. The realistic savagery of the mid-19th century animalier hunting bronzes seems as it were from a distant age. This is a very good cast, although it is important to look out for spelter examples which were equally well made. This example would be better presented on a marble base, which it almost certainly had when first produced.
Signed 'Ary Bitter': 44 x 76cm (17¼ x 30ins.)
*c.1930*                                                          *£700 — £1,100*

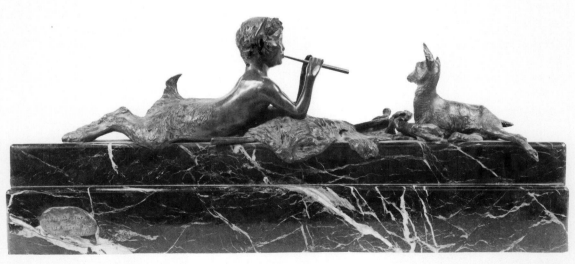

**De36** Here the sculptor Ary Bitter has borrowed a theme from a model of the 1860s by Frémiet. An infant satyr, lying on a lion's pelt entrances a fawn. A very well cast bronze group which is technically unbeatable and a major triumph. The whole composition is helped by the good quality verde antico stepped marble plinth.

Signed 'Ary Bitter' in script and with founders' signature 'SUSSE FRERES EDIT. PARIS CIRE PERDUE'
28cm (11ins.): green/brown patination
*c.1925*                                                            *£400 — £700*

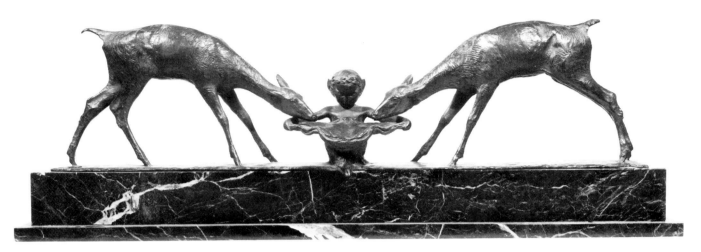

**De37** Another competent Art Deco bronze with an unusual emphasis on balance for the period. A young satyr holds up an enormous scallop shell for two roe deer. The hooves of the satyr can just be determined in the centre foreground of the model, hanging slightly over the edge of the verde antico plinth which shows the sculptor's original intention to create the model with a marble base, as it would stand awkwardly without one.

Signed 'Ary Bitter', and 'Susse Frs Edts Paris Cire Perdue'
24cm (9½ins.): chocolate brown patination
*c.1925* £800 — £1,100

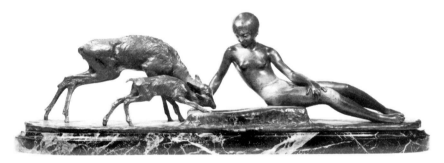

**De38** An adolescent girl with fashionably cut short hair, sits naked by a pool at which a doe and her fawn timidly drink. What a contrast these soft and gentle bronze groups must have been to the general public after the horrors of the First World War. The animals are very well modelled with comparatively little of the contemporary, German influence that has shaped the slender figure of the girl. The verde antico marble base is typical of the period.

Signed 'Ary Bitter': 26.5cm (10½ins.): dark green patination
*c.1925* £800 — £1,000

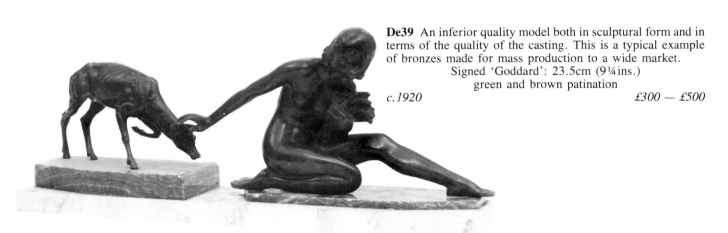

**De39** An inferior quality model both in sculptural form and in terms of the quality of the casting. This is a typical example of bronzes made for mass production to a wide market.

Signed 'Goddard': 23.5cm (9¼ins.)
green and brown patination
*c.1920* £300 — £500

195

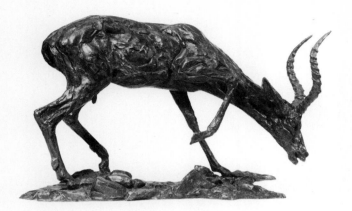

**De40** A contemporary model of an impala at a waterhole showing Kenworthy's impasto technique.

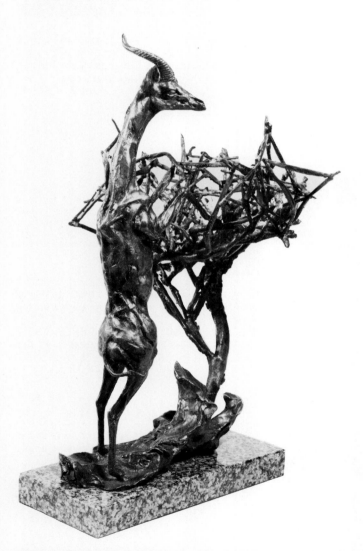

**De41** A gerunuk by Jonathan Kenworthy in typical posture as it rises on its hind legs to take the leaves from the top branches of a bush. A sketchily modelled but very realistic bronze.

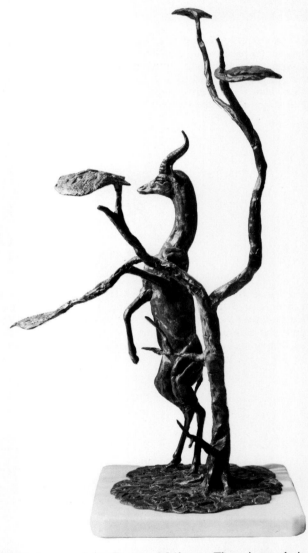

**De42** A gerunuk by Terence Mathews. There is an obvious similarity in style between Mathews and Kenworthy, and both have an essentially modern sympathy. De41 shows a more rugged finish, the sculptor using his thumbs in the modelling agent whereas Mathews applies small dabs of plasticine to his models to create the required effect, this time on the base to represent dry, caked mud.

196

Five modern bronzes, four by Kenworthy, one by Terence Mathews are shown
on pp.196-197. The modern sculptor here breaks away from captive zoo animals and
places his subjects firmly in the wild. Both use a fully developed impasto technique which gives
an added dimension of light and shade and subtly adds to the sense of movement.
These groups all date to the late 1960s, early 1970s and are rarely,
if ever, seen on the open market as yet.

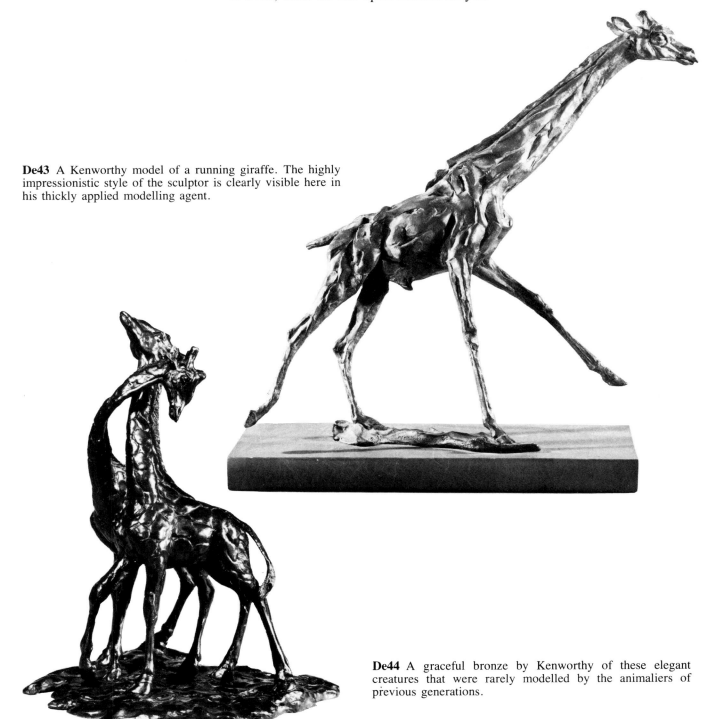

**De43** A Kenworthy model of a running giraffe. The highly
impressionistic style of the sculptor is clearly visible here in
his thickly applied modelling agent.

**De44** A graceful bronze by Kenworthy of these elegant
creatures that were rarely modelled by the animaliers of
previous generations.

197

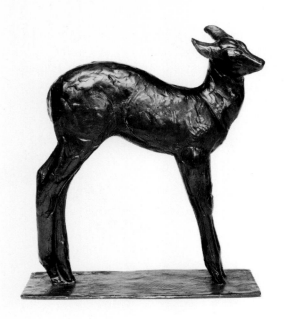

**De45** An endearing small model of an alert young fawn. All the life and energy of the animal has been captured by this brilliant young sculptor. The lost wax technique is evident even from a photograph. The sculptor, in his characteristic way has built up an impasto effect in the original model, which the founder Hébrard has admirably reproduced. The finger and thumb marks of Bugatti can clearly be seen, sketching out the form and shape of the animal's body. The only possible defect is in the highly stylised front legs, both at the shoulder and the feet, where too much is left to impressionism and where a little more finish might have improved the model. Another cast recorded at 32cm (12¾ins.).

Signed 'R. Bugatti' in florid script and with founders' seal
'A.A. Hébrard Cire Perdue' and numbered 'B4'
rich dark brown patination

*c.1910*                                                    *£2,000 — £3,000*

Rembrandt Bugatti was one of the best animaliers and his models of other animals, especially the big cats and birds, appear throughout this book. His highly individual style is easily recognisable and invariably popular, but at first glance may not immediately appeal. His fluid, impressionist style can sometimes be a little heavy as with De45 but usually his animals are full of grace and elegance.

**De46** A group of three exceptional bronzes cast by Hébrard for Bugatti. There is an immediate feeling of inner grace in these animals, especially the two family groups, one with two does encouraging a fawn to walk, the other a mother suckling her fawns. The stag possibly suffers a little from the heaviness of the fawn in De45 but the lightness of step created in the animal is typical of Bugatti's work.

the stag 48cm (19ins.)

*all c.1906*                    *the two groups £3,000 — £4,000*
                               *the stag £2,000 — £3,000*

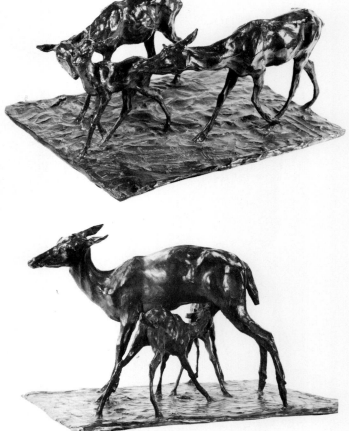

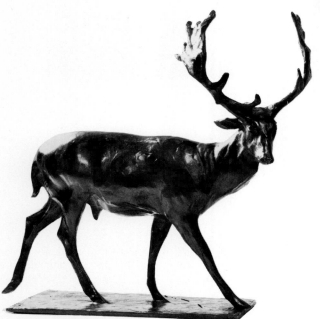

# The Dog Family

Dogs must surely follow horses in popularity and, being as a rule cheaper, they are a very good subject for the beginner to collect. Breeds have changed over the centuries and different countries use sometimes confusing names for various breeds. It is always interesting to be aware of dogs in early paintings, often to be seen accompanying the master or mistress of a house in formal portraits. For example the lurcher is a breed not officially recognised in Britain but is often seen in French and English sculpture in the 1800-1850 period. The variations of the dog groups and, more especially the single dogs carrying game, are endless. Mêne, Moigniez, Fratin, Delabrièrre and Dubuchand all sculpted similar dogs with only slight variations in posture.

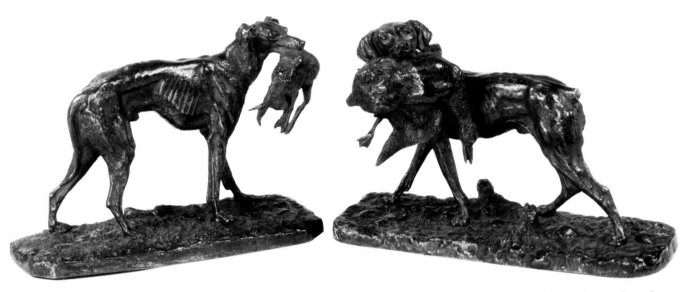

**D1** A pair of dogs in poor condition, by Mêne, one a greyhound with a hare, the other a pointer (tail missing) with a mallard. The greyhound was first exhibited at the 1845 Salon in bronze without the hare, 'Lévrier Espagnol, Grand Espèce'. Both models are heavily rubbed and even the solid base of the greyhound has become bent. Initially quite good casts although the animals are somewhat rangy in appearance. Both appear as dogs without game in Mêne's catalogue, the pointer as No. 78 available in three sizes. Jane Horswell has recorded a model as 18cm (7ins.) high.
Both signed 'P.J. MÊNE': greyhound 13 x 18cm (5¼ x 7ins.) pointer 19cm (7½ins.) wide: both rubbed brown patination
*1840s*                                              *greyhound £500 — £700*
                                                     *pointer £400 — £700*

**D2** A fine and rare cast by Fratin. The alert lurcher stands with a hare at its feet, and the modelling, sculptural quality and general balance of the group are exceptional. The flat sided base is typical of Fratin's early casts with a very good signature.
Signed 'FRATIN': 23cm (9ins.): rich dark brown patination
*c.1840*                                              *£1,000 — £1.500*

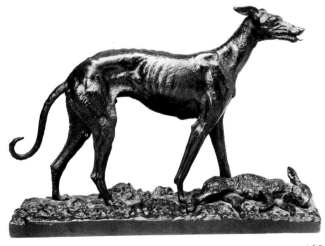

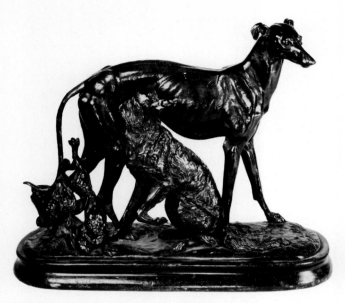

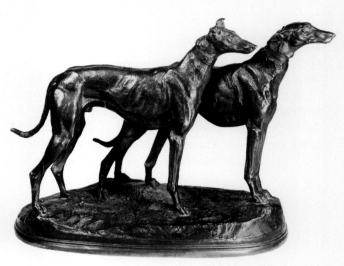

**D3** An unusual group by Emile Loiseau-Rousseau of a greyhound and Irish setter posed by a brace of dead partridge and a hare. An ideal mantelpiece sculpture, rather formal but well cast and rare. The greyhound's tail rests awkwardly on the tree stump to give the tail strength. The balance is typical of the mid-19th century Paris school in its classical mannerisms but the group is in fact much later.

Signed 'Emile Loiseau': 37cm (14½ins.)
dark brown patination

*1890s*                                   *£700 — £1,000*

**D4** A fine model and cast of a greyhound and wolfhound by Frémiet. This rare model is extremely elegant, well detailed and shows an underlying quality not always appreciated in Frémiet's work. His animals have very real character particularly expressed in their faces. (A 19cm (7½ins.) version in silvered bronze is in the Victoria and Albert Museum, London.)

Signed 'E. Fremiet' and 'F. BARBEDIENNE', Fondeur'
25.5cm (10ins.): rubbed mid-brown patination

*£1,500 — £1,750*

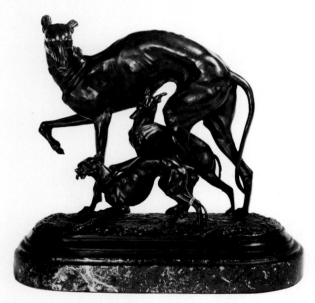

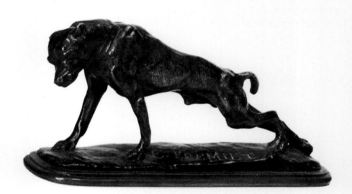

**D5** A greyhound bitch with her two pups in an unsigned group that has a lot in common with the work of Mêne but somehow does not come up to his standards and the texture is uncharacteristic. A complicated cast to model, the lively pups are realistically portrayed as they prance in and out. The marble is a good red colour and contemporary.

30cm (11¾ins.): brown patination

*c.1860*                                   *£500 — £800*

**D6** A greyhound by Frémiet, dated 1844 in the cast, with rounded rather than chamfered corners to the base.

Signed 'E. FREMIET': 19cm (7½ins.) long

*c.1844*                                   *£600 — £900*

200

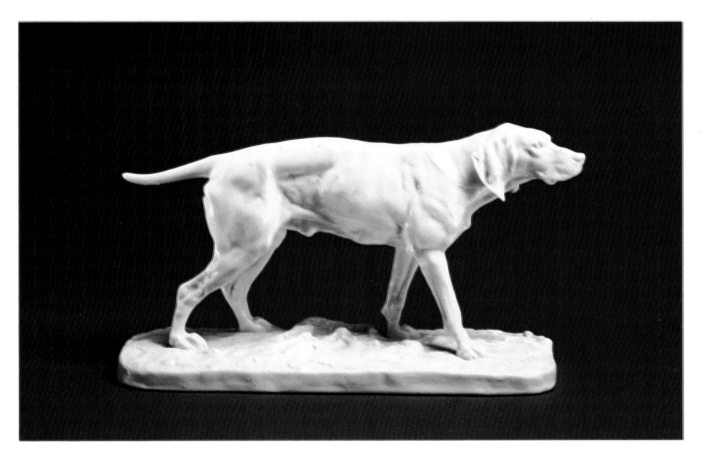

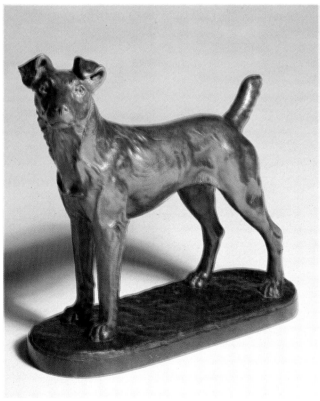

## Plate 5 (above)

The work of Pierre Jules Mêne was copied in several European countries and this porcelain model of a bloodhound 'in the white' is by the Nymphenburg factory of Munich. The Nymphenburg works had been set up in 1753 at the height of the German supremacy of porcelain manufacture at the Meissen factory with the famous animal models of J.J. Kändler. This model bears Mêne's conventional signature and presumably was manufactured under licence granted by the commercially successful and aware Mêne. These models are very popular in porcelain when in very good condition appearing to a wide market. It is worth noting that porcelain looses approximately 20%, or nearly twice as much as bronze when cooling.

Signed 'P.J. MÊNE' with shape number and impressed shield mark: 12 x 20cm (4¾ x 8ins.): white glazed
*c.1900*                                                    *£550 — £800*

## Plate 6 (left)

A good, very decorative and well-modelled bronze by a minor artist who is unrecorded in the standard works. Signing himself 'A. Laplanche', his Christian name is unknown. This is quite a large bronze and, standing as it does four-square, it looks well in most positions. The face is a nice friendly one and the dog attractive enough for any dog lover and so its appeal is not likely to be limited to owners of terriers only. The sculptor has concentrated on the patination of the work and produced a lively effect.

Signed 'A. Laplanche': 34 x 34.7cm (13½ x 13¾ins.)
rich mid-brown patination with dark brown and grees hues.
*c.1890*                                                    *£400 — £600*

201

Pierre Jules Mêne produced various groups and single figures of whippets and King Charles spaniels playing together. Cast in very large numbers, they are as popular today as they must have been in the mid-19th century. Sizes vary considerably, and there are bronze and iron casts attributed to the Coalbrookdale Iron Foundry in England. Spelter models also appear. Although the thin legs of these dogs in bronze appear vulnerable to damage, they are normally in good condition, but it is worth checking to see if they have been repaired.

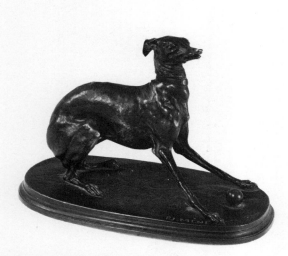

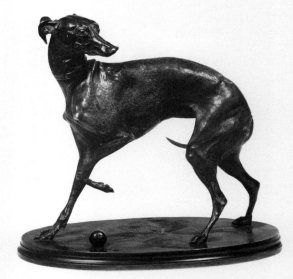

**D7** A model of 'Gisella' by Mêne that often is seen on the same base with 'Jiji' in D8, forming a larger, well balanced group. A little odd by itself but full of charming anticipation.
Signed 'P.J. MÊNE': 14cm (5½ins.): black patination
*1850-1875*                                          *£400 — £600*

**D8** The companion bitch to D7 called 'Jiji' that works very well alone. She is very lean but well modelled and cast. A delightful bronze to handle.
Signed 'P.J. MÊNE': 16.5cm (6½ins.)
rubbed dark brown patination
*1850-1875*                                          *£400 — £600*
*The combined group £1,000 — £1,400*

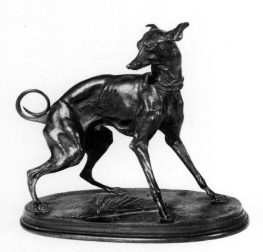

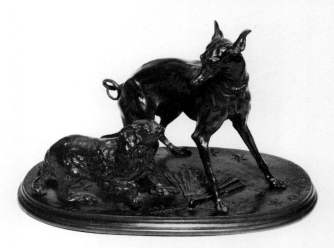

**D9** A bronze model of the Italian greyhound that is often seen as part of a group, as in D10. The dog is a successful single sculpture, the only problem being the long curly tail but in this example the curl is even and firm and probably the shape the sculptor originally intended.
Signed 'P.J. MÊNE': 15cm (6ins.)
dark brown patination
*1850-1875*                                          *£400 — £600*

**D10** A good companion group and an equally popular model, the open fan on the carpeted base is a nice 'drawing room' touch. A finely detailed cast, even down to the lock on the collar. This example is cast-iron and probably Coalbrookdale.
Signed 'P.J. MÊNE': 16.5cm (6½ins.)
black patination
*c.1870s*                                            *£300 — £600*
*A Paris cast in bronze £800 — £1,200*

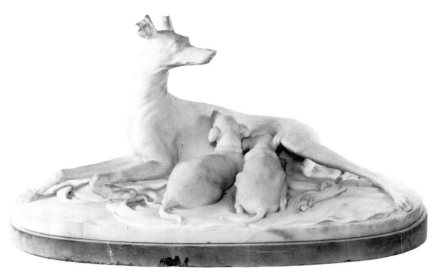

**D11** This rare white Carrara marble group by Joseph Gott compares with the Cardwell in D12 and is in a similar romantic vein but retains the neoclassical overtones that carried over from the late 18th into the middle of the 19th century. A nice subject of a greyhound suckling her two pups.

Signed 'J. GOTT': 41 x 81cm (16 x 32ins.)

*c.1830*                                                    £3,000 — £4,000

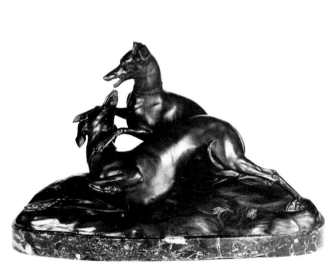

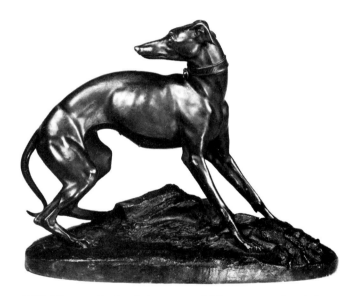

**D12** This rare group, in a similar style to D12, is a sand cast bronze by Holme Cardwell. Cast in Italy, where he spent his working life, the group is complicated sculpturally but technically the casting is absolutely superb in a very light thin cast. Both bodies are completely worked with fine hair that cannot be seen clearly in the illustration. Difficult indeed to value such a cast, it realised £780 at Sotheby's Belgravia in 1973 due to its rarity. English bronzes of this period are highly sought after and the competition would be fierce should it ever appear again at auction.

Signed 'Holme Cardwell Roma': 48m (19ins.)

mid-rich brown patination

*1840s*                                                £1,500 — £2,500

**D13** Thomas Gechter's bronzes, which are normally sand cast like this greyhound bitch, have a distinctive character of their own. Although Mêne modelled a greyhound in a similar manner there can be no mistaking the difference between the work of the two sculptors. This smooth skinned animal is well cast with a nicely balanced pose, and a purposeful contrast between the grassy plinth and the animal itself, a detail which many sculptors would not bother about. A dead hare at the dog's feet can just be made out.

Signed 'GECHTER': 35.5cm (14ins.)

medium rich brown patination

*Dated 1838*                                              £700 — £1,000

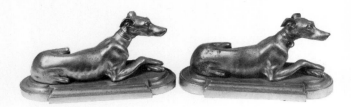

**D14** These two lurchers are identical (unlike a matched pair in which one would expect to see a slight difference in each animal to balance them as they faced each other) a hangover from the English Regency period, when this type of dog in a peaceful but uneventful pose was popular, normally with a rich red-brown varnish patination. Although attention has been paid to the hair and details they are poorly sculpted, but popular subject and sizes; the gilding is not considered very attractive today.

9.5cm (3¾ins.): gilt-bronze patination
*1825-1850* *the pair £200 — £400*

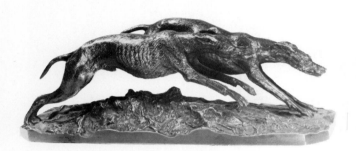

**D15** A rare group by Fratin of two racing greyhounds. The sculptor in his typical way has concentrated on giving an impression of movement, rather than paying attention to detail, in contrast to some of his contemporaries.

Signed with FRATIN stamp: 11.5cm (4½ins.)
bronze patination
*Probably c.1840* *£600 — £900*

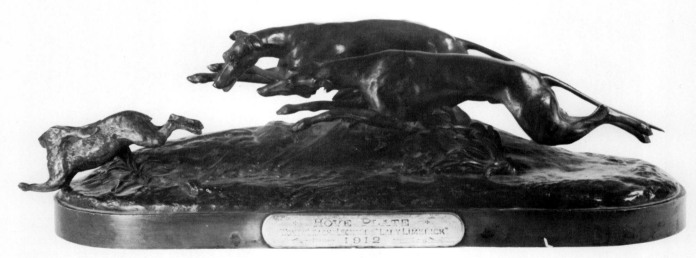

**D16** An amusing but somewhat naïve group that has been used some forty or fifty years later as a trophy for the Hove Plate Hare Coursing race. It can often be misleading to date bronzes by the engraved plaques applied to them and it is always important to check with the bibliography of the sculptor. A pleasant enough and fairly rare sand cast which is far larger than it at first may seem.

Signed 'R.H. Moore': 53cm (21ins.) wide
dark brown patination
*1850-1875* *£500 — £800*

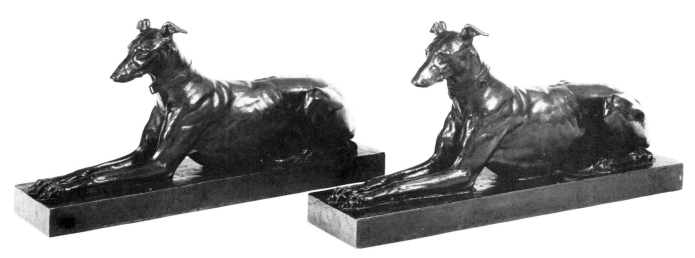

**D17** A magnificent identical pair of bronze greyhounds by Barye. The recumbent figures at first appear to have a formal, classical look, so typical of the early 19th century. They are in fact full of the immense power and dramatic realism that made Barye's work so different at the time in his treatment of animals as proper subjects.

Signed 'BARYE': rich brown green patination
*c.1840*                                   *the pair £1,000 — £1,500*

**D18** Another well-known and popular group by Mêne entitled 'Chasse au Lapin' (no. 24 in his catalogue). Less decorative than D19 as all the dogs are crouching, presenting a mass of bronze but nevertheless a lively and amusing group. The two excited terriers are joined by a griffon which is an unusual dog today but was very popular in 19th century France, a fact reflected in the sculpture and painting of the period. The casts are usually good without being exceptional and all have good detail. This particular model demonstrates the difficulty in accurately dating these bronzes as the bronze is dated 1853 in the cast and therefore in the original model, but the wax was not exhibited at the Salon until the Exposition Universelle of 1855. The bronze was exhibited for the first time at the Salon in 1872, nineteen years after the model was first made. It would be difficult therefore for anyone to date such a bronze as c.1853 and the only satisfactory conclusion would be the third quarter of the 19th century. (The catalogue size is 20 x 39 x 18cm (8 x 15½ x 7ins.) Also cast by Barbédienne.

Signed 'P.J. MÊNE': 21 x 38cm (8¼ x 15ins.)
rich rubbed brown patination
*1853-1875*                                   *£700 — £1,100*

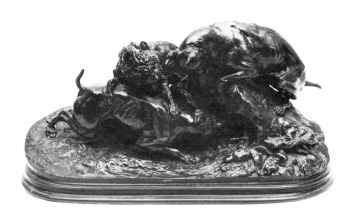

**D19** A ferocious but fine quality cast by Mêne, of two hounds cornering a fox. This is a rare group in which the subject matter may well be too violent for today's tastes, and is indeed an unusually violent subject for this sculptor, but the composition is superb. It is not listed in Mêne's catalogue.

Signed 'P.J. MÊNE': 28cm (11ins.): black patination
*Dated 1849 but probably cast*
*in the next decade*                                   *£1,000 — £1,500*

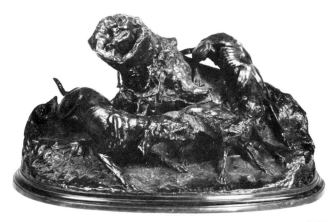

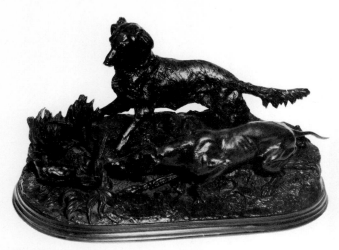

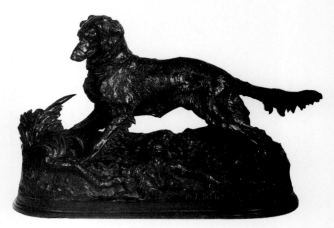

**D20** One of Mêne's best known dog groups, and a very popular one that was made in several large editions. Exhibited in wax at the 1848 Salon and again in bronze two years later, it is listed no. 25 in his catalogue. The dogs are Sylphie the setter and Tac the pointer, both of which appear as separate subjects (see D21). Entitled 'Chasse à la Perdrix', the cowering partridge can be seen in the undergrowth to the left. In this group the undergrowth is part of the composition and does not have any 'mechanical' use to support the dogs. This cast varies in quality but should normally be very good. (The catalogue size is 21 x 42 x 22cm (8¼ x 16½ x 8¾ ins.) and a cast-iron version is recorded as 21.5cm high.)
Signed 'P.J. Mêne': 23cm (9ins.): rich dark brown patination
*Dated 1847 but cast throughout*
*the third quarter of the 19th century* £1,200 — £1,800

**D21** An Irish setter by Mêne, from the larger group 'Chasse à la Perdrix', no. 25 in his catalogue but listed separately as 'Chien epagneul (Sylphie) no. 69'. A well cast and vigorous model in a style favoured by Moigniez. This is based on D20 and was also cast by Coalbrookdale in cast-iron, 32cm high.
Signed 'P.J. MÊNE': 21.5cm (8½ins.): brown patination
*c.1860* £600 — £900
*Cast-iron £400 — £600*

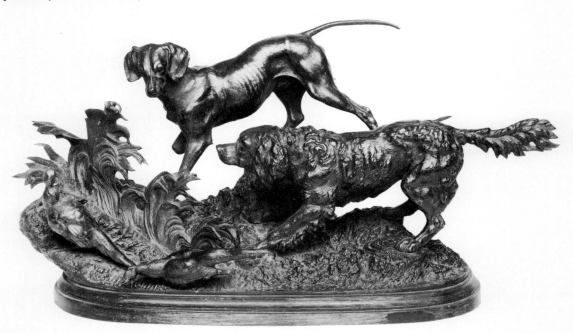

**D22** A very similar subject to D20 this time by Pautrot, using the same type of dogs but their positions reversed and with a brace of unsuspecting pheasants. The composition is not up to Pautrot's usual standard and certainly compares unfavourably with Mêne's group. This could be one of his models of the early 1860s when he first started exhibiting, and he has taken Mêne's composition of a decade or so earlier as his inspiration. The wall of foliage is unsatisfactory, but the casting is good with plenty of detail.
Signed 'F. PAUTROT': 14cm (5½ins.)
rich red/brown patination
*1860s* £400 — £500

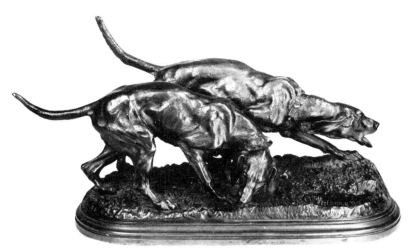

**D23** A rare pair of bloodhounds by Isidore Bonheur in a wonderfully lively group. The reflection of light on the well detailed hair and skin of the dogs accentuates their muscles and heightens the sense of movement as they seek out the scent. Typical of Isidore's better models the animals are full of character, an essential ingredient for today's market.

Signed 'ISIDORE BONHEUR': 23cm (9ins.)
rich dark brown patination

*1870s*                                                      *£1,200 — £1,800*

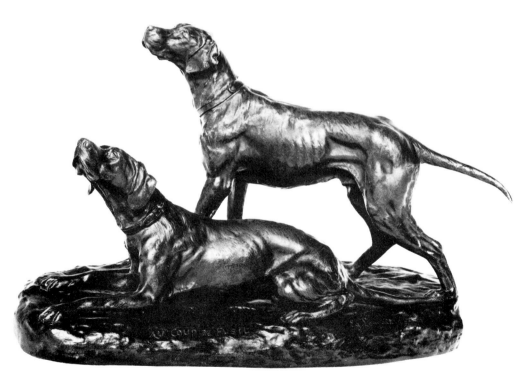

**D24** A fine group of alert pointers entitled 'AU COUP DE FUSIL' by Eglantine Lemaître. This group is well cast and highly decorative which will put it in the higher price bracket regardless of the fact that she is a little known artist.

Signed 'Eg. Lemaître' and bearing the foundry seal A.G.
28 x 46cm (11 x 18ins.)
rubbed chocolate brown/copper red patination
with green hues to the base

*c.1890*                                                      *£1,500 — £2,000*

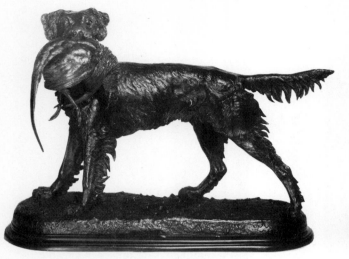
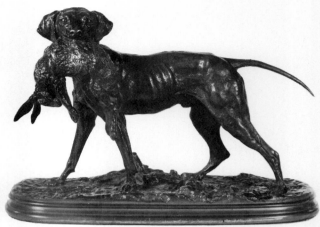

**D25** A lively and fine cast by Moigniez of a retriever carrying a pheasant in its mouth. Both Mêne and Moigniez tried to satisfy the needs of the same market and consequently produced many very similar groups, the lead being taken by the older and more established Mêne. Here Moigniez has managed to soften the reality of this group with a lot of character in the face and stance of the retriever. A similar model is recorded by Fratin of a pointer holding a mallard, 19cm long, £800 — £1,000.

Signed 'J. Moigniez': brown patination
c.1865                                                    £800 — £1,000

**D26** No. 68 in Mêne's catalogue and made in two sizes of which this is the larger, this pointer ('Chien braque') carries a hare in almost the same alert and lively pose as the retriever in D25. A good cast without being exceptional; note the vulnerability of the long thin tail which is cast separately in almost all cases and here is becoming loose at the joint. This dog was also cast without the hare. Fratin sculpted a similar model 25cm high, £800 — £1,200.

Signed 'P.J. Mêne': 20cm (8ins.): brown black patination
1860s                                                    £800 — £1,200

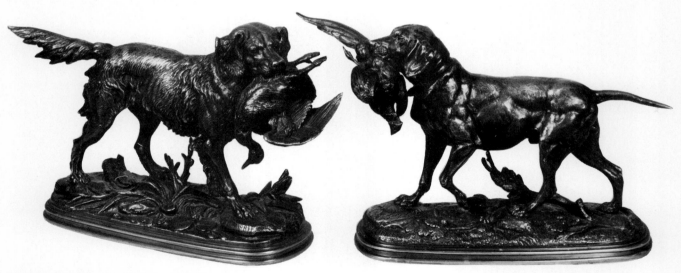

**D27** An appealing pair of dogs by Delabrierre, the retriever carrying a mallard and the labrador a pheasant. These models are plainly influenced by Mêne and by Moigniez, in the dogs and the foliage respectively. The combination makes these one of the more successful pairs, much sought after but rarely seen on the market.

Signed 'E. DELABRIERRE': 20.5cm (8ins.)
rubbed rich brown/brass patination
1860-1880                                        the pair £1,200 — £1,800

**D28** An amusing if rather stiff group by the Comte du Passage of two terriers trying to get at a rat caught in a trap. This sculptor always works in a traditional way and appears some twenty years behind his contemporaries in the style and form of his groups. Perhaps a harsh criticism for a popular artist whose subjects are always pleasant and very well detailed shown in this example by the treatment of the dogs' hair and the grain of the wood from which the trap is made.
Signed 'Cte du Passage': 13.5cm (5¼ins.): brown patination
*c.1880*                                               *£400 — £650*

**D29** A pair of hunting dogs by Mêne entitled in his catalogue 'Chasse au Lièvre dans les Vignes' and numbered 23. Both dogs are well modelled and the whole group is very lively. Although uncommon, this group would never be much sought after because two dogs tearing their prey apart tend to appeal only to the dedicated collector! This example is exactly the size given in the catalogue.
Signed 'P.J. MÊNE': 21 x 40 x 20cm (8¼ x 15¾ x 8ins.)
light brown patination
*1860s*                                               *£1,000 — £2,000*

209

**D30** A good Delabrierre model of workable size. The alert hound stands squarely on a base with the inevitable branches, which with the benefit of hindsight and the simplicity of Bugatti's work could well be discarded. A uncommon model that represents good value for money.

Signed 'E. DELABRIERRE': 19cm (7½ins.) high rich light to mid brown patination

*c.1870*                                                    *£500 — £600*

**D31** A good rare group by Delabrierre, that is very well cast and a popular subject. The foliage cast into the base is well executed and the base works well without being complicated. The leaves on the right, however, share the mediocrity of other contemporary bronzes. Delabrierre also modelled a similar dog following a scent (12cm high £400 — £600).

Signed 'E. DELABRIERRE': 26.7cm (10½ins.) dark brown patination

*1860-1880*                                                *£750 — £1,100*

210

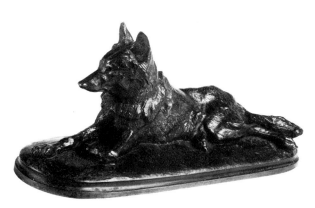

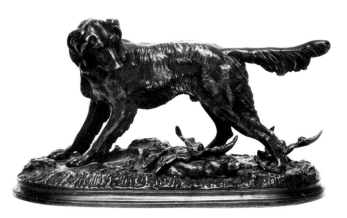

**D32** A wolf-like alsatian lying down in an alert pose, by Louis Charles Builot. This is a good model by a sculptor whose work is not often seen and, like most animalier subjects, if not a piece by one of the recognised names then it sells very cheaply. A good well finished model.

Signed 'Builot': 10cm (4ins.)
rich mid to dark brown patination

*1880s*                                                    £220 — £280

**D33** An Irish setter and hare by Moigniez, very much in the style of Mêne. Its companion piece of a pointer in the same pose but facing to the right, with a partridge in the undergrowth at its feet, was exhibited in plaster at the Exposition Universelle in 1855 and at the Salon in 1859 in bronze. These casts are never particularly good, but are charming and popular and a good size for modern rooms.

Signed 'J. MOIGNIEZ': 13.3 x 22cm (5¼ x 8¼ins.)
black patination

*1860s*                              the setter £500 — £800
                                    the pointer £450 — £750

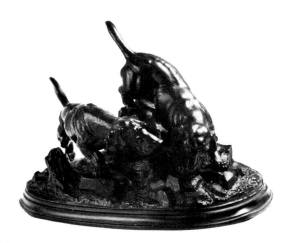

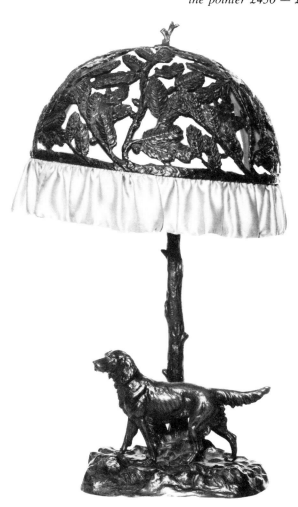

**D34** A rare small group by Moigniez of two hunting dachshunds, tracking inquisitively over rocky ground. The simple attitude of tails achieves the liveliness in this little model. Moigniez treats the slab sided rocks in a similar manner to Gechter.

Signed 'J. MOIGNIEZ': 10 x 19cm (4 x 7½ins.)
rich dark brown patination

*1855-1860*                                                £600 — £900

**D35** A dual-purpose bronze figure of a setter, standing under a tree with a large umbrella of leaves which forms a lampshade, an idea used quite commonly in the 1920s but the quality often varied a great deal. This bronze work is good with pleasant stylisation to the leaves of the tree better than the mid-19th century animaliers usually achieved. An item that would probably appeal more to the decorative market than the small band of purest animalier collectors.

50cm (19¾ins.): rich mid-brown patination

*1920s*                                                    £500 — £800

211

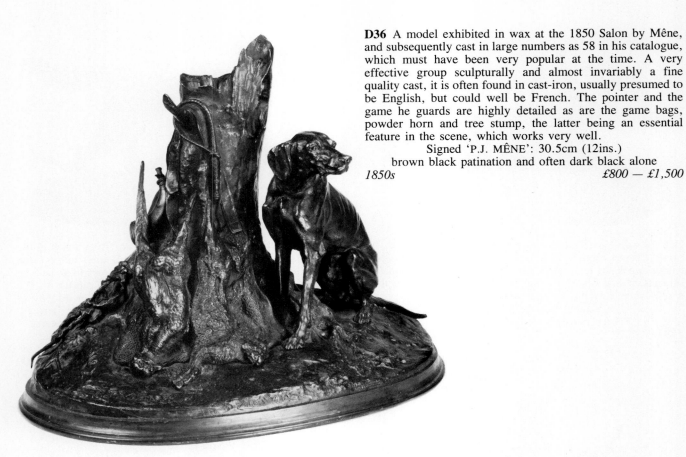

**D36** A model exhibited in wax at the 1850 Salon by Mêne, and subsequently cast in large numbers as 58 in his catalogue, which must have been very popular at the time. A very effective group sculpturally and almost invariably a fine quality cast, it is often found in cast-iron, usually presumed to be English, but could well be French. The pointer and the game he guards are highly detailed as are the game bags, powder horn and tree stump, the latter being an essential feature in the scene, which works very well.

Signed 'P.J. MÊNE': 30.5cm (12ins.)
brown black patination and often dark black alone
*1850s*                                        *£800 — £1,500*

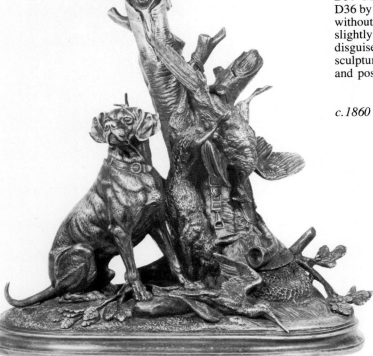

**D37** Mêne's influence is clear in this very similar group to D36 by Delabrierre, who uses a rather stocky dog as his model without the character of Mêne's animals. Delabrierre has slightly changed all the features of this group as though to disguise the inspiration for the model. Much good detail but sculpturally poor for an artist who could be very good indeed and possibly a comparatively early model.

Signed 'E. DELABRIERRE': 41cm (16ins.)
heavily rubbed mid-brown patination
*c.1860*                                        *£800 — £1,500*

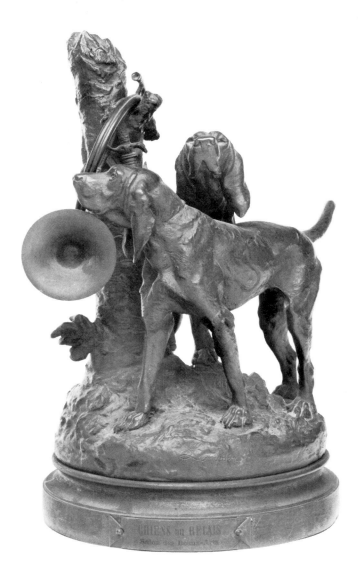

**D38** A charming group of two hounds by Lecourtier entitled 'Chiens au Relais', which shows some of the character and sensitivity of his master Frémiet. The group is effective sculpturally, the French horn and other hunting trophies, although derivative of Mêne, are a nice feature. This group was exhibited at the Salon, but there is no record of the year.

Signed 'Lecourtier' with foundry stamp
'H. Hirschauld, Berlin'
39cm (15⅜ins.): mid-brown patination

*1890s*                                              *£600 — £900*

The pointer in 19th century France was always called a 'chien braque' and in some instances of sculpture it is difficult to identify correctly the different breeds of hunting hounds.

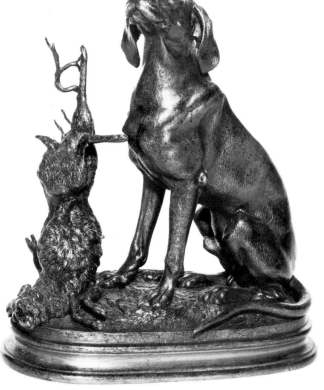

**D39** A pointer guarding a dead hare, by Ferdinand Pautrot. Not fully effective as a piece of sculpture, but has charm and character and is very well detailed. The hare hangs from the flimsiest of branches and its other hind leg is attached to the dog for support.

Signed 'Pautrot': 26cm (10¼ins.)
rubbed brown gilt patination

*c.1860*                                              *£550 — £900*

213

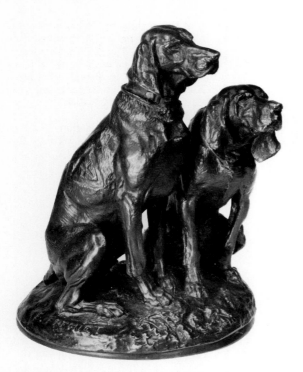

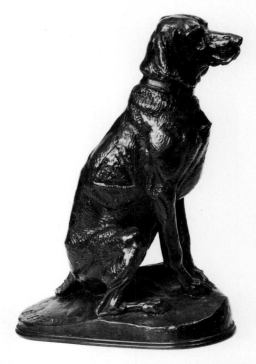

**D40** A fine portrait group by Frémiet, of a pair of hounds that must have been favourite hunting dogs. Typically of Frémiet there is a tremendous amount of character in these two animals with their most appealing faces. The very large brand mark on the flank of one dog reminds us that these were working dogs and not pets.

Signed 'E. FREMIET': 24cm (9½ins.)
dark brown patination

*1860-1880* £1,000 — £1,500

**D41** This very handsome and proud hound by Frémiet, is the same dog as in D40, which makes a very nice model by itself. Mêne used his animals in the same pose for different models, and Frémiet has created a good and interesting shaped plinth.

Signed 'E. FREMIET': 25cm (10ins.): brown patination
*1860-1880* £600 — £800

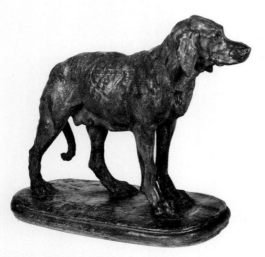

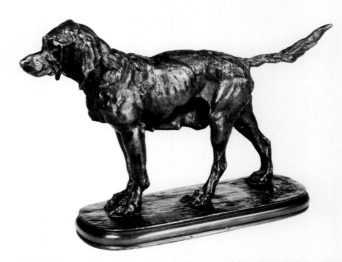

**D42** A very rare terracotta model of a hound bitch by Frémiet. This model called 'Lile' is a portrait of great sensitivity and attractive although the brand can be a little disturbing. A terracotta of this type and quality could easily realise as much as a bronze of the same model, especially if uncommon.

Signed 'E. FREMIET': 19cm (7½ins.)
*1860s* £800 — £1,200

**D43** This could be the same bitch as in D42 but this time in bronze. There are variations notably to the tail and to the base.
Signed 'E. Frémiet' 19cm (7½ins.)
dark brown patination
*c.1870* £800 — £1,200

214

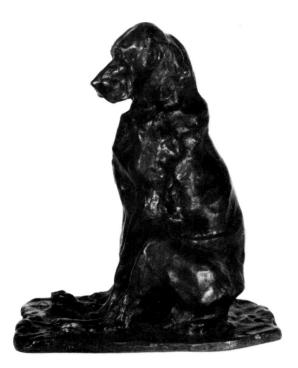

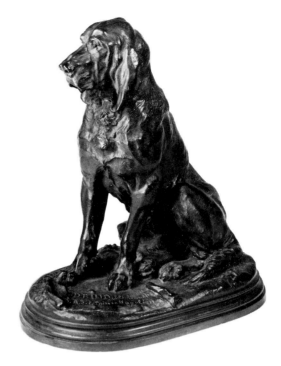

**D44** Chronologically this fine bronze by Troubetzkoy should be placed at the end of the section but the sensitive portrait, although impressionist in style, fits in well with the earlier animalier work. The sculptor appears to have been directly influenced by Frémiet and has captured the sad and endearing expression on the dog's face, so familiar to all dog lovers. Because of the sculptor's lightness of touch there is no need for the heavy detail that would normally be a requirement in an earlier bronze.
Signed 'Paul Troubetzkoy': 25cm (9¾ins.): black patination
*Dated 1893*                                         *£1,200 — £1,800*

**D45** An immensely sensitive and rare portrait of the bloodhound 'Druid' belonging to Prince Napoleon (later Napoleon III). Cast by Peyrol for the society portrait sculptor Jules Gelibert entitled 'DRUID bloodhound S.A.J le Prince Napoléon'. This famous model is not often seen on the market now but firmly deserves a place in the annals of the animaliers. It illustrates well that the competent sculptor can turn his hand to almost anything. The treatment of the dog's body suggests a style well ahead of its time. A pair, on circular socles, 17.5cm high, is also recorded, one cast with a head turned, a bone at its feet (£500 — £800).
Signed 'Jules Gelibert' and with the Peyrol foundry mark
35.5cm (14ins.): even brown black patination
*1840s*                                                  *£1,500 — £2,000*

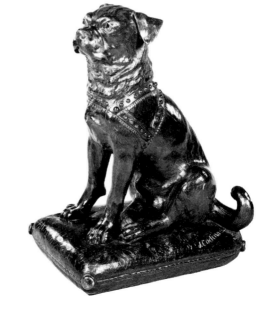

**D46** A rare model of a pug dog by Codina, who was a little known sculptor but a very competent portraitist. This large bronze has an enormous appeal for those who admire pugs and has a market separate from the general run of the animal field. A very well modelled bronze, cast with sharp detail. Note the use of the cushion that was very popular around the Charles X and Louis-Philippe period of the second quarter of the 19th century and a prop used by no less a sculptor than Antoine-Louis Barye in his early period.
Signed 'J. Codina, L': 50 x 37cm (19¾ x 14½ins.)
good even mid-brown patination
*c.1850*                                                 *£4,000 — £6,000*

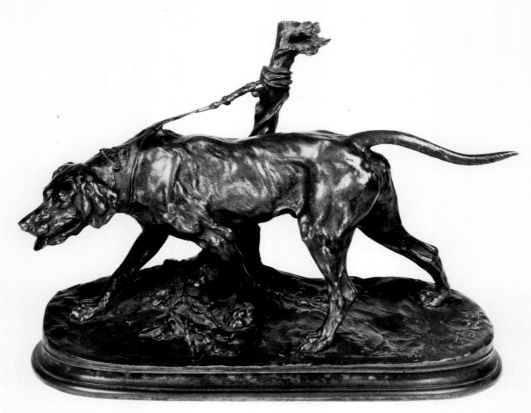

**D47** This fine and popular bloodhound by Mêne illustrates just what a good sculptor he could be; in many ways he dominated the second half of the 19th century and it was not until the impressionist period that his style was really bettered. Entitled 'Chien Limier' in Mêne's catalogue (no. 67), it is a very lively and sensitive study. By the 1860s Mêne had rounded his style and had begun to treat his animals more in the manner of Frémiet.

Signed 'P.J. MÊNE': 24 x 32 x 14cm (9½ x 12½ x 5½ins.)
rich golden brown patination
*1860s*                                              *£800 — £1,200*

**D48** This model and D49 are miniatures that Mêne produced in quantity at the height of his prolific career, this greyhound is illustrated in its larger size as D1 and both sizes are comparatively rare. A thin, mean looking dog at the best of times it can become decidedly mangy in an ill-treated miniature. This example has only suffered the broken tip of the tail, which a good restorer could easily mend. First modelled in full size in 1844.

Signed 'P.J. Mêne': 6.5cm (2½ins.)
green/brown patination
*c.1850*                                              *£300 — £400*

**D49** Another miniature by Mêne of a pointer 'Tac' and a setter. A good model although the illustrated example is very worn and rubbed, with very little detail. Once the nose of an animal is knocked or flattened it does spoil the look of the model, and devalues it accordingly. The pointer is also cast separately 4.5cm (1¾ins.) high.

Signed 'P.J. MÊNE': 6.4cm (2½ins.)
rubbed dark brown patination
*1860s*                                              *£300 — £500*
*14cm model £800 — £1,200*
*pointer alone £200 — £300*

**D50** A very fine pair of hounds by Delabrierre demonstrating his competence. This surely must rank amongst the best of his works in terms of detail and sculptural form. One problem with tethered animals is that the leash or reins can become damaged over a period of time, and then look unsatisfactory, or are replaced as in this case, by inferior work. Bronze wires can be replaced by an expert restorer and it is always worth having this work done. The sculptor has perfectly positioned the heads and legs to capture the scene without overcomplication.

Signed 'E. DELABRIERRE': 46 x 53.5cm (18 x 21ins.)
rubbed golden brown patination
*1870s*                                    *£1,200 — £1,800*

**D51** Here the animalier's quest for realism has almost surpassed itself. It is difficult to imagine what the collector of the day would have made of this model by Delabrierre. A well executed model, but the subject matter will inhibit the value.

Signed 'DELABRIERRE': 16cm (6¼ins.)
gold/brown patination
*1860-1880*                                    *£300 — £500*

217

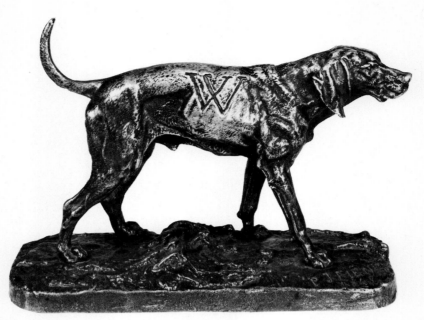

**D52** A Mêne model, possibly without the character of Frémiet's dogs, but still a good and rare cast. The rubbing on this animal will not help its value, and it may be preferable to have it repatinated, not an action that should be contemplated without advice from a good dealer. Note the typical early base.

Signed 'P.J. MÊNE': 15cm (6ins.)
rubbed brown/black patination

*Dated 1845*

£750 — £1,100

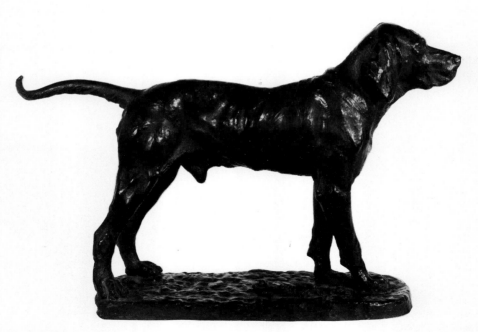

**D53** A vigorous portrait by Gatti, so sensitively modelled that it must have been the portrait of a favoured pet. The modelling has much in common with that of Gelibert, although executed some forty years later. Probably an Italian cast which are normally of high standard with lots of texture. The model shows a tendency towards impressionism in the fluid detail of the model and Gatti may well have been working in Rome at the same time as Troubetzkoy, and it would be fascinating to know whether or not he was influenced by him.

Signed 'G. Gatti': 25.5cm (10ins.)
black/brown patination

*1880s*

£800 — £1,200

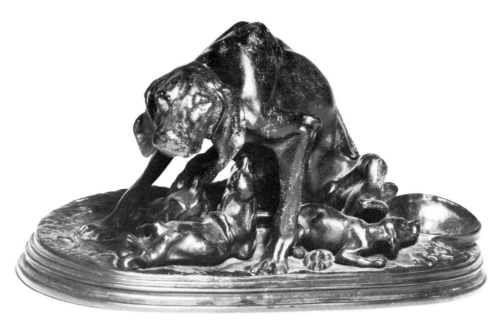

**D54** A good group of a Saintongeoise pointer bitch and her pups. Typically sentimental for the period and verging on the 'chocolate box' style of contemporary painters, the plaster of this model, entitled 'Chien de Neute avec ses Petits' was exhibited at the 1859 Salon. The bitch is reused in another group (no. 57) in Mêne's catalogue, with a dog to the left of the bitch, standing over her and this is possibly a more satisfactory composition. The illustrated example demonstrates the smoothness of texture and lack of crisp detail indicative of cast-iron and these, coupled with the pitting and speckling of the patination are tell-tale signs.

Signed 'P.J. MÊNE': 25x 45 x 22cm (10 x 17¾ x 8¾ins) black pitted patination

*1860-1880*                                               *£350 — £500*
*The bronze £600 — £900*
*The group of two adult dogs £1,500 — £2,000*

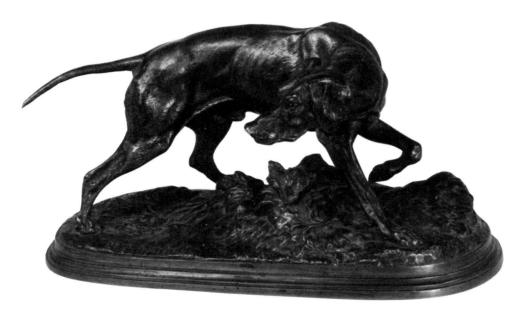

**D55** A pointer by Mêne, a good but not inspired model. The low head of the animal although realistic, does not help the sculpture as the 'skyline' of the head is always a useful feature with such a dark material. An average cast with moderate detail.

Signed 'P.J. MÊNE': 14 x 23cm (5½ x 9ins.)
copper brown patination

*1860s*                                               *£500 — £800*

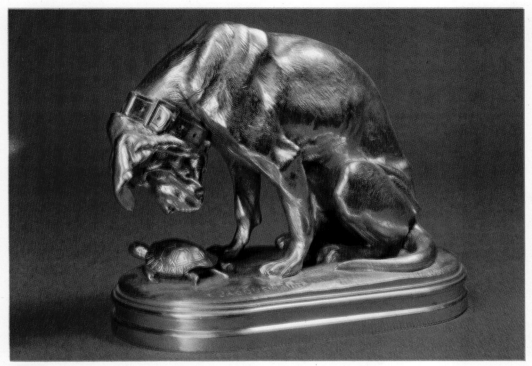

**Plate 7**

A good gilt-bronze version of Jaquemart's bloodhound studying a tortoise as it slowly walks in front of his nose. The gilding is very bright and not a very popular colour today, although gold and silvered versions of animal bronzes were in great demand in the 19th century. Many today are repatinated to suit the transient fashion of our time, to be lost to future generations forever.

Signed 'A. JAQUEMART': 16cm (6¼ins.): gilt-bronze patination

*1860s*                                                                                           *£400 — £600*

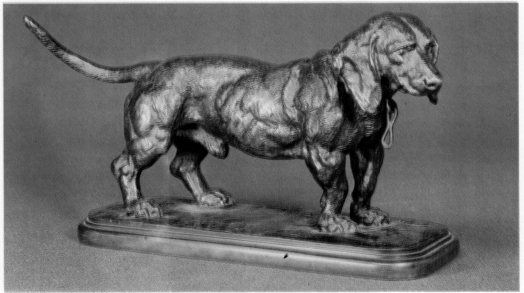

**Plate 8**

A very good version of Barye's 'Chien Basset Debout', first modelled in the 1830s and listed in the sculptor's first catalogue in 1847. An inferior cast is shown as D57. A pair of a seated basset (15cm, 5⅞ins.) was modelled at the same time and also featured in the first catalogue though this is not quite so popular.

Signed 'Barye' and numbered 12: 16cm (6½ins.): rich brown patination

*c.1850*                                                                                        *£1,400 — £1,800*
                                                                    *seated basset of equal quality £1,200 — £1,600*

**D67** A Mêne cast of a dog named Médor and called 'Epagneul Anglais' in his catalogue, no. 73 at 15 x 28cm (6 x 11ins.). A good early cast of an attractive if slightly stylised model. The straight sides of the plinth are indicative of casts in the early 1840s, later ones usually have moulded plinths.

*c.1840*

Signed 'P.J. MÊNE': 15.2cm (6ins.)
rich black patination

*£700 — £1,000*

**D68** A fine model of an Irish setter by Barye. The base works well, the deep cutting adds to the dramatic effect and there is no attempt to reproduce weak foliage.

Signed 'BARYE': 10cm (4ins.) the cast numbered 4
dark brown patination

*1850s*

*£600 — £900*

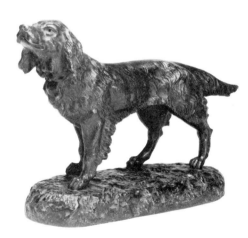

**D69** A poor cast by Omerth of a retreiver. The style is very similar to D64. The eyes and paws are bad and the large deep base is heavy for such a small animal.

Signed 'G. Omerth': 18cm (7ins.)
rich light brown patination

*c.1900*

*£250 — £400*

225

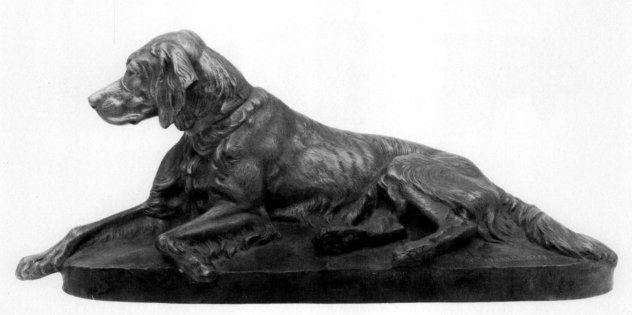

**D70** An elegant dog by Masson that is well cast although the patination has worn over the years developing a flat look, emphasised by the photograph. The inscription suggests that this actual model was exhibited at the Salon but the model cannot be traced.

Signed 'C. Masson'
inscribed 'Salon des Beaux-Arts' and 'vrai bronze'
24cm (9½ins.)': gilt and brown patination
*c.1900* £400 — £700

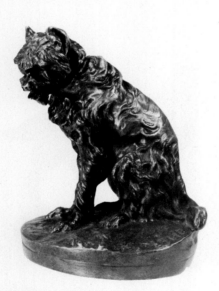

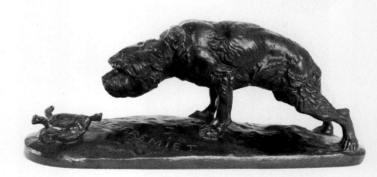

**D71** The griffon, an unusual dog today, was very popular in the 19th century, in bronzes and in paintings. A slow seemingly friendly animal it has plenty of appeal but is not very sought after. The same dog is used for another model with two pigeons. The hair of the dog is so loosely modelled that one might mistakenly think it a poor cast.
Signed 'MÊNE': 18cm (7ins.)
dark rich brown patination

*1850s* £600 — £800

**D72** An amusing bronze by Frémiet of a griffon and tortoise. Signed 'E. FREMIET': 9cm (3½ins.): light brown patination
*Probably 1850s* £500 — £800

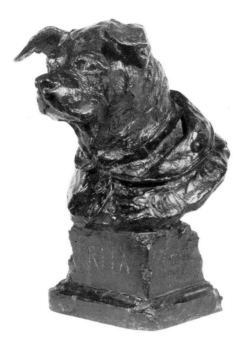

**D85** An imaginative 'portrait' head of 'RITA' modelled by Merculiano and cast by Valsuani. The inscription in the artist's script reads 'A Mlle M.R. Ferrand Hommage Reconnaisant, J. Glle et Henriette Merculiano, Maison Lafitte, 1915'. A well cast and amusing bronze and quite possibly unique. The dog is wearing a jacket. It is possible that the bronze commemorates a favourite pet and was modelled in collaboration with the sculptor's wife and daughter. (The sculptor signed his name J. Merculiano but is always recorded as G. Merculiano.)

Signed 'J. Merculiano' and inscribed: 29cm (11½ins.)
brown/black patination
*c.1915*                                                    £400 — £550

**D86** A well finished plaster model of a handsome pet pug that has been cold-painted in the style of the Viennese bronzes discussed on p.391. The cushion on which the dog sits is similar to one or two models of the 1830s, and of one by Barye shown as D73. Plaster is fragile and does not usually sell well but 'ugly' dogs such as this have a great following and are in demand within the decorator market. Compare with D46.

28cm (11ins.)
*c.1900*                                                    £600 — £900

**D87** A small rather ugly stylised bronze of a pug, somewhat reminiscent of Barye but without his panache.

7cm (2¾ins.) approx.: black patination
*c.1850*                                                    £150 — £250

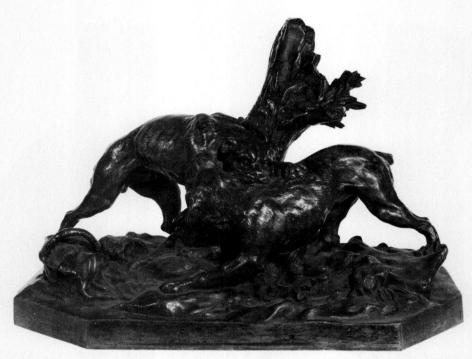

**D88** A rare, possibly English group of two savage dogs fighting. It is just possible that this group is German by Gradler, but as yet no signed model has been recorded. The dogs appear to be fighting over a pannier to the left which is a good feature but the tree stump is unnecessary both sculpturally and for shape.

34cm (13½ins.): rubbed brown/black patination
c.1850                                                           £550 — £900

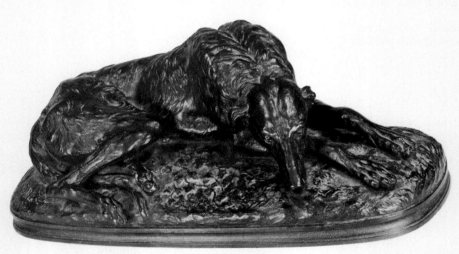

**D89** One of the most copied bronzes ever modelled but usually copied in resin. The value of an old model is not high enough to warrant anyone making a bronze cast for commercial reasons, but huge quantities of resin casts were made in the 1970s to satisfy the demand for deskweights, and were commonly found in the street markets generally selling for around £50. The Irish wolfound is popular and in this pose, a cast is easily made in one piece. The example illustrated is a good period cast in bronze by the sculptor Gayrard with the date of 1848 (which of course always looks good on a copy). Cast in London it is indeed a fine animal bronze, but the number of resin copies (a process discussed on p.40) unfortunately keeps down the price of the originals.

Signed 'Gayrard' and 'London': 8.6 x 14cm (3½ x 5½ins.)
rich brown black patination

c.1848                                                           £600 — £1,000

*(An unsigned model sold at auction in 1979, without the date or London inscription, was of 19th century origin and realised only £165. A silvered bronze of the same dog has also been recorded, signed and dated but without London, 6.5cm (2½ins.) high.)*

**D90** The theme of a dog playing with a ball is certainly one that complements the style of Mêne's work, but the finish and position of the animal are difficult to believe. Firstly, the model appears to be unrecorded but this is not a reason to condemn a bronze. Secondly, there is a flow to the long hair of the animal, but not as detailed as Mêne, or indeed Moigniez would require. Thirdly, the paws are particularly badly modelled. No animal with four points of anchorage would need the foliage for support and so it is unlikely that a competent sculptor would include it as it only serves to detract from the model. Although the base is in the style of Mêne c.1860 the signature is totally different from his recorded signatures as he invariably signed with a circumflex over the first 'E'. It must be concluded that this bronze is at best a made up model possibly with an added chased signature, or that it is a total fake done within the last twenty to forty years.

Signed 'P.J. MENE': 12 x 17.6cm (4¾ x 7ins.)
rubbed black patination

*19th century*                          *£60 — £100*

**D91** A bronze group by Trodoux of a boxer trapping the tail of a rat with his paw. An amusing, lively group with well detailed ears of corn strewn on the base and woven basket behind. This sculptor produced small bronzes of this type which were always well modelled and detailed subjects of the highest quality. (A nice variation of this bronze is in the author's collection which intended as a desk weight, shows only the dog and the rat, mounted on a good quality red marble plinth. Another is recorded with a sign titled *On ne passe pas.*)

Signed 'TRODOUX': 16cm (6¼ins.)
rich brown patination

*c.1890*                          *£300 — £400*
*The desk weight would be less value at £180 — £220*

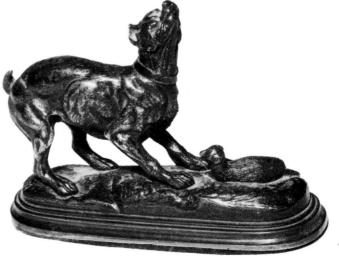

**D92** The cry of pain and anguish can almost be heard from this terrier bitten by a weasel. An unusual subject to capture but amusing and somewhat tongue in cheek, as it is usually the dogs who have the upper hand in these small bronzes. There is a similarity in the legs, paws and general finish of this bronze and D90 with the dubious Mêne signature.

8cm (3¼ins.): badly worn dark brown patination
*c.1850*                          *£250 — £400*

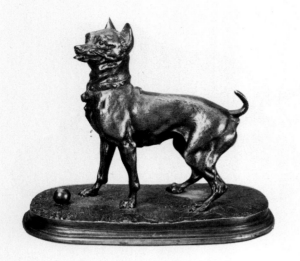

**D93** A very good model of a crop-eared terrier by Mêne. How often have we all been tricked into throwing a ball by such appealing look and stance only to find that we have a friend for the afternoon and are expected to play for hours. Mêne has captured the situation in a masterful way and this makes for a popular small bronze, although the choice of dog is not to everyone's taste today.

Signed 'P.J. Mêne': 11.4cm (4½ins.)
medium brown patination

*1860s*　　　　　　　　　　　　　　　　　£400 — £600

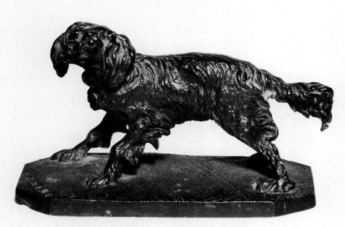

**D94** The Cavalier King Charles spaniel is still a very popular small dog today and Mêne obviously felt they had commercial potential when he modelled this one. This early model looks a little awkwardly overemphasised in the eyes, even considering the bulbous eyes of the breed. The early, flat-edged base with canted corners is criss-crossed with a flowerhead trellis pattern to represent a carpet, as this is a house pet and not a hunting dog. This, like many of his dogs, must have been a portrait.

Signed 'P.J. MENE' with the early letter stamp
8.5 x 14cm (3¼ x 5½ins.)
rubbed rich brown patination

*1840s*　　　　　　　　　　　　　　　　　£300 — £450

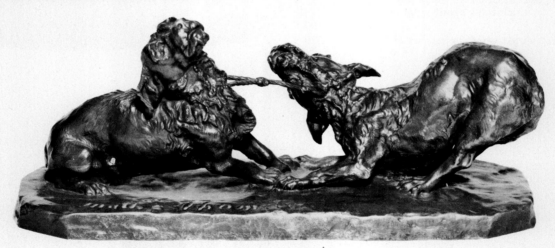

**D95** A playful group of two dogs in a tug-of-war, amusingly and realistically captured by Mathilde Thomas, particularly the right hand dog who is decidedly digging in his heels. A good loosely handled cast by a good founder. Note the lower case 'm' in the signature.

Signed 'math. Thomas'
foundry signature 'Fondeur Paris Thiebauts Freres'
14cm (5½ins.): light brown patination

*1880s*　　　　　　　　　　　　　　　　　£250 — £400

234

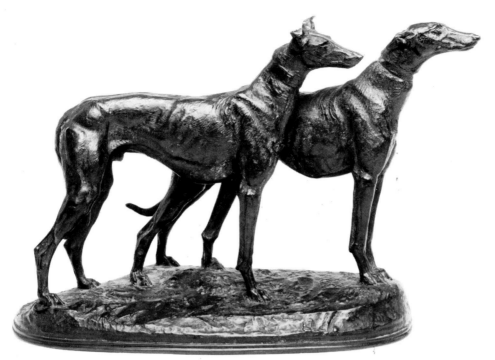

**D96** A fine and handsome pair of greyhounds by Frémiet, where the sculptor has deliberately set out to create a sense of balance and form which he has achieved with dramatic success. The attentive pair are full of life and vigour. The subtle rise in the base from left to right contributes to the stance of the dogs, and to the whole composition.

*c.1860*

Signed 'Fremiet': 25cm (9¾ins.)
rich dark brown patination

£1,000 — £1,600

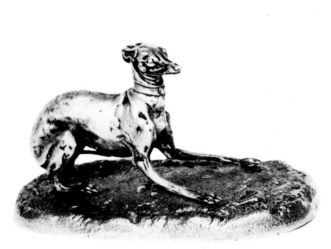

**D97** A small bronze desk tidy, unsigned but based on a model by Mêne, the whole of the dog's body is sprung to allow it to lift as a paperclip. It has obviously been on a desk for many years and lovingly 'cleaned' as there is virtually no patination left.

10cm (4ins.): heavily rubbed

*Late 19th century*
£100 — £160

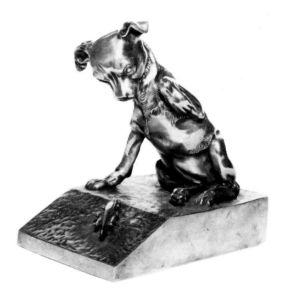

**D98** A silvered bronze group of a chihuahua toying with a grasshopper, intended as a desk weight by the sculptor G. Laurent, it is easily dated by the angular style of the dog's mouth and the plinth, as well as the treatment of the hair and body texture. Not a particularly good model but amusing enough.

Signed 'G.M. (or H.) Laurent': 23cm (9ins.)
silvered bronze

*1920s*
£200 — £300

235

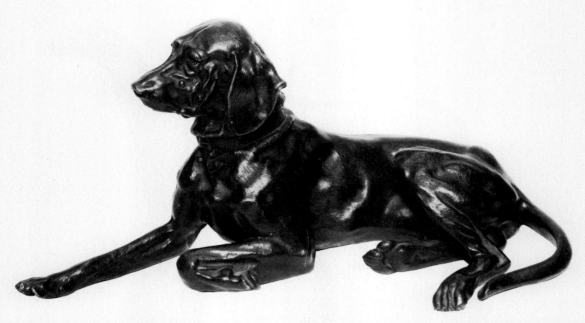

**D99** Russian bronzes are normally comparatively easy to identify, as once the collector has seen a few the colour and style become easily recognisable. This bloodhound, however is not so obvious and for this reason has been included here rather than in the small section devoted to Russian bronzes on pp.382-390. Close inspection reveals the signature in Cyrillic around the collar by Nicholai Ivanovich Lieberich, which leaves little doubt as to its origins. Influenced by the Viennese style the dog sits without a base as in D80, and is a fine model of a bloodhound.

Signed in Cyrillic with founders' signature
'Fabr. C.F. Woerffel'
approximately 20cm (8ins.) long: dark brown patination
*c.1900*                                                   *£400 — £600*

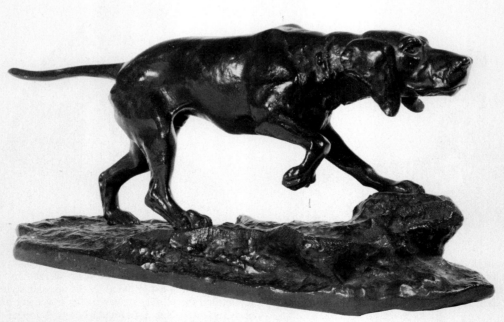

**D100** A good Drouot pointer, frozen in a difficult pose. A nice quality bronze, still relatively inexpensive.
Signed 'E. Drouot': 15cm (6ins.): green/brown patination
*c.1900*                                    *£500 — £700*

236

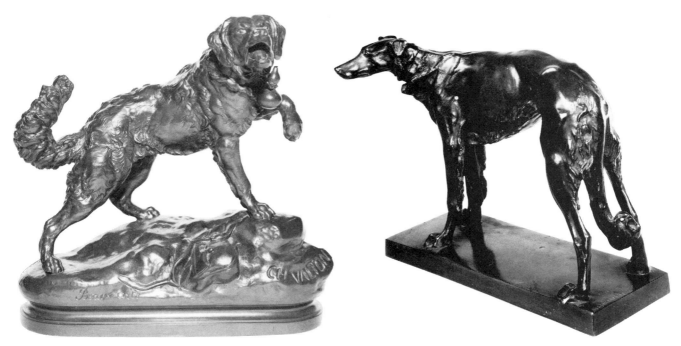

**D101** A Salon Exhibition model by Valton of a St. Bernard dog with a brandy gourd tied around his neck. The animal looks unnaturally defiant for his breed, and is caught in a most ungainly posture as he tests the wind for the scent having come across an abandoned bag lying on the ground. One of a pair exhibited in 1881.
Signed 'CH. VALTON' and inscribed 'Beaux Arts'
50cm (19¾ins.): rich brown patination
*c.1881* £1,200 — £1,800

**D102** A fine model, this time a German cast by the sculptor Gustav Reissmann. The lean figure of the Irish wolfhound, makes it a highly suitable subject for sculpture, with the trunk of the animal forming two triangles, one inverted. This model was cast at a time when German sculpture was beginning to develop along cold hard lines but this escapes the disadvantages of the new German school and reaps the benefits of its simplicity of line. Note especially the return to the simple, flat-sided rectangular base that was popular in the 1830s and 1840s but became superseded by the softer line of the moulded plinth.
Signed 'G. REISSMANN': 29cm (11½ins.) long
black patination
*c.1910* £600 — £900

**D103** This dog is truly asleep without any pretence at keeping one eye open. Modelled by Louis Guij as a desk weight it is a simple, one-piece cast with good detail and character. The floppy ears are particularly well modelled.
Signed 'Louis Guij': 3.5 x 14.6cm (1½ x 5¾ins.)
rubbed black/brown patination
*Dated 1876* £80 — £120

**D104** A fine model of a setter by Fratin, possibly the same dog which he modelled in a four square position. The recumbent pose may not be the most popular but one cannot deny the fine casting by Quesnel and the good patination.
Signed 'FRATIN', with founder's mark 'Quesnel Fondeur'
10cm (4ins.): brown patination
*c.1840* £400 — £600

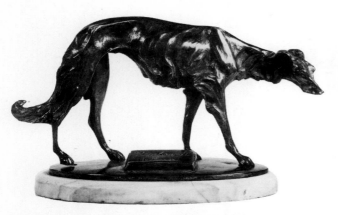

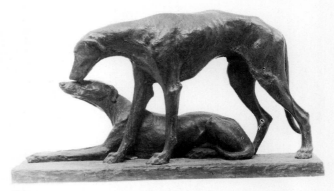

**D105** An unsigned model of a saluki 'Rembrandt de Maroi', the title on the raised plaque. Here the animal looks a little too thin for general appeal although it is a good study of the species and doubtless a good portrait. The treatment of the saluki's hair is not very successful in this case, but possibly helps to identify the period of the bronze as the turn of the century.

19cm (7½ins.) excluding contemporary marble oval plinth
*c.1910* £350 — £550

**D106** A highly stylised and tender group with the standing dog affectionately licking the face of his mate. Sometimes the stylisation of the 20th century so dominates the subject matter that it takes away much of the sensitivity of the bronze. In this instance the sculptor has managed to combine both very successfully.

Signed 'Jacques Cartier': 34cm (13½ins.)
flat dull green patination
*Dated '33 (for 1933)* £450 — £700

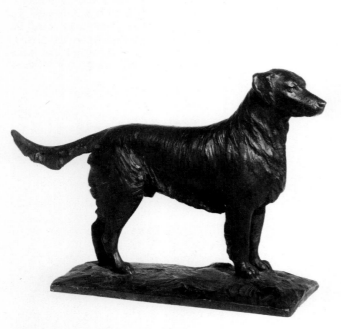

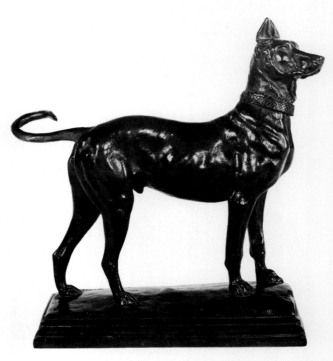

**D107** An unsigned bronze cast, possibly of English origin and almost certainly a portrait work by a gifted amateur. The modelling is a little heavy and lacks depth in the detailing. This type of bronze would not be expected to command a very high price at auction or in the showroom, and therefore represents good value for money as a decorative bronze. Should the provenance be known the price would increase especially if by a well known person.

21.5cm (8½ins.): black patination
*c.1900* £300 — £500

**D108** A majestic figure of a bull mastiff by Alfred Barye, proving his worth as a competent sculptor. The well modelled muscles and the dramatic posture make for a very good, decorative sculptor. Note the subtle incline of the plinth.

Signed 'ALF. BARYE. FILS': 22cm (8¾ins.)
green patination
*c.1870* £700 — £1,000

238

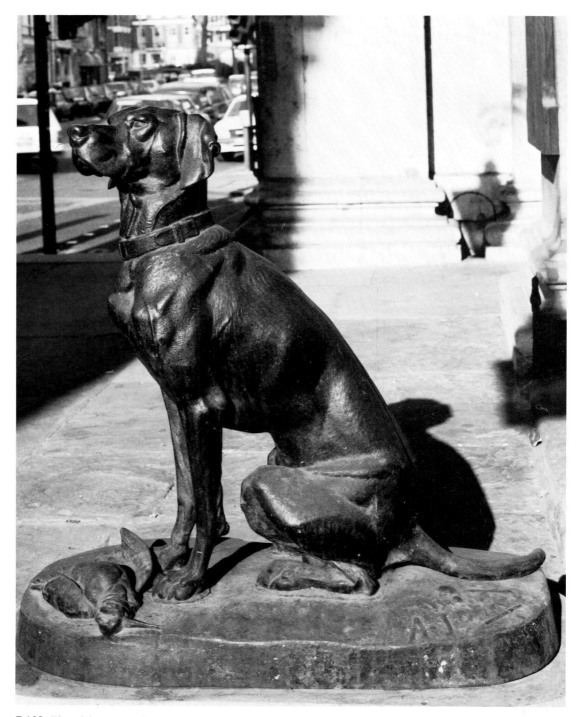

**D109** The visitor to Sotheby's may take time to admire the church in St. Georges' Street almost opposite the rear entrance where a pair of these dogs guard either side of the main door, life-size cast-iron models by Adrian Jones.

Signed 'A.J.' with indistinct founder's mark BARBEZAT(?) et Cie Val d'Osne': 95cm (37½ins.) *c.1890*

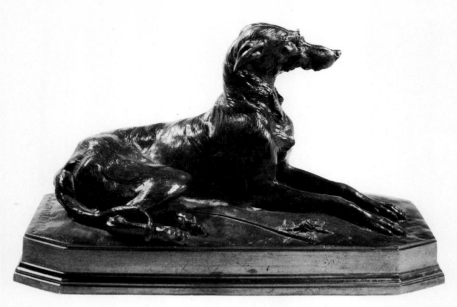

**D110** A fine and majestic animal by Comoléra and probably one of his best models. The posture of the dog expresses excitement and anticipation as he waits patiently and obediently. The riding crop and rose, strewn almost casually on the base, is a charming addition. The hair of the animal is well detailed and the patination perfectly complements the model.

Signed 'Comoléra'

c.1860                                                    £700 — £1,000

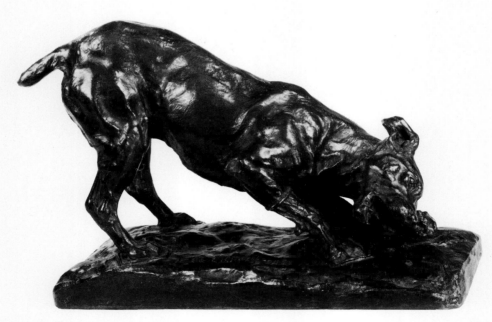

**D111** A very realistic model by Louis de Monard of a dog gnawing at a bone, a subject infrequently attempted by sculptors. Louis de Monard produced monumental works as well as studies of terriers and horses. In this model the eye is drawn to the castings below the dog's footpads which are let into the base in a surprisingly crude way, and are accentuated rather than smoothed off. The most difficult part to explain is the bronze ring and dowel in the right foreleg. Certainly the dowel would be used if the leg had been cast separately but it is most unusual to leave it exposed. Possibly this cast was rejected for some reason, and patinated for the artist's use or for one of the foundry workers, and the footpads and leg left unfinished. Remember the signature would be in the plaster of wax model, not chased into the bronze when finished, so that even a rejected cast would bear a signature.

Signed 'L de Monard': 32cm (12½ins.)

dark brown patination

c.1910                                                    £400 — £700

The three illustrations on this page show two different bronzes by Charles Paillet on the same theme. He fashioned a great amount of sentiment into his animal figures, the best example of which is the statue 'Two Friends' in the Luxembourg Gardens in Paris.

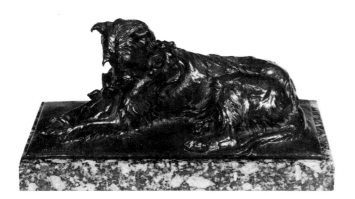

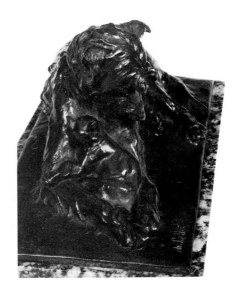

**D112** This model of a large and gentle wolfhound is an excellent lost wax cast of a very pleasing subject. In the detail a sleeping cat can be seen nestling between the dog's legs, its tail flicked around a huge paw. The detail of the hound's coat is good and the whole subject is given a loose treatment which is typical of a lost-wax cast in the style of the late 19th century. Although a good cast of an interesting subject this type of bronze is underappreciated at the present time and

consequently undervalued. (Another version of this bronze is recorded cast by Ferdinand Barbédienne & Fils à Paris, cire perdue, in exactly the same size but the signature of the sculptor is in an oval cachet. Also recast by Leblanc Barbédienne in c.1950.)

Signed 'ch. Paillet' and marked 'Cire Perdue'
15 x 33cm (6 x 13ins.): brown green patination
*c.1900*                                               *£1,000 — £1,500*

**D113** Another fine cast, possibly of the same animal but this time with her own family of two pups, one suckling, the other romping. The bitch's coat is possibly even better modelled on this than the previous cast. The two bases are the same size

and the sculptor may have intended them as a pair.
Signed 'ch. Paillet': 33 x 71.5cm (13 x 28ins.)
slightly rubbed rich dark brown patination
*c.1900*                                               *£1,000 — £1,500*

**D114** An unusual bronze group of two Salukis in a varied posture with one howling dog standing over the other. A well constructed and detailed group of good quality.
Signed 'MATH. THOMAS': 58.5 x 51cm (23 x 20ins.)
rubbed rich brown patination

*c.1910*                                                    *£2,000 — £3,000*

**D115** Terracotta is a very pleasing albeit vulnerable medium but this model by Benjamin Creswick of Birmingham has been coloured bronze, possibly when it was modelled. Colouring spoils the warm effect of the material but perhaps the sculptor coloured his work so that his client could see what the finished bronze would look like. The howling deerhound is in a posture that would not normally be considered particularly commercial.
Signed 'B. Creswick'
68.5 x 62cm (27 x 24½ins.) (excluding base)
brown patination

*Dated 1915*                                                 *£400 — £700*

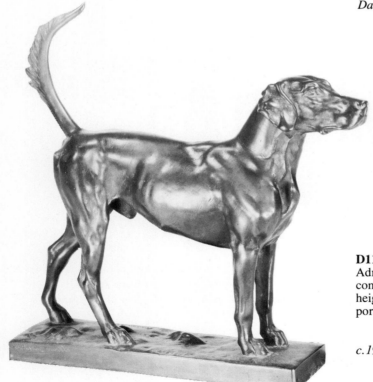

**D116** A decorative bronze of 'Forager', by the sculptor Adrian Jones, who was also an army Veterinary officer. A competent, if uneventful model with an unusual smooth finish, heightened by the light patination which was probably the portrait of a favourite hunting dog.
Signed 'Adrian Jones' and 'A.B. Burton Founders'
27cm (10½ins.): light brown patination

*c.1910*                                                    *£500 — £800*

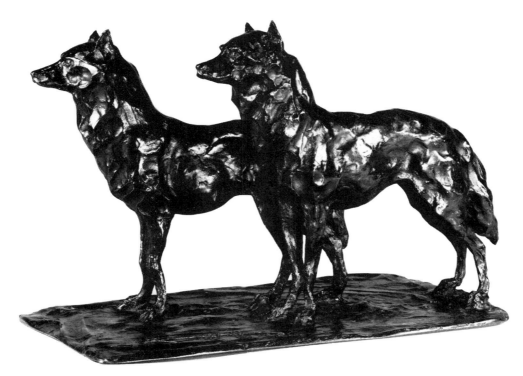

**D135** The modelling technique and genius of Rembrandt Bugatti is generally accepted to be the best in the animalier world. Despite his short career at the latter end of the animalier period his only serious rival must be the great Barye himself. His use of his thumbs to model the clay for this group of two wolves can clearly been seen and the undulation gives a rippling effect to the play of light. The ability to give an impression in bronze without precise modelling necessitates a very highly developed sense of form.

Signed 'R. Bugatti, Paris' and 'A. Hebrard cire perdue'
24cm (9½ins.): brown/green patination
*c.1910* £4,000 — £6,000

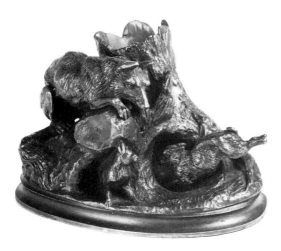

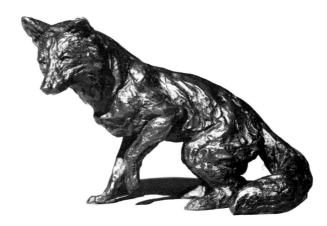

**D136** An unusual Moigniez group but a bad cast in which the detail certainly is up to standard but where the tree stump has several casting faults. (Possibly a rejected cast taken home by a foundryworker?) Reynard the fox peers into a warren as one rabbit hops in and another looks out. A sweet model, but not up to the sculptor's normal standard of modelling or finishing.

Signed 'J. MOIGNIEZ': 8cm (3¼ins.) high
light brown patination
*1870s* £400 — £500

**D137** A modern work by the sculptor William Tymym and one of a limited edition. The sculptor has taken a middle line between the impressionism of Bugatti and the realism of the mid-19th century Paris school and the effect is a pleasing 'up to date' result. The thick, sketchy, almost impasto modelling creates a good lighting effect.

rich copper/brown patination
*Late 1970s*

249

# Elephants and Rhinoceroses

The large mammals of the world hold as much fascination for people today as they did in preceding centuries. The majesty of the elephant is a natural target for the realist sculptor and most modellers of these fine beasts succeed well. The rhinoceros appears in sculpture, prints and drawings from the 16th century onwards but is not common in the 19th century. Barye, once again, is an early and convincing sculptor of the elephant with Valton and Godchaux at the beginning of the 20th century, a century splendidly heralded by Rembrandt Bugatti. Once again, as in the previous century, there is a gap until the modern sculptors, mainly from the 1970s such as Kenworthy and Terence Mathews, took up the modern trend in animalier work with their animals modelled realistically, as though in their natural environment.

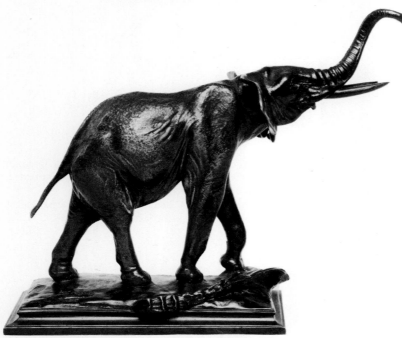

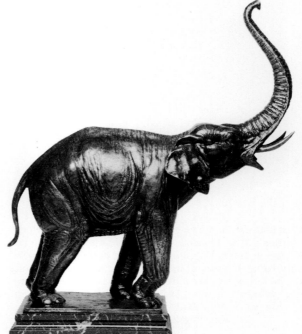

**E1** A good and rare cast of a young African elephant trampling a palm tree by Auguste Seysses, a portrait and genre sculptor born 1862 who lived and exhibited in France from 1884 to 1937. Although a good study, it is not a highly commercial bronze as the comparatively unusual movement of the animal, frozen in time, seems a little awkward.
Signed 'Aug. Seysses', founder's signature 'Susse Freres Edts.'
19cm (7½ins.): rubbed brown patination
*c.1900*                                    £800 — £1,200

**E2** An Italian cast by G. Beneduce of Florence. Whether the elephant is in the act of pulling down a tree with his trunk or is simply trumpeting angrily is debatable. A well modelled and beautifully cast bronze that almost breaks away from traditional realism into the more angular form of the early part of the 20th century. The sculptor appears to have been influenced by impressionist technique in his treatment of the folds of the skin, but has not followed the idea right through.
Signed 'G. Benduce Firenze': 67cm (26¼ins.)
light to dark brown patination
*Dated 1910*                              £1,200 — £1,800

250

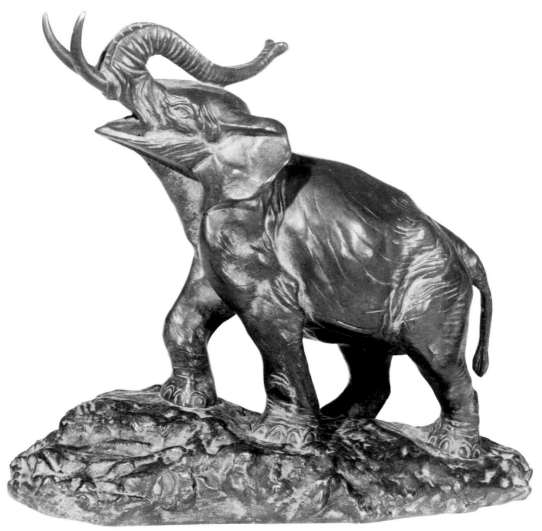

**E3** A stylised and awkward figure by I. Rochard, an unrecorded sculptor, who has here attempted to detail the skin with bold lines but achieved little sense of movement. The triangular shape is clearly seen with the point over the animal's head and the forefeet on a rising slope to heighten the effect, so typical of the early 20th century sculptors. The trumpeting animal appears heavy and unattractive in this less than threatening pose.

Signed 'I. Rochard', numbered 8651: 25cm (9¾ ins.)
even brown patination

*c.1910* £300 — £500

An elephant in a similar stance but with a hind leg tied to a tree trunk was modelled c.1880 by Delabrierre, 20cm (8ins.)
£700 — £1,000

251

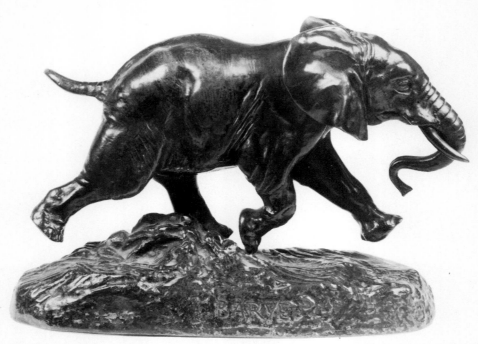

**E4** A good cast of the 'Charging Senegal Elephant' by Barye, listed in his 1855 catalogue and cast in quantity. The value is maintained by the popularity of this small model. Technically and sculpturally Barye has created a masterpiece — it was no mean feat in the mid-19th century to create a model at full run with only one foot touching the ground without other means of support — yet a very strong model and, to date, the author has seen none with a crack or break in the back leg.

Signed 'BARYE': 13.5 x 20cm (5¼ x 7¾ins.)
green and brown patination
*c.1855*                               *£1,200 — £1,500*

This model is occasionally seen in a Barbédienne Gold Initial cast in two sizes. A good gold initial cast can make as much, or even more than an indifferent cast by Barye and judgement should be made on quality alone. Gold initial casts by their very nature are special editions and tend to be consistently good.

Signed 'BARYE', with gold F.B. initials
green and brown patination
*c.1870*           13.5cm (5¼ins.) model with gold 'F.B.'
*£1,200 — £1,500+*
25cm (9¾ins.) model £1,600 — £1,800

**E5** Another version of the Barye charging elephant but on a different and unusual base. Seen from the other side it shows how well these small models work in the round; this version has been seen as an identical pair with one facing the other.

Signed 'BARYE': 23.5cm (9¼ins.): green patination
*c.1920*                               *£800 — £1,200*

252

**E6** Japanese bronzes are discussed separately on pp.380-1 but by including these examples a direct contrast can be made between the two styles. It is not always easy to distinguish between European bronzes and those of the Japanese. Often the Japanese versions are signed, usually on the underbelly of the animal, and they do not normally have bronze bases but wooden detachable stands. Another clue is the high copper content of the Japanese bronzes which heightens the red brown colour considerably. This rather friendly little animal is made for the European market and is a charming rather than good sculpture, but the casting is excellent with good detail to the folds of the skin.

14cm (5½ins.): brown red patination
*c.1900*                              *each £150 — £200*

**E7** Another small elephant by Barye that has more in common with his son's style. A good but not very spirited model, very well cast with excellent treatment of the folds of the skin.

Signed 'BARYE': 25cm (10ins.): green patination
*c.1920*                              *£800 — £1,200*

**E8** An unusual model by Alfred Barye in a very similar style to his father. It is a brave subject to model with the complicated interplay between trunk and foot and the resulting creasing of the skin works very well; it is fair to say that this model compares well with his father's earlier casts. Although Alfred Barye is generally regarded as inferior to his father, he was a good sculptor in his own right.

Signed 'Alfred Barye': 15cm (6ins.): dark green patination
*Probably 1860s*                          *£600 — £900*

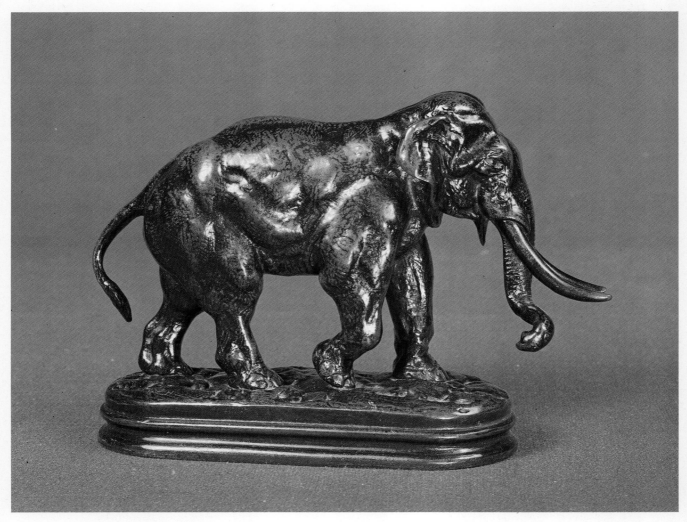

**Plate 9**

A fine and rare elephant by Barye and one of several studies that he modelled of this magnificent species. A very small model that is a delight to handle and ideal for desk or display shelf, the very fact that this model is so small is a contributory factor to the wonderful patination on this example. In the creases and folds of the elephant's skin there is black patination with the body of the animal in a range of browns from red brown to an even mid-brown. The plinth has an overall hue of green with a copper red/brown colour coming through. The range of colours themselves give life and movement to the figure much as the sculptor intended but so does the additional patination which has formed as a natural film of copper carbonate aided by continual handling. A bronze of this quality and colour feels very good in the hand, a feeling recognised by any one constantly dealing with this type of bronze.

Signed 'Barye': 19 x 13cm (7½ x 5ins.)
copper red brown to green patination.

*c.1850*                                          *£1,500 — £2,000*

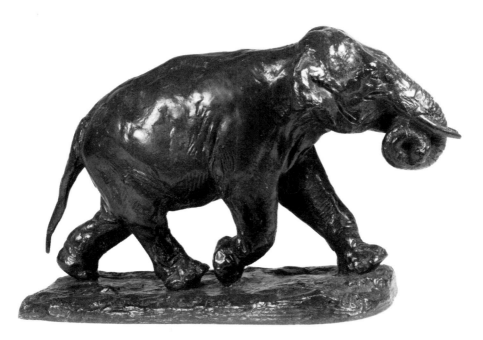

**E9** A fine lost wax cast by Roger Godchaux. This sculptor consistently produced good casts and had a sensitivity towards his animals that is lacking in some of the better known animaliers. Certainly his work appeals to modern taste although it is still underrated financially. This Susse Frères cast is up to their highest standards and is a nice small model with plenty of movement. The rough quasi-impressionistic technique plays the light very effectively, heightening the sensation of movement.

Signed 'Roger Godchaux' and 'Susse Fres. Edts. Paris'
16cm (6¼ins.): mid-brown patination

*c.1900*                                                    *£1,000 — £1,500*

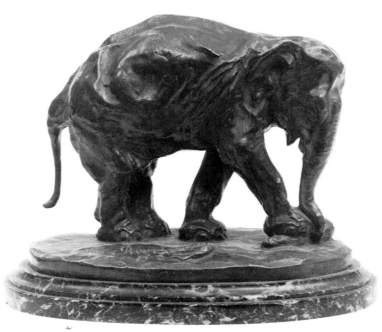

**E10** A very impressionistic treatment by an uncommon sculptor. The huge animal in the familiar role of jungle transporter is rolling a log using his foot and trunk. The sense of movement is spoiled a little by the two static back legs which are cast in one, allowing no light through giving the model a heavy feel. A good cast but rather rubbed and neglected, something that would be helped by a good wax polish which should bring it to life quite quickly.

Signed indistinctly 'Martin Rysnich': 28cm (11ins.)
brown/green patination

*Dated 1930*                                                    *£350 — £550*

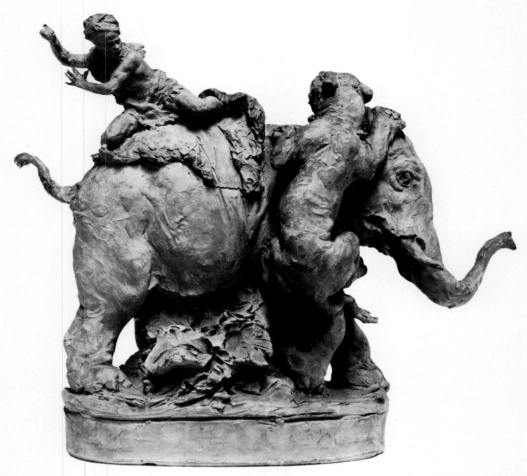

**E11** Terracotta models are very hard to find today as they rarely survive intact. The material itself has a very subtle quality of texture and colour that makes it attractive and popular despite its fragility. This quality, combined with the certain fact that the sculptor has actually worked the clay up himself adds to the attraction and fascination. This is a rare model by Prosper d'Epinay full of action and power. The mahout, tiger and elephant are all caught up in a horribly realistic life and death struggle and here the soft colouring of the terracotta only serves to heighten the realism. The mahout and rug are detachable.

Signed 'Epinay': 34cm (13¼ins.)

*Dated 1879*                              £900 — £1,600

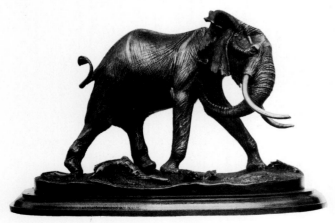

**E12** A recent cast of a charging African elephant by a young African-based sculptor. A vigorous model and immediately identifiable as a post-war cast by the style that reflects the African paintings of David Shepherd. The detail in the mould of the skin on the trunk and legs is very good but the cold-chiselled cross-hatching on the flank of the animal lacks realism.

rich medium brown patination

*1970s*                              £800 — £1,200

256

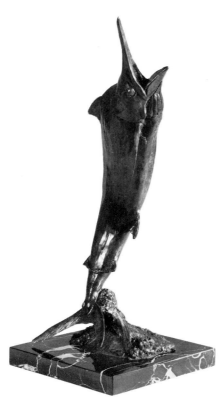

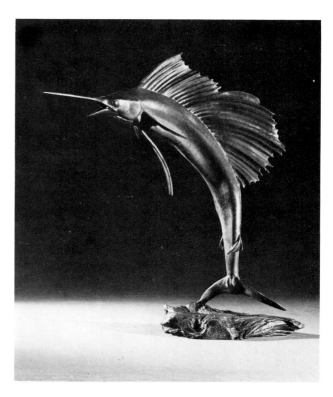

**F4** A fine contemporary bronze of a black marlin by Jonathan Kenworthy. Technical achievements unavailable in the 19th century allow the great fish to leap clear of the water, held at the tail by a small wave. The great interest in marine life and the popularity of deep sea fishing means that there will be many potential buyers of such a bronze.

<div align="center">Signed in script, and numbered 7/7</div>

*Dated 1979*

**F5** A fine contemporary model of a sailfish by Terence Mathews. Leaping dramatically out of the water held incredibly by the very tip of the tail, the great dorsal fin that gives the fish its name spreads out in a wide fan.

<div align="center">Signed 'TOM'</div>

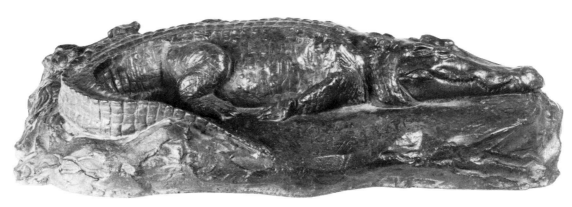

Reptiles are rarely sculpted in bronze; Barye modelled a turtle by itself, and a turtle with a stork standing improbably on its back illustrated on p.101. The crocodile is the victim of a tiger by Barye, exhibited at the Salon of 1831, and the alligator a victim of a Fratin lion illustrated on p. 152. The 'Boy on a Crocodile' was produced in porcelain by Royal Doulton in 1920, designed by C.J. Noke, but no such figure has been cast in bronze.

**F6** America is a fine source of inspiration for the animal sculptor and this alligator by Paul Wayland Bartlett is a rare and excellent model. The sleepy reptile appears relaxed yet at the same time belligerent, capturing the mood of these beasts exactly. Two toads sit at the rear, doubtless waiting for insects to settle on the alligator.

<div align="center">Signed 'Paul Wayland Bartlett' and<br>founder's monogram 'S.F.'</div>

<div align="center">5 x 33cm (2 x 13ins.): greenish light brown patination</div>

*Dated '95 (for 1895)*                    £600 — £1,000

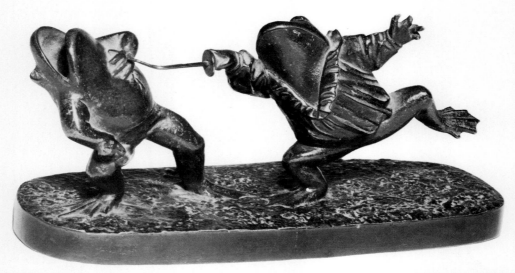

**F7** An unidentified Susse Frères cast of two duelling frogs in the anthropomorphic manner popular in the second quarter of the 19th century (see the Fratin bears on pp.68-9). This is certainly an early cast with its flat-sided base and varnished patination. In the manner of Fratin, the sculptor has given a vestige of clothing to one frog only, to humanise the subject. Not very good sculpture but interesting historically. One frog has lost the blade of his foil altogether, and the patination is poor, the varnish having become chipped over the years with incessant handling, no doubt by eager children.

<div align="center">

Signed with founder's stamp 'Susse Fres.'
9.5 x 20.5cm (3¾ x 8ins.)
chipped varnished mid-brown patination

</div>

*1840s*       £220 — £300

**F8** A frog tied to a lotus pod cast for Frémiet, in the form of a desk seal that has not in this case been cut on the underside with a crest. A lighthearted subject for such an important sculptor but very well modelled. The frog has presumably been harnessed for future consumption.

<div align="center">

Signed 'FREMIET': 11.5cm (4½ins.)
rich brown patination

</div>

*1860s*       £200 — £250

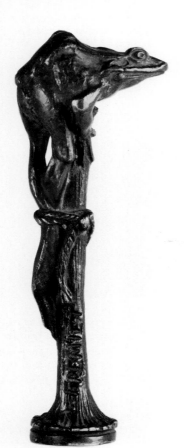

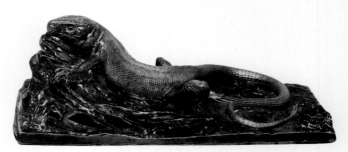

**F9** A very finely detailed slush casting, discussed on p.37, of a lizard by the little known sculptor Grohé. The sculptor has been able to create such realism by the simple use of a real lizard as his model and as his mould.

<div align="center">

Signed 'Gust Grohé': 6 x 18.5cm (2¼ x 7¼ins.)
copper and gilt patination

</div>

*c.1910*       £100 — £200

# Goats

Mêne models are probably the most frequently seen in this group, a fairly popular subject that is not particularly common. Goat models seem to date around the third quarter of the 19th century, as do all on these pages except for the early Barye, G10 and the Jones of almost one hundred years later, G6.

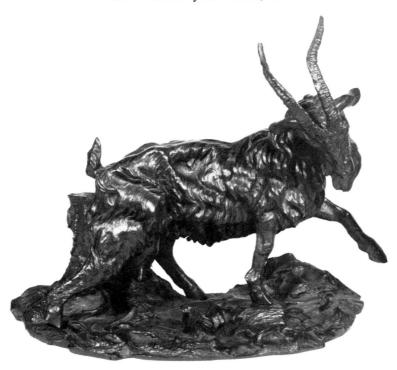

**G1** A good model of a female goat in a similar style to the work of Fratin. The animal is full of character as it turns to butt. The detail is very good and crisp, the cast in original condition with little wear or loss of patination.

28cm (11ins.): medium brown even patination
*c.1850*                                                     *£700 — £1,000*

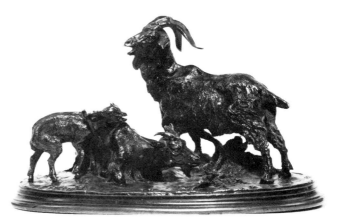

**G2** A fine Mêne group and a rare cast of a family of goats. The kid has a collar around its neck, crudely made from sticks, to stop it forcing its way through gaps in hedges. A lively scene with the proud father keeping a lookout.
Signed 'P.J. MÊNE' and stamped O and M on the underside
13 x 22cm (5 x 8¾ins.): black rubbed patination
*1850s*                                                         *£550 — £800*

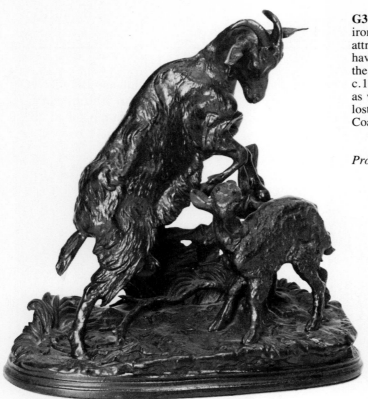

**G3** In contrast to the fine bronze casts in G3 and G4, this cast-iron model looks very dull, with none of the crispness or attractive mid-brown colour and tactile quality. It is known to have been cast in bronze by the Coalbrookdale Foundry and the casting is every bit as good as the French. Modelled c.1850 it is difficult to date accurately. Cast-iron does not pour as well as bronze and so some of the fine detail is inevitably lost. Records of the rare bronze version of this cast by Coalbrookdale suggest a height of 25cm (9¾ins.).

Signed 'P.J. MÊNE' and Coalbrookdale Company
23.5cm (9¼ins.): black patination

*Probably 1870s* £300 — £350
*Bronze version £700 — £900*

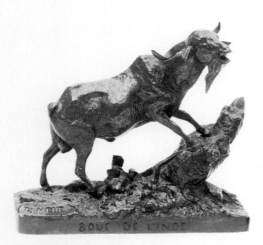

**G4** A rare Mêne model of an Indian male goat. The word 'bouc' in the title is defined in a contemporary French dictionary as having 'horns longer than the female, with a strong and disagreeable odour'. It is an unhappy model, although extremely well detailed and in good condition, the posture is contrived and has none of the flow of the more mature work of this great sculptor.

Signed 'P.J. MÊNE' entitled 'BOUC DE L'INDE'
12cm (4¾ins.): medium brown even patination

*1840s* £500 — £700

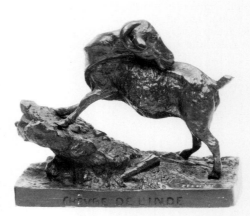

**G5** The companion figure of a nanny goat is more lively and realistic than its mate and equally well modelled. Note that both these rare models have the early, flat-sided base.

Signed 'P.J. MÊNE' entitled 'CHEVRE DE L'INDE'
11cm (4¾ins.): medium brown, even patination

*1840s* £500 — £700

266

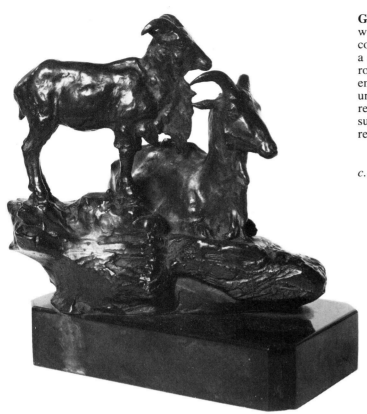

**G6** A very good model by Jones (probably Adrian Jones) which shows the completely different approach to sculpture common to the English New School at the turn of the century, a style later developed by Rodin. The smooth animals on their rock perch have only the long strands of their coats emphasised and the sculptor uses the light to capture the undulation of the bodies which gives an extraordinary sense of realism. The base is contemporary but to many minds may be superfluous. Never get rid of an old base if you wish to remove it, keep it in case one day you part with the bronze.

Signed 'Jones': 28cm (11ins.)
rich green brown patination

*c.1910*                                              *£750 — £1,000*

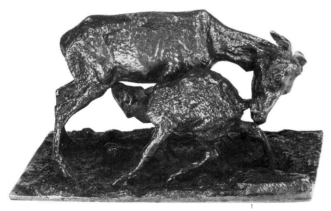

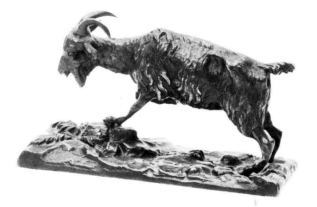

**G7** A sensitive and interesting group of a nanny goat suckling her kid by V. Delaplane, an unrecorded arist. The modelling has a lot in common with that of Frémiet, with the detailing of Mêne. One curious feature is the exaggerated nose of the mother, which makes the goat look more like a wolfhound. The style of the simple, square cut base would normally suggest a comparatively early date.

Signed 'V. Delaplane': 10cm (4ins)
even mid-brown patination

*c.1850*

*£220 — £260*

**G8** A miniature bronze figure of a goat by Mêne, a small popular and inexpensive model, both at the time of casting and at the present day. Not a particularly good cast and heavily rubbed around the body where it has been picked up. The thin legs are liable to damage. A somewhat silly looking model; Mêne at his least inspired and his most commercial.

Signed 'P.J. Mêne': 7.5cm (3ins.)
rubbed mid-brown patination

*c.1850*                                              *£280 — £450*

267

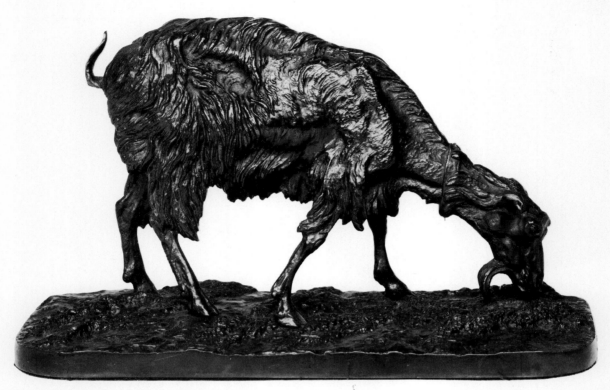

**G9** A Mêne goat, this time a grazing nanny, often seen with a large bell around her collar. Less awkward than his other single goat studies of this period, it is a friendly and inoffensive bronze that is always popular.

*c.1850*

Signed 'P.J. MÊNE': 15cm (5⅞ins.)
rich brown patination

*£400 — £500*

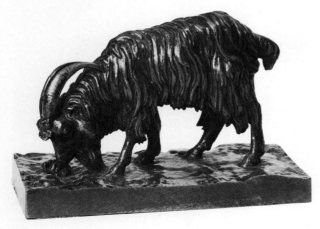

**G10** This does not seem at first glance to be the work of Barye and it would be almost, if not completely impossible to identify on stylistic grounds without the signature. The square, flat sided base is typical of all the early animaliers until the 1840s and it looks more like the familiar work of Mêne. It is a very early Barye model, almost certainly dating to the period in the 1820s when he worked for Fauconnier, Goldsmith to the Court. There is little of the dynamic Barye that was to change the world of animal sculpture within the next decade in this small model, but it does have a very definite assurance and sense of reality.

Signed 'BARYE': 7 x 9.5cm (2¾ x 3¾ins.)
rubbed dark brown patination

*1820s*

*£350 — £500*

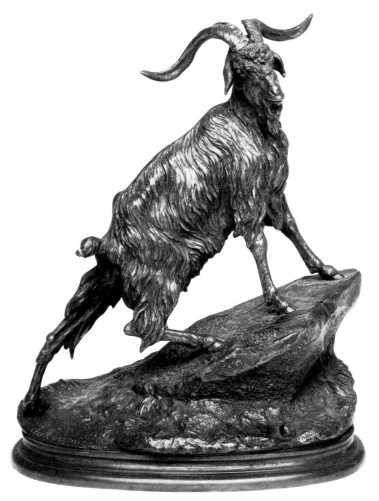

**G11** A rare model by Moigniez, of a well detailed male goat in a proud and defiant posture that looks more realistic than most. Every inch of the model is worked on with no smooth surfaces and a lot of chiselling in the long hair of the animal. This is probably half of the entry in wax to the 1867 Salon by Moigniez, listed simply as 'a billy and a nanny goat'.

Signed 'J. Moigniez': 25.5cm (10ins.)
dark brown patination

*c.1870*                                                    *£700 — £950*

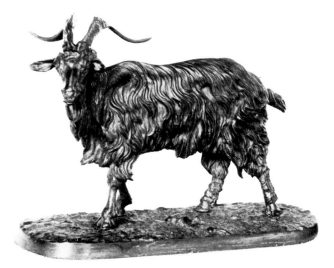

**G12** A cast-iron figure, attributed to Mêne, of which there can be little doubt, but unsigned. A very good cast and the patination is for once not the usual black but a dull gold.
            20cm (8ins.): dull gilt patination

*1870s*                                    *£200 — £240*

# Horses

The horse will probably always have pride of place amongst sculptors and artists of animals. From the paintings of cave dwellers to the modern day animalier they have always been highly popular subjects, with a grace and a muscular complexity to challenge even the most competent artist. Most animalier collectors put a horse at the top of their priorities, a fact reflected in the price one has to pay.

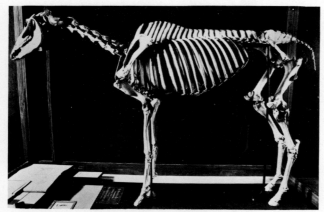

The exceptional horse is not only celebrated in oil on canvas and in bronze but may even be preserved in skeletal form long after its death as a model of the 'ideal' anatomical form of a racehorse and of a stud horse. This is the skeleton of 'Eclipse', born in 1764 and incredibly, never beaten in his racing career. He raced as a five year old a generation before the classical races that mean so much to us today. Not surprisingly he became a successful stud horse, himself the third generation foal of one of the three Arab horses originally imported into England in the 18th century. Today an astonishing eight out of ten thoroughbred horses are direct descendants of 'Eclipse', a record that deservedly ensures his bones a permanent resting place at the National Horseracing Museum in Newmarket High Street.

Artists studied their models in the flesh, studied their bones and, in the case of Stubbs and Barye, even dissected them to understand their subjects to the best possible degree. Today we can so easily take hundreds of photographs of a subject we wish to paint or model, a facility denied the Stubbs and Baryes of this world. It was not until the 1870s that photographic studies were made of the horse in motion, proving once and for all that the horse does indeed have all four feet off the ground when at the gallop. This sequence of photographs by the pioneer photographer Eardweard Muybridge, who was born in Kingston-upon-Thames but who worked in the United States, is taken from his study 'L'Equitation' from a larger work about animal locomotion and has proved an aid and inspiration to succeeding generations of artists. Photographed with the aid of a zoopraxiscope, they show a thoroughbred horse galloping at a speed of a mile in 102 seconds. Copyright was taken out in 1887.

**H8** A fine exhibition model by Mêne, modelled in 1848 and shown in bronze at the Salon in 1849. Numbered 43 in the sculptor's catalogue it was available in two sizes, one listed as 29 x 3 x 15cm (11½ x 15¼ x 6ins.). The typical rustic fence is alone enough to date the style of the bronze to the middle of the 19th century. Known as 'Cheval à la Barrière' the horse is called 'Djinn' and is a good example of a stallion calling a mare. A popular model that has often been copied in recent years and there are many later casts.

Signed 'P.J. MÊNE': 29cm (11½ins.)
rubbed mid-brown patination

*c.1870*                                    £2,200 — £3,000

**H9** A comparable model to H8, this particular example by Moigniez is an exceptional cast of large size. Less attractive than H8, the horse has much heavier features and is somewhat less convincing.

Signed 'J. Moigniez': 52.5 x 52.3cm (20¾ x 20½ins.)
heavily rubbed gilt bronze patination

*1860s*                                    £3,500 — £5,000

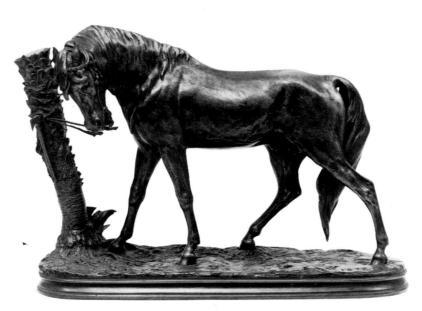

**H10** One of a series of famous casts by Mêne of a tethered Arab stallion entitled 'Cheval au Palmier' and numbered 42 in the sculptor's catalogue. Only one size is recorded of this very fine and powerful model which shows the full character of a thoroughbred horse struggling to break away from its tether. A palm tree has been used to tie up the horse with the wonderfully romantic idea of the rider's axe hacked into the tree to

hold the rein. Again dating is made easier with the help of other subjects such as the romantic North African paintings that were becoming popular by the 1850s and 1860s. A good well detailed model and one often seen cast by Susse Frères.

Signed 'P.J. MÊNE': 29 x 40 x 14cm (11½ x 15¾ x 5½ins.)
rich rubbed mid-brown patination

*Dated 1877*                                £2,200 — £3,000

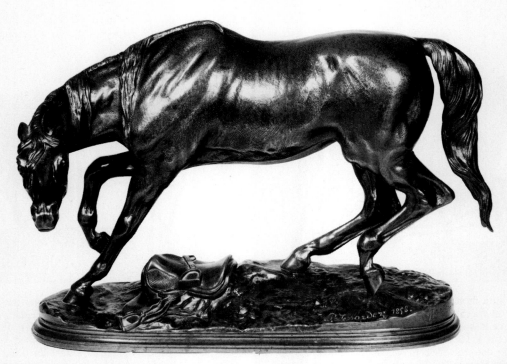

**H11** Any horseman is familiar with the problems of saddling a horse that is quite determined not to co-operate. This is a fine and rare model by Pierre Lenordez of an unwilling mare, by a good foundry Broquin et Lainé. There is no doubt that a horse with its head raised high is more commercial but this unusual cast is a must for the serious collector. Possibly a unique piece.

Signed 'P. Lenordez' and 'Broquin et Lainé Frères'
32 x 42cm (12½ x 16½ins.): rich varnished brown patination
*Dated 1858*                                    *£8,000 — £9,000*

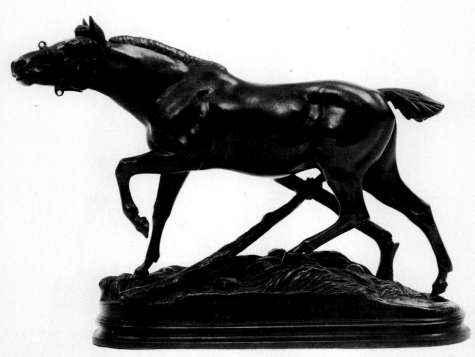

**H12** The wild horse was a continuous source of inspiration to the romantic sculptors of the 19th century and here Moigniez offers his own version of a horse breaking away from a rustic fence. His subjects are so much heavier than Mêne's and it is therefore not surprising that Mêne's models were cast in much larger quantities than most other sculptors, as his work was more popular in the 19th century and still is today.

Signed 'J. Moigniez', titled 'COQUET S'ECHAPPE!!!'
19.7cm (7¾ins.): dark even brown patination
*1870s*                                         *£600 — £800*

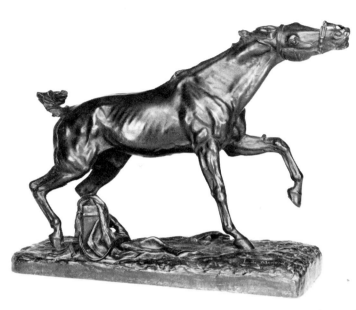

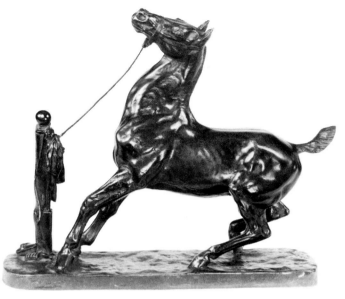

**H13** A vigorous model by de Monard and presumably made as the companion piece to H14 but it is unlikely that they were modelled at the same time or intended as a pair as the bases are so very different. Here the mare appears to have bitten through her bridle completely breaking away from the tethering post, draped with the remains of the bridle and a riding coat. The detail and quality of the base is better than the rather heavily muscled horse, in what is again a rather awkward composition.

Signed 'L. de Monard': 41.5cm (16¼ ins.)
rubbed mid-brown patination

*c.1880* £600 — £800

**H14** Mêne's work was often an inspiration to the next generation, but rarely were his ideas copied successfully as this awkward but amusing model by de Monard illustrates. A well detailed cast of a tethered stallion shying away from a post. Over the post hangs the groom's apron, and at the bottom lie his brushes. An unusual cast for a collector but the value is far less than the more conventional Mêne bronzes which are sought after by the collector and the casual buyer.

Signed 'L. de Monard': 29cm (11½ ins.)
dark brown patination

*c.1880* £600 — £800

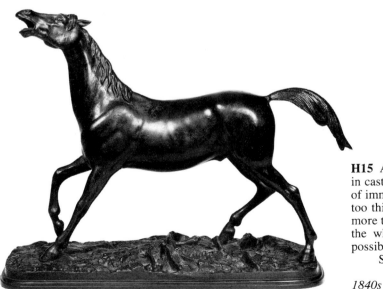

**H15** A rare, early and not particularly good model by Mêne in cast-iron which may well be one of the reasons for its lack of immediate appeal in the illustration. The horse is generally too thin bodied and lacking in detail for Mêne and has much more the style of Moigniez. The base may be slightly later but the whole is a good example of the young Mêne's work, possibly working with his father, an iron founder.

Signed 'P.J. MENE': 26 x 30cm (10¼ x 11¾ ins.)
black patination

*1840s* £600 — £1,000

277

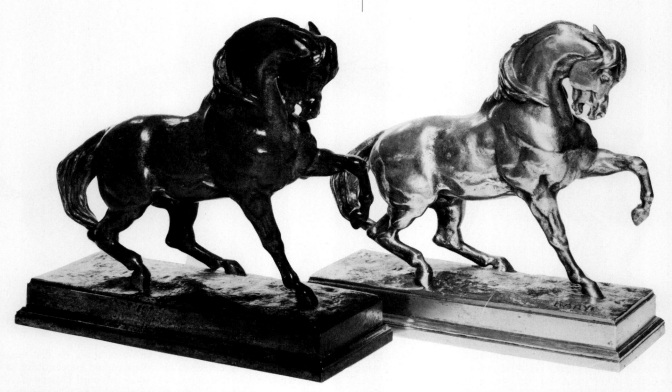

**H16** One of the most powerful of the romantic animalier bronzes the 'Cheval Turc' was also one of the earliest models by Antoine-Louis Barye. Jane Horswell chose it for the front cover of *Les Animaliers* and it has subsequently become one of the most sought after and expensive models. It was cast in various sizes from 29cm (11½ins.) to one of 38cm (15ins.), cast later by Barbédienne. The patination varies enormously and the buyer has to beware of later casts of the early 20th century and the modern post-war recasts. This horse was believed to be modelled for the first time c.1838 but was still listed in Barye's 1847 catalogue.

This is a Ferdinand Barbédienne Gold Initial cast and one of a special series. Although somewhat weakly detailed it retains all of the sculptor's powerful modelling and gives a realistic impression of a finely bred stallion pounding at the ground.

Signed 'BARYE' and with the 'FB' gold initials:
19.2cm (7½ins.) square: green patination
*c.1860* £6,500 — £8,000

**H17** This is the identical model but cast as a special commission in silver by the lost wax process, it has suffered a slight reduction in size as the accurate measurements show. Cast as a novel and amusing silver wedding anniversary present it makes no attempt to be anything but a recent model.

Signed 'BARYE' with 'FB' initials
18.7cm (7⅜ins.) square: silver
*Hallmarked 1971*

*Prices for 'Cheval Turc' have risen considerably in recent years. A rare pair, one with the right, the other with the left foreleg raised realised £55,000 at Sotheby's in June 1984. A single cast realised £17,050 in March 1985.*

The photograph (right) shows the underneath of both the casts shown above, the silver example on the left and the bronze on the right. It shows quite clearly the reduction in size of the later cast. On the bronze example the round headed period bolts can clearly be seen together with a deeply scratched number '47' which interestingly enough does not have the Continental 7. Traces of ink numbers, 3308 and 80, can be seen. These numbers are quite commonly found on Barye's and Mêne's work, and must have been control numbers written on by the foundry foreman after casting and finishing.

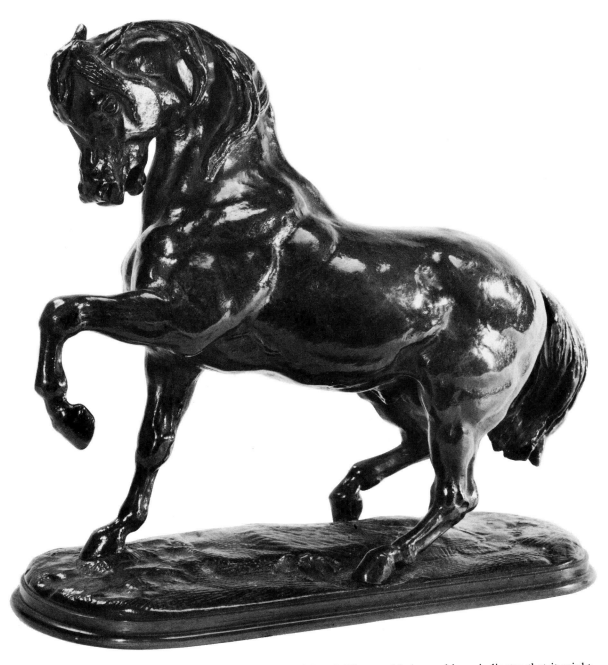

**H18** This is an exceptionally fine version of the 'Cheval Turc'. The moulded round base indicates that it might be one from Barye's 1847 catalogue. The fine rendering of the somewhat over-emphasised muscles is typical of Barye's early dramatic work with comparatively little detail. Note that the base is different from the version shown opposite.

Signed 'BARYE': height unrecorded: dark rich green patination

*1840s*

£5,000 — £8,000

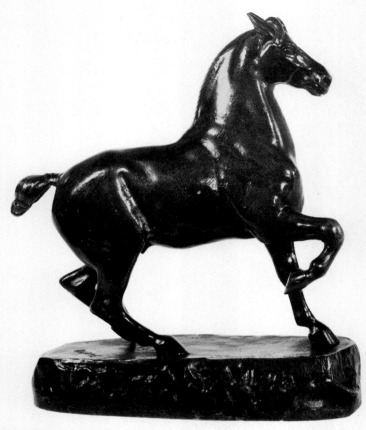

**H19** A less common Barye model and subsequently not as popular amongst collectors for the simple reason that it is not particularly well known. A model of a Percheron stallion c.1850 and listed in the 1855 catalogue, it is directly influenced by Renaissance sculpture, especially that of Bernini. The simple slightly raised base is typical of Barye's work and here we see his romantic side. There is comparatively little detail, the sense of movement and musculature being all that is needed to emphasise the dramatic content of the model.

Signed 'BARYE', numbered 5 on the underside
28cm (11ins.): green brown patination
*1850s* £3,500 — £4,500
*41cm (16ins.) size £4,000 — £7,000.*

**Plate 11** (opposite above)
A fine cast of Pierre Jules Mêne's 'Normandy Mare', first modelled in 1868. Titled 'Jument Normande Seule' numbered 33 in his catalogue, the size given as 45 x 49 x 18cm (17¾ x 19¼ x 7ins.). One of the sculptor's most popular models and one that is often seen with a foal. This fine cast is well detailed with realistic veining and is a superb colour with time and the original patination playing a part in the finish.

Signed 'P.J. Mêne': 42.5 x 49.5cm (16¾ x 19½ins.)
rich copper gilt patination
*c.1870* £3,000 — £4,000

**Plate 11** (opposite below)
Another Mêne model and an equally popular one, titled 'Jument arabe et son poulain' and number 31 in his catalogue. This is amongst the early group of horses by the sculptor and was exhibited at the Salon in 1850. The catalogue offered the group in two sizes, one 30 x 50 x 9cm (11¾ x 19¾ x 22.9ins.) and the smaller size illustrated here. This is a reasonable cast but an average one for the group which concentrated more on the subject than the detail. The frolicking foal is about to receive a warning nip from its mother. The black patination is disappointing but has worn over the highlights to a very rich copper brown colour.

Signed 'P.J. MÊNE': 17 x 26.5cm (6¾ x 10½ins.)
black over copper brown patination
*c.1860* £1,800 — £2,500
*The larger model £3,000 — £5,000*

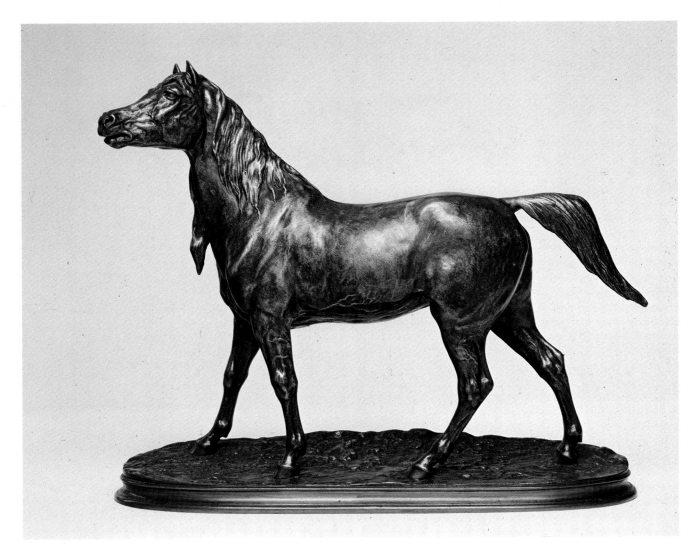

**Plate 10**

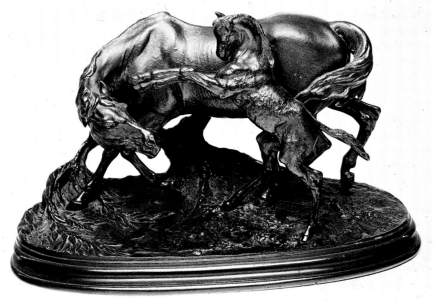

**Plate 11**

281

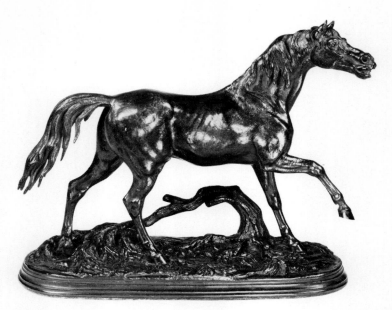

**H20** Having criticised Moigniez unfairly in H9 it can be seen here that although he was principally a bird sculptor, his models when cast in bronze are excellently detailed naturalistic subjects. The pose, however, is always a little contrived possibly because Moigniez invariably interpreted Mêne's models some ten or fifteen years later. This also appears as a group of a mare and stallion which interestingly is also the subject of Mêne's famous 'Accolade'.

Signed 'J. Moigniez': 20.5 x 25.5cm (8 x 10ins)
rich deep brown patination
*c.1870*                                    *£1,500 — £2,000*

**H21** Isidore Bonheur's horses are always far more original than Mêne's; although the subjects can appear a little stiff, they are always very well modelled and detailed and are excellent casts. This running horse was originally intended to be cast with an attendant groom in cavalry uniform running alongside holding the horse's bridle. A good study but better in its original composition.

Signed 'Isidore Bonheur': 30.5cm (12ins.)
rich dark brown patination
*1870s*                                    *£1,500 — £2,500*

282

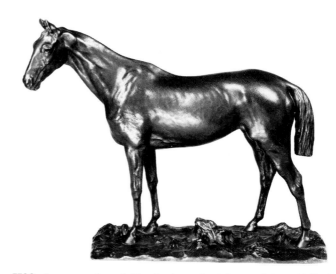

**H22** Until recently Lenordez' work was under appreciated but as prices have risen for good standing horse figures his work has become much more sought after. The quality of the casts is not as good as those of Mêne or Moigniez. The modelling is usually quite strong although sometimes a little lifeless as in this example. However, this horse with plaited mane has good depth of girth and length of tendon. Lenordez tends to use very dark black patination which rubs easily. Most of the horses, which are his most common subjects, are portraits.

Signed 'P. Lenordez', entitled 'La Toucques' and with founders mark Vt Boyer: 26.5cm (10⅜ins.)
heavily rubbed black patination

*1860s* £1,200 — £1,500

**H23** An unusual model by Jant, an Austrian sculptor. At first glance it has much in common with the Paris sculptors of the mid-19th century, but detailed inspection reveals a finish and patination similar to the Bergman foundry work in Vienna c.1900. A well detailed horse spoilt by the half-hearted attempt at the foliage on the base. These are still cheaper than the Paris models and probably well worth buying.

Signed 'Jant, Wien': 28cm (11ins.)
even chocolate brown patination

*c.1900* £800 — £1,200

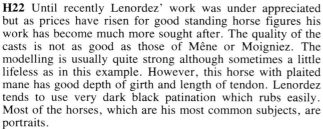

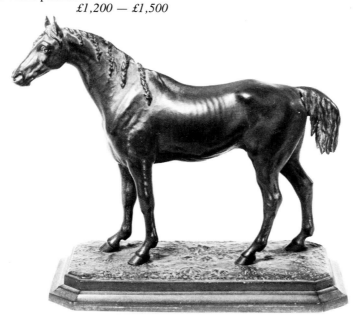

**H24** Another plaited mane and a horse with an extraordinary expression, an idealised perfect horse in which the strong shoulder and depth of girth contrast with the fine head. Technically the horse sits very badly on the base which has an indistinct signature. Could it be an English model?

22cm (8¾ins.): dark brown patination

*c.1890* £700 — £1,000

283

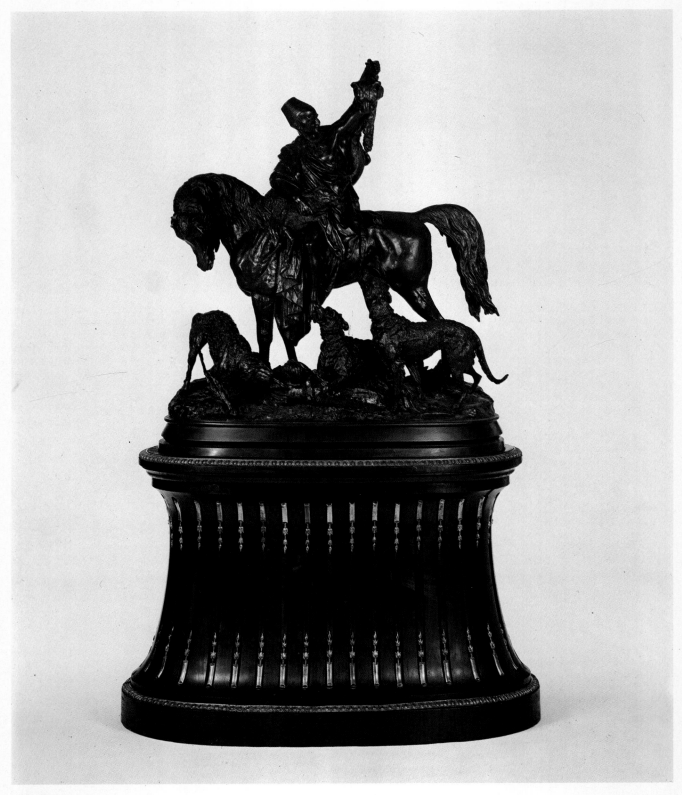

**Plate 13**

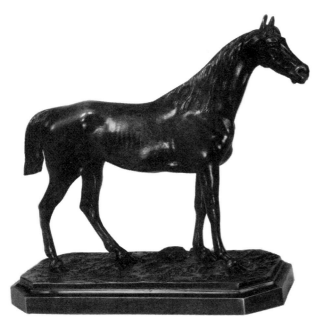

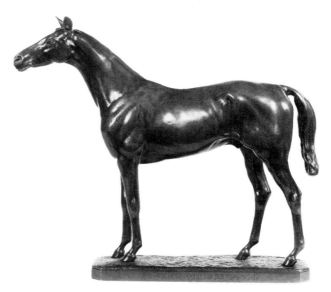

**H25** A meanly modelled horse by the Russian sculptor Lanceray. His models were copied in bronze, cast-iron and white metal and are often reproduced. Visiting trade union delegations are frequently presented with modern casts by their Russian hosts. There is little realism in this horse and the result is far removed from the sculptor's original conception.

Signed in Cyrillic: 21.5cm (8½ins.)
rubbed mid to dark brown patination

*c.1900*                                              *£1,000 — £1,500*

**H26** A rare racehorse by the English sculptor Robert Glassby. In the tradition of many horse sculptors Glassby appears to have earned his living by portrait work rather than inventing romantic scenes and groups of his own. This is a figure of 'Persimmon' with the dates of his hat trick of victory from 1895 onwards. It is therefore reasonable to assume that this model was finished some time after 1897. The body is well modelled but rather let down by the horse's strange eyes and ears.

Signed 'Robt. Glassby' entitled 'PERSIMMON 1895'96'97'
25cm (9¾ins.): red brown patination

*c.1897*                                              *£1,200 — £1,800*

## Plate 13 (left)
### Kabyoe, au Retour de la Chasse

A magnificent bronze group by the little known sculptor Waagen. Typical of the French love of North African subjects which started in the Napoleonic era with the, albeit brief, conquest of Egypt and continued as French influence spread into the hitherto little known countries of Tunisia, Algeria and Morocco in the latter part of the 19th century. It was a land romanticised by literature and the courageous exploits of the French Foreign Legion. The exotic and free life of the nomadic Arab was perfect for the prevailing romantic attitudes of the times and this life was eagerly depicted in decorative schemes and in some cases whole villas were built and designed in the *goût arabe*. Here a young hunter, dressed in an unlikely almost classical robe, but wearing the traditional fez, holds a rescued sheep over the saddle while triumphantly holding up the remains of a wolf caught by his three sturdy hunting dogs who whimper and strain to get at their prey. The beautifully modelled arab stallion appears as fresh and as vigorous as the dogs.

The contemporary base fits exactly with popular design of the time in an eclectic Louis XVI revival style. Veneered in ebony with *bronze doré* husk fillets in the fluting, it alone should realise £1,500 — £2,000 at auction. All pedestals have a dramatic effect on the presentation of a piece of sculpture and this is no exception. It is difficult to imagine the reduction in value of the bronze group itself if it did not have its original base but certainly it would be a reduction of more than the auction value of the base alone. This group is a rare example of an auctioneer recommending restoration to a work of art. Normally clients are well advised not to effect any restoration but as this group had been outside for a number of years and then kept in a barn the patination had deteriorated and the actual bronze had become ingrained with streaks of dirt. The component parts of the bronze and the base were stripped and cleaned and the bronze repatinated at a cost of just over £1,000. The effect was magnificent and the auction price soared well above the highest estimate, justifying the auctioneers decision.

Signed 'Waagen SC': Bronze 118.5 (46¾ins.)
with base 235.5cm (93ins.)

*c.1875*                                              *£15,000 — £20,000*

285

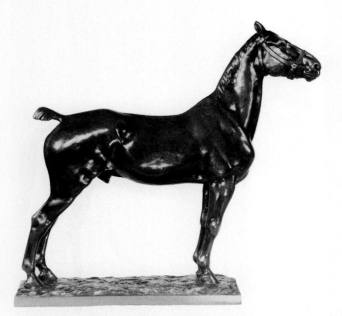

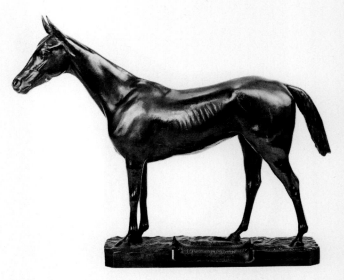

**H27** This fine and large model of a hunter is by the little known sculptor Pierre Tourgeneff. Entitled 'Cheval anglais No. 7' it is the sculptor's view of a most popular European breed. The horse is vigorously modelled and his proud stance is most realistic and attractive.

Signed 'Pierre Tourgeneff': 49cm (19¼ins.)
mid to dark brown slightly rubbed patination
c.1900                                          £1,500 — £2,000

**H28** A rare model by the little known sculptor Arthur Jaques Ledue. This is a portrait model, entitled 'Plaisanterie', with the details of the horse's victories set out on a parchment-like applied plaque. An intelligent alert horse and a fine thoroughbred.

Signed 'A.J. Ledue': 39cm (15¼ins.)
mid-brown patination
c.1885                                          £2,000 — £3,000

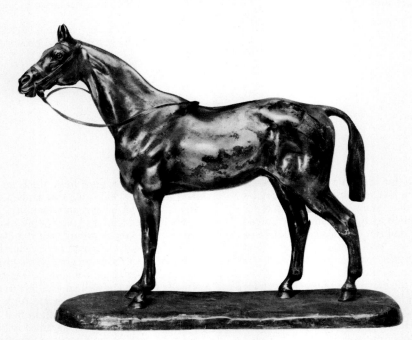

**H29** Many of these animals were electroplated in silver, a fashion which has been discussed elsewhere and one that is unpopular today. This horse by d'Illiers is in poor condition, and almost certainly since it was sold at Sotheby's in the late 1970s it has been resilvered or, more likely, stripped, and now repatinated in mellow brown or a similar suitable tone. This horse is nicely modelled with an intelligent alert look which makes it attractive and consequently more saleable.

Signed 'G. d'Illiers: 26 x 29cm (10¼ x 11⅜ins.)
rubbed silver patination
c.1900                                          £800 — £1,200

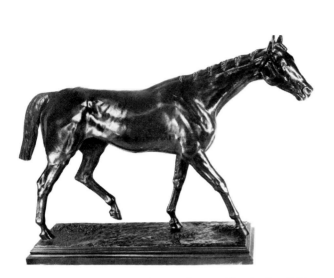
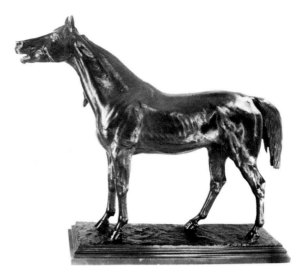

**H30** A fine and rare pair or thoroughbreds by Isidore Bonheur. It is not known whether these two models are portraits or whether Bonheur has created a romantic group of a wild stallion luring away a well disciplined mare, suggested by the plaited mane and well groomed tail of the mare contrasted with the free mane and unkempt tail of the stallion. The modelling is of first class quality with plenty of veining in the legs and some indications of hair on the flanks of the stallion. Unfortunately there is no record of the size of each horse. A similar horse to the one on the left with jockey up is recorded as 63.5cm (25ins.) wide.

Signed 'I. Bonheur': rich dark brown patination

*c.1880*         *the pair £8,000 — £12,000*

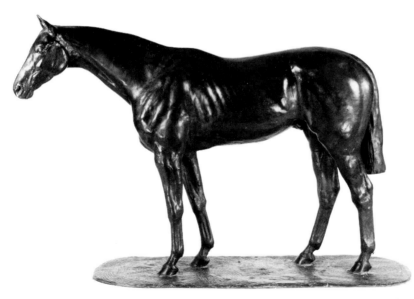

**H31** An exceptionally fine and rare model by Herbert Haseltine, whose work is not commonly found in Europe and is always highly sought after. The modelling of the stallion is excellent with powerful shoulders and detailed rib cage, and almost looks as though the sculptor started with the bone and then added the muscles and skin to achieve this standard of realism. This is a cast from Valsuani the Italian foundry which produced most of this sculptor's work, and, as always, is technically brilliant. The smoothness of this model contrasts with the sculptor's impressionistic technique which is very much in evidence in two fine wax models on view at Elton House, near Oundle.

Signed 'H. Haseltine', and 'Valsuani Fondeur', numbered 2

57 x 74cm (22½ x 29ins.): rich deep brown patination

*Dated 1914*       *£5,000 — £8,000+*

287

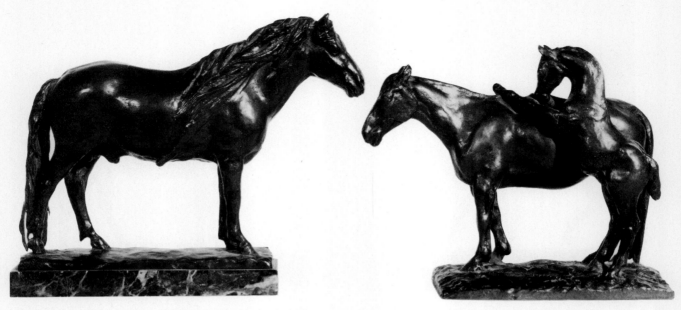

**H32** These two models are by the English sculptor Sybil Barlow. On the left a wild stallion with a long tousled mane and ungroomed tail reaching to the ground; possibly the mare and her foal were intended as a companion group. The modelling is anatomically accurate but highly romantic. This type of 'sweet' subject either appeals enormously or is considered too 'chocolate box' depending on one's point of view.

*c.1930*

Both signed 'Sybil Barlow'
stallion 25cm (9¾ins.) long
mare and foal 21cm (8¼ins.) long
deep rich even brown patination

*each £800 — £1,200*

**H33** A limited edition by the Morris Singer Foundry taken from a model of a tired work horse by the painter Thomas Gainsborough. It is worth reflecting for a moment that the original of this model was executed in the 18th century but has close similarities with the slab-sided work of Constantine Meunier in Belgium in the late 1890s, and even a similarity to the impressionistic models of Degas. These limited edition

reproductions may lose value for the first years of their life but eventually will become sought after collectors' pieces.
Signed with the Morris Singer Foundry seal
and with a title plaque 'Thomas Gainsborough 1727-1788',
numbered 13 out of 500: 23cm (9ins.) long

*1970s*

*£300 — £500*

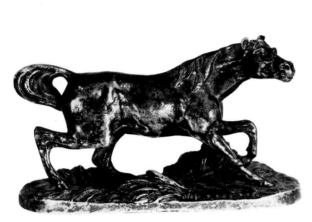

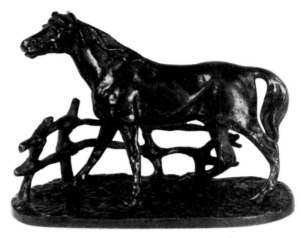

**H34** A miniature model of a stallion by Mêne that is becoming more and more difficult to find. These small models which appeal to collectors outside the animalier field are easily portable and fit into any decorative surrounding, consequently the prices fluctuate considerably. Miniatures are often crudely cast and poorly detailed and are examples of the sculptor's commercial bread and butter work for the consumer market rather than his highly romantic sculpture, and are often vulnerable, this one has been squashed down, being supported only by the thin legs.

<div align="center">

Signed 'P.J. MÊNE': 9cm (3½ins.) wide
heavily rubbed black patination
</div>

*c.1870* £300 — £500

**H35** Another miniature by Mêne, a reduction of the Barbary stallion 'Djinn', more commonly known as 'Cheval à la Barrière'. The modelling is good but with little detail but nevertheless very popular.

<div align="center">

Signed 'P.J. MÊNE': 6.5cm (2½ins.)
dark rubbed black patination
</div>

*c.1870* £300 — £500

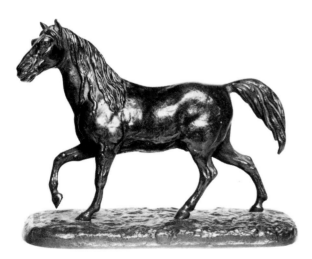

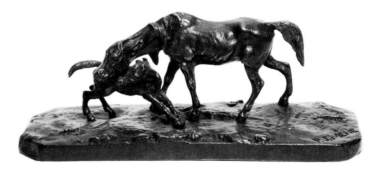

**H36** An unconvincing horse by Mêne, which although well modelled lacks detail in the face, especially the nostrils which are badly cast. The figure itself has a lot in common with Mêne's horses but it is difficult to believe that the base is the original.

<div align="center">

Signed 'P.J. MÊNE': 10.3cm (4ins.)
mid-brown patination
</div>

*Probably a late 19th century cast* £300 — £500

**H37** This miniature group by Mêne is quite an early one from the 1840s. A later version has a wide flat basket at which the mare was attempting to feed and also has the more typical moulded oval base.

<div align="center">

Signed 'P.J. MÊNE', 7 x 20cm (2¾ x 8ins.)
rubbed red brown patination
</div>

*1840s* £500 — £700

289

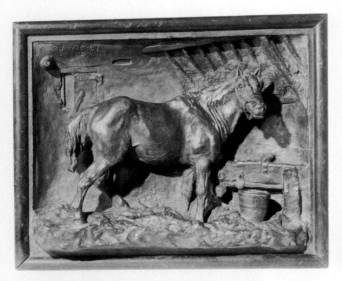

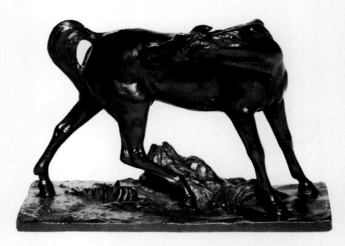

**H38** This plaster plaque in full relief of a stallion in a stable with a charmingly rustic hay rack and trough epitomises its period bearing in mind that this was modelled in 1840. Only copper electrotypes of this model have been seen by the author, and it may well be possible that Mêne modelled this to experiment with electrotype casting which was in its infancy in the middle of the century. An unusual model for animaliers but not of wide appeal.

Signed and stamped 'P.J. MÊNE': 38cm (15ins.)wide
*Dated 1840* £600 — £1,000

**H39** An exceptionally finely modelled young stallion by Theodore Gechter, who was working in the second quarter of the 19th century. Most of his models are of horses sometimes with a rider, and many appear to be sand cast. Note the simple square-sided base which is indicative of the early period. This model, which is an exceptional cast with a wonderful plastic quality, is a very touchable bronze. The collector to begin with uses sight only to judge quality, but the sense of touch is equally important and only comes with experience.

Signed 'T. Gechter': 9.2 x 13.3cm (3⅝ x 5¼ins.)
dark brown patination with traces of gilt
*1840s* £500 — £800

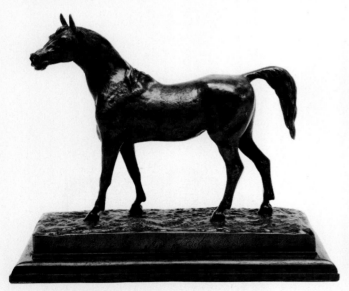

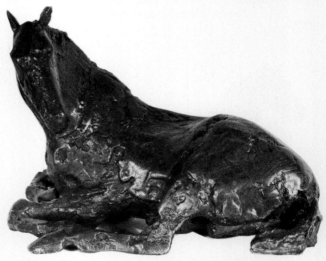

**H40** A small portrait model of a racehorse entitled 'Arc-en-Ciel', that has been slightly overshadowed by the large bronze base and even larger oak plinth. The rectangular wide base with severely straight sides is typical of the earlier models. Models before about 1850 often have a rather charming naïvety under appreciated by collectors. This horse is well detailed and a good small collector's model.

Signed 'FRATIN': 30.5cm (12ins.)
rubbed dark brown patination
*c.1850* £1,500 — £2,500

**H41** By the middle of the 20th century sculptors had amalgamated impressionist, cubist and modernist theories and here is the delightful result in the work of Elizabeth Frink. To the uninitiated this irregular cast may look like a reject but the undulating surface of the horse's body is an effective medium for the reflection of light giving a sense of movement and living tissue; the horse has been modelled just in the process of turning his head.

Signed 'Frink' and numbered 8/12
16cm (6¼ins.)wide: copper bronze patination
*c.1972* £4,000 — £6,000

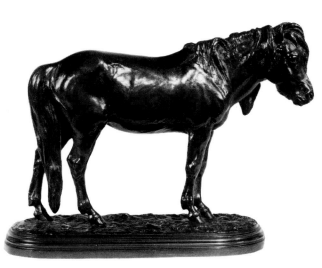

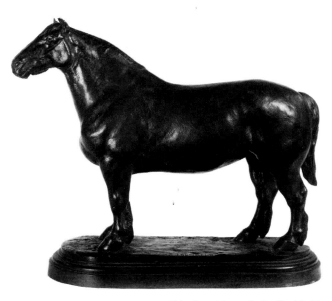

**H42** A very sensitive model by Isidore Bonheur of a mountain pony with a sad and dejected look in his eye, perhaps intended to be a portrait of a pit pony. Bonheur's subject which is vigorously modelled and wildly romantic and not unlike H32 by Sybil Barlow, is a full generation's work earlier which must always be taken into account.

Signed 'I. BONHEUR', and with Peyrol Foundry stamp
18.5cm (7¼ins.): rich dark brown patination
*c.1880*                                                  *£800 — £1,200*

**H43** Bonheur is again responsible for this technically highly competent Percheron horse. The horse may not appeal as a decorative subject for the amateur collector but one has to admire the sculptor's anatomical skill. Every part of the horse's coat is detailed. Barye modelled a similar horse in the 1850s, Bonheur's model lacks only the powerful movement of Barye's work. This model was exhibited at the Salon in plaster in 1870.

Signed 'I. BONHEUR', stamped with foundry stamp Peyrol
Editeur: 26cm (10¼ins.): deep brown bronze patination
*1870s*                                                  *£2,000 — £3,000*

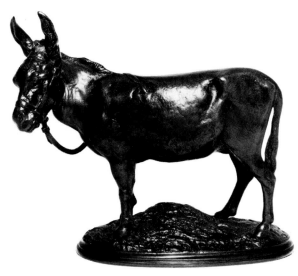

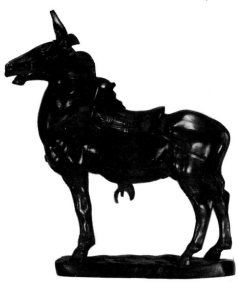

**H44** A charming small model of an African donkey by Cain. Sculptors and painters alike found great inspiration in the French conquests of Northern Africa in the second part of the 19th century. This one is modelled in detail and not often seen on the open market today. For such a docile animal it is very powerfully modelled and has a lot in common with Cain's exotic life sized animal groups in the Tuileries.

Signed 'A. CAIN', entitled 'ANE d'AFRIQUE'
14.5cm (5¾ins.): dark rich brown patination
*c.1865*                                                  *£800 — £1,200*

**H45** A mule by the sculptor G. Parvis who has been influenced by North Africa; the saddlery is very Moorish. Parvis here is copying Frémiet's 'Ass of Cairo'. A strange little model but quite decorative.

Signed 'G. Parvis': 18cm (7ins.) wide
black brown patination
*Dated 1904*                                              *£300 — £500*

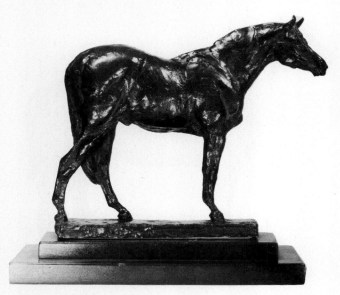

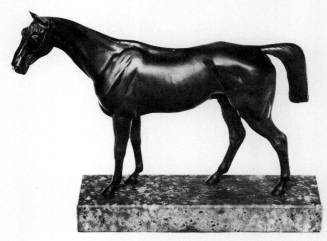

**H46** An early 20th century cast of a horse called 'Decision'. The modelling is influenced by the impressionistic techniques of Degas and Bugatti. The work of the thumb and finger on the wax model can clearly be seen in the photograph.
Titled 'Decision': 23cm (9ins.) wide: dark brown patination
*1920*                                                    *£700 — £1,000*

**H47** The period of this horse should by now be obvious but the model lacks all the characteristics and power of H48. If a sculptor cannot model an eye correctly then the rest of the animal will look wrong, however competent. As is so often the case with a marble base there is no signature; perhaps the sculptor does not wish the work to be marked down for posterity?

dark brown/black patination
*1910-1920*                                              *£300 — £500*

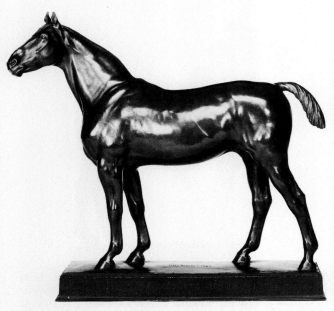

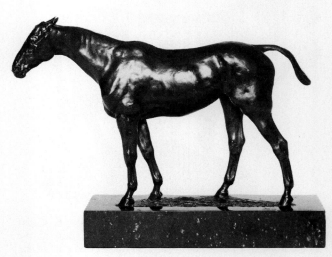

**H48** A fine German model by Otto Richter which has all the characteristics of the German *jungendstil*. Like the previous model it is smooth skinned but characteristic with a very black patination. In the last two or three years, mainly because of the work of the sculptor Frans Stuck, this type has become much more popular.
Signed 'Otto Richter': black patination
*Dated 1925*                                              *£800 — £1,200*

**H49** A good model except for the uncharacteristic tail. The smooth surface of the horse is possibly a little off putting, and although certainly an accurate portrait it is not a very attractive or commercial bronze. The small base that just encompasses the four hooves is a novel idea and possibly would look better not mounted on marble.

*£1,200 — £1,800*

292

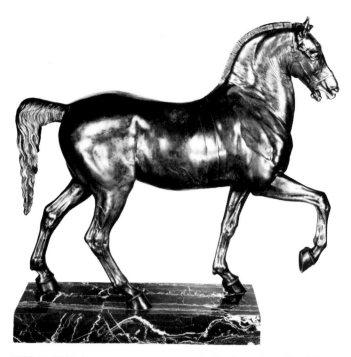
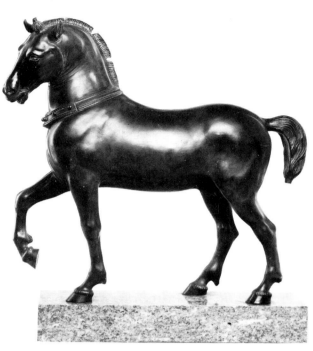

**H50 & H51** Two contrasting models (both unsigned) of the famous horses from the Basilica of St. Mark's in Venice. The even dull black patination of H51 makes it seem lifeless compared with H50 which has a rich undulating patination reflecting light. The modelling of the latter horse is finely detailed with a very powerful head and mouth. There are many copies of this famous horse and there is no reason why they should not have their own intrinsic value as good decorative objects.

Both 105cm (41¼ins.)

c.1900                                      *H50 the pair £5,000 — £7,000*
c.1900                                      *H51 the pair £4,000 — £5,000*

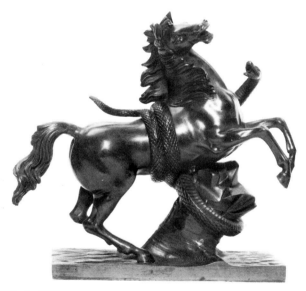
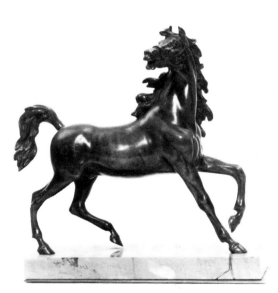

**H52 & H53** Both these unsigned models are probably sand casts and the type of figure modelled for jewellers and clockmakers to stand above marble clocks made in the 1830s and '40s. The eclectic medieval and gothic style, known in France as 'le Style Troubadour' in the reign of Charles X had passed, and the fashion for animals had taken its place. The patinations are very smooth and usually black. The snake around the first horse disguises the fact that this complicated model was made in several parts and joined at the girth.

H52: 24cm (9½ins.): rubbed black patination

c.1840                                            *£300 — £400*

H53: 23cm (9ins.): rubbed black patination

c.1840                                            *£300 — £400*

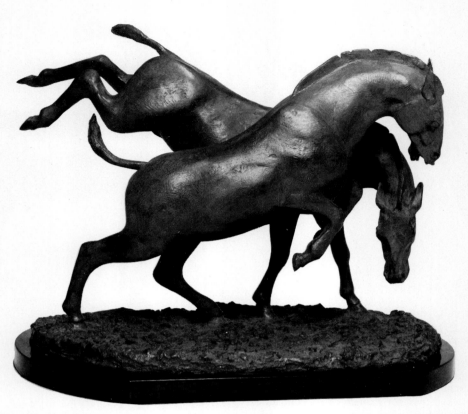

**H54** This group is by Terry Mathews a contemporary sculptor, whose work is exhibited at the Tryon and Moorland Gallery. He often concentrates on African subjects and here he has modelled an exotic group of a pair of cavorting zebras. The modelling is very loose, and the eye should not be drawn to the lack of detail but the balance and sense of movement of the subject. Contemporary sculptors rarely try to simulate a grassy base, unlike the earlier animaliers, who often spoilt good sculpture by distributing naïve foliage on the bases of their work.
*c.1975*

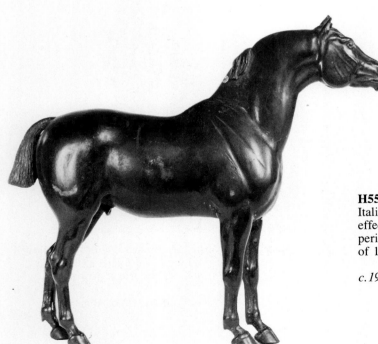

**H55** A good model of a stallion in late 16th early 17th century Italian style, and often reproduced. This horse is quite effective without a base which is in keeping with the intended period. A good decorative subject without the sentimentality of 19th century concepts.

35cm (13¾ ins.): worn black patination

*c.1900* £500 — £800

294

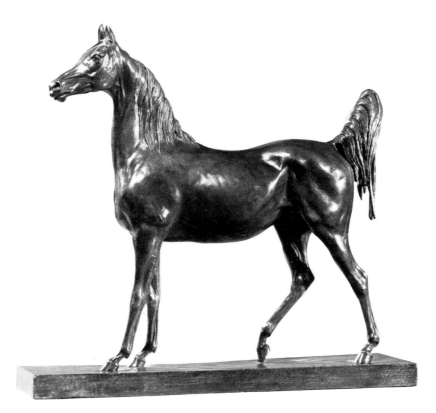

**H56** A very dainty Arab mare by Pamela du Boulay and one of a limited edition. The horse called 'Shammah' is a very lively portrait of a highly strung nervous creature. It is interesting to note that the sculptor has reverted back to a simple slab sided base of the second quarter of the 19th century.

Signed 'Pamela du Boulay'

*c.1970*

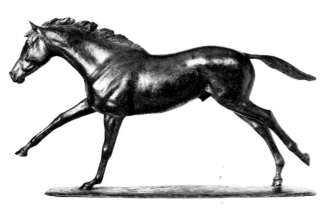

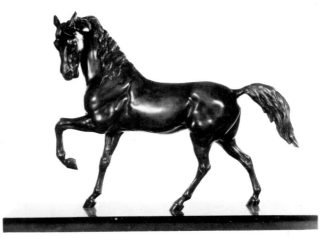

**H57** A galloping horse by Adrian Horsley, a contemporary sculptor. Here the surface has been left deliberately uneven to give a sense of texture and the sculptor has not attempted to give excessive detail to the mane and tail. The movement is bold but a little difficult to live with. The horse 'Grundy' was born in 1972 and had a highly successful season in 1975.

Signed 'Adrian Horsley' 2/12, and
with Manningford Studios foundry mark: 79cm (31ins.) long
*Dated 1976*                                    £1,200 — £1,800

**H58** This high stepping animal dates from c.1900. The smooth skinned horse is mounted on a black Belgian slate base signed 'Ch. Valton', but it is unlikely that Valton who was working in the late 19th century would have used a base of this type and the style of this horse is very far removed from his normal practice. It must be assumed that somebody added the signature to the base, which seems a strange thing to do for such an under-appreciated sculptor. Modern casts in spelter have been seen of this model.

Signed 'Ch. Valton': 40cm (15¾ins.)
green/brown patination

*c.1910*                                          £600 — £900

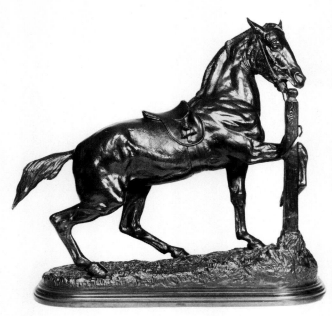

**H59** A fine and rare model by Isidore Bonheur of a mare tied to a post. The impetuous animal has managed to catch its foreleg in the reins and is beginning to struggle frantically. This is a very well modelled figure with a lot of detail and vigour and is very much a period piece, in which the sculptor has modelled the stirrups correctly run up. A very light cast in weight, an important factor in a period casting remembering that the foundry man's time was not as expensive as the bronze material used and that 'light is right'.

Signed 'ISIDORE BONHEUR'
37.5 x 37cm (14¾ x 14½ins.): black brown patination
*c.1870s* £4,000 — £5,000

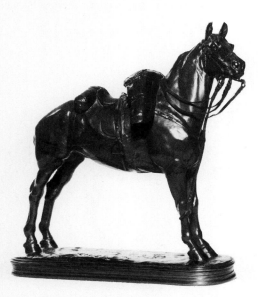

**H60** An exceptional cast by Frémiet of a very rare model of a military horse tethered in the field. This model was exhibited at the Salon in bronze in 1859. Here Frémiet has captured some of the power and realism of Barye's work in the eager look on the alert horse's face, but is in danger of becoming sentimental. The attention to detail of the tack is first class. The saddle cloth is marked with a cipher of a flame above a sphere and is possibly from the Regiment of Engineers. Some authorities think it may be Napoleon's horse.

Signed 'FREMIET': the harness numbered one
30 x 30.3cm (11¾ x 12ins.): rich brown red patination
*c.1860* £2,500 — £3,500

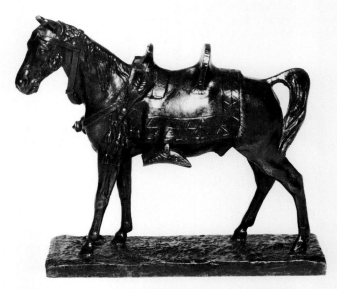

**H61** This horse is instantly recognisable as Gechter's work, the saddle possibly disguising a join in a sand cast. The horse is lightly muscled and with an elaborate saddle typical of the North African horseman, is a comparatively early interpretation of Arab influence in French sculpture. Unfortunately Gechter's work is often over simplified and it does not make this a particularly attractive subject. Note the early base.

Signed 'T. Gechter': 11.5 x 13.7cm (4½ x 5½ins.)
heavily rubbed brown patination
*c.1843* £600 — £900

296

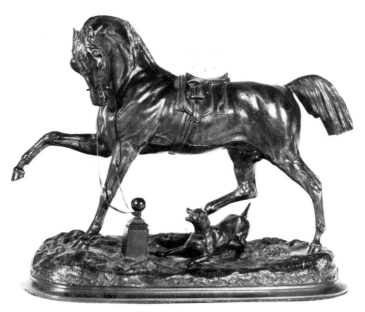

**H62** A very fine and comparatively rare cast by Lenordez, entitled 'Angelo' which is exceptionally well modelled in detail for this sculptor and on a theme presumably influenced by H59. Here a French terrier has frightened the stallion and altogether this concept makes for a delightful conversation piece. Another version has a greyhound leaping up at the saddle.

Signed 'P. Lenordez', and with founder's mark V. Boyer
40cm (15¾ ins.): rich dark brown patination
*c.1855* £2,000 — £3,000

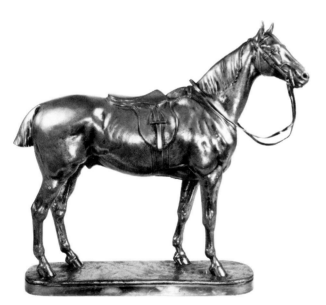

**H63** One of the best known English horse sculptors is John Willis Good, but unfortunately his models are very popular which has meant many recent copies of these works. Good models are difficult to find and if they are ever sold from a good collection the bidding is extremely competitive. This alert horse wears well modelled tack that does not detract from the form of the horse, and the surface is finely detailed.

Signed 'J. Willis Good': 41cm (16ins.)
dark brown patination
*c.1880*
in bronze £2,500 — £3,500
*if plated £1,500 — £2,500*

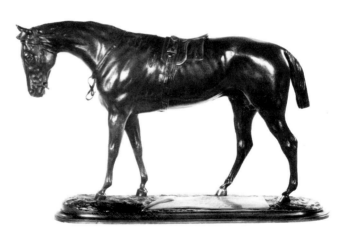

**H64** The exact authorship of this model is not known and although it is signed Boyer Frères this must surely be a model by Lenordez. The patination stance and character are very similar to this sculptor's work and in H62 we find Boyer casting Lenordez' models. The cast is a little worn and the sad horse looks less than triumphant after his victory.

Signed 'Boyer Frères', entitled 'Boiard Vanquer du Derby et Grand Prix de Paris 1873': 23cm (9ins.)
rubbed dark brown patination
*c.1873* £1,200 — £1,600

297

These two pages show the work of an active and leading participant in the contemporary return to the romantic modelling of animals in natural poses and settings. Annette Yarrow often captures fleeting glimpses of horse movement that the human eye sees but does not normally register. She works from ideal surroundings as her studio directly overlooks a field in which she keeps her own horses, who become the models for her sculpture. Aided by her husband, John Elliot, a professional photographer, she is able to harness modern techniques to capture every movement of her models.

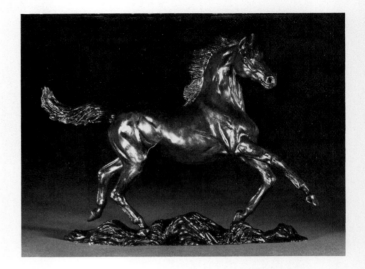

**H65** 'Kelpie' — a water spirit in the form of a young stallion, executed with a vigorous sense of movement heightened by the swirling impression of waves that form the base. This model has a delightful waxy feel to it and a very good, strong chestnut rich brown patination.
*c.1980*                                                  *£4,800*

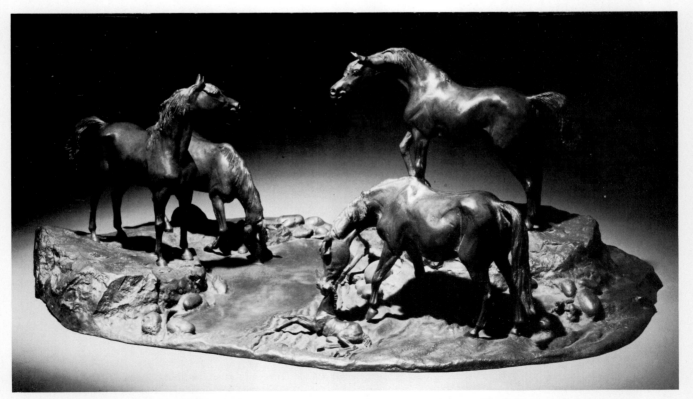

**H66** Five horses in one group is something that was rarely attempted in the 19th century. Only the German influenced foundries casting for Lanceray created these highly complex groups of up to one metre across. Here the horses, three generations of the same family are grouped by Yarrow around a waterhole in the desert.
*c.1980*                                                  *£9,750*

298

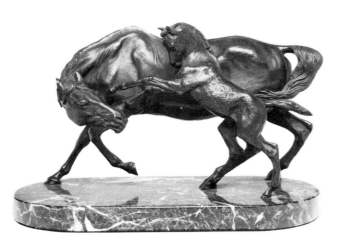

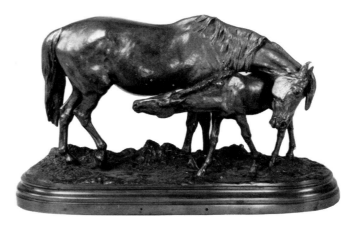

**H78** This is possibly a somewhat unfair example of Mêne's 'Jument arabe et son poulain'. A better version is illustrated in colour on p.281. This model with its presumably contemporary marble base is almost certainly a very late cast possibly between 1910 and 1930 when bronzes were often mounted on marble as with the art deco groups. There is of course always a possibility that this unsigned version has lost its 19th century base but the general patination and feel suggest a 20th century cast.

<div align="center">

27.5 x 42cm (10¾ x 16½ins.)

even mid-matt brown patination

</div>

*c.1930*                                           £500 — £800

At least this version will be considerably cheaper than a mid-19th century cast in the smaller size of 15cm (6ins.), which could realise £1,800 — £2,500.

**H79** This is a rare and excellent group by Isidore Bonheur whose work is always to a consistently high standard possibly lacking only in its sense of adventure. This was exhibited at the Salon in plaster in 1859 and became a very popular commercial model. Most are cast by his uncle Hippolyte Peyrol although the cataloguer in 1973 in this instance made no note of the stamp. This is a good time to remind the Bonheur collector of how very small the Peyrol stamp can be, no bigger than 3mm (⅛in.) wide.

<div align="center">

Signed 'I. Bonheur': 18 x 30.5cm (7 x 12ins.)

rich even dark brown patination

</div>

*1860s*                                          £2,500 — £3,500

**H80** Fratin's sensitive work includes at least three mare and foal groups, and two variations are listed in *Les Animaliers* on pp. 92 and 93. The version illustrated here although with the added attraction of a well chewed feed barrel is not quite as sought after because the small foal hiding beneath its mother's belly tends to create a less elegant mass of bronze.

<div align="center">

Signed 'Fratin': 29 x 36cm (11½ x 14¼ins.)

dark rich brown patination

</div>

*c.1840*                                          £2,500 — £3,500

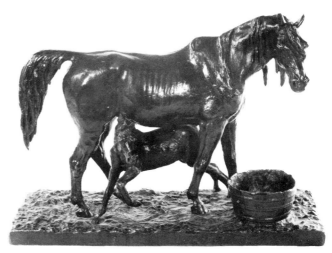

The group below, known as 'L'Accolade', is one of the best known and most popular examples of Mêne's work. It was numbered 27 and entitled 'Group Chevaux Arabes' in Mêne's catalogue, available in three sizes, one being 44 x 68 x 24cm (17¼ x 26¾ x 9½ins.). Originally exhibited in wax at the Salon in 1852, it was exhibited in bronze the following year. The two horses 'Tachiani' and 'Nedjibé' both appear as separate models. Combined as a group they epitomise the romantic but realistic work of the mid-19th century and 'L'Accolade' has been often copied in bronze, cast-iron and white metal, including modern reproductions. H83-H87 show a selection of models whose sculptors clearly drew inspiration from this famous bronze.

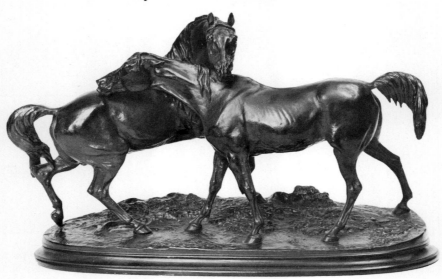

**H81** This large group of 'L'Accolade' by the Scottish Falkirk Foundry is in cast-iron. Quite legitimately it still bears the signature of P.J. Mêne and is a fine example of a reproduction almost certainly cast towards the end of the sculptor's life but with his cognizance.

Signed 'P.J. MÈNE': 53cm (20¾ins.) long
dark brown patination

*1870s*                    £1,200 — £1,800

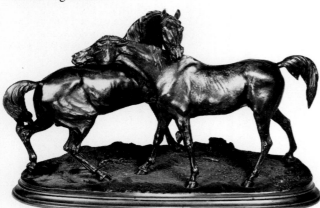

**H82** A fine example of a more common size of approximately 34cm which is also the most convenient and popular size for modern living. The patination is a little rubbed but there is plenty of detail on the horses' coats and veining in their legs. It is of course impossible to date the cast exactly especially in such a popular model which would have been cast from the 1850s onwards but it would be reasonable to assume that one of this quality was c.1860.

Signed 'P.J. MÊNE': 34cm (13¼ins.)
rubbed dark brown patination

*c.1860*                    £3,000 — £5,000

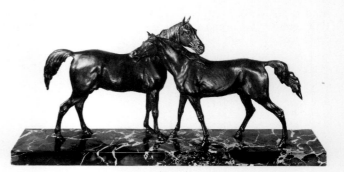

**H83** These two horses are well modelled and well placed on their marble plinth. The detail is quite good and the general effect is of a pleasing group for the collector with a smaller budget. The one on the left is 'Ibrahim', the other is the 'Barbary Stallion', both Mêne models, but this cast is unsigned.

23cm (9ins.) wide
rubbed mid-brown patination

*c.1910*                    £700 — £1,000

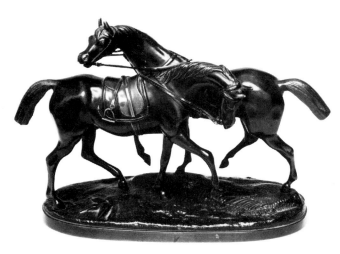

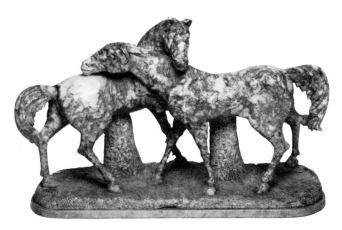

**H84** This unsigned small group is well modelled with a lot of attention paid to the horses' tack, but with wild staring eyes and a stance much associated with the work of Gechter. An inventive sculptor, his casts were mainly sand casts as in this case where the two halves of the body have been joined together hidden by the girth. If indeed this is by Gechter it must pre-date Mêne's 'L'Accolade' by almost a decade.
13.3 x 17cm (5¼ x 6¾ins.)
even varnished copper brown patination
*1840s*                                    *£400 — £600*

**H85** A very crude group in poor quality grey veined white Carrara marble. The bronze founder has an advantage over the marble sculptor who needs to support the underbelly of each horse with an unrealistic 'tree stump'.
57cm (22½ins.) high
*c.1900*                                    *£600 — £900*

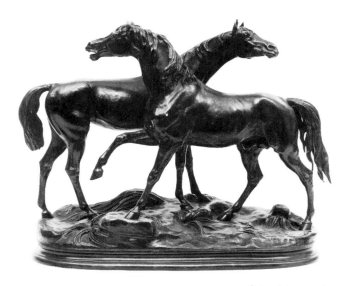

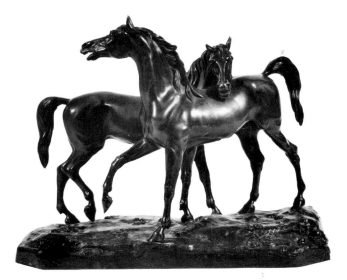

**H86** The best of the similar groups is possibly this one by Moigniez. However, the sense of balance is not as good and there is a lack of originality. This base is particularly elaborate and altogether makes a handsome and less expensive group.
Signed 'J. Moigniez': 33cm (13ins.)
rich black patination
*c.1860*                                    *£2,500 — £3,000*

**H87** Another very similar and early group in the style of Moigniez but one suffering again in the sense of balance. The horses are very smooth skinned and lacking in detail, a fact which the sculptor has tried to make up for in the uneven base elaborately strewn with flowers.
25cm (9¾ins.)
rubbed dark green/brown patination
*1850s*                                    *£1,200 — £1,600*

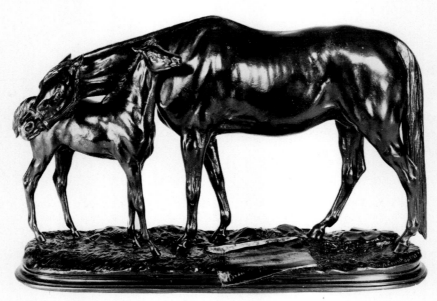

**H88** A very sensitive, rare portrait group by Lenordez, a mare and foal version of 'L'Accolade', typical of his work. Yet again he has a 'paper' scroll on the base giving the details of the foal who was born in 1858, and the fact that the mare won the Epsom Oaks. As well as the sculptor's signature the base is inscribed 'Duplonet Salle'.

Signed 'P. Lenordez Sc.': 29cm (11½ins.)
black patination

*c.1860*                                    £2,200 — £2,800

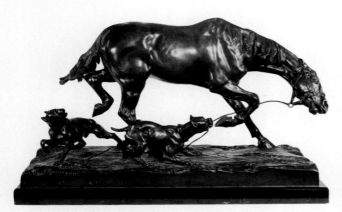

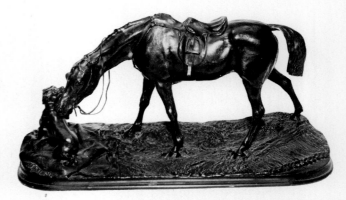

**H89** An amusing group by A. Marazzani where the poor horse is being terrorised by two French bull dogs one of which is about to be kicked out of the way. The balance and action of the animals is very well executed and the position of the horse's head being pulled down by one of the dogs must have been very difficult to model. There are so many very good sculptors producing competent animal groups but, because their work has not been seen, are under appreciated, especially in the sale room. Had this been a group by one of the mid-19th century Paris animaliers it would be worth at least twice as much.

Signed 'A. Marazzani': 36cm (14¼ins.)
even mid-brown patination

*c.1880*                                    £1,200 — £1,800

**H90** This well-loved group by Pierre-Jules Mêne titled 'Jument a l'Ecurie Juoaunt avec un Chien', was exhibited in the Salon of 1859 in bronze and appears as No. 34 in Mene's catalogue, the size listed being 25cm x 47cm x 18cm. It is possibly a little too 'chocolate box' for some but an interesting group as part of a representative collection. This group is fondly termed 'The Good Companions'.

Signed 'P.J. MENE': 24.5 x 48cm (9¾ x 19ins.)
rich dull brown patination with traces of gilding

*c.1860s*                                   £2,000 — £3,000

306

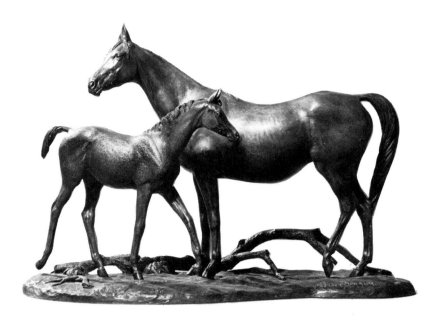

**H91** Pamela du Boulay must rank among the finest contemporary animalier sculptors. It is interesting to compare her mare and foal group with H88 and to reflect that there is over a hundred years intervening between their conception. The du Boulay version appears far more confident and better balanced. Every millimetre of the surface of the horses is finely worked with care, and at last the animalier sculptor has been able to decorate the base of the group sensibly with a realistic fallen branch.

Signed 'PH du Boulay': rich copper brown patination
*c.1970*

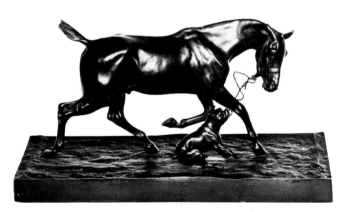

**H92** At first glance this unsigned group has a lot in common with the Marazzani group in H89 but is much cruder with far less attention to detail. The base in this instance is too big and the sculptor has made the mistake of not positioning the dog so that it can be more clearly seen.

20cm (8ins.) wide: rich chocolate brown patination
*c.1900* £500 — £800

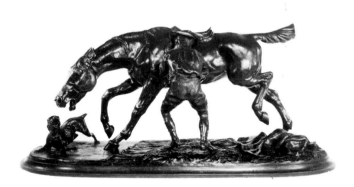

**H93** This surely is one of the more amusing animalier groups, possibly inspired by his tutor Mêne's group in H90, but this version by le Comte du Passage incorporates the highly original idea of the groom struggling with an excited horse. There is no mistaking the nationality of this group with the typically French griffon snarling ferociously at the horse. The groom with his head tucked under the saddle flap to tie up the girth is a marvellous touch. A comparable group by du Passage of a groom running with a horse is illustrated in *Les Animaliers* p.274, and worth in the region of £2,500 — £3,500.

Signed 'A du Passage': 29cm (11½ins.)
rich mid-brown patination
*c.1890* £1,800 — £2,500

**H94** Comparatively little of Paul Gayrard's work is available and this version of his 'Cheval d'Attelage Harmaché et Bridé' is certainly the most powerful of his figures. It is in complete contrast to his other work of the same period and almost in the class of Barye in this instance. This version appears in several sizes and the smallest size of 33cm (13ins.) can be found in a technically almost perfect finish. The detail of the horse's hair and the harness is invariably excellent and the stance of the horse gives the figure immense power. The plaster was exhibited in the Salon of 1847, and the highly acclaimed bronze a year later. The large versions are highly decorative and can often be superb Boyer casts.

Signed 'P. GAYRARD': 64cm (25¼ins.)
rich dark green patination
*1847* £2,500 — £3,500
*32.5 (12¾ins.) version £3,000 — £4,000*

**H95** This powerful unsigned version in plaster of a horse, has similarities in style to the work of Meunier but lacks the Belgian sculptor's in-built sense of power. This however is a good study of a horse at work, but not very popular due to its large size.

60 x 60cm (23½ x 23½ins.): bronzed patination
*c.1900* *the plaster £400 — £600*
*the bronze £600 — £900*

**H96** An extremely powerful group in the style of Constantin Meunier by a Czech sculptor. This group is typical of the period in the early years of the 20th century in which the sculptor has amalgamated Belgian, French and German ideas. The empathy between man and beast is well portrayed, man appearing almost secondary to the powerful horse. Much European sculpture of this period is still underappreciated and, although stylised, must be a sound investment for the future.

Signed 'Ladislad Saloun': 39cm (15¼ins.)

rich very dark green patination

*c.1910*                                                *£800 — £1,200*

**H97** An indifferent and rather naïve version of a dray horse by Louis Kley. The blinkered horse in full harness looks rather bored with the whole affair, and the quality of the casting is somewhat indifferent. Compare this with Gechter's work.

Signed 'L. Kley': 12.8cm (5ins.)

rich dark brown rubbed patination

*c.1870*                                                *£300 — £400*

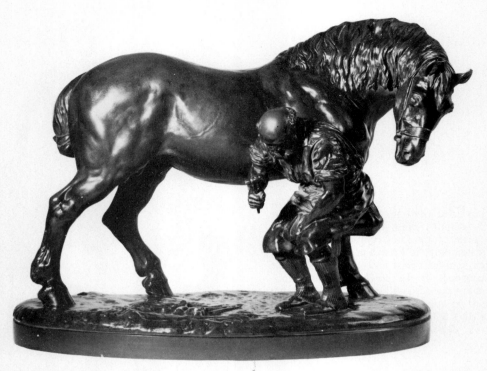

**H98** A fine and rare group by Boehm of a farrier shoeing a Suffolk Punch. An unusual and difficult subject, in this instance it works very well indeed. The elderly craftsman has made his patient relax to an unusual degree and it is nice to see the added detail of some of the tools of his trade on the stable floor. A sensitive and well balanced group. This must be the model exhibited by Boehm at the Academy in 1869 and is almost certainly a *pièce unique*.

Signed 'Boehm': 42cm (16½ins.)
rubbed deep copper brown patination

*c.1869* £4,000 — £6,000

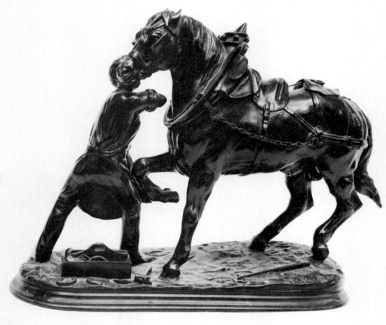

**H99** A lively group from the studio of Pierre Lenordez. The heavy horse stands with its right foreleg in the hand of the farrier who is shouldering the horse's head out of the way. A well detailed group which is unusual for this sculptor. The addition of the farrier's tools on the ground adds interest. Lenordez also produced an excellent version of a Welsh mountain pony illustrated in *Les Animaliers* p.272.

Signed 'P. Lenordez Sc': 27cm (10½ins.)
black patination

*c.1870* £1,500 — £2,500
*Welsh mountain pony £1,200 — £1,800*

310

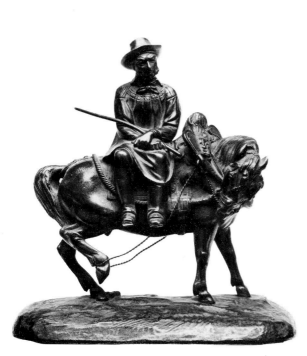

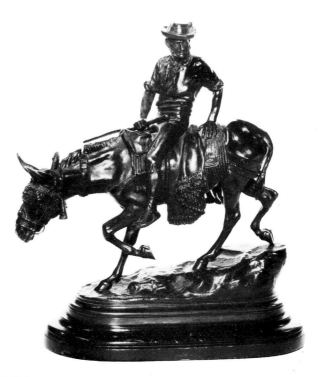

**H100** Gechter has again used his favourite sand cast dray horse, its foot caught up in the harness and this time with the addition of a serious looking farmer seated somewhat incongruously in an unconventional riding position.
Signed 'T. Gechter': 16cm (6¼ins.)
mid-brown patination

*1840s* £300 — £500

**H101** Large men on small mounts invariably look out of scale and are very difficult to model satisfactorily. This well detailed group by Isidore Bonheur of a donkey and his peasant rider possibly from the Pyrenean mountains, is not listed in the sculptor's exhibits at the Paris Salon, and is probably a purely commercial exercise.
Signed 'I. BONHEUR': 35.5cm (14ins.)
rich dark brown patination

*1880s* £1,000 — £1,500

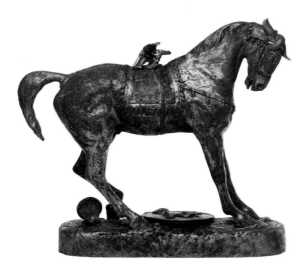

**H102** This is a poor quality cast albeit of an unusual subject, the lively horse is part of a circus act and at his feet are a clown's hat and discarded paper hoop. The only problem is that the animal that jumped through the hoop, presumably a monkey, has long since disappeared and been replaced by a rather unimperial eagle.

Signed 'Walter Winans': 58cm (22¾ins.)
rubbed silvered patination

*Dated 1910* £700 — £900

311

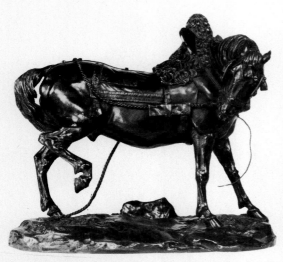

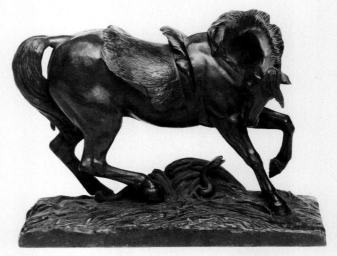

**H103** This fine sand cast model of a dray horse by Gechter was used several times with slightly different variations. The horse is caught up in his rope harness which is excellently detailed, as is the musculature of the horse. Gechter was a fine sculptor capable of giving his figures immense power but because his work is somewhat repetitive he is under appreciated.

Signed 'T.H. Gechter': 37cm (14½ins.)
black patination

*1840s* £800 — £1,200
*A smaller version, 28cm (11ins.), sometimes with green patination £700 — £1,000.*

**H104** This sand cast bronze sand cast is unsigned but if compared with H103 the addition of the signature is hardly necessary. It is a variation of the horse by Gechter in more classical posture which is quite understandable as the sculptor was working in the 1830s and '40s. Oliver Cromwell is sometimes modelled on this horse.

28cm (11ins.): black patination

*1840s* £400 — £600

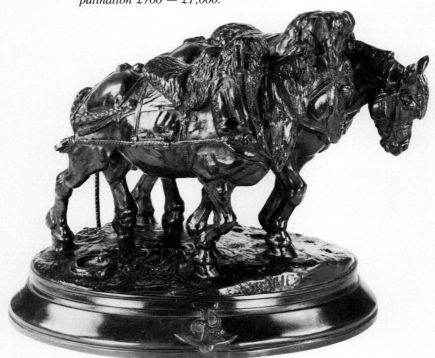

**H105** This fine group of a pair of barge horses by Frémiet exhibited at the Paris Exhibition Universelle in 1855, also appears in the sculptor's catalogue of c.1860. This is a very individual group and an early model of animals at their work. Although there is a certain amount of detail the sculptor has sought to give an impression of movement rather than concern himself too much with anatomical exactitude. It is strange that such a powerful group has only been seen in such a small size.

Signed 'E. FREMIET': 24cm (9½ins.)
dark brown patination

*1860s* £2,000 — £2,500

312

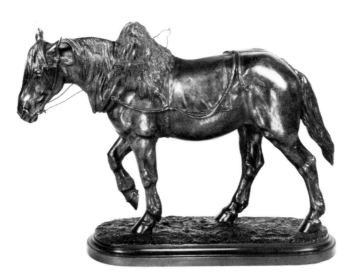

**H106** A rare Peyrol cast by Isidore Bonheur of an exhausted horse plodding slowly back from the fields. This figure is full of expression and one cannot help but have sympathy for the animal. As with H101 this work is not listed amongst his Salon exhibits and the exact date of execution is uncertain. A fine model.

Signed 'I. BONHEUR', with Peyrol Founder's stamp
30.5cm (12ins.): rich slightly rubbed dark brown patination
*1880s* £1,200 — £1,800

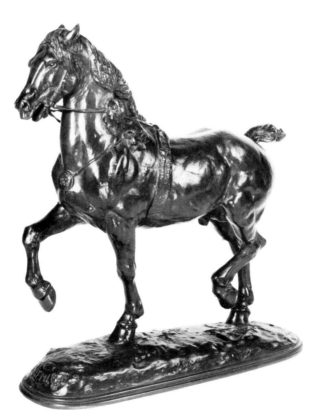

**H107** Another very powerful figure by Frémiet, of a very acceptable subject that stands well in any room and can be viewed three dimensionally. It has sometimes been considered to be the poor man's version of Barye's 'Cheval Turc'. This Frémiet model, which was some twenty years later than Barye's, is more realistic and consequently seems more of a portrait.

Signed 'E. FREMIET': 39.5cm (15½ins.)
rich brown patination
*1860s* £2,000 — £2,500+

313

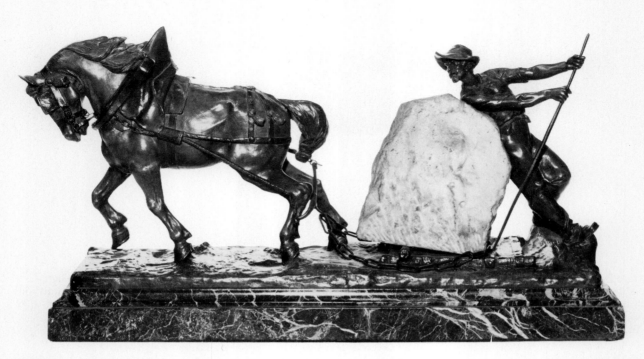

**H108** By the early 1900s the use of more than one material was becoming commonplace in sculpture. Here the sculptor has very cleverly incorporated a carefully carved marble rock at which the quarry man is pushing with all his strength. The horse too is pulling for all his worth but unfortunately the chains have been made too long, and their slackness spoils the whole effect. However it is an interesting model and very well detailed on an elaborate moulded verde antico base.

46cm (18ins.) wide
rich dark brown patination

*c.1910*                                    *£1,000 — £1,500*

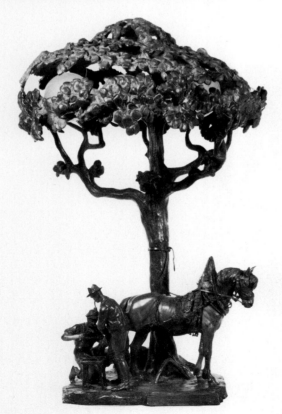

**H109** This is a very unusual group and highly practical, as hidden in the branches of the tree are two light bulbs. A fascinating combination of sculptural technique and modern technology, the whole thing was conceived as a lamp and not, as one might think, a later alteration. The two farriers are going about their work in a serious manner while the dray horse stands patiently still.

Signed 'T. Curts': 50cm (19¾ins.) approx.
rich dark brown patination

*c.1910*                                    *£1,500 — £2,000*

314

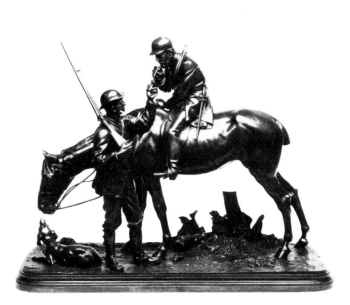

**H131** A fine small group by Isidore Bonheur whose range of subjects seems almost endless. This is a rare and particularly interesting group in terms of period costume and accoutrements. It is worth comparing this with the Mêne horse and dog in H90.

Signed 'I. BONHEUR': 49 x 60.5cm (19¼ x 23¾ins.)
even black brown patination

*1870s*                                                    *£4,000 — £6,000*

**H132** A rare group by Christophe Fratin in which the handling of the surface of both horse and base are typical of his rugged approach. There is a tremendous amount of movement and realism in the leaping horse although, as with many sculptures, the rider is not quite as convincing. The fence must be quite an obstacle for any horse and the sculptor has cleverly used the wizened trees at either side of the fence to support the body of the horse. In keeping with Fratin's humorous approach to this work, the fox is hidden amongst the foliage.

Signed 'Fratin': 45cm (17¾ins.)
rich chocolate brown patination

*c.1860*                                                    *£2,500 — £3,000*

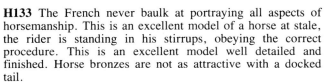

**H133** The French never baulk at portraying all aspects of horsemanship. This is an excellent model of a horse at stale, the rider is standing in his stirrups, obeying the correct procedure. This is an excellent model well detailed and finished. Horse bronzes are not as attractive with a docked tail.

Signed 'E. Pinchon': 44.5cm (17½ins.)
rich chocolate brown patination

*c.1910*                                                    *£1,800 — £2,500*

323

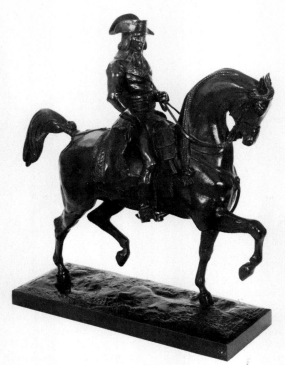

**H134** This is an extremely popular and very handsome group by Barye of the young Bonaparte. His style of dress is still basically that of the late revolutionary period and he is not yet depicted in military costume. It is interesting to see the young leader with long hair in a conventional pose, very different from the image commonly portrayed of him in sculpture. Both horse and rider are very powerfully modelled, and the horse, although in a classical posture, is bulging with muscle and energy in a way that only Barye was capable of capturing. The wonderful long ribbon-tied plaited mane shows Barye's eye to period detail.

Signed 'BARYE': 36cm (14¼ins.): dark green patination
*1840s*                                                                      *£4,000 — £6,000*

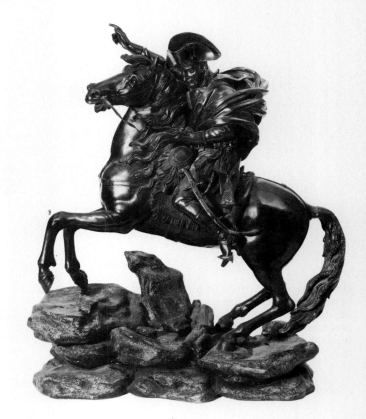

**H135** Here is Napoleon in a defiant mood, scaling the heights of the Alps and urging his troops forward. Almost completely in the 17th century classical style it looks slightly out of place when compared with the work of Barye. The horse is extremely well detailed and only the base lets it down. This is a fine sand cast probably by Gechter.

60cm (23½ins.): dark brown patination
*c.1840*                                                                      *£1,000 — £1,500*

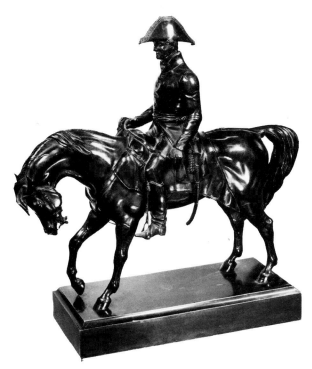

**H136** A good competent model of the Duke of Wellington on his horse 'Copenhagen' by le Comte d'Orsay also illustrated in H137 showing the meticulous attention to detail and the difference in patination between two bronzes. The base of H137 is of a type normally associated with the early French bronzes of the late 1830s and 1840s and the moulded, even base of the example illustrated here is much more typical of the English foundries.

Signed 'D'Orsay': 75cm (29½ins.): black patination
c.1850 £2,000 — £3,000

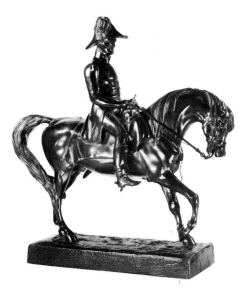

**H137** Another view of the Duke of Wellington shown in H136. In common with most English sculpture of the mid-19th century the style is still basically classical with as yet little influence from Paris. The skin of the horse is completely smooth and the whole effect somewhat stylised.

Signed 'D'Orsay Sculp',
and 'J. Watesby Publishers, 15 Waterloo Place, London':
43cm (17ins.): dark brown/black patination
c.1850 £1,200 — £1,800

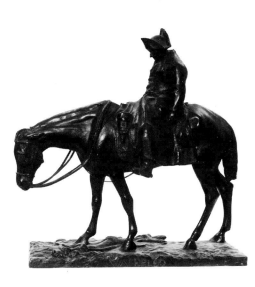

**H138** This group is entitled 'WATERLOO'. The seated Emperor Napoleon is slumped back into his saddle and even his horse defines the sad and dejected feeling of the moment. A well detailed cast but not something the French would be keen to buy! Another version of this group is in the Modern Art Gallery, Milan — birthplace of Riccardo Ripamonti.

Signed 'R. Ripamonti': 63.5cm (25ins.)
dark brown/black patination
Dated 1908 £1,000 — £1,500

325

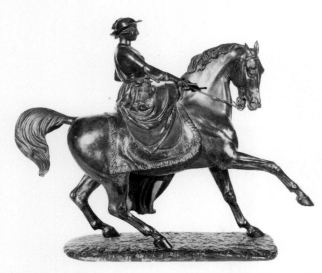

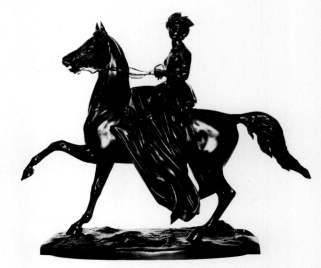

**H139** A good model of the young Queen Victoria on horseback by Thomas Thornycroft. It is a superbly composed group and was a very popular one at the time of casting, so much so that the Art Union of London published an edition of fifty. The group is very classical in style and has not been influenced at all by contemporary Paris. It is thought that the sculptor worked on each of the bronze versions in this limited edition, possibly commissioned by Prince Albert.

<div align="center">

Signed 'T. Thornycroft Fecit'
and inscribed 'Art Union of London 1853'
54cm (21¼ins.): slightly worn dark brown patination

</div>

c.1853                                                    £5,000 — £8,000

**H140** A very similar group of the young Queen, this time by another English sculptor, John Foley. Although exactly ten years have passed since the previous model there has been no change in style. A rare group by this sculptor although presumably the founders, Elkington would have produced quite a large edition originally.

<div align="center">

Signed 'J.H. Foley' and 'Elkington & Co Founders':
47.5 x 40cm (18¾ x 15¾ins.)
dark black/brown patination

</div>

Dated 1863                                              £5,000 — £6,000

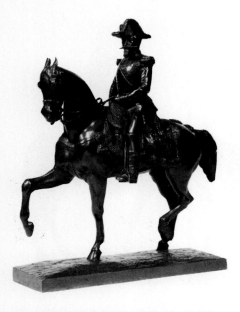

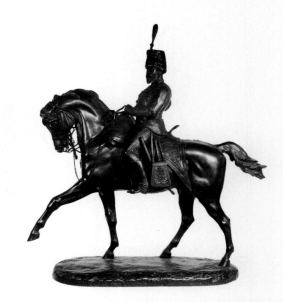

**H141** It is interesting to compare directly the life and energy in this French group of Napoleon III mounted on his horse 'Phillippe', to H136. This model by Frémiet was executed in the late 1850s and was roughly contemporary, but the whole concept is completely different. This very rare model was the only one saved from fire at the Tuileries.

<div align="center">

Signed E. FREMIET: 38cm (15ins.)
rich dark brown patination

</div>

c.1860                                                    £1,800 — £2,500

**H142** This English model by Remington Clarke of the Prince of Wales as an Hussar has a lot in common with the stiffness of the model of the Duke of Wellington in H136 although it must be some ten or twenty years later. The detail and the technical ability, however, are faultless and this is a fine quality bronze.

<div align="center">

Signed 'Remington Clarke': 75cm (29½ins.)
rich even black/brown patination

</div>

c.1870                                                    £2,500 — £3,500

326

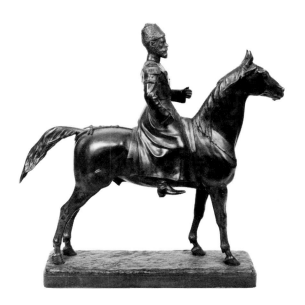

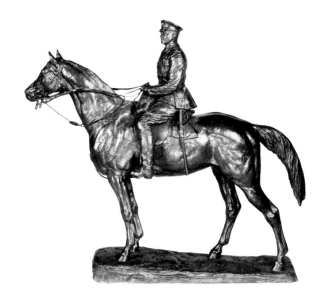

**H143** Le Compte de Ruille is responsible for this fine model of Tsar Nicholas. It is well detailed and balanced but the sculptor is more familiar with the technique of modelling horses than of men and has left his sitter looking ridiculously stiff and formal. Almost certainly the sculptor modelled his horse, and in limited sessions with the Tsar modelled him astride a mock saddle presumably holding imaginary reins.

Signed 'Cte. G. de Ruille': 50 x 39cm (19¾ x 15¼ins.)
rubbed brown patination

*c.1870* £1,500 — £2,000

**H144** This is the most outstanding cast and one of the very best works of Sydney March. The March family who were extremely talented, worked in Farnborough, Kent in the early part of this century. Their work is often underestimated today and the quality of their work under appreciated. This portrait group, as well as being highly realistic, is very sensitive, and one can almost see the slight movement of the alert horse.

Signed 'Sydney March': 56cm (22ins.)
rich even brown patination

*Dated 1920* £2,000 — £3,000

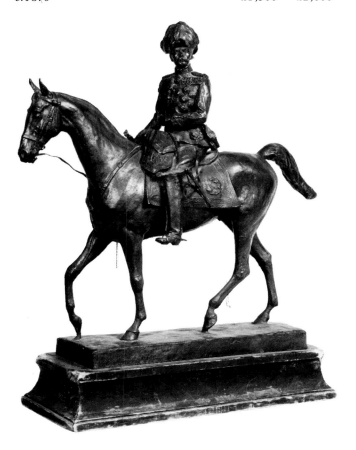

**H145** A good equestrian group of Kitchener in full military costume. The sculpture is very much in the style of the March family (see H144), and is a well balanced and a vigorous well detailed portrait.

dark even brown patination

*c.1905* £1,000 — £2,000

327

**H146** There are many versions of this large group of Louis XIV. This model is inspired by the group by Girardon, modelled in 1699 for the Place Louis le Grand. It is a magnificent edifice of classical sculpture and one that was often reproduced in the second half of the 19th century. Usually these are very easy to date, an important factor as there is a huge difference between the early 18th century and the later models. This is a fine and large cast.

109 x 94cm (43 x 37ins.)
deep brown/black patination

*c.1850*                                             *£5,000 — £7,000*

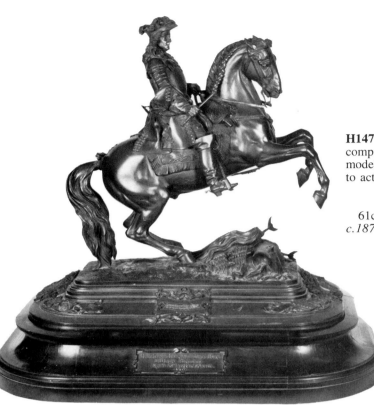

**H147** This is a group of the German Eugene of Savoy and a companion to H148, severely classical but very well modelled. Note how the sculptor has cleverly used the long tail to act as an extra support for the rearing horse.
Unsigned but with a plaque inscribed
'Equiti Rutherford Alcock'
61cm (24ins.) overall: very dark brown even patination
*c.1870*                                                    *£2,000 — £3,000*

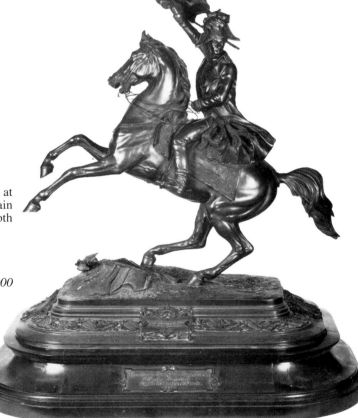

**H148** The Arch Duke Charles of Austria in defiant mood at the head of his troops, waving his standard in the air. Again the pose is classical with meticulous attention to detail in both tack and uniform.
Unsigned but with a plaque inscribed
'Equiti Rutherford Alcock':
76cm (30ins.) overall: very dark brown even patination
*Dated 1870*                                        *£2,500 — £3,000*

329

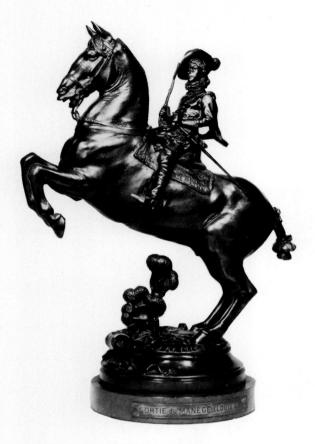

**H149** A fine and rare group of young Louis XIII by Frémiet entitled 'Sortie du Manège'. The horse is powerfully modelled and at first glance in a classical style but with the romanticism and realism that Frémiet and Barye inevitably incorporated into their work. A well detailed cast and superbly balanced with great technical skill employed in supporting the whole weight of the bronze on the horse's hind legs.

Signed 'E. FREMIET': 45cm (17¾ins.) excluding base
copper/red-brown patination

*1890s*                                                  *£3,000 — £5,000*

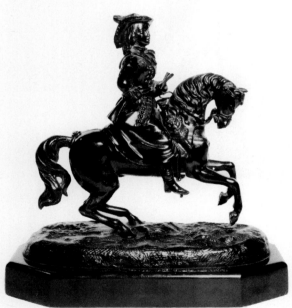

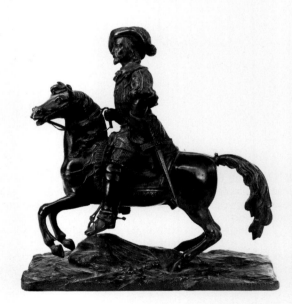

**H150** An unusual bronze equestrian group of a woman in early 18th century costume riding astride a prancing horse. The horse's tack bears what appears to be the Hapsburg crest which may eventually be a clue as to the rider. Not a very well modelled group with poor detail and unsigned.

19.8cm (7¾ins.): black patination

*c.1860*                                                  *£400 — £600*

**H151** A naïvely modelled group with the rider dwarfing his unfortunate mount. The horse is in the classical style with a stylised flowing mane. Not a very inspired model and consequently not expensive. Another unsigned sand cast probably by Gechter.

25.3cm (10ins.): dark brown patination

*c.1850*                                                  *£300 — £500*

**H152** A powerful historical group of St. Hubert proudly riding his horse in its Gothic trappings. Again this illustrates the 19th century love of romanticism that carried through architecture to furniture and through paintings to sculpture. A good group slightly worn but very rare.
Signed 'FREMIET' entitled 'LA St hubert 1520'
59cm (23¼ins.): silvered and rubbed dark brown patination
*1870s*                                    *£2,000 — £3,000*

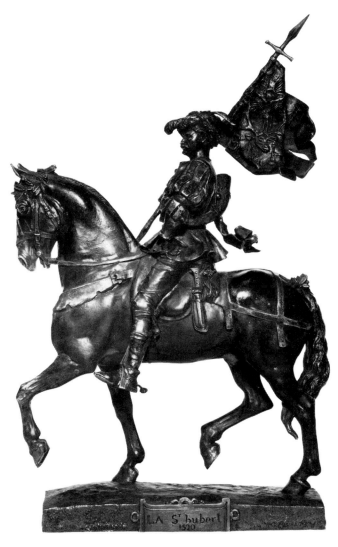

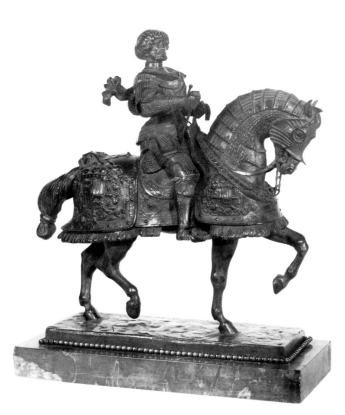

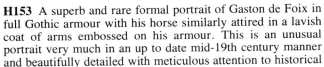

**H153** A superb and rare formal portrait of Gaston de Foix in full Gothic armour with his horse similarly attired in a lavish coat of arms embossed on his armour. This is an unusual portrait very much in an up to date mid-19th century manner and beautifully detailed with meticulous attention to historical accuracy. A masterpiece by Barye but not a particularly commercial bronze, really only one for the avid Barye collector.
Signed 'BARYE', entitled 'Gaston de Foix': 33cm (13ins.)
rich matt and burnished dark brown patination
*c.1838*                                    *£1,500 — £2,500*

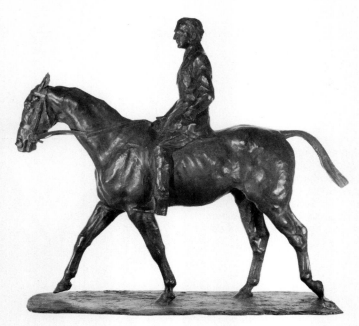

**H154** Herbert Haseltine is another of the early 20th century sculptors who used an impressionistic technique in varying degrees to great effect. This is a fine well poised portrait group and a highly decorative subject. The sitter is unknown to the author, and this type of portrait consequently becomes desirable to a wide range of collectors as it is anonymous and simply a good sculpture.

Signed 'Herbert Haseltine', and with founder's mark
Valsuani, numbered 1
75cm (29½ins.): even flat mid-brown patination
*Dated 1913*                                   *£3,000 — £5,000*

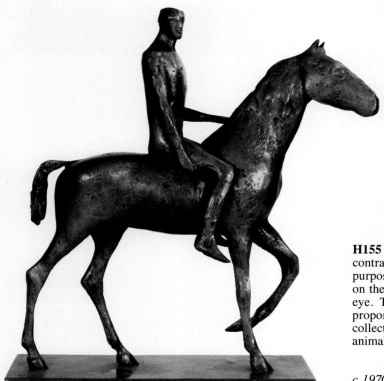

**H155** This simple model by Elizabeth Frink is in stark contrast to the others in this section. Detail has been purposefully eradicated, the sculptor using slight indentations on the wax model to indicate the rider's boot and the horse's eye. The combination is very effective and the balance and proportion very good. This type of work is more likely to be collected by painting and sculpture enthusiasts rather than the animalier collector.

Signed 'Frink' No. 2 out of 7:
50.2cm (19¾ins.): copper brown patination
*c.1970*                                   *£3,000 — £5,000*

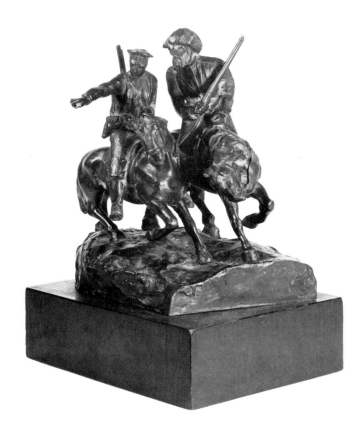

**H156** A group of two scouts, one in formal uniform the other in Cossack dress by Amort. Entitled 'Franton Anyz', this is a good model in impressionistic style and obviously refers to a specific incident in the early part of this century.

Signed 'W. Amort': 22cm (8¾ins.)
dull flat brown patination

*1910-1920*                                    *£600 — £900*

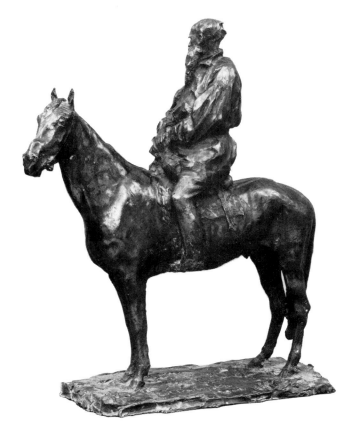

**H157** The early 20th century produced possibly one of the most fascinating styles in sculpture, and Prince Paul Troubetzkoy the sculptor of this group ranks among the best in his class alongside Degas and Bugatti. Here the impressionistic technique is not as obvious as in some of his work but it is a highly sensitive and well balanced model. The photographer was obviously indecisive as to whether he should show the face of the sitter or the horse. Another model of this group is in the Luxembourg Museum, Paris.

Signed 'Paul Troubetzkoy': 53cm (21ins.)
golden brown patination

*Dated Moscow, 1899*                          *£1,200 — £1,800*

333

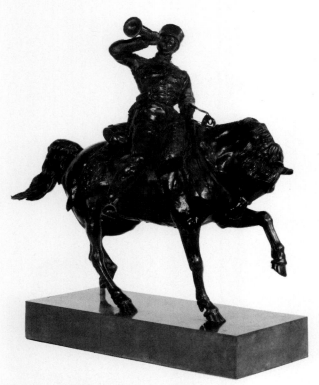

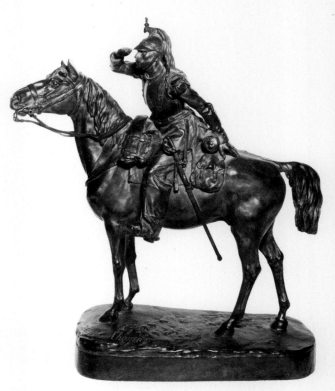

**H158** This army bugler was once attributed to the Russian Lanceray but is more likely to be by a Paris sculptor. The horse is putting on a great show of eagerness as it paws the ground impatiently. The heroic group illustrates perfectly the desire for battle ingrained into the 19th century upper class. The base on this group is later, and we are therefore without the benefit of the sculptor's signature.

35.5cm (14ins.): dark brown/black patination
*1870s*                                                    *£800 — £1,200*

**H159** This is a popular model by Mathilde Thomas of a French cavalry scout shading his eyes as he peers into the distance. The horse too is apprehensive, and the whole group has a very pleasing and well balanced effect. Until recently this type of group was never really appreciated and could easily have been bought at auction for under £1,000.

Signed 'Math. Thomas', and with founder's stamp 'Thiebaut Freres': 57cm (22½ins.): green/brown patination
*c.1870*                                                  *£2,500 — £3,500*

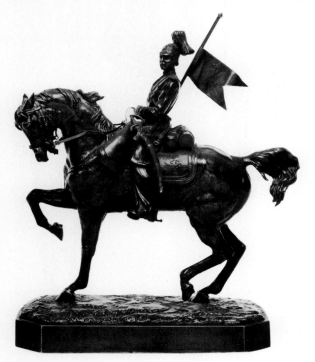

**H160** A good Russian equestrian group by Lanceray showing the same eagerness for battle but without the panache of H158. Here again the horse is a better model than the young soldier, who sits rather stiffly. Further Russian groups are discussed on pp.382-389.

Signed in Cyrllic: 28 x 21cm (11 x 8¼ins.)
rubbed mid-brown patination
*1870s*                                                  *£1,000 — £1,500*

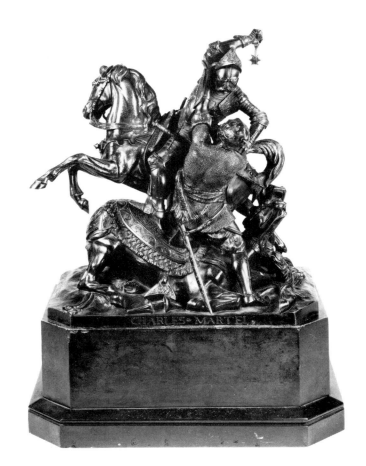

**H161** A rare and complicated group by Gechter, portraying
Charles Martel defeating his adversary Abdérame, the King of
the Saracens. It is a good historical group, excellently detailed
and although a little naïve basically well balanced. Great
attention has been paid to the detail of both the warriors'
armour and their horses' tack. This is typical of the romantic
groups in the 'Style Troubadour'.
  Signed 'TH. GECHTER': 32cm (12½ins.) excluding base
                    black brown patination
*Dated 1848*                              *£1,000 — £1,500*

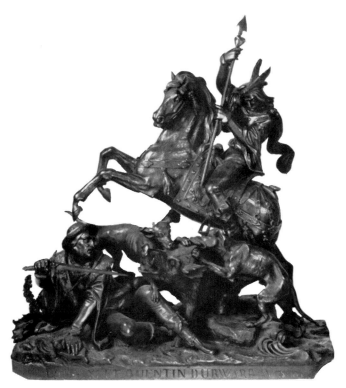

**H162** A lively group of Louis XI being saved by his huntsman
Quentin Durward. The huntsman and the two dogs (one with
the fleur de lis brand) are viciously attacking the boar and the
luckless king attemps one last stab at the powerful animal's
neck. A typical romantic composition of the second quarter of
the 19th century. The whole group is inspired by the writings
of Sir Walter Scott, and is almost certainly by T. Gechter.
  Entitled 'LOUIS XI ET QUENTIN DURWARD W SCOTT'
        52cm (20½ins.): dark brown patination
*c.1850*                                  *£1,500 — £2,000*

335

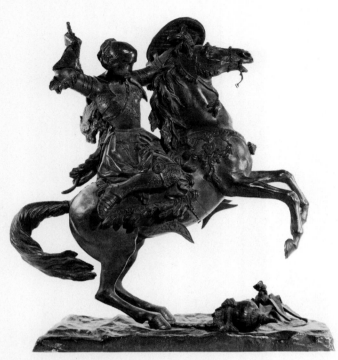

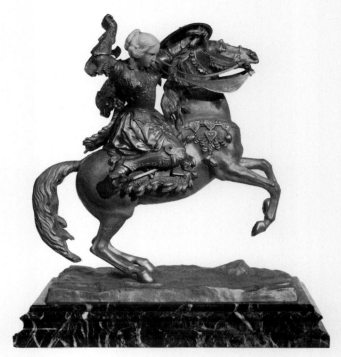

**H163** This unsigned model of Clorinda epitomises the 'Style Troubadour' of the Charles X and early Louis Phillippe period. Clorinda was an Amazon leader, beloved of Tancred, a hero of the First Crusade, but she cared only for the glories of war. It is the type of subject commonly used to surmount clock cases. Compare with H164.

Entitled 'Clorinde': 52cm (20½ins.)
dark rich brown patination
*Stylistically c.1840 but possibly later*          £1,500 — £2,000

**H164** A slight change to the horse's trappings, the removal of the Saracen helmet, and Clorinda has become Jean Hachette (Joan of Arc). This group is signed by G. Abell and it is logical to assume he is the sculptor of H163. The style would suggest the second quarter of the 19th century but the use of ivory and gilt-bronze is more commonly a late 19th century technique.

Signed 'G. Abell': Entitled 'Jean Hachette'
56cm (22ins.): gilt-bronze patination
*Late 19th century*          £2,000 — £3,000

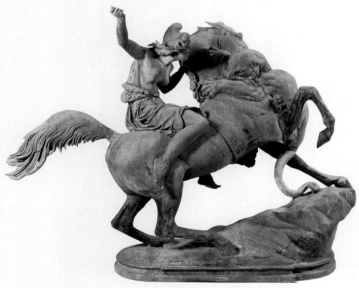

**H165** Several versions were produced of this powerful group by Karl Edward Kiss the German sculptor. This large unsigned model was in white metal and is a variation of that produced for the 1851 Great Exhibition. There is immense realism in the way the lion is biting and clawing at the horse's neck although the horse is stiffly classical in its posture as is the Amazon, dressed in Grecian costume.

117 x 160cm (46 x 63ins.): pitted and weathered patination
*Mid 19th century*          £4,000 — £6,000

**H166** A good quality copy of a late 17th century Siena bronze equestrian group of Louis XIV as a Roman centurion. Many of these copies were made throughout the 18th and 19th centuries, and there is a considerable difference in price between the early and the later casts.

39cm (15¼ins.) overall: rubbed black patination
*1825-1850* £700 — £900

**H167** Marcus Aurelius, after an antique model. A reduction of the monument in the Piazza del Campidoglio, Rome.

59cm (23½ins.) excluding white marble base
*c.1880* £2,000 — £3,000

**H168** A dashing study of the relationship between man and horse by a little known sculptor. A good quality German cast and typical of the German modern movement between 1900-1920 but compares with the work of Constantin Meunier. Not an 'animalier' but more for the modernist as a decorative group.

Signed 'Splieth': 44cm (27¼ins.)
rich black/brown patination

*Dated 1919* £2,000 — £3,000

**H169** An amusing and inventive English New School sculpture by Charles Sykes, the author of 'The Spirit of Ecstasy' now familiar as the Rolls-Royce car mascot. This pillion pair is an allegorical group of a satyr riding a mule over turbulent waves with a nymph clinging on tightly behind. The style is very loosely modelled in a late impressionistic manner.

Signed 'Charles Sykes': 17cm (6¾ins.) excluding base
rubbed dark brown patination

*Dated 1924* £600 — £800

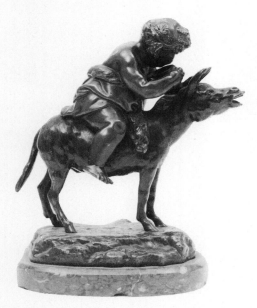

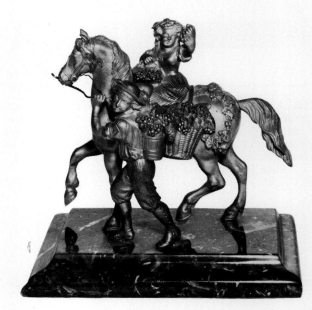

**H170** A very drunken bacchic infant on a protesting mule, by Vernon March. The mule is especially well modelled and the corpulent infant reminiscent of the late 17th early 18th century style.

Signed 'Vernon March': 20cm (8ins.)
even dark brown patination

*c.1910* £450 — £550

**H171** This decorative and amusing gilt-bronze group has little sculptural merit. The boy is leading a young girl on a horse on the way back from the grape harvest. The faces are not very well modelled and like the horse, look back to the late 18th century techniques.

23cm (9ins.): gilt bronze patination

*c.1850* £350 — £450

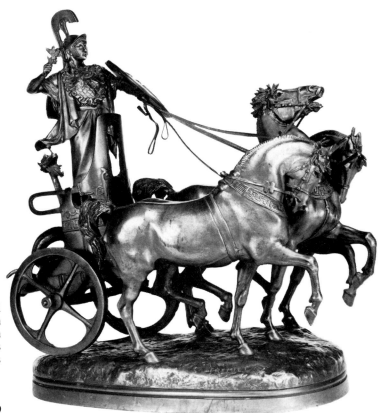

**H172** This is a very unusual chariot group by Emmanuel Frémiet which at first glance is entirely classical, but yet again this sculptor has incorporated an extra power and dimension to the horses rendering them undeniably 19th century. This model of the Grecian warrior Antiope is a fine example of this sculptor's monumental work.

Signed 'E. FREMIET' and 'F. Barbedienne Fondeur':
55cm (21¾ins.): gilt bronze patination
*1870s*                                                   *£2,000 — £3,000*

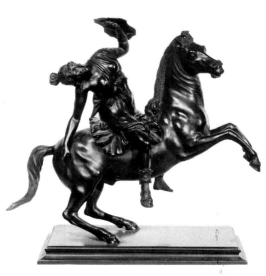

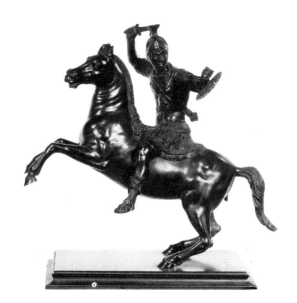

**H173** There is a completely different appeal in the early classical bronzes as compared with the 19th century romantic bronzes. The original early bronzes are highly sought after and the 19th century copies such as these can still be bought very reasonably. It is only when the bronzes come into the category of 'decorators' art' at about one metre high that they become in any way expensive. These models are casts after

Sabatino of Naples and are typical of Neapolitan reductions of early works in the Naples Museum.

Signed 'Sabatino Napoli': 52cm (20½ins.)
black patination
*Dated 1885*                                    *The Pair £1,000 — £1,500*

339

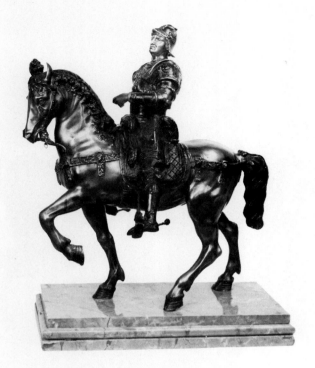

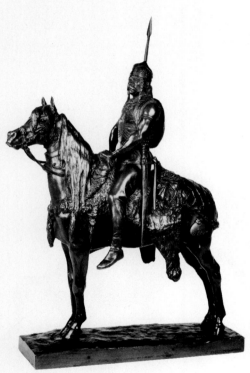

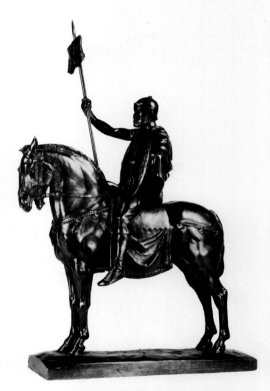

**H174** Another bronze reduction of the equestrian monument to Bartolomeo Colleoni by Donatello. A fine quality bronze and perfectly acceptable provided it is sold with the correct date and that nobody tries to pass it on as a 17th century cast.
64cm (35¼ins.)
rich copper gilt patination

*Mid-19th century*                                                                    *£600 — £900*

**H175 and H176** These are two fine examples of Frémiet's monumental work, reminding us that he thought of himself as a monumental sculptor rather than an animalier. H175 (left) is of a Gallic horseman and was exhibited in the Salon of 1863 in plaster and a year later in bronze, and H176 (right) of a Roman cavalryman was exhibited in the Salon of 1866 in bronze. Both were then exhibited at the Paris Exhibition Universelle in 1867 and make a fine pair. There are many examples of these bronzes available varying considerably in quality. The two illustrated are cast by Barbédienne and are of good quality. They are usually not expensive and although strictly speaking not animalier, show strict attention to detail in the difference between a Roman and an Arab horse.
Signed 'E. FREMIET' and 'F. BARBEDIENNE'
H175 37cm (14½ins.): H176 42cm (16½ins.):
Each rich dark brown patination

*1870s*                                                                    *Each £1,000 — £1,500*

340

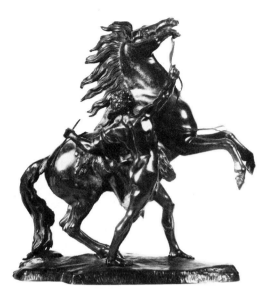

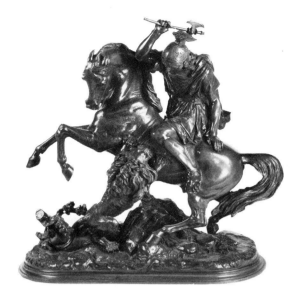

**H177** This bronze will be very familiar to any regular frequenter of the salerooms. It is the popular bronze reduction, one of a pair, known as the 'Marly Horses'. Originally modelled in stone for Louis XIV's chateau at Marly, they now stand at the entrance to the Champs Elysées. Most bronze reductions date from c.1850 to c.1920 and vary in price depending on quality and size.

<div align="center">Signed 'Coustou': 60cm (23¾ ins.)<br>black patination</div>

*c.1880*                                         *£1,800 — £2,500*
                          *48cm (19ins.) version £1,200 — £1,800*
                       *39cm (15¼ins.) version £800 — £1,200*

**H178** Influenced by the 17th century but far too plastic to be anything but Paris of the mid-19th century, this is a fine group of a Roman soldier being attacked by a lion. The addition of profuse foliage is a typical 19th century feature and the soft lines of the warrior's face are a constant reminder of the different way faces are modelled by sculptors and painters throughout the ages. The signature is more likely a title than the sculptor's name; this model is rather similar to the prolific Gechter's work.

<div align="center">Signed 'D. TORIS': 49.5cm (19½ins.)<br>rich dark brown patination</div>

*c.1870*                                         *£1,800 — £2,200*

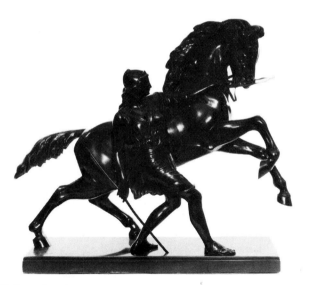

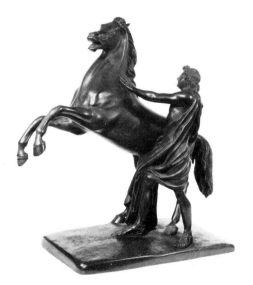

**H179** A female Grecian warrior restrains her rearing horse. The horse is well modelled and would probably be a better article of sculpture without the human form. This is one of a pair.

<div align="center">58.5cm (23ins.): rich brown patination</div>

*1850-1900*                          *the pair £1,800 — £2,600*

**H180** From an early Roman source for the Marly Horses, in which the stylisation is completely different and far stiffer in conception to that of H177. Not common in 19th century reductions.

<div align="center">34cm (13½ins.): black patination</div>

*1850-1900*                                         *£400 — £600*

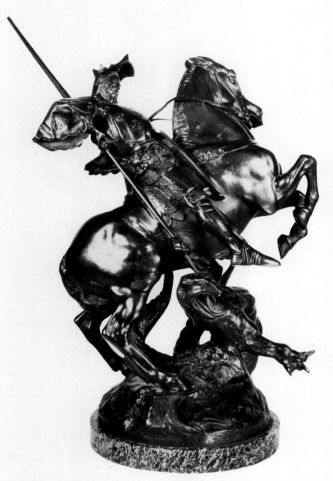

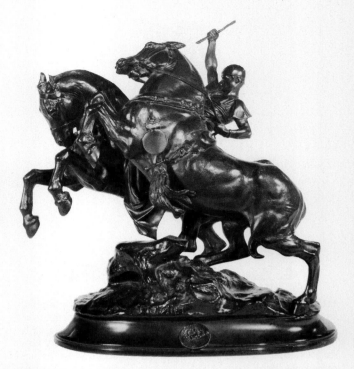

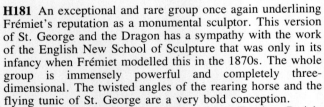

**H182** Here Frémiet has modelled horses in similar positions to H183 and where the relationship between the horse and horseman is extremely powerful. Frémiet has returned to a favourite theme of ancient Rome, and again produced a fine three-dimensional sculpture.

Signed 'E. FREMIET': 39cm (15¼ins.)
rich dark brown/black patination

*c.1870*                                                            *£2,000 — £3,000*

**H181** An exceptional and rare group once again underlining Frémiet's reputation as a monumental sculptor. This version of St. George and the Dragon has a sympathy with the work of the English New School of Sculpture that was only in its infancy when Frémiet modelled this in the 1870s. The whole group is immensely powerful and completely three-dimensional. The twisted angles of the rearing horse and the flying tunic of St. George are a very bold conception.

Signed 'E. FREMIET' and 'F. Barbédienne Fondeur Paris'
48cm (19ins.): rich dark brown patination

*c.1870*                                                            *£3,000 — £5,000*

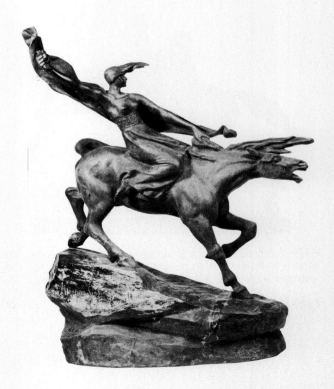

**H183** Inspired by Wagner's epic opera 'The Ring', this equestrian group of the Valkyrie by Stephan Sinding was cast in Berlin. The cast varies considerably in quality, and until recently has not been particularly popular outside the sculptor's native country of Denmark, although it is a good decorative bronze with art deco influence. Unfortunately here the blade of her sword is missing.

Signed 'Stephan Sinding', and with Founder's mark
'Akt-Gee-Gladenbeck-Berlin': 48cm (19ins.)
weathered mid-green patination

*c.1910*                                                            *£2,000 — £3,000*

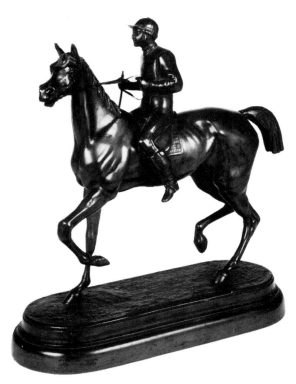

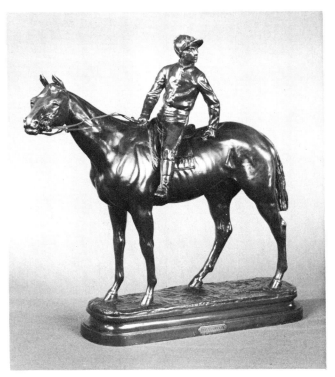

**H213** Entitled 'Frisky to Start' this is a charming bronze group of which the history is available. The horse is called 'Iroquois' and the jockey is Fred Archer. The sculptor Paul-Louis Emile Loiseau is relatively unknown and bridges the gap between the fully rounded 19th century romantic bronze and the more stylised versions of the early part of the 20th century.

Signed 'E. Loiseau': 29cm (11½ins.)
rubbed varnished brown patination

*c.1900*                                    *£1,400 — £1,800*

**H214** Most of the animalier sculptors, even those who are relatively unknown, seem to have produced at least one good quality horse and jockey group which in each case appears to be almost a 'chef d'oeuvre'. This model by Bureau is of a fine quality with a lovely well rubbed rich chocolate brown patination. It compares favourably with the Moigniez in H208 and again the jockey appears to be sitting back nonchalantly waiting for the other runners to enter the paddock. The horse's head detracts somewhat from the overall effect.

Signed 'L. BUREAU': no size available
rich rubbed chocolate brown patination

*c.1890*                                    *£2,000 — £3,000*

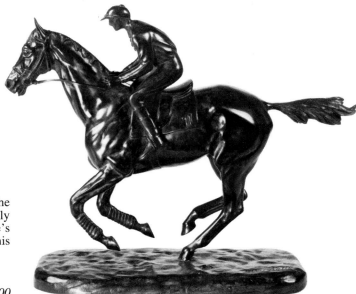

**H215** Another turn of the century group where detail is at the half-way stage between realism and impressionism, especially in the hollowed out effect of the jockey's face and the horse's flanks, although there is still considerable movement in this nice compact group.

Signed 'Illiuvielle': 28cm (11ins.)
black patination

*c.1900*                                    *£800 — £1,200*

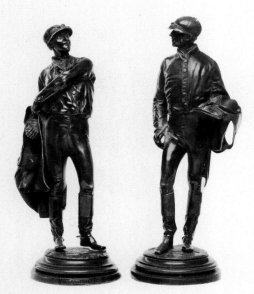

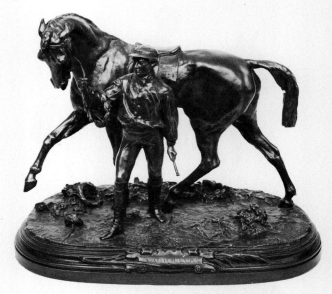

**H216** This is a rare pair of standing figures of jockeys, the nationality of which is not entirely clear. They could be either English or French; the plaque on the base of one of the sculptures bearing the date November 17th 1871 and the words registered 'J & W Vokins' does not necessarily prove they are of English origin. There is a certain similarity to the work of Mêne but without the detail one would expect.

Bearing a label 'J. & W. Vokins'

28 x 31cm (11 x 12¼ins.) overall: dark brown patination

*c.1871*                                          *The pair £1,500 — £2,000*

**H217** Compare the jockey in this model with the pair in H216. This marvellous group by Mêne entitled 'VANQUER!!!' is richly detailed, the floor strewn with victory flowers and the proud horse prancing excitedly. The model was exhibited at the Salon of 1863 in wax, and a year later in bronze, and is No. 13 in Mêne's catalogue, entitled 'Jockey Vanquer du Derby'.

Signed 'P.J. MÊNE': 35 x 43 x 22cm (13¾ x 17 x 8¾ins.)

rubbed mid-brown patination

*Dated 1866*                                          *£5,000 — £6,000*

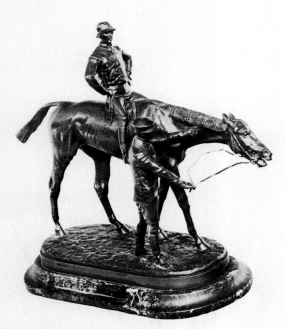

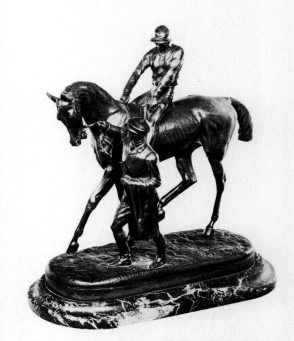

**H218** A fine pair of bronzes by Willis Good, in which the figures are becoming a little stylised; the addition here of the trainer leading each horse is an original touch. These are marvellous conversation pieces and would be highly sought after by anyone in the racing or collecting world.

Signed 'Willis Good' and 'Elkington and Son'

rubbed mid-brown patination

*Dated 1881*                                          *The pair £10,000 — £15,000*

354

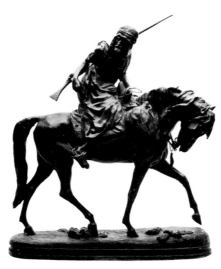

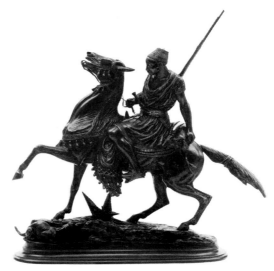

**H219** This group is in white metal apart from the base and rifle which are of bronze, but such a good decorative subject always sells well provided the quality is adequate and the condition good. This bearded North African horseman is seated on a fine strutting Arab. The sculptor Letourneau has strewn the base with cacti to give the impression of desert.

Signed 'Edouard Letourneau'
and with founder's signature 'E. Blot F.'
81 x 73cm (32 x 28¾ins.): weathered patination
*1880-1900*                                       £4,000 — £5,000
                                       *in bronze* £7,000 — £10,000

**H220** A well detailed group by Delabrierre. The whole concept is just a little unconvincing but makes a good decorative subject. The North African hunter has a small goat slung over the rump of his horse, and a mountain-lion hidden in the rocks has surprised horse and rider.

Signed 'E. DELABRIERRE': 50 x 44cm (19¾ x 17½ins.)
rubbed dark brown and gilt-bronze patination
*c.1880*                                       £2,500 — £3,000

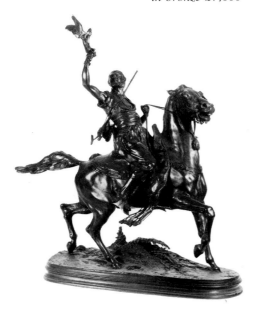

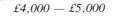

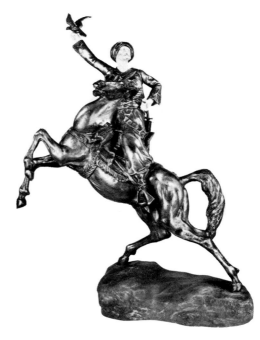

**H221** A well detailed lively model by Mêne. The North African falconer is sending up his bird as his blinkered horse shies. This large and impressive group was exhibited in wax at the Salon in 1873, and in bronze a year later. No. 4 in Mêne's catalogue it is entitled 'Fauconnier Arabe à Cheval' (Chasse du Falcon).

Signed 'P.J. MÊNE', and 'F. Barbédienne fondeur'
75 x 58 x 26cm (29½ x 22¾ x 10¼ins.)
rich dark brown patination
*c.1880*                                       £4,000 — £5,000

**H222** A large and impressive group by Cartier using bronze for the horse and rider, ivory for the rider's face and hands and carved stone for the base. This is very much in keeping with the style developed c.1900. The overall effect is very impressive and very different from the groups of twenty to forty years earlier.

Signed 'T. CARTIER': 76cm (30ins.)
gilt-bronze patination
*c.1900*                                       £3,000 — £5,000

355

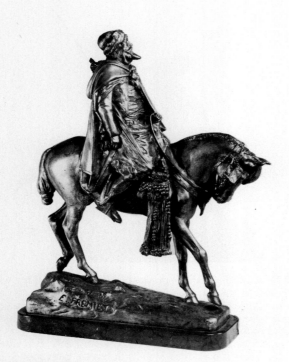

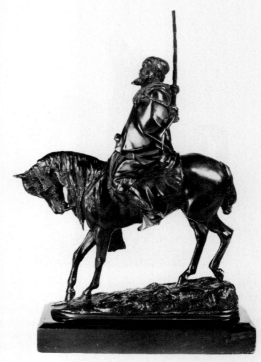

**H223 and H224** Two views of two slightly different casts of an Arab tribesman by Frémiet, possibly the 'Arab Chief on Horseback' shown at the 1865 Salon. This comparatively rare model has become considerably more popular in recent years. The sculptor conveys a fine impression of the horse picking his way carefully down a mountain slope. It is a pity the rifle is missing in H223 (left) but this could be replaced for about £50.

H223 Signed 'E. FREMIET', and 'F. Barbédienne fondeur Paris': 33cm (13ins.): gilt-bronze patination
*c.1880* £2,000 — £3,000
H224 Signed 'E. FREMIET': 33cm (13ins.) rich dark brown patination
*c.1865* £2,500 — £3,000

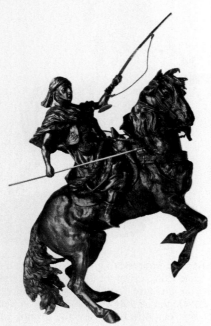

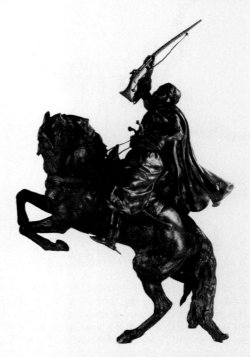

**H225** A pair of lively and well detailed bronzes cast at the turn of the century, that are good decorative objects. The sculptor is unknown and may well have signed the base which in this case might possibly have been in marble.

53 and 63cm (21 and 24¾ins.) respectively
rubbed and slightly chipped dark brown patination
*c.1900* *The Pair £2,000 — £3,000+*

356

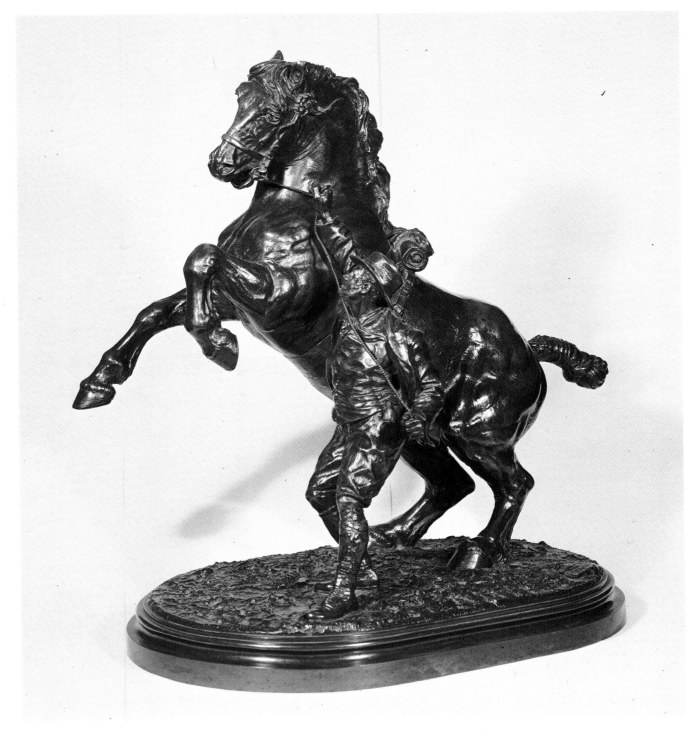

### Plate 14

A magnificent Suffolk Punch by Sir Joseph Edgar Boehm, the Austrian sculptor who became the popular Court Sculptor to Queen Victoria. As well as his rather traditional court sculpture and portrait busts, he modelled domestic animals, cattle and horses and it was with the horse that he excelled. He could afford the very best foundries and this group is a very fine cast indeed. It was exhibited at the Royal Academy in 1869 and is one of his most lively groups. The size and power of the horse is emphasised as it rears up, only just restrained by its trainer. Like much of Boehm's work it is derivative of classiscism and the influence of Coustou's Marly Horses is plain to see.

Signed 'BOEHM': 59 x 50cm (23¼ x 20ins.)
rich dark rubbed brown over copper brown patination

*Late 1860s* £10,000 — £15,000

**H226** A good quality cold-painted Austrian group of an Arab leader on horseback. This type is frequently cast by the Bergman foundry of Vienna. The painting often becomes severely chipped which will obviously reduce the value and sometimes the models are repainted which again decreases their potential. It is important to be aware of recent casts of these Austrian bronzes which although decorative do not have the intrinsic value of the earlier models.

   39cm (15½ins.): gilt painted and bronze patination
*c.1900*                                    *£1,200 — £1,600*

**H227** An exceptionally fine quality bronze by Lanceray. This is one of the best examples of Russian sculpture in the latter part of the 19th century. There is a tremendous affinity between horse and rider and the horse especially is sensitively modelled. The detailing is extremely good.
Signed in Cyrillic: 49cm (19¼ins.)
rich dark brown patination
*1880s*                                        *£2,000 — £3,000*

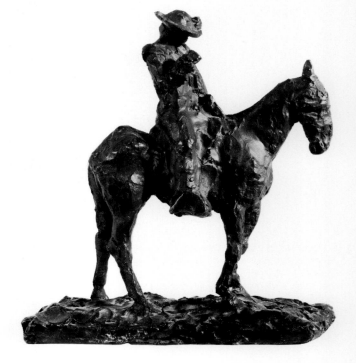

**H228** A fine impressionistic model in lost wax by Herbert Haseltine. The picador is resting his imaginary lance on the ground after a long battle. The style is unmistakably that of Haseltine with his own peculiar brand of impressionism where he used his fingers to build up the model in the original wax. A rare cast.

   Signed 'Herbert Haseltine', and 'G. Valsuani cire perdue'
   30.5cm (12ins.): textured dull brown/black patination
*Dated 1914*                                    *£2,500 — £3,000*

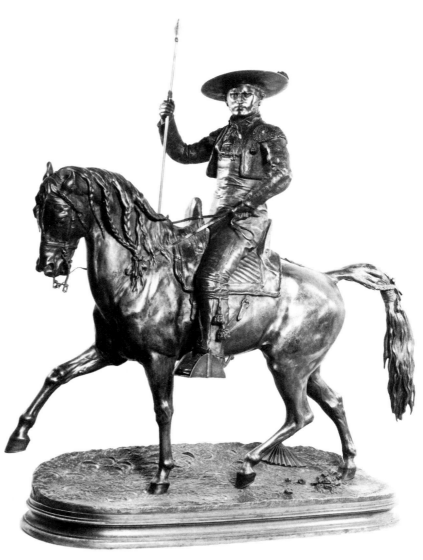

**H229** This is a major work by Pierre-Jules Mêne of a proud picador parading triumphantly around the bull-ring with a lady's fan and garlands of roses at the horse's feet. Beautifully poised and modelled, it is finely detailed. Numbered 3 in Mêne's catalogue and entitled 'Picador à Cheval', it was exhibited at the Salon in 1876 in wax, and a year later in bronze.
Signed 'P.J. MENE': 72 x 59 x 29cm (28¼ x 23¼ x 11½ins.)
rich golden brown patination

*c.1880* £10,000 — £15,000

**H230** This is an equally fine cast of a matador by Mêne and included here for purposes of comparison. Number 9 in Mêne's catalogue it was exhibited at the Salon of 1877 in wax, and a year later in bronze. Although well detailed this particular cast sometimes appears a little worn.
Signed 'P.J. MENE': 52 x 22cm (20½ x 8¾ins.)
dark golden brown patination

*c.1880* £2,500 — £3,000

359

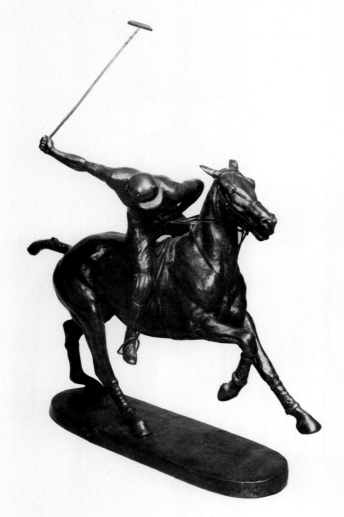

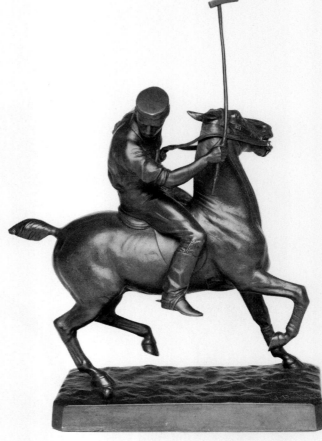

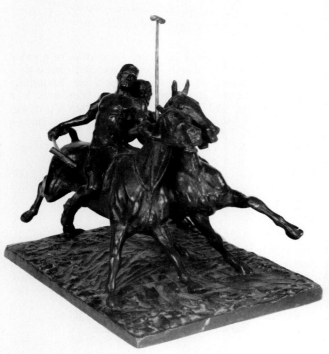

**H231 (above left)** This fine group entitled 'Under the Neck Shot' is by the contemporary sculptor Amy Oxenbould who exhibits at the Tryon and Moorland Gallery. This type of bronze, as well as being a good sculpture, is obviously very commercial, there being a ready market amongst the wealthy polo playing fraternity.

Signed 'Amy Oxenbould', numbered 1/10
rich dark brown patination

**H232 (above)** A fine group of a polo player about to play a shot, by the English sculptor Roche whose jockeys are illustrated as H127 and H128. This is altogether a much better conceived and finished group, very rare and highly desirable.

Signed 'W. Roche': 30.5cm (12ins.)
Coalbrookdale bronze, rich dark brown patination
*Dated 1882*                    *£1,600 — £2,500*

**H233 (left)** This somewhat impressionistic group has a considerable amount of movement in the clash between the two horses and players. Detail has been subverted to give a feeling of speed and movement producing a good three-dimensional effect.

Signed with initials 'F.H.': 38cm (15ins.)
rich dark brown patination
*Dated 1917*                    *£2,500 —£3,500*

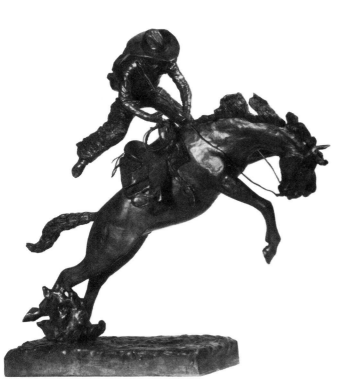

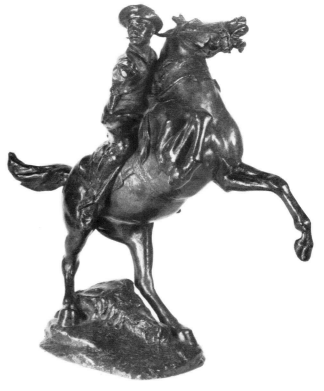

**H234** There is a great revival amongst contemporary sculptors in the United States of America of animal and cowboy subjects. This school, known as the Western Bronzes School is today very active indeed producing a wide range of models with varying degrees of success, continuing the strong traditions of Frederick Remington. This could make a pair with the steer shown as Catl 29. This bronco throwing his cowboy rider out of the saddle, is of very good quality, and a lively subject that has local rather than international appeal.

Signed 'E.W. Bascomb': no size available
rich dark brown patination

*c.1970* £1,800 — £2,200

**H235** A fine group by Adrian Jones, an army vetinerary surgeon who retired in 1882 to take up sculpture. This startled rearing horse is well modelled but unfortunately does not do him justice. The rider's sword arm is damaged.

Signed with the monogram 'AJ': 32cm (12½ins.)
thin black brown patination

*1890s* £1,800 — £2,200

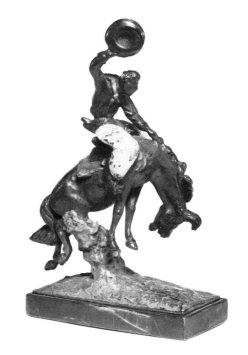

**H236** A cold-painted bronze group of uncertain nationality. Most are Austrian and many are of Western subjects. This somewhat impressionist bronco and rider is quite possibly of American origin. There is an indistinct impression on the base ... AUL HEAT...

Chipped cold-painted patination

*c.1910* £800 — £1,200

361

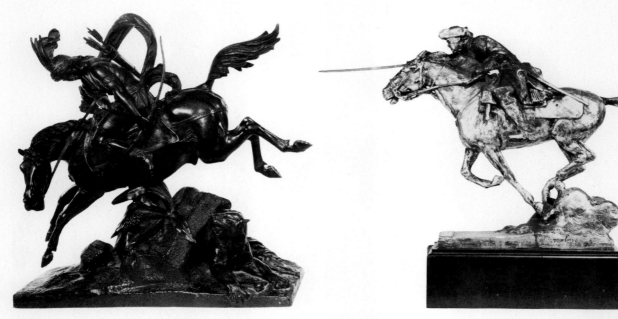

**H237** An exciting but complicated and somewhat naïve group of a Red Indian on a partly harnessed horse leaping a rock and turning to shoot an arrow at a snarling mountain-lion. The detailing is good, and the base with the hidden lion is very realistic. The sculptor has very cleverly extended one of the lion's paws over the side of the base to give the feeling of the animal about to leap, very much in the style advocated by Barye. This unsigned model must be attributed to Gechter.

50.5cm (20ins.): mid to dark brown patination
*c.1850* £2,000 — £2,500

**H238** A silvered bronze group of Paul Revere, the hero, with sword extended, at full gallop. The idea of placing three of the horse's legs against a rock base gives a very good impression of pace, and this is altogether a very successful popular group with obvious historical interest.

Signed 'C. Fagerberg' and entitled 'Paul Revere' with Austrian founder's mark Herman Bergman Bergmanford
34cm (13½ins.): silvered patination
*c.1910* £2,000 — £3,000

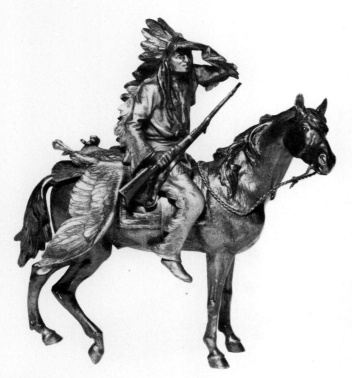

**H239** An Austrian cold-painted bronze of a Red Indian scout scanning the horizon. The whole group is not at all well modelled but is a decorative and interesting subject. It is interesting to note the eagle with wings outstretched thrown over the horse's rump.

Patent Mark 'Geschutz': 16cm (6¼ins.): cold-painted
*c.1900* £600 — £900

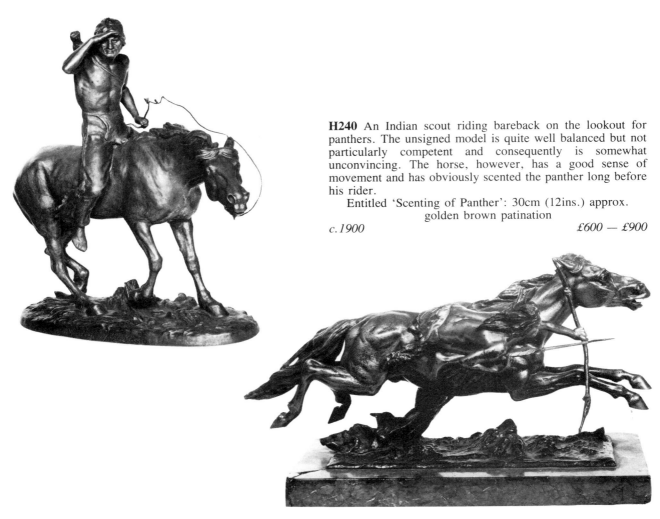

**H240** An Indian scout riding bareback on the lookout for panthers. The unsigned model is quite well balanced but not particularly competent and consequently is somewhat unconvincing. The horse, however, has a good sense of movement and has obviously scented the panther long before his rider.

Entitled 'Scenting of Panther': 30cm (12ins.) approx.
golden brown patination

*c.1900*                                                    *£600 — £900*

**H241 & H242** These are two rare and well modelled groups by Drouot with instant appeal to the American collector. Both illustrate clever use of the horse in Indian fighting tactics and although possibly not conceived as a pair they go well together.

H241 (above). Signed: 'E. Drouot, Etling Paris'
26 x 57cm (10¼ x 22½ins.): rubbed gilt bronze patination
*c.1900*                                                    *£1,800 — £2,200*

H242 (below). Signed 'E. Drouot'
26.5 x 56cm (10½ x 22½ins.)
rubbed brown and black patination

*c.1900*                                                    *£1,800 — £2,200*

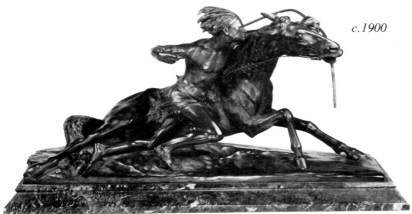

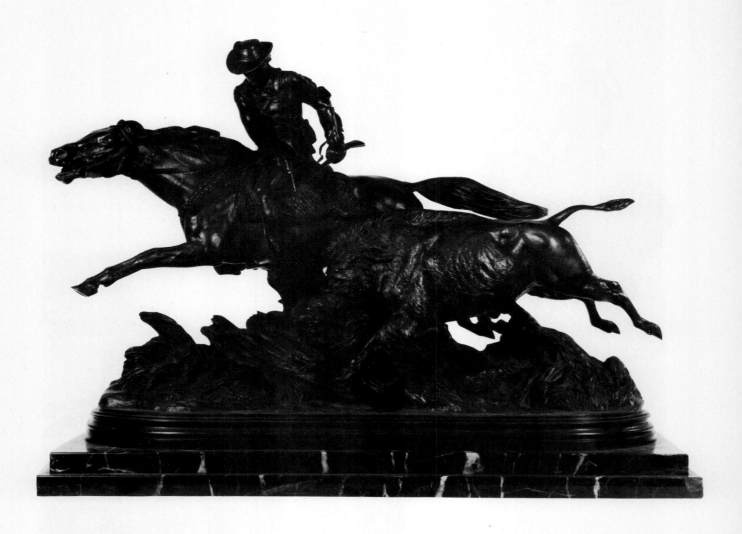

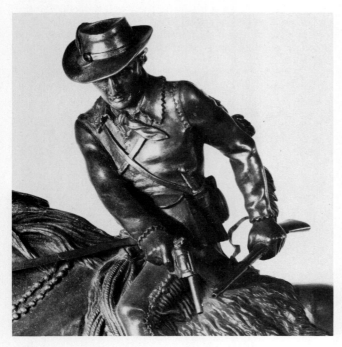

**H243** This must rank amongst one of the most impressive and finest bronzes of the wild west. Modelled by Isidore Bonheur it cannot be called a 'western bronze' in the American sense and quite possibly is not as meticulously detailed as would be an American contemporary sculpture. It is not recorded whether or not Bonheur ever visited America, and almost certainly the inspiration for this group would have come from seeing a travelling circus of Buffalo Bill Cody on one of his extended European tours. Certainly Isidore's sister Rosa was influenced by Cody's circus. This is a fine and lively group although a little crude in detail and is a rare model indeed.

Signed 'I. Bonheur', stamped Bronze
42 x 59cm (16½ x 23¼ins.): dark brown patination
*c.1880*                                                    £4,000 — £6,000

The study of American western sculpture is a separate subject well covered by American writers. Prices for the best examples such as those by Frederick Remington, notably his 'Trooper of the Plains' of which there are fifteen known bronze casts, can reach $250,000. This for a bronze 68 x 51cm (24¾ x 20ins.) is certainly an exceptional price and one unlikely to be met by comparable European sculpture for some time to come.

# Rodents

Unattractive to many in real life, the rodent is a popular,
albeit rare item of sculpture. Often in anthropomorphic poses and always in amusing situations,
they are still inexpensive especially when made as desk ornaments.

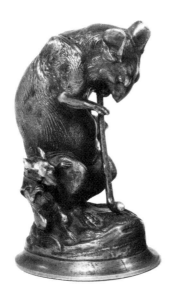

**R1** A rat in a serious, concentrated pose, holding a hockey stick but looking as though he is about to putt. An amusing and small bronze by Arson and a very low priced start to a small collection. These small tongue-in-cheek bronzes must have been made in large quantities but comparatively few are seen on the market today. Many may have become damaged and thrown away or simply lost, and doubtless there are many in children's secret hideaways, long since forgotton. The minute rat at the side is seriously studying the player's style.

Signed 'ARSON': 10cm (4ins.)

*1860* £300 — £400

**R2** A small bronze desk piece, possibly intended as a seal but like many of the same shape not cut with the seal of the owner. The tiny animal is gnawing a bone and it is almost impossible to be sure if it is indeed a mouse, or is a member of the cat family. Although tiny it is beautifully modelled and finely detailed by the unidentified sculptor.

Signed 'P.W.B.': 11cm (4¼ins.): dark rich brown patination
*Dated '86 (for 1886)* £120 — £150

**R3** A very fine and amusing small desk weight by Cain of a field mouse trying to burrow its nose into an oyster shell. The detailing is very good and excellently coloured. A rare model and nice to own as a piece to start a modest collection.

Signed 'A. Cain': 7.5 x 7cm (3 x 2¾ins.) (base width)
rich rubbed gilt-brown over copper red patination
*c.1880* £140 — £180

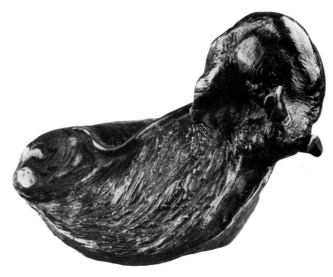

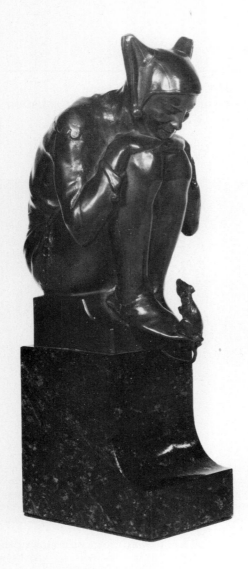

**R4** An early 20th century group by Elischer, a German sculptor. A court jester in medievil costume sits chatting to the friendly little mouse perched on the end of his long curled shoe. Note how the dark green serpentine marble base has been shaped to protect the mouse, whose tail curves down below the base of the bronze.

Signed 'Elischer': 19cm (7½ins.) overall
even dark brown patination

*c.1910* £250 — £350

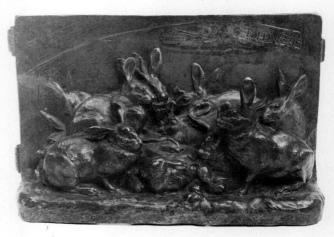

**R5** A sweet little group by Louis-Théophile Hingre, a specialist in two dimensional bronzes, or plaques worked in low relief. There are at least thirteen rabbits crowded on to this plaque, most of them contentedly eating away at a selection of vegetables. This is modelled fairly loosely, in a similar manner to the Mêne group illustrated in Plate 15, p.368.

Signed 'T. HINGRE': 15cm (6ins.)
rubbed mid-brown patination

*c.1890* £300 — £500

**R6** Cain was obviously very fond of these small, friendly animal models. This one of a squirrel sitting quietly on a lily leaf gnawing a nut makes a charming pen tray, and must have been a popular item.

Signed 'A. CAIN': 22cm (8¾ins.) long
black/brown patination

*c.1880* £200 — £300

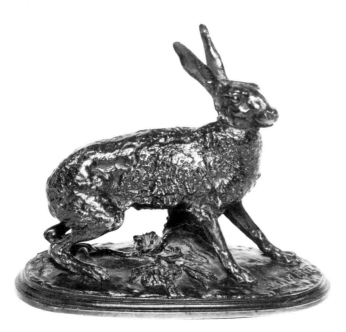

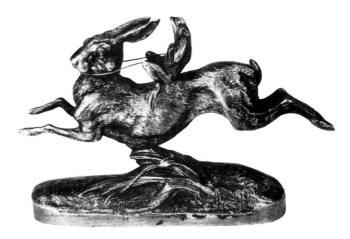

**R7** This hare by Mêne is a miniature and a very good alert model, crisply cast. A typical model that will be appreciated by a wide range of collectors which may cause considerable fluctuation in price, particularly at auction.

<div align="center">

Signed 'P.J. MÊNE': 10.2 x 12.4cm (4 x 5ins.)

rubbed black patination

</div>

*1850s*                                                            *£600 — £800*

**R8** Frogs are commonly used in art and literature in anthropomorphic situations. Here the frog is seated in a majestic pose with head raised on a 'galloping' hare which seems to be a willing partner in the scheme. The sculptor Arson, was fond of these small almost tongue-in-cheek models. They are comparatively rare but too frivolous for most serious collectors.

<div align="center">

Signed 'Arson', and 'Rene Ft': 9cm (3½ins)

rubbed mid-brown patination

</div>

*c.1870*                                                            *£280 — £350*

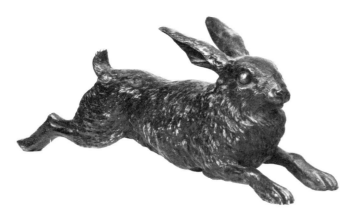

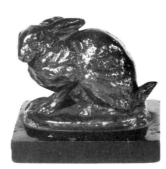

**R9** An unsigned bronze hare, quite possibly a Viennese cast but there are no traces of cold painting which is a typical feature, nor was the animal obviously repatinated. A lively model but with little of the sophistication of the other examples on these pages. Animals with bulbous eyes are unattractive in bronze and sculptors who underplayed this feature would have more success with their models.

<div align="center">

22cm (8¾ins.) long: mid-brown patination

</div>

*1880-1900*                                                        *£200 — £280*

**R10** A tiny unsigned Barye model of a rabbit, similar to two others in his 1847 catalogue. Once again a very popular subject and an excellent model. A difficult bronze to find in today's market as these small models are rarely sold.

<div align="center">

4cm (1½ins.) (excluding plinth)

rubbed brown green patination

</div>

*c.1850*                                                            *£300 — £400*

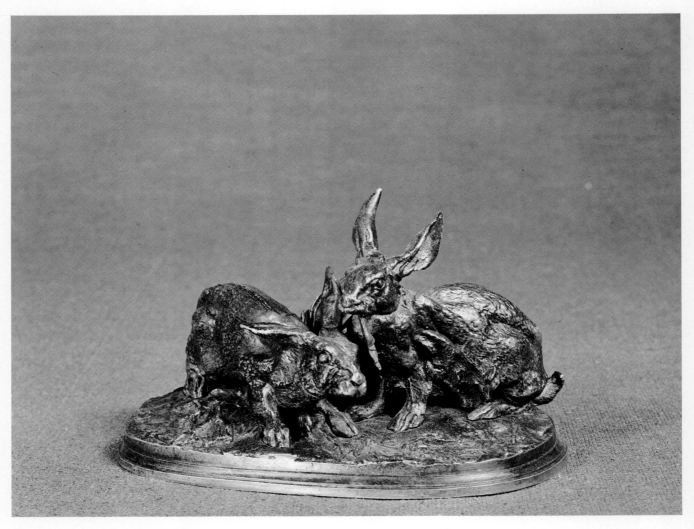

### Plate 15

A very popular model by the master of the small decorative model, Pierre-Jules Mêne. He must have produced quite a large edition of this model but very few are seen on the market today, mainly because of the wide appeal of the subject, far outside the animalier collector field. Most rabbits are comparatively poor and are so often handled that they become rubbed and dented easily, especially the ears and noses. This combined effect can often make a good bronze *seem* at first glance to be a poor one, so it is important to look again more carefully. These small groups, almost in the class of miniatures, were rarely exhibited at the Salon as they were not considered important enough. This can make them difficult to date accurately. A well, if loosely modelled cast. A fine water-gilt cast-iron version is recorded as being the same size.

Signed 'P.J. Mêne': 9.5 x 14cm (3¾ x 5½ins.)
rubbed mid-brown patination

*c.1850*                                                    *£700 — £1,000*

**R11** Two views of a very popular miniature model of a hare by Barye. This small cast varies enormously in quality and is comparatively easy to copy so prospective purchasers should beware of dubious casts and take advice. If in doubt buy only from established dealers who will never want a modern cast and take great care not to buy them. This model was sculpted in the early 1820s but reappears in Barye's first catalogue of 1847. This is a good cast in good condition; even in this comparatively small work the chunkiness of Barye's modelling is evident, in the ample rounded face, thigh and neck muscles.

Signed 'BARYE' and F. BARBEDIENNE, numbered 43
copper/bronze patination
*1850s* £300 — £500

**R12** An unsigned bronze hare without attribution, the finish of which is very solid and chunky in a lumpy, angular sense rather than the generous rounding that Barye would use. An appealing model with forepaws bent and ears erect. Unlike the well-known Barye models this type of bronze will sell at a far cheaper price.

10cm (4ins.) approx.
flat mid-brown patination
*c.1910* £120 — £160

**R13** A very good and proud model of a hare by Gardet, and in keeping with the high standards of this good sculptor. The posture like R7, is typical of the species and very easy to identify. An attractive model with wide appeal combined with good sculpture. Gardet's sense of proportion and quality of detail puts his work in the very top drawer. He also has an uncommon sympathy with the animals he portrays, making them even more attractive to the human eye and sensibilities. The contemporary verde antico marble plinth has gilt bronze edges.

Signed 'G. GARDET', and F. Barbedienne Fondeur
19.5 x 14cm (7¾ x 5½ins.) excluding plinth.
rubbed brown patination with unusual gun metal hue
*c.1900* £450 — £600

# Sheep

Wool is a testing substance for the sculptor to
produce in bronze but, when well done, is
highly effective, producing detail of exceptional quality.

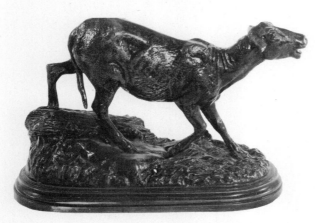

**S1** A very good model of an ewe by Bonheur. A very
competent model and a very endearing one that will always
remain popular amongst both collectors and casual buyers.
The detail is a little worn by handling but still good, and the
bronze has that soft, mellow look essential in a really good
model.

Signed 'I. BONHEUR': 17.5 x 20cm (7 x 8ins.)approx.
mid to light brown patination

*1850s* £700 — £900

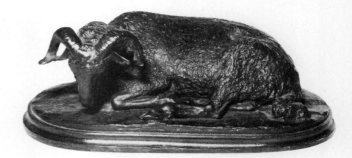

**S2** An uncommon bronze of a resting ram by Rosa Bonheur,
almost certainly made as a pair to her reclining ewe of c.1845,
itself a rare model. Although difficult to display well, they are
both very good, accurate models, with fine detail and casting,
the latter normally by Peyrol. Rosa Bonheur, an eccentric and
highly individual character, was able to portray her few
bronze models with an exact sense of realism, more akin to the
paintings and sculpture of Eugène Verboeckhoven than to
Landseer, whom she much admired.

Signed 'ROSA B.': 9 x 23cm (3½ x 9ins.)
mid to dark brown patination

*1840s* £800 — £1,000

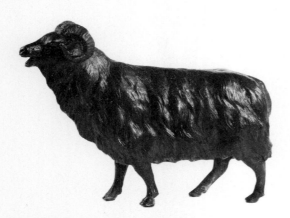

**S3** From one extreme to the other, this indifferent model is
typical of the large number of miniature animals that were cast
and manufactured in the latter part of the 19th century. They
are quite commonly German; this new nation was beginning
to flex its newly established industrial muscles and exploited
every market that it could, usually producing cheap, inferior
goods to undersell local, especially the French, trade. Poor
detail and a very stiff posture make this a suitable children's
toy and not serious animalier art.

9 x 14cm (3½ x 5½ins.) approx.
greasy black brown patination

*c.1900* £80 — £120

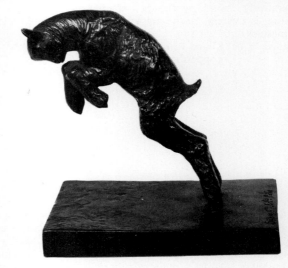

**S4** Paul Silvestre had many sets of these charming bookends
cast in pairs by Susse Frères. Their charm is not only that they
are spring lambs pretending to butt each other, but they do
form very effective bookends if so required, whilst looking
like well designed sculpture if simply placed on a shelf. A
popular and still inexpensive model.
Signed 'Silvestre' and 'Susse Fes. Edts., Paris': 16cm (6ins.)
rubbed brown over red/green patination

*1910-1920* *a pair* £300 — £350

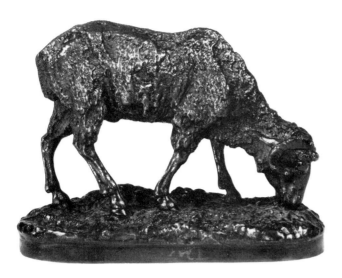

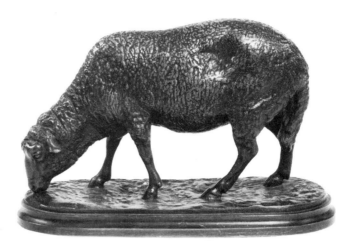

**S5** A very crisp comparatively rare model of a grazing ram by Mêne, showing his tendency to portray rangy animals, this is especially so for his models in the 1840s. Nevertheless, a very good model that is easy to display and nice to handle. The rich patination is in excellent original condition.

Signed 'P.J. MENE': 12.5cm (5ins.)
rich even dark brown patination

*c.1850* £800 — £1,000

**S6** An average cast by Rosa Bonheur of a grazing ewe, modelled in contrast to the reclining ram in S2. The detail is quite good but the bronze has been handled and cleaned so many times that the patination has rubbed, taking the sharp edges from what detail there was in the cast. A comparatively common bronze that equates so well with the popular paintings of the period, and must have been a good commercial cast.

Signed 'Rosa B.': 15.4cm (6ins.)
rubbed dark brown patination

*c.1850* £700 — £800
*for a Peyrol cast in good condition up to £1,000*

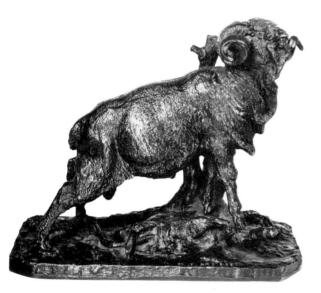

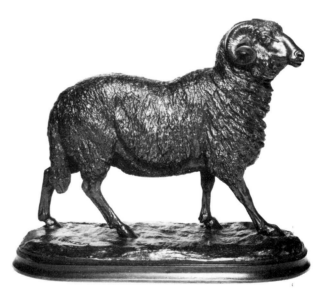

**S7** An exceptionally fine bronze model of a merino ram by Mêne, full of life and detail. The lifting of the animal's head has attenuated the legs and as a result the sculptor has had to add a tree stump for support. The flat sided base is a slight variation on the normally plainer early bases, and Mêne must have put a lot of effort into this fine model, which was exhibited at the Salon in bronze in 1840, Mêne's second year as an exhibitor. It must be compared with the excellent Moigniez group of merinos in S9, remembering that Mêne's model was exhibited a generation before, in the very early days of the animalier style.

Signed 'P.J. MENE': 21.5cm (8½ins.)
black with brown undercolour

*c.1840* £1,200 — £1,600

**S8** Another rare very sharp model by Isadore Bonheur in the style of his sister but without the easy, relaxed naturalism that Rosa instilled in her dozen or so animals. The detail and structure of the body are excellent but the stiff posture is a little difficult to accept in the permanent form of bronze. Eyes are always difficult to get right, and the staring, bulbous eyes may contribute to the discomfort of the viewer.

Signed 'BONHEUR': 21.1 x 18cm (8¼ x 7ins.)
dark brown even patination

*c.1850* £800 — £1,100

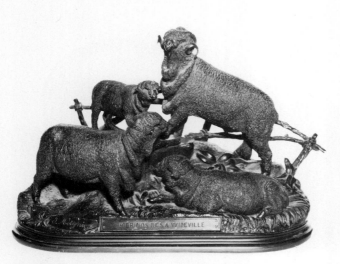

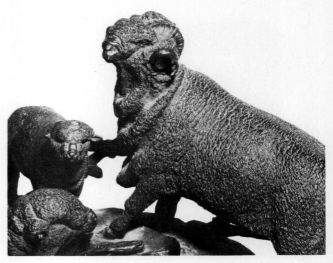

**S9** As the detail shows, one of the sharpest casts ever seen throughout the whole period of animal bronzes. A superb cast by Jules Moigniez, one of four models exhibited at the 1861 Salon, this model being shown in wax. Not only has the sculptor created an attractive, well balanced family group but he has detailed every curl of the wool and modelled an almost Barye-like series of folds in the loose skin and wool of the necks. In common with the accepted ideas of the period he has put one of the sheep, in this case the proud ram, with his front feet on a rock, giving the model added height and perspective, allowing the onlooker's attention to be drawn in a slightly asymmetrical triangle. An excellent cast that has only been seen twice by the author and both times at auction, it is certainly an underappreciated model that would be very difficult to beat for sharp detail and foundry technique.

Signed 'J. Moigniez' and titled
'MERINOS NES A WIDEVILLE': 31 x 40cm (12½ x 15¾ins.)
rich even dark brown to black patination
*1860s* £1,500 — £2,000

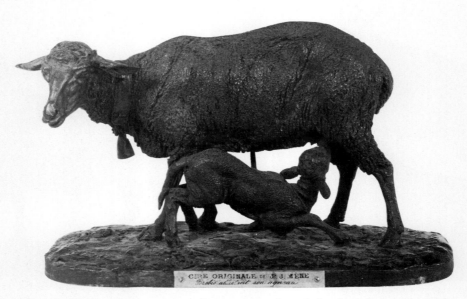

**S10** Another rare and finely detailed model which at first glance may not appear to be the original wax cast by Mêne, but the small stick-like support under the belly of the ewe is a tell-tale sign, and necessary in a wax model to support the weight of the sheep, as the wax has little integral strength and becomes very brittle over a short period of time. This model could have been intended as a pair to the grazing nanny goat on p.268 and is rarely seen in bronze. The Ashmolean Museum in Oxford has a wax equestrian group, as does the Los Angeles Museum, both of which were intended as models for piece-moulds or sand casts but it is possible that this group was intended to be a lost wax model.

It is interesting to compare this wax with the Moigniez bronze in S9, especially the detail of the wool. If one thinks how skilled the sculptor has to be to model the fine detail in wax then spare a thought for the technical problems of transferring the wax into bronze.

Signed 'P.J. MENE' and titled
'CIRE ORIGINALE DE P.J. MÊNE Breebis allaitant son agneau'
15cm (6ins.)
*Dated 1845* *The wax* £1,000 — £1,500
*The bronze* £900 — £1,200

# Swine

A wounded boar may have limited appeal but models of pigs are always popular
and consequently achieve higher prices. The detail given to boar groups can be very high,
the 19th century hunter had great respect for these ferocious beasts!

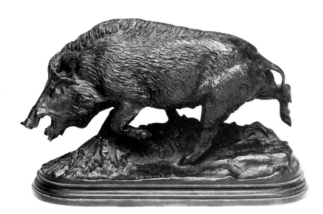

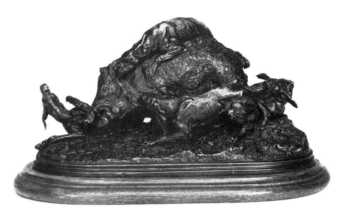

**Sw1** A good Isadore Bonheur model of a running, or charging wild boar. Cast by Peyrol it is of a typically high standard and in this case a lively, more imaginative work than some by Bonheur. The animal is running with one leg touching the ground and unfortunately, the sculptor has added two fallen branches to support the model, something that a modern sculptor would not have to concern himself with, using stronger contemporary materials. A rare well detailed cast.

Signed 'I. BONHEUR' with Peyrol foundry stamp
19cm rich mid-brown patination

*c.1865* £650 — £800

**Sw2** Another rare group titled 'Chasse au sanglier', and an unusually violent one for Mêne. This type of subject was not often modelled after the late 1840s and it is presumed that, as he controlled his own foundry, that he did not issue many recasts of the work he did not favour himself. It featured in the 19 rue de L'Entrepôt catalogue as 28 x 50 x 21cm (11 x 19¾ x 8¼ins.) It is a finely detailed cast and very well modelled, if a little complicated.

Signed 'P.J. MENE': 28 x 50 x 21cm (11 x 19¾ x 8¼ins.)
slightly rubbed dark brown patination

*Dated 1846* £1,500 — £2,000

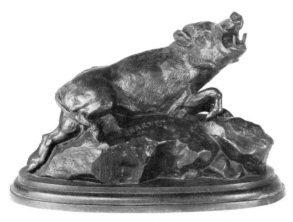

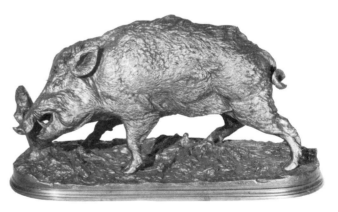

**Sw3** The style of this model is very distinctive and recognisable as by Barye. A very rare model, the wounded boar is struggling to stand as it drags itself over a rocky outcrop. The slab sided rocks are typical of Barye who never overdressed his bases. The detail is good without being too marked and most of it appears to be in the model, not chiselled out after casting.

Signed 'BARYE': 27cm (10½ins.) wide
green/black patination

*1840s* £1,200 — £1,500

**Sw4** Mêne's commercial instincts gave him a secure and comfortable life and his talents were greatly admired by his public. He often used an animal for more than one model, this boar is the same as in Sw2. Certainly it is readily saleable today but not as valuable, being smaller and less dramatic. A good but not exceptional cast.

Signed 'P.J. MENE': 21 x 31cm (8¼ x 12¼ins.)
bronze patination

*1850s* £1,200 — £1,600

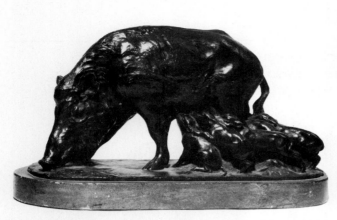

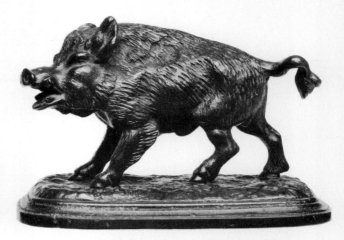

**Sw5** A good model of a sow suckling her five piglets which are jostling for position; the composition is good and compares with the Russian group of a similar subject on p.390. Models of pigs are always very popular and as long as they are reasonable casts they sell well, regardless of sculptor or nationality.

Signed 'Schmidt-Kestner': 21cm (8¼ins.)
brown patination

*c.1910*                                                           *£300 — £400*

**Sw6** A strange little unsigned bronze that at first glance looks like the work of the mid-19th century animalier school but may well be German imitating the Paris style towards the end of the century. The special attention to the eyes and the facial detail suggests that it is possibly a 'portrait' of some disliked associate. The coat reflects the impasto technique that Fratin used and has been very thickly applied in the model.

7.5 x 10.8cm (3 x 4¼ins.)
rich dark brown patination

*1880-1900*                                                        *£280 — £340*

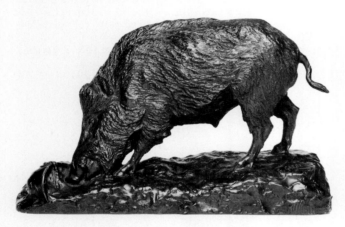

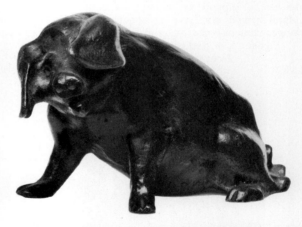

**Sw7** A fine model by Gardet in his very best form in which the body of the boar is very well modelled and proportioned and the casting by Valsuani is superb. The subject matter must be put into context with the time it was executed shortly after the First World War. Feelings obviously have mellowed today but this sculpture will always remind us of the painful memories, as the boar has dug up a Prussian helmet. It is difficult to establish what the value of the bronze would be without the helmet, certainly it would be more and many people who would eagerly bid for such a magnificent cast may be put off by its poignancy.

Signed 'G. GARDET', and the foundry mark
'C. Valsuani Cire Perdue: 38 x 25cm (15 x 10ins.)
rich medium brown patination

*c.1920*                                                           *£800 — £1,000*

**Sw8** A poor model by Carvin of a friendly little sow of which his mentors Frémiet and Gardet would not have approved! Not a good cast, almost totally lacking in detail and badly worn and battered. These small models must have been made in large quantities and may well have been intended for children.

Signed 'CARVIN': approx. 7cm (2¾ins.) wide
black patination

*c.1910*                                                           *£50 — £70*

# Miscellaneous

## (Including Ornaments, Japanese, Russian and Viennese Bronzes)

## ORNAMENTS

Several of the early animaliers produced elaborate decorative vases, candlesticks and boxes, cast in bronze and encrusted with flowers. They were cast in full or low relief with animals, in often charming and unusual ways. Today they are not very easy to find and have more value to collectors than practical use.

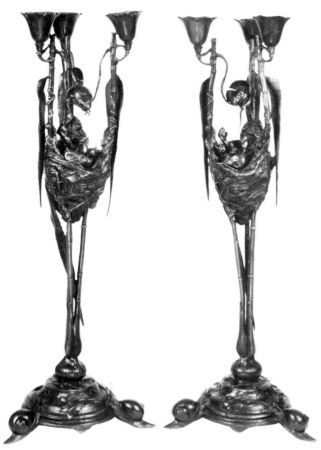

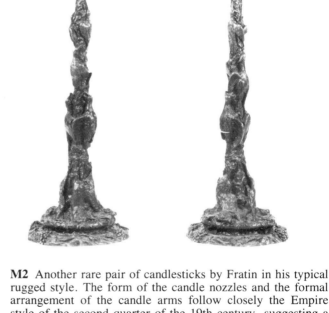

**M1** Cain had one of the most humorous talents in the animalier world and his fine pair of three branch candlesticks are typical of the naturalism that prevailed in the Paris and London style of the mid-19th century. Neither rococo nor baroque, it was an individual style that underwrote the whole conception of animal sculpture in the romantic idiom. At first glance there is a definite trace of the art nouveau style that was to engulf the artistic world by the end of the century and it is important to learn to differentiate between the naturalistic and art nouveau styles. Here a linnet feeds its young in a nest supported by bamboo canes entwined with lilies. The leaf-cast socle is supported by three snails cast in full relief. Fine quality and unusual content make these sought after models, especially in good condition.

Signed 'CAIN': 51cm (20ins.): even mid-brown patination
*c.1860*                          *the pair £600 — £900*

**M2** Another rare pair of candlesticks by Fratin in his typical rugged style. The form of the candle nozzles and the formal arrangement of the candle arms follow closely the Empire style of the second quarter of the 19th century, suggesting a comparatively early date. The sculptor is having yet another dig at the human race and has placed an ape at three of the candle sconces, blowing each one as if it were a hunting horn; this again helps to place quite an early date. The stems are ruggedly cast with a mass of dead game, and the socles have the essential bunches of grapes.

Signed 'Fratin': 46cm (18ins.)
light brown patination
*c.1840*                          *the pair £700 — £1,000*

375

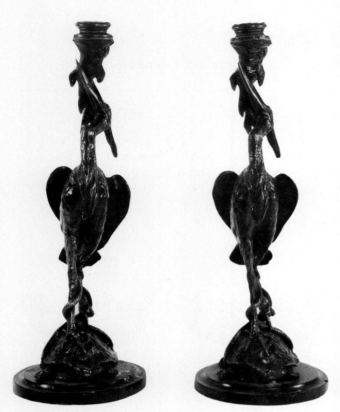

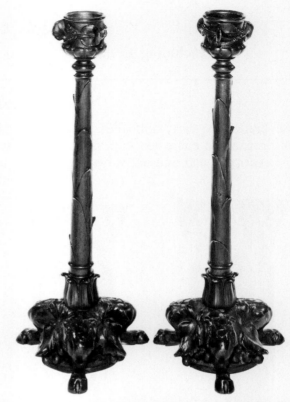

**M3** The heron in a familiar pose, standing on the back of a long suffering turtle, which is worth comparing with the model on p.101. The heron's leg is held by a snake and in turn the heron holds a fish whose gaping mouth forms the candle nozzle. An amusing model but not very well detailed.

Signed 'FRATIN': 33cm (13ins.)

even mid-brown patination

c.1855                                          the pair £700 — £1,000

**M4** The triform, classical base suggests an early date to these single candlesticks by Barye, and shows an early indication of the naturalistic style. The three *pieds de biche* are hardly animalier and have their origins in early Rome.

Signed 'BARYE': 23cm (9⅛ins.)

dark brown patination

c.1830                                          the pair £250 — £300

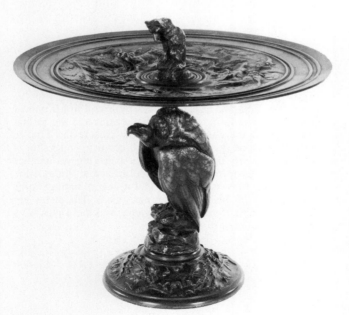

**M5** A well detailed tazza by Moigniez in similar style to M7 with a very bored looking eagle carrying the weight of the plate on its back, the plate cast with a fox from Aesop's Fables.

Signed 'J. Moigniez': 28cm (11ins.)

slightly rubbed mid-brown patination

c.1870                                          £220 — £320

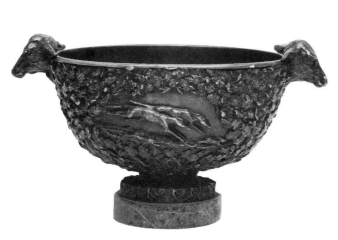

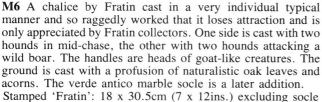

**M6** A chalice by Fratin cast in a very individual typical manner and so raggedly worked that it loses attraction and is only appreciated by Fratin collectors. One side is cast with two hounds in mid-chase, the other with two hounds attacking a wild boar. The handles are heads of goat-like creatures. The ground is cast with a profusion of naturalistic oak leaves and acorns. The verde antico marble socle is a later addition.
Stamped 'Fratin': 18 x 30.5cm (7 x 12ins.) excluding socle
rubbed dark brown patination
*1840s*                                                         £600 — £700

**M7** Tazzas are not very useful ornaments and are not popular today, but are often sources of fine detailed modelling and casting. This is one of a pair by Louis-Emile Cana. The eagle's outstretched wings support the plate which is profusely cast in low relief with rabbits on one side and pheasants on the other.
Signed 'E. Cana': 24cm (9½ins.)
mid-brown patination
*c.1870*                                                  *the pair £300 — £360*

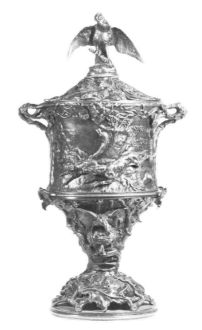

**M8** These bronze vases by Mêne show good examples of animals modelled in relief with elaborate naturalism. Although interesting they are too lumpy to be very decorative and are consequently not very popular. The lids are cast with a falcon on one and a heron on the other, while a stag stands his ground to a pair of hounds on one of the sides, and a hound catches up with a scrawny fox on the other. The tapering base of one is cast with a bird about to snare a fly, and the other has a

snake about to steal eggs from a nest guarded by a parent bird. The intricate web of branches and oak leaves also form the handles. Some pairs are dated (usually on the stag vase). The signature may include the circumflex. The height varies depending on how bent the lids have become.
Signed 'P.J. MENE': 38 to 40cm (15 to 15¾ins.)
even dark brown patination
*Dated 1849*                                          *the pair £1,200 — £1,800*

377

Moigniez modelled at least five slightly different versions of these velvet-lined jewel boxes (M9-M12), with varying degrees of ornate decoration and presumably at different prices. They are similar in form to the ornate boxes in ormolu and Sèvres style porcelain exhibited by Samuel Wertheimer at the Great Exhibition in 1851, and Moigniez is recorded as exhibiting one at the London Exhibition of 1862. All are mounted with recognisable bronze groups by the sculptor into elaborate eclectically designed boxes of a mixed mannerist and baroque form, the popular 'Jacobethan' style that was in fashion for ornament, decoration and furniture at the time. They must have been cast in some quantity but are becoming infrequent visitors to the salerooms and galleries. The casting of the boxes does not always match up to the high standards of the bronze group on the lid, and it is worth looking carefully and only paying a 'top' price for a top quality box. Typically of Moigniez, all the boxes are surmounted by birds which were his *métier*.

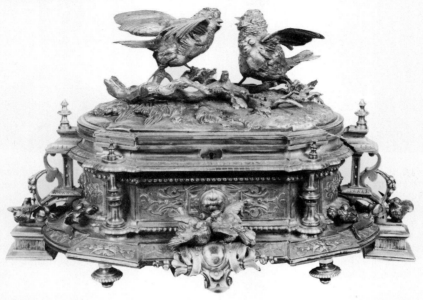

**M9** The best example silver electrotype casket cast to a high standard, with a more than usually elaborate arrangement of supporting columns and pierced side 'supports'. The group on the top is Moigniez's model of 'Sparrows Fighting' illustrated on p.98.

Signed 'J. MOIGNIEZ' on the bronze group
24 x 38cm (9½ x 15ins.)

*1860s*                                                      *£900 — £1,100*

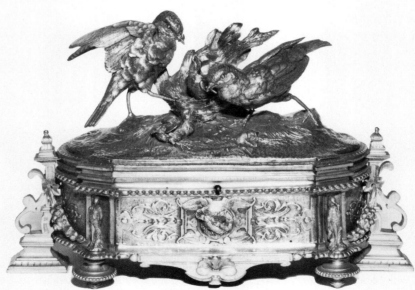

**M10** Another good box but not quite as elaborate as M9. The unusual group of birds consists of two parent birds feeding their young in a nest and is a good group in itself. The bird theme is repeated on the box castings.

Signed 'J. Moigniez' on the group: 19.5 x 28.5cm
(7¾ x 11¼ins.): parcel-gilt and silvered bronze
*1860s*                                                      *£650 — £850*

378

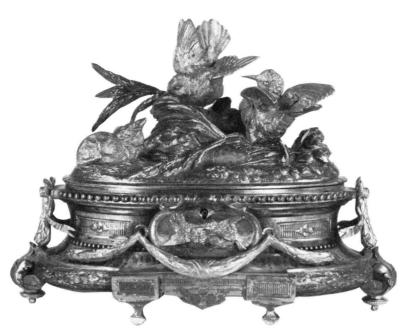

**M11** A silvered copper and bronze casket, the box signed by Tahan of Paris. The colour combination is unusual and leads one to think that the copper colour was intended to be either silvered or gilt and either this was never done, or it has been stripped. The bronze group was available by itself and is discussed on p.98. The box is of disappointing quality for such a good maker of *meubles de luxe* and *objets de goût*. The fact that the box is signed by a well known maker of furniture and small objects suggests that Moigniez had all the work for the boxes done by other workshops and this accounts for the inconsistency in casting quality. The house of Alphonse Tahan flourished from c.1830 to c.1880 and was a supplier to Napoleon III. The poor quality of the signed box is inconsistent with the normal high standard of their work.

<div align="center">

Signed 'J. Moigniez' on the bronze and
'Tahan Fr. de l'Empereur': 23cm (9ins.) wide
silvered copper and bronze patination

</div>

*1860s*                                                                 *£500 — £800*

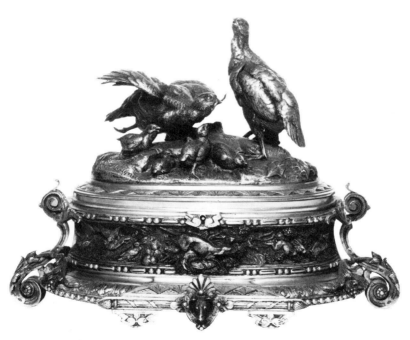

**M12** Another typical group by Moigniez and a good and unusual one of a brace of woodcock and their chicks. The concave sides are cast with a frieze of foxhounds chasing a hare, centred by a silvered mask of a fox. A good quality casket.

<div align="center">

Signed 'J. Moigniez' on the bronze: 30 x 24cm (11 x 9½ins.)
silvered and gilt-bronze

</div>

*1860s*                                                                 *£750 — £950*

# JAPANESE BRONZES

Most collectors at some stage come across extremely well-cast bronzes that do not quite fit into the normal pattern of the Anglo-French animalier theme and cause a certain amount of concern until one realises that they are probably one of the formidable range of fine Japanese models cast for the most part, in the latter part of the 19th and early 20th centuries.
Ranging from articulated crayfish to hares and tigers to toads,
they are cast with meticulous detail and many of the smaller models are life size and cast with an accuracy that suggests that they were cast from real animals.
One giveaway is that many animals have glass eyes, a technique rarely employed in Europe and the wood stands are carved in a typical Oriental fashion.
In many but by no means all cases the animals have a stamp or signature in Japanese calligraphy, usually on the underbelly, and generally are very thin casts,
even compared with the very best European casts, and have a distinctive copper-red patination caused by the high copper content in the bronze alloy itself.

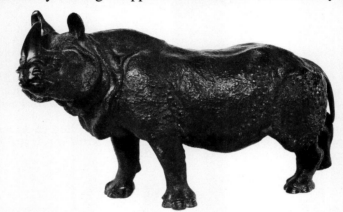

**M13** A rhinoceros by Genryusa Seiya, a Tokyo School artist, very realistically cast with great attention to the folds of the skin and with fine cold chasing to the bronze. An unusual choice of animal and always a popular one which helps the price.
Cast mark of the sculptor: 49cm (19¼ins.) long
*c.1900*                                    *£1,900 — £2,800*

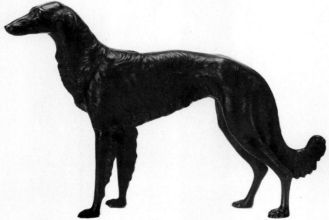

**M14** A Scottish deerhound, in the Japanese manner! A very unusual cast that without previous knowledge or experience of Oriental casts would be very confusing. The general run of these Japanese bronzes were cast for the vast European and American export market and this one seems a positive attempt to compete directly with Paris. Although a bronze with fine detail and good patination, and one that compares favourably with a French equivalent in price, it does not have the European flair and balance. Mechanical excellence does not make up for an animal that must have been rather unfamiliar territory for the unknown sculptor.
16.1 x 23.5cm (6¼ x 9¼ins.)
*c.1910*                                        *£420 — £500*

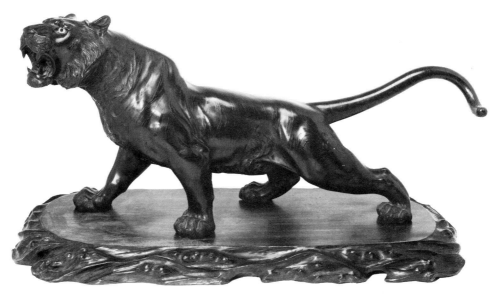

**M15** A fierce looking tiger by Genryusa Seiya and a fairly typical model, popular both in the late 19th century and again in the last ten years. Very cleverly the animal's distinctive stripes are emphasised in the patination. There is a strange lack of sophistication in the general handling of the pose of the tiger that appears unrealistic. However, a good and large cast.

Cast mark 'dai Nihon, Genryusa Seiya tsukura'

c.1900                                            £1,800 — £2,500

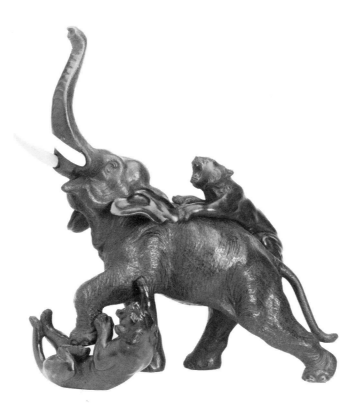

**M16** A good example of the Japanese love of complicated groups of animals by Seiya, a prolific maker, mainly working for the export market, but again showing a naïvety impossible in the European schools. Unfortunately these groups of fighting animals never seen to have been sculpted as a uniform group. Here the tusks are made of real ivory, a common feature, but they must be in good condition. One of the tusks has been repaired on this example.

Signed 'Seiya saku'

c.1900                                            £300 — £400

# RUSSIAN BRONZES

Many of the popular bronzes cast in Russia in the 19th century
and the first few years of the 20th century centre on the horse and its use by man.
Consequently they can be classified as animal bronzes to an extent.
They focus on the romantic side of life in Tzarist Russia,
including many Cossack groups and peasant scenes. Many were cast by German founders
such as Woerffel who worked not only in bronze but also cast-iron.
The magnet test is important if the material used is not immediately obvious.
The Russian foundries also cast a number of farmyard animals in cast-iron,
which are often very good models albeit thickly cast and rather heavy.
Pierre-Jules Mêne's shaggy haired goats were often cast in iron by the Russians,
some of them being signed in Cyrillic. As with the French,
all the Russian bronzes were cast for some time after they were first modelled
and there are many modern casts on the market today.
Three other Russian groups H160, 196 and 227 have been included in the section on horses
where they may be compared directly with their European counterparts.

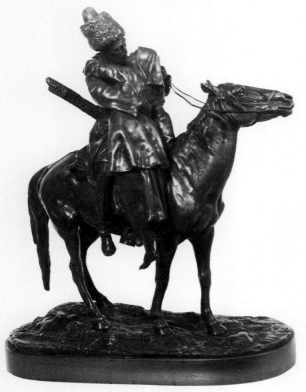

**M17** This is possibly one of the best known Russian groups and consequently a very popular one by Lanceray. 'The Sweetheart's Farewell' is a sensitive model both in conception and in execution. Variations of this group include a model by Gratchev in which the soldier wears a peaked cap; both versions are worth approximately the same, the Lanceray model being finer but the Gratchev rarer. Well detailed groups that are highly sought after, especially for good casts.
Signed in Cyrillic and with the Cyrillic Chopin foundry mark
41cm (16ins.): rubbed medium brown patination
*Dated 1878*                                           *£1,800 — £2,200*

**M18** A fine and rare model by Gratchev and an attractive and appealing cast with a Cossack allowing his sweetheart to take the reins. The detailing is very crisp and sharp with special attention paid to the faces; the girl is giving her lover a wry smile.
Signed in Cyrillic 39.5cm (15½ins.)
even rich dark brown patination
*Dated 1878*                                           *£1,800 — £2,200*

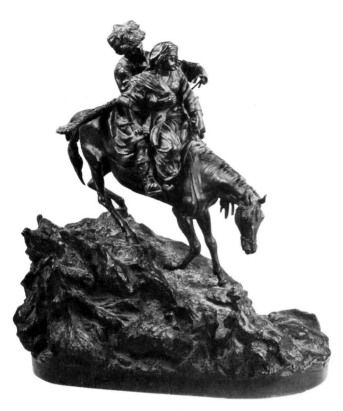

**M19** Another good but loosely modelled cast from the Woerffel foundry by Gratchev. The idea of a horse taking a steep slope is a very successful one sculpturally that first seems to have been used in Russian bronzes but was soon to be taken up by Remington in New York. A model that delights with its sense of horsemanship as the Cossack rider casually guides his surefooted horse, holding on to the girl who appears to be from the Bokhara region.
Signed in Cyrillic and Arabic, and with the founders' signature 'Fab. C.F. Woerffel, St. Petersburg' 34cm (13½ins.): dull black/brown patination
*Dated 1877* £1,300 — £1,600

**M20** A far less assured group in a similar manner to M19. The girl nervously takes the reins while her apprehensive admirer looks on.
Signed in Cyrillic 'M. Wulff': 29cm (11½ins.) heavily rubbed brown patination
*c.1890* £800 — £1,000

**M21** A good and unusual Gratchev model of a herdsman with a lasso, which is a very well detailed group and finely modelled with the horse shying realistically. An identical model of this bronze, 21.5cm (8½ins.), is recorded signed 'M. Bonger'.
Signed in Cyrillic: 23cm (9ins.) even mid-brown patination
*c.1880* £1,000 — £1,500

383

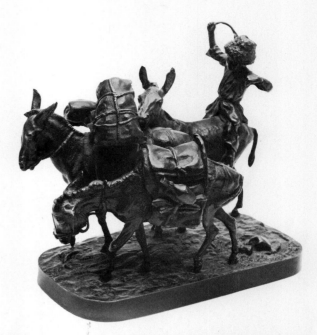

**M22** A well cast bronze group of a farmer riding into market on a mule, carrying a pannier of melons. The dress and style of the man suggest the group is modelled on a southern scene, possibly in Georgia. The mule is sensitively modelled, a good animal work in its own right.

Signed in Cyrillic: 17.5cm (7ins.)
even mid-brown patination

*c.1900*                                                   *£550 — £700*

**M23** A popular and fairly common group by Lanceray of a southern boy driving three mules, two of them laden with heavy packs. In this model his whip is missing. The boy is naïvely modelled but it makes an attractive group.

Signed in Cyrillic: 23 x 21cm (9 x 8¼ins.)
black patination

*c.1900*                                                   *£900 — £1,000*

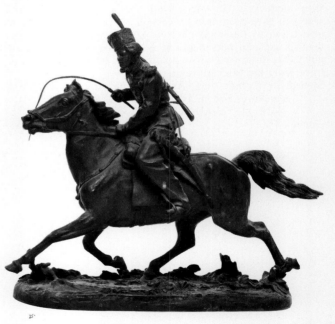

**M24** A cossack walking his dogs as he lights his pipe. Two borzois at the feet of the horse add interest to this Gratchev group. Another crisp and well detailed model with very sharp definition.

Signed in Cyrillic: 43cm (17ins.)
dark even brown/black patination

*Dated 1877*                                             *£1,600 — £2,000*

**M25** A dashing equestrian group by Lanceray but a stiffly modelled one, the figure in this instance being better sculpted than the horse, which appears to have very short legs. Inexplicably the young soldier appears not to have a sabre in his scabbard.

Signed in Cyrillic with Chopin foundry mark: 36cm (14¼ins.)
flat dark brown patination (in need of a good polish)
*c.1900*                                                  *£1,200 — £1,600*

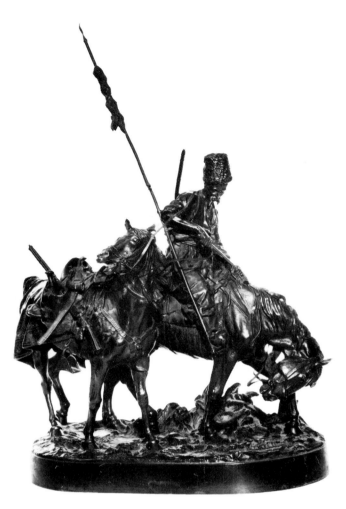

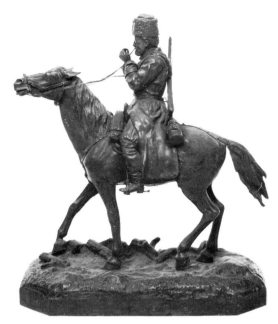

**M27** A similar model to M24 but lacking the interest of the dogs. The soldier is very well modelled and this makes for a very satisfying and realistic decorative group.
Signed in Cyrillic: 45cm (17¾ins.)
dull even brown patination
*c.1900*                                    *£1,500 — £1,900*

**M26** An excellent model, attributed to Gratchev, which sums up all that is good about the sculptural skill and foundry technique of Russian bronzes. This mustachioed warrior is resting after a skirmish, sheathing his dagger in a weary manner. The equally weary horse rubs his leg as the other horse whinnies in anguish, looking back to the battlefield. It is not absolutely clear whether the riderless horse belongs to friend or foe but judging from the different trappings it is probably intended to be an enemy horse, its rider lying on the battlefield. The addition of the lance to this group is a sculptural triumph, adding a new dimension to what is already a good model. There are many extremities that will get lost and damaged on this group if neglected, and a buyer should expect to pay far less for a badly damaged cast, however rare.
33cm (13ins.) approx: rich mid to dark brown patination
*1880s*                                    *£3,000 — £5,000*

**M28** A bold sculptural model by Lanceray in his series of Cossack subjects. The famous trick of the Cossack standing on the saddle to gain height to shoot is a well known one, and the sculptor was probably aiming at a wide market, not only his home market. The photographer's angle is slightly unfortunate but the model is at best a little awkward. This example is not a particularly good cast but they can be far better. The wax maquette realised £480 at Sotheby's in 1976.
Signed in Cyrillic: 27cm (10½ins.): black patination
*c.1910*                                    *£600 — £800*

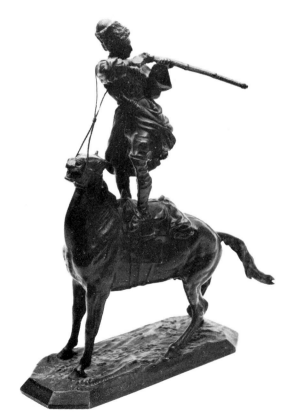

385

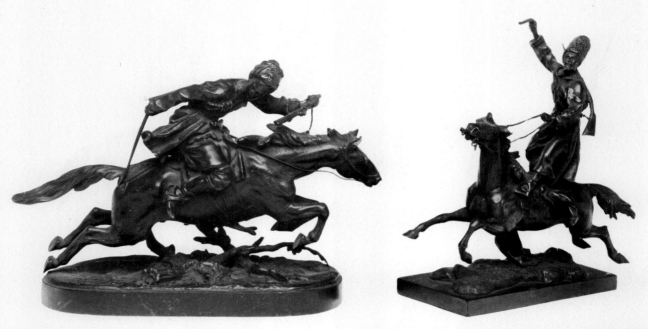

**M29** An extraordinary group of a Cossack standing in the saddle of his galloping horse with the remains of a whip in his outstretched hand. A naïvely modelled group that has been badly neglected.

21.5cm (8½ins.): deep brown patination

*1880-1900*                                              *£450 — £550*

**M30** Another dashing model by Gratchev of a horse and Cossack rider jumping a fallen branch at full gallop. His style is similar to Lanceray's but without the inbuilt skill of his modelling.

Signed in Cyrillic: 18.4 x 21.6cm (7¼ x 8½ins.)
dark brown patination

*c.1890*                                                 *£500 — £700*

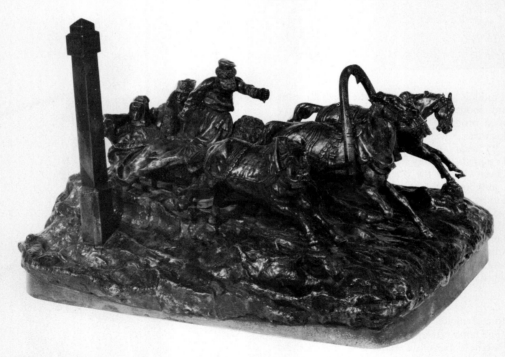

**M31** A finely modelled and chiselled group of a troika racing past a signpost. The figures are all well wrapped up against the harsh weather, the passengers snug beneath a fur rug. A good cast which embodies all that is Russian in the style, composition and finish of the model.

Signed in Cyrillic 'L.B.P. Gratchev and K.F. Woerffel'
48cm (18¾ins.) wide

*c.1880*                                                 *£3,000 — £4,000*

**DU PASSAGE, see PASSAGE**

**DUPON, Josué (1864-1935).** Belgian, born at Ichteghem. Studied under Vinçotte (q.v.) and worked in the popular mixed media of bronze and ivory in great demand at the turn of the 20th century. His 'Vulture Swooping on its Prey' in the Antwerp Museum in turn inspired his pupil Scutter (q.v.). A pair of lions is in the Antwerp Zoo collection. An example of his work is shown on p.53.

**DU PORTUGAL, Antonio Coello (b.1948).** Spanish, born in Madrid. Educated in Spain and at the Tower Hill School in Delaware where he studied Art and then studied Architecture at Madrid University and is now a practising architect. A keen competitor at show jumping events he began to draw animals and to sculpt in the mid-1970s. He has had exhibitions in Madrid, Las Vegas and at the Spanish Institute in London. His style differs from many of his contemporaries in that he is often content to capture the spirit of the 19th century animaliers in sculptural form and texture with a most pleasing effect. Models include 'Fell at the Last', bronze, edition of 15; 'Horse's Head', bronze, edition of 20; 'The Afternoon Ride', bronze, edition of 15; 'Horses Fighting', bronze, edition of 20.

**DURAND, Amédée-Pierre (1789-1873).** French, born in Paris. A portraitist who studied at the Beaux-Arts winning the Prix de Rome in 1810. He as also a medallist who inherited a thriving bronze casting workshop from an uncle and the foundry's signature is sometimes found on animal as well as other bronzes. His casts always have the meticulous feel of the exactness of a medallist and are always highly prized by the collector. Most casts seem to span the second quarter of the 19th century.

**DURASSIER, Eugène (fl. early 20th century).** French. He exhibited at the Salon des Artistes Français. His animalier work was mainly confined to bird studies.

**DUROIDZE.** An example of his work is illustrated on p.185.

**EGGENSCHWYLER, Urs (b.1849).** Swiss. Like several of the animaliers he studied his subject matter at zoos but in this case had a private zoo of his own to work from. He also drew inspiration from the various travelling circuses. He specialised in lion subjects, many of which now adorn municipal buildings in Switzerland. He worked for a limited time for 'mad' King Ludwig of Bavaria.

**EHRLICH, Georg (1897-1966).** Austrian, born in Vienna where he studied, but settled in England after the First World War. He was a gold medallist at the 1937 Exposition Internationale and exhibited widely throughout Europe.

**ELISCHER.** An example of his work is illustrated on p.366.

**ELSE, Joseph (1874-1955).** English, born in Nottingham. Studied at the Royal College of Art and later became principal of the Nottingham School of Art. An amazing model entitled 'Zeus, The Philanderer' shows a brazenly naked woman below a towering art deco bull in a style that could only be from the 1920s and 1930s. The sculptor has created a figurative bull but retained correct anatomical form.

**EPINAY, Prosper d' (b.1836).** Born in Mauritius but studied in Paris and Rome. Mainly executed genre work. An example of his work is illustrated on p.256.

**EVENS, Otto Frederik Theobald (1826-1895).** Danish, born in Copenhagen. His father was a bronze founder, a trade that Otto continued to learn at the academy in Copenhagen. His only recorded animal group is 'Groom Watering his Horse'.

**FAGERBERG, C.** An example of his work is illustrated on p.362.

**FARNHAM, Sally James (1876-1943).** American, born in New York. Travelled widely in Europe and, encouraged by Frederic Remington (q.v.), she started sculpting in 1901. She lead a successful career, concentrating mainly on equestrian cowboy groups. Her models of horses showed her great love for them; all her models are lively and well finished.

**FAUGINET, Jacques-Auguste (1809-47).** French, born in Paris. He exhibited at the salon from 1831. His varied work included a number of bas-reliefs of animals and portraits of horses, betwen 1833-47. Lami lists numerous animal models, principally of horses, showing what must have been a successful studio, although work by this artist is not common on the market.

**FAUQUE.** An example of his work is illustrated on p.146.

**FAVRE, Maurice (fl. late 19th/early 20th century).** French, born in Paris. His signature is shown below.

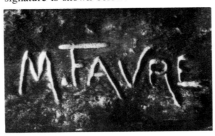

**FEHRLE, Wilhelm (b.1884).** Born in Southern Germany. He studied in Berlin, Munich and Rome, later exhibiting at the Salon d'Automne. His bronzes were almost exclusively animals.

**FERNKORN, Anton Dominik Ritter von (1813-78).** Austrian. His main speciality was portrait work but his over life-size figure of the 'Lion of Aspern' in Vienna is a sobering reminder that large monumental works can convey the realism and sensitivity of smaller subjects.

**FERRIÈRES, Armand de (b.1873).** French, born in Paris. Son of the animal sculptor, the Count de Ferrières (q.v.), he worked with his father and also Maillol. He exhibited at the Salon des Artistes Français from 1905.

**FERRIÈRES, Louis-François-Georges, Comte de (1837-1907).** French, born in Paris. He exhibited widely at the Salon from 1865-93, showing wax and plaster groups mainly of dogs but also horses and other animals. Lami lists twenty different models and groups.

**FIERO, Emilie (fl. 2nd quarter 20th century).** American, born in Missouri. She studied in Paris where she appears to have continued with her career, exhibiting numerous small bronze and plaster figures of animals at the Salon des Artistes Français from 1925-27.

**FIOT, Maximilien-Louis (1886-1953).** French. Susse Frères cast a 'Couple de panthères au repos', 13 x 21cm (5 x 8¼ins.) (lost wax). An example of his work is illustrated on p.244.

**FOLEY, John.** An example of his work is illustrated on p.326.

**FORD, Edward Onslow (1852-1901).** English. Studied in Antwerp and in Munich, returning to London with his début at the Royal Academy in 1875. A monumental sculptor and a portraitist he was a follower and developer of the English New School of Sculpture. His romantic, highly realistic sculpture was full of innovation and combined the use of different materials to heighten the overall effect. An example of his work is illustrated on p.119.

**FORNANDER, Andreas (1820-1903).** Swedish, born in Stockholm. He studied and worked almost exclusively in Sweden as an animalier. His 'Roe Deer' is exhibited in Stockholm.

**FOUQUES, Henri-Amédée (1857-1903).** French, born in Paris. He exhibited at the Salon 1881-1903 with a mixture of classical, archeological and animal bronzes. Lami lists eleven in the animal category with such titles as 'Five-o'Clock, a hunting dog', the marble exhibited at the Salon in 1905, and the plaster at the 1900 Exposition Universelle. Other titles are 'Amour conjugal; lion et lionne' plaster 1900, bronze 1901, and 'Petit chat guitariste', 1902, plaster. His 'La Fiancée du Lion' was shown in plaster in 1903 and again in bronze the year after his death.

**FOURNIER, Pierre-Émile (1829-92).** French, born in Paris. An interesting sculptor whose studied drawings and models of animals were supplied to veterinary colleges and zoos. He was a talented painter and had studied his animal sculpture under Frémiet and Barye (qq.v.). Between 1864-92 he exhibited 20 wax and bronze figures including a gazelle, sandpiper and dragonfly, deer attacked by a bear, and a bull and bull mastif.

**FRANZ see PIRNER UND FRANZ**

**FRASER, James Earle (1876-1953).** American, born in Minnesota. Since his death, he has come to be regarded as one of America's foremost Western sculptors. He studied in Chicago and in 1894 went to Paris where he studied under Falguière, returning to American in 1900. He quickly established a reputation as a competent and varied

sculptor but his models of cayuses, the small sturdy horses of the American west, and a group of buffaloes, all cast after his death, show a rare American feeling for impressionism whilst retaining that peculiarly American feeing for 'Western' animal sculpture.

**FRASER, Laura Gardin (b.1889).**
American, wife of James Earle Fraser (q.v.) having studied under him from 1907-10 in New York. Apart from a small amount of medal work she concentrated on small animal figures such as 'Baby Goat' (1920), a bronze puppy and a piglet.

**FRATIN, Christophe (1800-64).** French, born in Metz. Comparatively little is known about this fascinating and highly competent sculptor of the animalier school. His understanding of the form and structure of his subjects gives them an eerie realism with most of his animals appearing rather too thin by the well fed standards of animals today, and his subjects consequently can be a little off-putting to the modern eye with their protruding rib cages and often slightly flat quality. This basic understanding doubtless comes from helping in his father's practice as a taxidermist. His early studies in sculpture were under Pioche who had returned to Metz after a successful career in Paris but the talented pupil became frustrated with the by now senile Pioche and settled in Paris where he studied under the far sighted and adventurous painter and sculptor Géricault (q.v.), a friend and fellow student of Delacroix. Géricault's affinity for the horse had a profound effect on Fratin whose first entry at the Salon in 1831 was an English thoroughbred, no doubt also influenced by Géricault's exile in London where he had concentrated on prints and paintings of English horses. Fratin's work was highly popular in many European countries as well as America and England. Jane Horswell in *Les Animaliers* records him as being accorded 'the greatest animal sculptor of his day' at the Great Exhibition in London in 1851. Fratin's work was highly romantic in interpretation without the dramatic treatment that Barye so successfully managed, he tended to prefer domestic animals but always captured his subject in motion, not always successfully and occasionally a little too stiff but with flowing manes and tails. Some of his most favoured and collected works are his numerous dancing bears, none of which appear to have been shown at the Salon during his two periods of presenting exhibits 1831-42 and 1850-62. Several of his works were refused entry at the Salon in the late 1830s but present history does not record whether this was the reason for the eight years in the 1840s when he did not exhibit. Founders: Susse Frères in the 1830s, Quesnel until 1847 and Daubré. Jane Horswell lists Fratin's 46 exhibits. Many of his works were reproduced for commercial purposes during his lifetime. In March 1857 he held an auction of seventy terracotta models. His work may be found in the following museums (mainly consisting of outside statuary and plaster work): Metz; the Wallace Collection, London; the Peabody Institute, Baltimore, and the Eisler Collection, Vienna. An example of his signature is shown below. On some of his early bronzes the 'N' is reversed. Examples of his work are illustrated on pp.2, 62, 63, 68, 69, 70, 71, 72, 78, 137, 152, 156, 157, 171, 176, 178, 183, 190, 199, 204, 228, 237, 265, 273, 290, 302, 303, 323, 352, 375, 377.

**FRÉMIET, Emmanuel (1824-1910).**
French, born in Paris 6th December 1824, and died there on 10th September 1910. A highly respected and successful sculptor during his own lifetime, both as one of the foremost animaliers and as a monumental sculptor executing numerous public commissions. The early part of his career was mainly concentrated in his numerous editions of small animal bronzes. He studied under his celebrated uncle François Rude and was influenced at an early age by his aunt Sophie Rude (née Frémiet), herself an accomplished painter. In spite of these advantages it was some time before he was taken on at his uncle's studio in the rue d'Enfer. Like so many sculptors Frémiet had spent some time studying drawing in a morgue, also taking himself to the Jardin de Plantes to study animals where he later was to succeed Barye as Professor of Drawing. He exhibited at the Salon from 1843 attaining many high posts in the years thereafter. He paid constant attention to detail in all his animal and historical works, a practice that led to much criticism of his monumental sculpture after his death. Today his small, technically very competent well executed bronzes are comparatively common and highly prized. Many of his smaller works were sold from his workshop at 42 Boulevard du Temple and later the Fauborg Saint-Honoré.

In the late 1840s Frémiet became discouraged and wrote to a friend with the idea of giving up sculpture altogether. This depression which occurred in his mid-twenties, seems in itself to have been a boost to his own career as his work seemed to develop rapidly with eight models exhibited at the Salon of 1850 alone. Lami lists 163 titles (in 1855-60 he executed 55 models of soldiers for Napoleon III, under one title), however, his commercial catalogue, dated 1850-60, in the *Archives Nationales* lists 68, mostly animalier, titles. In the author's opinion he created some of the most realistic animal bronzes without over-romantiscising. His works are highly varied and individual, capturing his animals largely unposed and his small, up to six inch casts are very good buys for the collector starting out with limited funds. Frémiet was possibly the sculptor with the most influence on the numerous young students flocking to Paris from America and many of them studied under him. His work was almost invariably of a soft and gentle, often amusing nature, he shied away from the crueller works. Apart of his universally acclaimed 'Jeane d'Arc', a huge gilded equestrian group in the Place du Rivoli near the Louvre, one of his most powerful, though not most attractive works, is his blindfolded, life-size cart horse awaiting the abattoir, a monument outside the Toulouse Veterinary College. Examples of his work are shown on pp.65, 75, 123, 159, 200, 214, 221, 222, 226, 235, 264, 296, 312, 313, 326, 330, 331, 339, 340, 342, 352, 356.

**FRINK, Dame Elizabeth (b.1930).**
English, born in Suffolk. An important contemporary animalier working in an abstract vein. She studied firstly at Guildford and then at Chelsea School of Art. Her first exhibition was held in London at the age of only twenty-two and from this she has developed an impressive reputation which has brought her numerous public commissions. Examples of her work are shown on pp.112, 290, 332.

**FRISENDAHL, Karl (1886-1948).**
Swedish. Having moved to France just before the First World War he became a pupil of Antoine Bourdelle and exhibited widely in Paris and Europe. His animalier work consisted mainly of bears, bison and horses.

**FRIZON, Auguste-Joseph-Xavier (b.1839, exh.1859-82).** French, born at Crest. He studied at the Beaux-Arts and exhibited at the Salon. A generalist, he is recorded as sculpting one animal group 'The Pigeon and the Ant'.

**FROMENT-MEURICE, Jacques-Charles-François-Marie (1864-1948).** French, born in Paris. He exhibited his animalier work at the Salon des Artistes Français. Some equestrian groups are recorded such as 'Le Cheval Nitouche' signed and dated 1891, 32 x 48cm (12½ x 19ins.), as well as numerous dogs.

**FUHRMAN & CO.** A modern Austrian founder, working in Vienna and reproducing Carl Kauba's Indian bronzes and the popular Vienna cold-painted animals from the early 1900s.

**FUMIERE.** French, almost certainly a Paris founder flourishing in the 1850s, who cast the Percheron horse for Barye in conjunction with Thiebaut.

**FURSE, John Henry Monsell (1860-1950).** English, born in Surrey. Studied at the Slade School and at the British Museum between 1881-87. He exhibited at the Royal Academy in the 1890-1910 period. His work includes portrait sculpture as well as groups and bas reliefs of animals. His career was short due to prolonged ill-health and his subjects are wide ranging and underappreciated today.

**GAETANO.** An example of his work is illustrated on p.349.

**GALLARD, Sansonetti (b.1865).** French, born in Nancy. He modelled animal groups and studies of differing breeds of dogs. He also worked in the classical style.

**GALLO, Ignacio (fl. early 20th century).** Spanish, working in Madrid and Paris. An example of his work is illustrated on p.88.

**GALLWEY, Antionette-Célestine.** French, born in Le Havre. Like her sister (q.v.) she exhibited animal models in wax at the Salon, in this case between 1867 and 1870. She was fortunate to have been one of the comparatively few recorded students of Barye.

**GALLWEY, Emmeline Henriette (exh.1864-77).** French, born in Paris. Exhibited at the Salon, mainly showing her models in wax. Amongst her varied domestic and farmyard animals she exhibited a goat at the Salon in 1877.

**GARBE, Emy Roeder see ROEDER-GARBE, Emy**

**GARBE, Louis Richard (1876-1957).** English, born in London. He sculpted a wide range of bronzes in an individual style in the tradition of the English New School. His works included animal studies, many of which he exhibited at the Royal Academy from 1908. The zenith of his various teaching posts was his position as Professor of Sculpture at the Royal College of Art from 1929-46. He lived at Milton Way House, Westcott, Near Dorking, Surrey.

**GARDET, Georges (1863-1939).** French, born in Paris. A highly talented and undervalued sculptor whose early studies were with his father, Joseph, and Aimé Millet who himself was taught by David d'Angers and the architect/designer Viollet-le-Duc, two of the most influential figures in the development of art in the 19th century. Another strong influence, clearly seen in some of his work is that of Frémiet under whom Gardet later studied at the Beaux-Arts. He started to exhibit at the Salon des Artistes Français at the age of twenty, culminating in the Grand Prix at the 1900 Exposition Universelle. All his animals are executed in an extremely powerful vein, each having an individual character of its own unlike many of the other animaliers who so often were coldly reproducing an animal in bronze. His beasts are proud and romantic and this, combined with a very high technical standard of finish leaves a very fine overall effect. Occasional glimpses of Barye's work are found in his treatment of his animals. Not all of his varied models were cast in bronze as many were originally carved in marble and only reproduced as bronze reductions for the most popular groups. Many of his models were successfully copied in porcelain, especially by the Sèvres factory. Examples of his work are shown on pp.73, 85, 128, 148, 180, 243, 369, 374.

**GARNIER, Henri-Adolphe (b.1803).** French, born in Paris. Exhibited at the Salon 1831-35 including a 'Study of Dogs' in 1833 and a 'Griffon Bitch' in 1834.

**GARRARD, George (1760-1826).** English, born in London. An animal painter until 1795, Garrard was an early English influence on the development of the treatment of animals in painting and sculpture during the formative years of the 19th century. His numerous small plaster and bronze models of domestic and farmyard animals were highly accurate rather than expressive. An extensive collection of his work is at Burghley House, near Stamford, Woburn Abbey and Southill

in Bedfordshire where there are overdoors carved in relief with fighting wild horses in the manner of paintings by George Stubbs.

**GASPAR, Jean-Marie (b.1864).** Belgian, born at Arlon. An animalier and a painter who exhibited at the 1889 Exposition Universelle. His 'Panther' is in the Brussels Botanic Gardens and the Brussels Museum has a 'Walking Elephant'.

**GASPARY, Eugène de (fl. late 19th/early 20th century).** French. He won an Honourable Mention at the Salon des Artistes Français in 1894. One recorded model is a 'Wild Boar' with brown patination, 15 x 22cm (6 x 8½ins.).

**GASTON-GUITTON, Victor-Édouard-Gustave (1825-91).** French, born in La Roche-sur-Yon, died in Paris. He exhibited mainly genre subjects at the Salon from 1853-77, working in bronze and marble, notably 'The Pigeon'.

**GATE, Camille-Léon (1856-1900).** French. A portrait and genre sculptor whose first work at the Salon was a 'Working Dog' in plaster in 1885, showing in bronze the year after, and cast-iron at the Exposition Universelle of 1889.

**GATLY, Alfred (1816-63).** English, born in Cheshire, died in Rome where he was influenced by John Gibson. This sculptor worked in a classical vein, exhibiting from 1841-62 at the Royal Academy. A series of four recumbent animals were published by the *Art Union*.

**GATTI, Gesualdo (1855-93).** Italian, born and died in Naples. Exhibited in Naples, Munich and Vienna. A green patinated 'Dog lying down' 17 x 30cm (6¾ x 11¾ins.) is recorded, cast by Susse Frères. An example of his work is shown on p.218.

**GAUDIER-BRZESKA, Henri (1891-1915).** French, born near Orléans, killed in action. The son of a wood carver, he won scholarships which allowed him to study in England from 1906. He travelled to Nuremburg and Paris in 1909 returning to the London artistic circles in 1910 with Sophie Brzeska. It was then that this extraordinary young man turned to sculpture, achieving an incredible reputation in an all too short career. Most of his models were in clay, later carved in stone although a few of his works were cast by the lost-wax method. His talents are a mixture of Cubism, Vorticism and a wealth of new ideas emerging at the time. His studies of animals were made largely at London Zoo but his ever popular, endearing models of deer were probably modelled from his studies at Richmond Park. Exhibitions: Grosvenor Gallery 1913, the Alpine Gallery and the London Salon in 1914 and a retrospective at the Leicester Gallery in 1918. The work of this promising and highly talented sculptor is, not surprisingly, rare and highly sought after. In most cases a provenance is necessary to establish the authenticity of the often unsigned works. Examples of his work are shown on p.193, 245.

**GAUL, August (1869-1921).** German, born near Hanau, died in Berlin. A painter and sculptor in the animalier school, he was the son of a stonemason, and studied in Germany and Italy. His strongly Germanic stone carvings, clay models and bronzes in a realistic vein were highly popular and influential in Germany before the First World War. The Hamburg Museum has a collection of his bronzes, and there is a fine version of his romantic 'Bear dancing on a Ball' in the Frankfurt Museum.

**GAYRARD, Paul-Joseph-Raymond (1807-55).** French, born at Clermont. Studied under his father Raymond (q.v.) and exhibited at the Salon from 1827-55. He was a favoured society portrait sculptor with a considerable talent for animal modelling. His recorded bronze animal models date from the years 1846-48 with his powerful 'Harness Horse' exhibited at the Salon in plaster in 1847. Other animals are the group of 'The Monkey Steeplechase' which is amusing and original rather than being a fine piece of sculpture, and the ill-fated 'Deerhound', a cast which has the dubious honour of being a model much favoured by the modern 'cold-cast' bronze copiers of the 1960s and 1970s. Examples of his work are shown on pp.66, 232, 308.

**GAYRARD, Raymond (1777-1858).** French, born at Rodez, died in Paris. Like his son Paul (q.v.), his career was founded on portrait sculpture, exhibiting from 1814. His two recorded animal models 'The Sleeping Lioness' and 'Child Playing with a Hare', both at Montpellier Museum are early exploits into the romantic animalier field. His animal modelling is rare, especially in comparison with his prolific portrait work.

**GEBLER, W***.** German, probably Dresden, c.1900. An eagle recorded cast by Pirner und Franz.

**GECHTER, Jean-François-Théodore (1796-1844).** French, born in Paris. He studied under Bosio (q.v.) and Gros, where he must at some stage have made contact with Barye (q.v.). His prime occupation was at first his portrait work although possibly in the early 1830s, he turned his hand to animal sculpture. Most of his animal models centre around the same basic model of a horse, first shown in cast-iron at the 1838 Salon, shying with its neck lowered. In one version the horse is by itself, another trampling a fallen Amazon and another with a monkey jockey up. Yet another variant of the same horse includes a figure of a peasant attendant. Other recorded models include greyound, a good example of an English thoroughbred, a 'Stag and Lion' and an amusing group of a 'Beaver breaking in a horse'. Two further models sold in Sotheby's sale of 19th Century Decorative Arts on March 17th, 1983, may eventually be proved to be by Gechter. These two models both are obviously early casts, probably of the late 1830s or very early 1840s and have exactly the same feel of Gechter's better castings. Most if not all of this very competent sculptor's work was very cleverly cast in sand and each section of the body and then

the tail would be bolted together. Gechter's models do not hold a wide popular appeal as a general rule as they are old fashioned for the period and have none of the later romanticism of the next generation of animaliers, whose work was more prolific and generally more acceptable. However, for technical effort and interest research into his work proves most fascinating. His signature is shown below. Examples of his work are illustrated on pp.67, 203, 290, 296, 305, 311, 312, 324, 330, 335, 362.

**GEEFS, Jozef (1808-85).** Born in Antwerp. A leading figure of the Antwerp school who exhibited there and having won the Prix de Rome in 1836 became Professor of Sculpture at Antwerp Academy in 1841. His 'Indian rider attacked by two jaguars' is at Antwerp Zoo and is illustrated on p.52.

**GEEL, Johannes Ludovicus (1787-1852).** Belgian, born in Malines, died in Brussels. An accomplished if somewhat unexciting sculptor whose main contribution to the art of the animalier is his monumental 'Lions of Waterloo', which proudly commemorates the final victory over Napoléon.

**GELIBERT, Jules-Bertrand (b.1834).** French. An animalier painter winning medals between 1869-1900. His bloodhound shown on p.215 is a portrait of Louis-Napoleon's favourite dog, Druid.

**GEOFFROY, Adolphe-Louis-Victor (d.1915).** French, born in Paris. He exhibited portrait, genre and animal models at the Salon between 1861-1910. Like many young sculptors of the period his first exhibited work was an animal an 'African Greyhound', a plaster study of 1861, shown again in bronze in 1863. Other titles include 'A Horse Watering', 'Algerian Panther', a bitch called 'Lolotte', 'Sudanese Lion', 'Cochin Panther', 'Jersey Cow', 'Lion and Lioness, 'Tiger and Antelope', and 'Tigers' in 1892.

**GERHARD.** An example of his work is illustrated on p.106.

**GÉRICAULT, Jean-Louis-André-Théodore (1791-1824).** French, born in Rouen, died in Paris. Unfortunately comparatively little of this talented artist's sculptural work has survived. Mainly remembered as a leading painter of the early romantic movement, almost anticipating the ideas of Rodin and the realism of Dégas, his career was terminated by a fatal riding accident. Whilst Barye (q.v.) was still experimenting with his romanticism, Géricault was forced into exile in London. He later returned to Paris where he started to model a large monument with sketches of horses in wax and a fine écorché horse. Some of his wax models follow stylised classical forms, modelled from antique versions. At the turn of this century the founders Valsuani (q.v.) posthumously cast a limtied number of bronzes from his work.

**GÉROME, Jean-Léon (1824-1904).** French, died in Paris. A prominent painter, engraver and sculptor. He worked and studied in Paris from 1841 where he made studies of the animals in the Zoological Gardens, exhibiting from 1847 with his 'Cock Fight'. His first sculpture was exhibited at the 1878 Exposition Universelle. Not really an animalier but an influential and respected figure. His animal works include: 'Bronze Lion', Salon 1891; 'Thoroughbred Horse' (1892); and 'The Dying Eagle' for Waterloo, modelled in 1901. A major animalier work however is his two horses and their jockeys jumping a hurdle, after 1892, 38.2 x 35.5cm (15 x 14ins.) cast by Siot-Paris.

**GERTER, Robert (b.1885).** Swiss, born in Lucerne. Studied in Switzerland and Milan, exhibiting in Milan in 1906. Amongst his other styles he specialised in animals.

**GHAYE, Marcelle de see DE GHAYE, Marcelle**

**GIBSON, John (1790-1866).** Born in Wales, died in Rome. Studied under Canova from 1817 and became a much admired classical sculptor, continuing that particular style well into the 19th century. The City Museum and Art Gallery in Birmingham possesses a very fine marble head of a horse by Gibson which is a rare foray into the modelling of animals. In its late classical style it compares directly with similar work by Boehm (q.v.).

**GIGNOUX, Charles (fl. 2nd half 19th century).** French. An animalier sculptor with a group of 'Lion and Lioness at Play' in the St. Étienne Museum.

**GILBERT, Donald (1900-61).** English, born in Worcestershire, died in Sussex. Studied under the great English New School sculptor, Sir Alfred Gilbert and exhibited widely in bronze, wood, marble and stone. His main contribution to the field of animal sculpture is a magnificent bronze 'Turkey Cock' modelled in a very powerful art deco style with squared off feathers.

**GILBERT, L.** An example of his work is illustrated on p.104.

**GIRAUD, Pierre-François-Gregoire (1783-1836).** French, born in Luc, died in Paris. He produced only a small amount of sculpture with only one animal recorded, now in the Louvre, of a 'Dog Lying Down' which was later produced in a reduced bronze form. The marble was exhibited at the Salon of 1827.

**GLADENBECK, H. (fl. c.1900-10).** German. A Berlin firm producing a wide range of high quality bronzes for various sculptors. Most have a smooth black finish so loved by the German School sculptors at the time.

**GLASSBY, Robert Edward (d.1892).** English, a pupil of Boehm (q.v.).

**GLASSBY, Robert (c.1870-1908).** Son of the above. An example of his work is illustrated on p.285.

**GLEESON, Joseph-Michael (b.1867).** American, born in New York. Studied in Paris but returned to work in New York as an animalier sculptor, as well as a painter and illustrator.

**GLODINON, Émile.** French, born in Besançon in the mid-19th century, exhibiting at the Salon from 1881-82. His animal sculpture appears to have been restricted to cattle.

**GODCHAUX, Roger (b.1878).** French, born in Vendome. A talented pupil of the celebrated Gérome (q.v.), he exhibited at the Salon des Artistes Français from 1905. A popular model is his running elephant in the style of Barye (q.v.). Another elephant model, with a native rider, is powerful, if a little sentimental but a fine example of the lost-wax technique. His script signature shown below is a good example of a sculptor's own hand, signing the wax before casting. The 'Epeuve 2/5' is the no. 2 cast out of a small edition of five. Examples of his work are illustrated on pp.255, 260.

**GODDARD, Ralph Bartlett (b.1861).** American, studied in New York and Paris. Possibly the sculptor of the work illustrated on p.195.

**GONON, Eugène (1814-92).** French, born in Paris. Son of a sculptor and founder, known to have cast work by both Barye and Frémiet (qq.v.). He exhibited his own works from 1852-73, a well known model being the 'Combat between a Lion and a Snake', a popular theme in the 19th century and one also modelled by Barye. Like his father he used the cire perdue method of casting.

**GONON, Jean-Honoré (fl. early 19th century).** French. Father of the sculptor Eugène Gonon (q.v.). A leading founder during the earliest years of the animaliers who used the lost-wax method of casting. Cast for Barye and probably Cain.

**GONZALEZ GOYRI, Roberto (b.1924).** Born in Guatemala. Studied in his native country until a scholarship enabled him to go to New York in 1948. During the 1950s his style changed to an Expressionist theme. His earlier work was executed in bronze and tin and included animal groups and figures.

**GOOD, John Willis (1845-79).** English. Little is known about this popular and highly competent sculptor. He concentrated throughout his short and prolific career on hunting scenes, dogs and racehorses in bronze and terracotta. The occasional plaster model has been seen on the auction market. His work was exhibited at the Royal Academy from 1870-78. His bronzes are usually well finished and crisply modelled with a well defined script signature; the example of his signature shown below is a very weak one showing a late cast, one of many from the original model. The well-known silversmiths and inventive silver-

plating firm Elkington & Co. cast many of this sculptor's bronzes, especially around the year 1875. Examples of his work are illustrated on pp.297, 300, 318, 321, 350, 354.

**GORALCZYK, Jan (b.1877).** Polish. Studied in Cracow and Vienna, exhibiting in Cracow from 1896. He specialised in animal figures, favouring horses.

**GORNIK, Friedrich (fl. early 20th century).** Austrian. Born late 19th century. He studied at the newly established Vienna School of Arts and Crafts. His early career concentrated on animals, first modelling animals that were to be reproduced in porcelain and then modelling for bronze, casting carnivores, cattle and horses made by the founder A. Rubenstein.

**GOTT, Joseph (1786-1860).** English. Apprenticed to John Flaxman. Exhibited at the Royal Academy 1820-48. A portrait and monumental sculptor who executed several animal groups, mainly in marble: Dog and Puppies, 1825; Pug and Cat, 1828; Italian Greyhound, 1834; Spaniel, 1835; Dog and Rat, 1841; and greyhound and pups, illustrated on p.203.

**GOUGE, A (fl. third quarter 19th century).** French founder casting for Paul Comoléra amongst others.

**GOUGET, Émile-Joseph-Alexandre (fl. third quarter 19th century).** French, born at Bray-sur-Seine. A pupil of Barye (q.v.) who exhibited three animal figures at the Salon between 1868-70, titled 'Recumbent Lion', 'Lion and Viper' and 'Lion and Tiger fighting'.

**GOYRI, Roberto Gonzalez see GONZALEZ GOYRI, Roberto**

**GRADLER, Otto (b.1836).** German, born in Thuringia. Recorded as working in Charlottenburg. One recorded model, of a bear, dated 1888, is illustrated on p.72.

**GRATCHEV, A (fl.c.1880-c.1910).** Russian. Examples of his work are illustrated on pp. 382, 383, 384, 385, 386, 387, 388, 390.

**GRIMALDI DEL POGGETTO, Count Stanislas (fl. second half of 19th century).** Italian. He was a cavalry officer who painted and sculpted numerous equestrian subjects.

**GROHÉ, Gustave (fl.1900-20).** German. An example of his work is illustrated on p.264.

**GROOTAERS, Louis-Guillame (1816-82).** A naturalised French man of Belgian stock born in Nantes. He exhibited at the Salon from 1845 to 1882. Amongst his sculptural work he produced a strange group for the capital of a column entitled 'Lévrier foulant au pied un léopard abbatu'. The greyhound is a stiff model, in the style of 18th century gate capitals but the powerfully muscled fallen leopard is a tribute to the romantic style of Barye (q.v.).

**GRUET, (fl. third quarter 19th century).** A Paris founder who cast for the American sculptor P.W. Bartlett (q.v.).

**GUERET, Denis-Désiré (b.1828).** French, born at Boissy. A wood-carver who exhibited the three following models at the Salon, a still-life entitled 'Trophy', 1853, 'A Chicken surprised by a Cat, defending its Young', 1857, and 'Cockfight' 1863.

**GUIJ, Louis.** Appears to be unrecorded. The signature shown below is very difficult to decipher and time may prove the surname to be spelt differently. The only model known to the author is a mould sand cast of a labrador asleep in the midday sun, dated 1876, illustrated on p.237.

**GUILBERT, Charles (fl. early 20th century).** French, born in Paris in the late 19th century. A pupil of Valton (q.v.) he copied his master's work modelling animals and also genre subjects.

**GUILLEMIN, Emile Coriolan Hippolyte (1841-1907).** French, born in Paris. Exhibited at the Salon from 1870. Produced a varied range of fine quality genre figures and groups. An example of his work is illustrated on p.237.

**GUILLOT, Anatole (1865-1911).** French, born in Etigny, died in Paris. Exhibiting from 1889, he modelled in bronze and terracotta, both animal and genre subjects.

**GUIONNET, Alexandre.** French, born in Paris. A wood-carver who exhibited six animal figures and groups at the Salon between 1831-53.

**GUITTON, Victor-Édouard Gustave Gaston see GASTON-GUITTON, Victor-Édouard Gustave**

**GUYOT, Georges-Luçien (1885-1973).** French, born in Paris. A painter, sculptor and engraver, he had a one-man show at the Salon des Indépendants in 1943. He worked exclusively on animal subjects in all three media and also illustrated animal books. He loved portraying various members of the cat family, wild or domestic, as well as deer and pheasants. Some of his casts are exceptional, one by Susse Frères of a 'Seated Panther' 97 x 183cm (38 x 72ins.) although very powerfully modelled has the unfortunate distinction to look like the Pink Panther! One of his more romantic groups from an earlier period in a style that follows the traditional 19th century style is his group of a lion, lioness and cub, 51 x 51cm (20 x 20ins.).

**HAEHNEL, Julius (fl.mid 19th century).** Probably of German extraction, exhibited a Giraffe and a Camel at the British Institution in 1854.

**HAEHNEL, Julius (fl.1880s).** Thought to be the son of the above. Exhibited a Wild Boar and an Owl at the Royal Academy.

**HAIGH, Alfred Grenfell (1870-1963).** A British sporting painter who produced a few, highly individual, animal sculptures.

**HANBURY, Una.** English, born in Middlesex. A graduate of the Royal Academy of Fine Arts in London, she studied with Jacob Epstein. She spent twenty-five years in Washington and then moved to Santa Fé, New Mexico. Her work is based on the theme of the American West, concentrating mainly on horses.

**HARDING, George Frederick Morris (1874-1964).** English, known as Morris Harding. He studied under Bates in the English New School manner and under Macallan Swan (q.v.). A painter and sculptor of animals, an example of his work is illustrated on p.149.

**HARRY, Émile Perrault see PERRAULT-HARRY, Émile**

**HARTWELL, Charles Leonard, R.A. (1873-1951).** English, born in London, died in Sussex. Studied at the City and Guilds School and the Royal Academy, becoming R.A. in 1924. He specialised in genre bronzes continuing the individual approach of the English New School of a generation before. Subjects include a rare and amusing small animal group of a bulldog and cat.

**HARVEY, Eli (1860-1957).** American, born in Ohio, died in California. One of America's foremost animaliers, studying under Frémiet at the Jardin des Plantes in the Paris zoo. His work closely reflects his French training, especially in his animals modelled from the zoo. His bronzes are powerful and well modelled with an eye to detail but not as exact as his earlier French counterparts would have liked. He used the Roman Bronze Works and the Gorham Works whilst practising in New York in the first decade of this century. Models include 'Bear', 'Elk' (for the Order of the Elks), 'Longhorn' and 'Bison'.

**HASELTINE, Herbert (1877-1962).** Born in Rome, son of an Americn sculptor. He studied in Munich, Rome, at Harvard and at the Beaux-Arts in Paris and exhibited widely over a period of fifty years showing mainly animal figures and groups, from table size to monumental. During the First World War he served as an officer with the American Army which earned him numerous equestrian commissions. His commissions after the war included models of numerous champion cattle, sheep and pigs. He worked widely for Indian princes, mainly on equestrian portraits. His work can be seen at the Tate Gallery, the Victoria and Albert Museum and the Imperial War Museum in London, and the Smithsonian Institute and the Metropolitan Museum, New York. His models of horses often convey a sad and rather mournful animal and no doubt this sensitive sculptor was sympathetic to their plight as beasts of burden and their usage during the war. He developed a technique of impressionism popular in the first decade of the century with bold strokes that tell us all we need to know, without appearing to give much attention to detail. Examples of his work are found on pp.287, 332, 358.

**HASWELL, Ernest Bruce (b.1887).**
American, born in Kentucky. Studied in Cincinnati and in Brussels. He modelled animal and bird studies for incorporation into fountains.

**HATVANY, Christa-Winsloe.** French(?). One model of a dog entitled 'Bitch' with a black patination and cast by Susse Frères is recorded, 38 x 36cm (15 x 14¼ins.).

**HÉBRARD, A.A. (fl. late 19th/early 20th century).** Paris founder. Cast work from models by Degas (q.v.) in editions of up to as many as forty. Also cast much of Bugatti's work (q.v.). This foundry almost without exception produced the finest lost wax casts, up to the highest possible standards, combining the traditional skills of the period with more modern technology and able to take advantage of skilled labour which was still very cheap, therefore high standards and not time were the essence of the finished work. A wealthy collector and the owner of his foundry, he also cast Pompon and Troubetskoy's (qq.v.) works. Most of his editions were numbered.

**HEIKKA, Earle (1910-41).** American, born and died in Montana. A talented sculptor, Heikka committed suicide before any of his models, often made of cloth, wood, leather, plaster metal and papier-mâché, were cast in bronze. He was greatly influenced by the important Western sculptor Charles Russell who also lived in Great Falls. His work was first cast by the publisher Richard Flood in 1961. Most of his bronzes portray cowboy groups and horses but his 'Montana Wolf' continues the animalier tradition with an accurate portrayal of a hungry, slightly mangy animal, only the modern casting attempts an impressionist feeling.

**HEIZLER, Hippolyte (1828-71).** French, born and died in Paris. An animalier, his work was exhibited at the Salon from 1846 to the year after his death. He worked on the decoration of the Louvre and the Opéra, and completed an important commission for the Tzar, entitled simply 'Dogs' which was presented to the Empress Eugénie. Incredibly it was completed within a fortnight. He had a successful career, producing numerous bronzes commercially. His seventeen titles exhibited at the Salon include, 'Dog', 1846; 'Panther', in 1848; 'Lion and Antelope', 'Tiger and Prey', 'Fighting Bull and Bear' and 'The Wolf and the Sheep'. A title not listed at the Salon but seen at a Paris auction in 1980 was 'A Fox attacking a Stag', with brown patination, 14 x 19cm (5½ x 7½ins.). An example of his work is illustrated on p.98.

**HENJES, H\*\*\*.** French. The only record appears to be of a Bison, brown patination in a Paris auction in 1980, 16 x 31cm (6¼ x 12¼ins.). It is not certain whether or not this measurement included the marble base.

**HIERY, Oswald (b.1937).** Belgian. A cement cast of a White Rhinoceros at Antwerp Zoo. An example of his work is illustrated on p.54.

**HILLS, Robert (1769-1844).** An animal painter whose Stag, modelled in 1817, was shown in bronze at the International Exhibition of 1862, forty-five years after the first modelling!

**HINGRE, Louis-Théophile (1855-1911).** French, born at Ecouen, died at Lami. It is probable that the 1911 date is correct as Hingre exhibited his last work at the Salon in 1910, having first exhibited in 1863 with his 'Marsh Heron' in plaster. He exhibited over thirty different groups, mainly in plaster, including numerous framed sets of plaster plaques, all of animal studies. A model apparently not listed at the Salon, his 'Turkey' was in a 1980 Paris auction, 17 x 11cm (6¾ x 4¼ins.), with a clear brown patination. An example of his work is shown on p.366.

**HINTERSCHER, Joseph (b.1878).** German, born in Munich. Worked in Munich, Berlin and Paris. One cast is recorded, cast by Brandsetter (q.v.), 'Youth Feeding a Stag' c.1905.

**HOFFMAN, Frank (1888-1958).** American, born in Chicago, died in New Mexico. Primarily a painter and illustrator. Two known models of animals, possibly prepared as studies for paintings are 'Standing Buffalo' and 'Lying Down Buffalo', the latter 15.2cm (6ins.) high, modelled c.1920, cast posthumously c.1971.

**HORSLEY, Adrian.** An English contemporary sculptor. An example of his work is illustrated on p.295.

**HUGER, Arnold see ARNOLD-HUGER**

**HUNT, William Morris (1824-79).** American, born in Brathleborough, died in New Hampshire. An historical painter who first tried sculpture. Returning to America from his European studies in 1865 he became an influential authority with many pupils. The Metropolitan Museum in New York has a coloured plaster frieze, carved in high relief with three wild stallions leaping out of their frame, restrained by a trainer, in an allegorical tribute to the Persian river godess Anahita. It is a powerful group but modelled in a style that by 1848 was a generation out of date in Paris.

**HUNTINGTON, Anna Hyatt (1876-1973).** American, born in Massachusetts, died in Connecticut. A prolific and successful sculptor with a unique talent for portraying animals in an advanced style reminiscent of the inter-war period rather than the first decade of the 20th century when she did most of her modelling. She exhibited at the Society of American Artists from 1903 with her well-known model of two dray horses entitled 'Winter', a powerful model with a similar finish and almost slab like texture to that of Constantin Meunier (q.v.) which cries out the injustice to the animals in the way that Meunier portrayed the underprivileged working class.

She was given many awards for her work, becoming a Chevalier of the Legion of Honour and 'Woman of the Americas' in 1959. Her husband founded the Brookgreen Gardens in South Carolina for his wife's sculpture, which today is an important sculpture museum including many aspects of American sculpture. Her studies capture animals in highly realistic attitudes, consciously not attempting to freeze a pose in the way of the romantic animalier of the second half of the 19th century.

**HUSSMANN, Albert Heinrich (b.1874).** German, born near Cuxhaven. Exhibited in Berlin in 1909. Mainly modelled horses, including heads, other animals include stags. He worked in Great Britain from the 1930s.

**IAGIMOV, Igor von (b.1885).** Russian. Studied in Paris and Munich and working with Matisse and Bourdelle. At the end of the First World War he settled in Berlin exhibiting at the Secession. Produced animal models as well as other works.

**IFFLAND, Franz (fl.late 19th century).** German, working in Berlin. An example of his work is illustrated on p.180.

**ILLIERS, Gaston d' (b.1876).** French, born in Boulogne. Exhibited at the Salon des Artistes Français from 1899. He was an animalier favouring equestrian figures and groups and produced several works inspired by the First World War. An example of his work is illustrated on p.286.

**ILLIUVIELLE.** An example of his work is illustrated on p.353.

**ISHINGER, Hans (b.1891).** German, born in Munich. Studied at the Berlin Academy and specialised in animal figures and birds.

**JACKSON, Harry (b.1924).** American, born in Chicago. An accomplished and highly acclaimed sculptor of American Western Art. Not an animalier in the strict sense but his bronze groups are a fine tribute to the modern development of the animal in bronze. His horses and cattle are well modelled and full of action.

**JACQUEMART, Henri-Alfred-Marie (1824-96).** French, born and died in Paris. A leading contributor to the animalier school of the 19th century. His animal works were exhibited at the Salon 1847-79, his portrait work being shown until 1888. He executed numerous works for public monuments including 'Four Sphinxes' for a fountain in Paris (1858); 'Two Eagles', 230cm (90ins.) high, for the Saint-Michel fountain, Paris (1860-1861); eagles for the Opéra; lions for a bridge in Cairo in 1873, and eight more for the Chatêu-d'Eau in Paris the following year. He also contributed, with Frémiet, Cain and Rouillard (qq.v.), to the fountain in the Trocadéro, with a rhinoceros in 1878. His best known small work is his 'Valet au chiens', exhibited in plaster for the first time in 1866 which is a work seen quite often in bronze. After his first model, a 'Heron' in 1847, he appears to have been commissioned for most of his work in what must have been a successful career, travelling all around the eastern Mediterranean. An interesting part of his career was spent modelling for the silversmith Christophle. Examples of his work are shown on pp.102, 120, 220, 274.

**JAEGER, Ernst Gustav (b.1880).** German, born in Berlin. His nude male figures typify the early German interpretation of Jugenstil and his numerous models of bulls, deer,

dogs, horses and monkeys are in a similar vein.

**JANDA, Johannes (1827-75).** Born and died in Breslau. He exhibited in Berlin 1852-74, producing religious and portrait work as well as dogs and horses.

**JANETSCHEK, Hans (b.1892).** Austrian, born in Salzburg. He worked in Berlin specialising in human and animal models.

**JANKOVITS, Gyula (b.1865).** Hungarian, born in Budapest. Studied in Munich and Vienna. One animal group recorded 'Flight of Birds'.

**JANT.** An example of his work is illustrated on p.283.

**JARL, Otto (1856-1915).** Swedish, born in Uppsala, died near Vienna. Studied in Stockholm and Vienna and later turned away from portrait work to animals, especially his 'Polar Bear' reproduced in porcelain as well as bronze.

**JENSEN, Georg (1866-1935).** Danish, born near Copenhagen. He spent five years at the Copenhagen Academy from 1887, where one of his models produced was entitled 'The Boar Hunt'. He was soon to take up work as a jeweller and silversmith, founding the company that still bears his name. Although his rare bronze work is traditional, rather in the progressive Scandinavian style that was growing from the seeds sown by the English Arts and Crafts designers, it would be highly sought after for the name alone.

**JENSEN, Laurits (b.1859).** Danish, born in Viborg. After his studies in Copenhagen, he specialised in animal groups and figures and general sculpture.

**JESPERS, Oscar (b.1897).** Belgian. Exhibited in the 1930s in Brussels and Paris. An exponent of varied materials he started his career in an abstract form but turned to more convential figurative work in the late 1930s. An example of his work is illustrated on p.57.

**JOBST, Heinrich (b.1874).** German, born in Bavaria. A progressive sculptor who studied at the Munich Academy and later with the Jugenstil colony at Darmstadt at the request of its founder the Arch Duke of Hesse. Two of his bronze lions are now in the Hesse National Museum at Darmstadt.

**JOCHEMS, Frans (1880-1949).** Belgian. Exhibited at the Brussels Exhibition in 1910 and has several models in Antwerp Zoo, including an 'Alpaca', 'Monkey with a Frog', and a plaster group of vultures. Examples of his work are shown on pp.56, 57, 60.

**JOHNSON, Grace Mott (b.1882).** American, born in New York. Studied under Gutzon Borglum (q.v.) one of America's greatest Western sculptors, and also in Paris where she exhibited at the Salon des Artistes Français in 1910. She specialised in animal figures in bronze and also bronze and carved wood bas-reliefs mainly of zoo and circus animals.

**JOIRE, Jean (b.1862).** French, born in Lille. An animalier exhibiting at the Salon des Artistes Français, winning a third class medal in 1909.

**JONAS, Louis Paul (1894-1971).** American, born in Hungary (Budapest), died in New York. Emigrated to America at the age of fourteen having previously studied in Hungary. He worked at his brother's taxidermy studio, later studying at the New York Academy of Design. His most impressive group is the standing bear protecting her cub, entitled, somewhat poignantly, as 'Grizzly's Last Stand'. It is most impressive as a piece of monumental animal sculpture, standing 3.82m (12ft. 6ins.) high in the City Park in Denver. Other studies are 'Elk' and 'Caribou'.

**JONES, Adrian (1845-1938).** English, born in Shropshire. An artist and sculptor who exhibited sculpture from 1884 at the Royal Academy. A monumental sculptor who served as an Army Veterinary Captain and was a keen sportsman. The large monument at the top of Constitution Hill at Hyde Park Corner 'Peace in her Quadriga' is by Jones. His traditional style seems a little old fashioned for the period but is highly competent and well executed. Like Rosa Bonheur (q.v.) in Paris, he was influenced by Colonel Cody's Wild West Show when it was at Earls Court. His work has become more popular in this decade and an exhibition of his work was held at The Sladmore Gallery, London in 1984, one hundred years after his first exhibit at the Royal Academy. His Derby winner, Pertimmon, is at Sandringham. Examples of his work are illustrated on pp. 239, 242, 267, 361.

**JOST, Josef (b.1875).** German, born at Hecendalheim. Exhibited animal and other sculpture from 1903.

**JOUVE, Paul (1880-1973).** French, born in the Seine-et-Marne disrict. Primarily an animalier painter, engraver and illustrator of great importance whose rare bronze casts occasionally appear on the market where they are highly sought after. He first started exhibiting paintings at the age of fifteen, later illustrating for Kipling's *The Jungle Book* He at first appeared to concentrate on lions and other members of the cat family but later widened his repertoire to eagles, elephants, snakes and buffaloes. He was an outstanding artist whose occasional forays into three dimensional bronzes are always exceptional casts, modelled in exactly the same vein as his paintings, which in themselves are so realistic that, in judging them from black and white photographs, they almost appear three dimensional. One bronze recorded in a Paris auction in 1980 of 'Le Lion au Marcassin' with the lion powerfully tugging at the unfortunate young boar, measured 41 x 81cm (16 x 32ins.) and was an exceptional cast with green patination. His signature on bronze is very similar to his painting signature with the surname only, in lower case with the letters separated. Jouve's work follows on naturally from Bugatti (q.v.) and has much in common with Collin (q.v.).

**KAFKA, Bohumil (b.1878).** Born in Bohemia, and setled in Prague. He studied in Prague and Vienna and worked in London, Berlin and Rome an an animalier.

**KASS, Jaap (1898-1972).** Belgian. Moved to Antwerp as a child where he followed a course in Fine Arts. Like many of his contemporaries he became fascinated by the exotic zoo close by the railway station. At the outbreak of the First World War he returned to Amsterdam and later became Professor of Sculpture and Drawing at Rotterdam Academy. The Antwerp Zoo has a fine collection of his terracotta and bronze animals mostly executed in a mixture of watered down impressionist and modernist styles and normally small models with a very friendly appeal. His range was wide from the almost cheeky model to the serious. Some are in an almost Barye style, especially his very good earthenware model of a pair of 'Mating Tigers' at Antwerp Zoo.

**KAUBA, Carl (1865-1922).** Austrian. Studied in Vienna under Carl Waschmann and Stefan Schwartz. Little is known about the life of this interesting sculptor who, in true Viennese style nearly always, but by no means exclusively produced polychromatic bronzes, cold painted after casting and finishing. Initially inpsired by the romantic stories of the American West written by the German Carl May, his work is normally restricted to scenes from the Wild West rather than specific animals. His period casts are sometimes by the Bergman Foundry; modern copies are cast by Kark Fuhrman & Co., Vienna.

**KELETY** French(?). The only information available to the author is from a Paris auction catalogue of 1980 where a pair of book ends are listed entitled 'The Cat and the Mouse' signed Kelety, each with brown patination sized 22 x 21 and 28 x 14cm (8¾ x 8¼ins. and 11 x 5½ins.).

**KEMEYS, Edward (1843-1907).** American, born in Savannah, Georgia, died Washington. Studied in New York and after serving in the Civil War settled in New York after a disastrous attempt at farming in Illinois. He worked on the Central Park development as a tree feller and spent much time at the Central Park Zoo. Watching a man modelling the head of a wolf inpsired Kemeys to try his hand at sculpture. This first attempt entitled 'Hudson Bay Wolves' was an immediate success and was purchased by the Fairmount Park Commission in Philadelphia in 1872. After several years living in the wilds of the West he returned to New York to open a studio, exhibiting in the Philadelphia Centennial Exhibition in 1876 and a later later at the Royal Academy in London. In 1877 he went to study in Paris and exhibited his 'Bison and Wolves' at the Exposition Universelle in 1878. He hated the confines of formal study in Paris and soon returned to America. His first success upon his return was 'Still Hunt' a mountain-lion about to attack which was erected in Central Park. In 1892 he moved to Chicago where he exhibited with great success in the following year with twelve exhibits, and fifteen at St. Louis in 1904. Kemeys described himself as a hermit, preferring the company of animals

rather than men but man certainly appreciated his fine, realistic studies of animal wild life in the American West. He was the first sculptor to truly capture the spirit of the West and to portray its wildlife. His work is a self-taught impressionistic style, attending to movement before detail and the wild nature of his animals rather than softening their nature to widen their appeal.

**KENWORTHY, Jonathan (b.1943).** Born in Westmorland, studied at the Royal College of Art and Royal Academy Schools, winning gold and silver medals, as well as travelling scholarships. He has travelled widely on Study Tours, especially in South Africa and has held regular exhibitions since 1965 throughout the world. Examples of his work are illustrated on pp. 113, 114, 145, 196, 197, 259, 263.

**KESTNER, Erich Schmidt see SCHMIDT-KESTNER, Erich**

**KIESEWALTER, Heinrich (b.1854).** German, studying and working in Berlin, almost exclusively producing equestrian groups. An example of his work is illustrated on p.260.

**KIND, Georg (b.1897).** German, born in Dresden. Specialised in busts and statuettes of dancers and animals, also worked as an engraver.

**KING, John (b.1929).** Born near Salisbury. As an artist he was influenced by Lionel Edwards, becoming a professional artist in the 1960s. His bronzes, always produced in no more than a limited editon of ten, are usually commissions and include stags, horses and polo players.

**KIRCHNER-MOLDENHAUER, Dorothea (b.1884).** German, born at Poznan. Studied under Zügel (q.v.) she worked as an animalier producing models for various porcelain factories.

**KISELEWSKI, Joseph.** Polish but working and settled in America in the first half of this century. His sculpture included animal figures and groups.

**KISS, August Karl Eduard (1802-65).** German, born in Prussia, died in Berlin. Studied at the Berlin Academy producing allegorical and hunting groups such as 'Fox Hunt', 'End of the Hunt', and 'Return from the Hunt'. His 'Amazon defending herself against a Tiger' was exhibited to great acclaim at the Crystal Palace Exhibition in 1851. Entirely classical and rather stiff in feeling, it is often seen as a bronze or spelter reduction. An example of this work is shown on p.336.

**KISSNER, Erwin (b.1885).** German, born in Berlin. Specialised as an animalier.

**KITTLESTON, John (b.1930).** American, born in Arlington. Flourishing today in Fort Collins, Colorado. Works in wood and bronze modelling animals of the American West in their natural habitat. Founder 'Bronze Images', one title 'My Meat' 33cm (13ins.) of a grizzly bear defending its prey.

**KLEY, Louis (1833-1911).** French, exhibiting at the Salon from 1853 and at the Paris Exhibition of 1889. An example of his work is illustrated on p.309.

**KNIGHT, Charles R (1874-1953).** American, born and died in New York. Studied at the Metropolitan Museum of Art and became a successful painter and animal sculptor. Modelled bears, bison and wildcats.

**KOCH, Gottlieb von (1849-1914).** German born in Hirschberg, died at Alsbach. A painter and sculptor of animals working in Jena and at the artists' colony at Darmstadt.

**KORTHALS, Claudie Fréderique.** German, born in Frankfurt-am-Main. Exhibited in France as an animalier from 1927 and later settled in Holland.

**KRATZ, Paul (b.1884).** German, born in Coblenz. Worked as an animalier.

**KREITZ, Willy (b.1903).** Belgian. A very effective brass model of a 'Sea Lion' is at Antwerp Zoo.

**KRETZSCHMAR, Fritz (1863-1915).** German, born in Plauen, died in Dresden. Exhibited his animal sculpture at Berlin 1893-1912.

**KRIEGER, Wilhelm (b.1877).** German. Worked at Herrsching near Munich, specialising in animals.

**KRÜCKEBERG, Hans (b.1878).** German, born in Treunbritzen. Exhibiting in Berlin from 1911 animal, bas-reliefs and monumental sculpture.

**KUCHARZYK.** An example of his work is illustrated on p.127.

**KUOLLA, Ladislas (fl. 20th century).** Polish. Models children with birds and animals.

**LACHAISE, Gaston (1866-1935).** French, born in Paris, died in New York. Studied at the Beaux-Arts and worked with the glass manufacturer Lalique before emigrating to the United States in 1906. His work nearly always has a high finish and stylistically has similarities with Maillol. His 'Seagull' is the monument for the National Coastguard.

**LADISLAD, Saloun.** An example of his work is illustrated on p.309.

**LAESSLE, Albert (1877-1945).** American, born and died in Philadelphia. Studied widely in America and in Paris before returning to Philadelphia to practise as an animalier. His works include caricatures of animals, 'Billy', 'Chanticleer', 'Turning Turtle', 'First Effort' and 'Frog and Caryatid'. His work is of an individual nature, being both realistic but also characterising his subjects without the humanising that went hand in glove with treatment all too often in Europe. Once he had satisfied himself as to his own standards and choice of subject, only then did he show his work to the public, not necessarily for their acclaim but to show them what he had achieved. His studio was conveniently situated close to the zoo in Philadelphia. Like Barye and Rodin before him he was accused of casting his first group, a crab and a turtle fighting over the body of a giant crow, from life, so true to life was the detail (1901), the same happened in Paris at the Salon with his 'Turning Turtle' which is now in the Metropolitan Museum, New York. Other examples of his whimsical models include, 'Locust and Pine Cone', 'Outcast' (a newborn chick), an eagle as 'Victory', 'The First Step', 'Fan Tail Pigeon', 'Blue-Eyed Lizard', 'Turtle With Lizards' (adapted from his first rejected model), 'Turkey' and 'Drake Fountain'. Examples of his work are at the Metropolitan Museum of Art, Carnegie Institute and Pennsylvania Academy.

**LAINÉ see BROQUIN ET LAINÉ**

**LAIQUE.** An example of his work is illustrated on p.230.

**LAMI, Stanislas (1858-1944).** French, born and died in Paris. A writer on various art subjects and the compiler of the *Dictionnaire des Sculpteurs de l'Ecole Français,* Paris 1921. He also created his own sculptural work and exhibited at the Salon from 1882. Amongst his genre work is a bronze Great Dane.

**LANCERAY, Yevgeni Alexandrovich (Eugene) (1848-86).** Russian, born and died in St. Petersburg. A major Russian sculptor whose work centred upon horses and their relationship with man as working animals. Always working in the romantic idiom of the period, he produced a wide range of groups in his comparatively short career. From small groups of a Boy on a Mule to large, ambitious works of groups of five or seven horses or racing troikas, he always managed to convey a sense of realism, albeit in a rather traditional manner. All his casts are superbly executed with infinite attention to detail of faces, clothing and tack. He revived the romantic spirit of Russian folklore and gave extra swagger to the image of the Cossack. The Chopin foundry were responsible for most of Lanceray's excellent casts. Signature normally in Cyrllic. Many of this sculptor's models have been recast during the last twenty years from existing bronzes, with a subsequent reduction in size and, apart from an even chocolate patination which always looks new, there is none of the fine attention to detail of the original. Examples of his work are illustrated on pp.285, 334, 347, 351, 358, 382, 384, 385, 390.

**LANÇON, Auguste-André (1836-87).** French, born at St. Claude, died in Paris. Studied in Lyons and Paris where he became influenced by Barye (q.v.) and worked at the zoo at the Jardin des Plantes. His work consisted of drawings, engravings, lithographs and sculpture of animals, mainly of lions, tigers and deer. He exhibited at the Salon 1861-70.

**LANDSEER, Sir Edwin Henry (1802-73).** English, born and died in London. The third son of an art historian and engraver, Landseer first exhibited at the Royal Academy at the incredible age of thirteen. During his lifetime he became the doyen of the fashionable drawing room and he was much patronised and favoured by Queen Victoria. He was first and foremost a painter of animals but his major sculptural work stands high in the minds of all Englishmen and visitors to England. He was responsible

**SPIEKER, Klemens (b.1874).** German, born in Ottbergen. Worked at Wiedenbruck as an animalier.

**SPLIETH, Heinrich (1877-1929).** A German equestrian sculptor who also did monumental work. His father, Heinrich Joseph (1842-94) was also a sculptor. An example of his work is illustrated on p.338.

**STEELL, Gourlay (1819-94).** Scottish, born and died in Edinburgh. The son of a woodcarver, and brother of Sir John Steell (q.v.). Started modelling and exhibiting animals at the age of thirteen, succeeding his father as Professor of Modelling at the Watt Institute in Edinburgh. Exhibited at the Salon from 1865-80 and succeeded Landseer (q.v.) as animal painter to Queen Victoria. In 1882 he became Director of the Edinburgh National Gallery.

**STEELL, Sir John Robert (1804-1891).** Scottish, the son of a wood carver, brother of Gourlay Steell (above). An important Scottish sculptor who did much to invigorate his art north of the border. He started his own bronze foundry which came to be used by many Scottish sculptors. Exhibited at the Royal Scottish Academy from 1827-80 and at the Royal Academy from 1837-76. An example of his work is illustrated on p.246.

**STEGLITZ, Georg Meijer see MEIJER-STEGLITZ, Georg**

**STEINER, Arthur (b.1885).** German, born in Gumbinnen. Worked in Königsberg as an animl painter and sculptor.

**STEINLEN, Théophile-Alexandre (1859-1923).** Swiss, born in Lausanne, died in Paris. A sculptor, painter, ethcer and lithographer, he moved to Paris at the age of nineteen. Worked as an illustrator and co-founded the newspaper *Les Humoristes* in 1911. He worked prolifically and was a popular and well-known figure in Paris. He favoured cats in all media, concentrating on them for his bronze sculpture. Berlin Museum has his 'Chat Angora Assis' and a similar cast, by the founder Hébrard (q.v.) numbered 5, was recorded at auction recently 24 x 14.5cm (9½ x 5¾ ins.). All his bronzes should bear his signature and quite often his monogram. His small feline bronzes are very popular subjects and casts without signatures are often seen, and should be avoided unless carrying an irrefutable provenance. His bronzes are always very good quality lost wax casts worked on in a sketchy, impressionistic way. Examples of his work are illustrated on pp.132, 162.

**STENGLIN, Ernst Hugo, Baron von (1862-1914).** German, born in Schwerin, killed in action during the Great War. Studied at Munich Academy and worked as a painter and sculptor of hunting groups.

**STERN, Marguerite-Louise-Delphine (b.1866).** French, born at Marne-la-Coquette. Exhibited at the Salon des Artistes Français from 1914 and also worked in Holland. She specialised in animal sculpture, favouring dogs but also executed portraits and ballet subjects.

**STEUER, Bernard-Adrien (1853-1913).** French, born and died in Paris. He exhibited at the Salon from c.1882-1900, showing portrait busts and hunting groups.

**STEVENS, Alfred George (1817-75).** English, born in Dorset, died in London. Son of a painter and decorative sculptor, he spent his last years training in Italy where he fell under the spell of the Renaissance. He translated this into a personal style that looked ahead to the English New School of sculpture. His Lion is in the collection of the British Museum.

**STÖLZER, Berthold (b.1881).** German, born in Sömmerda. Executed animal and genre groups.

**STURBELLE, Camille-Marc (b.1873).** Belgian, born in Brussels. Studied in Brussels and Paris exhibiting at the St.Louis World Fair in 1904 where he won a silver medal. His animalier work was his main achievement such as 'English Bull Dog' and 'Billy Goat' but he also produced portraits.

**SURAND, Gustave (b.1860).** French, born in Paris. Exhibited his paintings and sculpture of animal subjects at the Salon des Artistes Français from 1881, also winning bronze and silver medals at the 1889 and 1900 Paris Expositions.

**SUSSE FRÈRES (fl. 1839-early 20th C).** One of the best known foundries founded by J.-V. (1806-60) and J.-B.-A. (1808-80) Susse. The brothers started their career by editing work in plaster and held an exhibition of their work in 1839. The success of this exhibition enabled them to start their own bronze workshop in the following year, favouring a rich mid-brown patination, which was changed to green as the fashion dictated at the turn of the century. Almost half of their work was exported and the profusion of these small, fine casts started a trend for the smaller, more manageable casts that are so popular today. The foundry bought up many studios, editing models posthumously to the very highest standards. The photograph of their signature includes the hand written *cire perdue* or lost wax authentication.

**SWAN, John Macallan, R.A. (1847-1910).** English, born in Middlesex, died on the Isle of Wight. Studied at the Worcester and then the Lambeth Schools of Art and later in Paris, where he studied sculpture under Frémiet. He exhibited at the Royal Academy from 1878 and internationally from then on.

He became R.A. in 1905. His bronzes and painting are well represented in museums throughout the world and his models of cats and bears have a distinctive quality which is instantly recognisable. His signature is shown below. Examples of his work are illustrated on pp.129, 153.

**SWANSON, Jack (b.1927).** American, born in Minnesota. Favours horse and cattle sculpture having a great affinity with the horse which he models with sensitivity and feeling. 'Her First Look' is a 1969 cast of a mare lying down glancing with discernible pride at her new-born foal.

**TACCA, Pietro.** An example of his work is illustrated on p.51.

**TARRIT, Jean (b.1866).** French, born at Châtillon-sur-Chalaronne. Sculptor concentrating on animal subjects, 'Cat catching a Mouse', carved ebony 60 x 35cm (23¾ x 13¾ ins.) (life-size). He exhibited at the Salon des Artistes Français in the late 19th and early 20th century.

**TEEUWISE, A.J.P.F. (b.1919).** A solid bronze warthog at Antwerp Zoo.

**TEINTORIER, Jules-Laurent.** French, born in Paris in the mid-19th century. Exhibiting animal figures and groups at the Salon from 1880.

**TESTORY.** An example of his work is illustrated on p.390.

**THIEBAUT FRÈRES.** Founders, see below.

**THIEBAUT, Henri-Léon (c.1846-99).** French, born in Paris c.1846 (some authorities say 1855), and died there. A sculptor exhibiting at the Salon from 1878 but better known as a founder of fine quality lost wax bronzes. A highly productive foundry.

**THOMAS, P.** An example of his work is illustrated on p.141.

**THOMAS-SOYER, Mathilde (b.1860).** French, born at Troyes. Studied under Cain (q.v.) and Chapu exhibiting her animal figures and groups at the Salon from 1879, as well as the Paris Expositions of 1889 and 1900. Groups include 'Dogs of the Auvergne', 'Cow and Wolf', 'Stag and Greyhound' and 'Dog-Fight', all in French provincial museums. Examples of her work are illustrated on pp.74, 234, 242, 334.

**THOMIRE, Pierre-Philippe (1751-1843).** French, born and died in Paris. The most sought after *bronzier* of the reign of

Louis XVI, Thomire's influence was to last well into the 19th century. Coming from a family of fine sculptors. Pierre's forte was his exquisite mounts for furniture, works of art and clocks and became chief modeller at the Sèvres factory. He retired in 1823, his foundry continuing under the name Thomire et Cie, later Thomire-Dutherme et Cie. An example of his work is illustrated on p.159.

**THORNYCROFT, Thomas (1815-85).** English, born in Cheshire, died in London. Studied in London and exhibited at the Royal Academy from 1836-74 as well as at the British Institute 1840-60. His equestrian groups are fine examples of the art of the animalier although Thornycroft did not specialise in animals. His work can be easily dated as it is overtly a mixture of classical and romantic sculpture so popular at the time. An example of his work is shown on p.326.

**TIMYM, William.** Austrian, born in Vienna, and grew up in the rich environment and highly disciplined atmosphere of the Vienna Academy of Art where he was a student. He had several Exhibitions of his work in Vienna and Cologne before he left Austria in 1938 due to the Nazi occupation. He then moved to England and has remained there.

William Timym's work is mainly concerned with animals but he has also done portrait commissions. During the war he undertook commissions for the Ministry of Information and other Government departments and therefore he sculpted a lot of British personalities including Sir Bertrand Russell, Sir Malcolm Sargent, and Sir Francis Chichester. Most of these are now on permanent exhibition in public places such as the Royal Albert Hall.

He has reached distinction in almost every field of art. For over 18 years he had a cartoon series running on BBC television — 'Bongo the Boxer' and 'Bleep and Booster'.

He has exhibited at the Moorland Gallery for many years and he has shown both bronzes and drawings. His work was shown at the Royal Academy in the Summer Exhibition of 1974 and in 1975 he exhibited at the Game Coin, Texas. In the same year he had work on show at the World Wildlife Convention in Las Vegas.

He has had a long standing association with London Zoo and in 1977 he donated a magnificent life-size bronze of a lion's head and a life-size bronze of 'Guy' the gorilla who died in 1978. He has also sculpted the giant panda Chi-Chi.

His aim has been to capture the fluidity of movement and behaviour of both domestic and wild animals, often choosing dramatic poses for his sculpture. His work is in great demand and can be seen in both public and private collections. Examples of his work are illustrated on pp.65, 144, 249.

**TOFANARI, Sirio (b.1886).** Italian, born in Florence. Self-taught, he worked in London and Paris. He was an animalier with models such as 'Billy Goats', 'She Wolf', 'Stag-hunt', 'Rabbit and Vulture'.

**TOURGENEFF, Pierre Nicholas (1854-1912).** French. A pupil of Frémiet (q.v.). He specialised in commission portraits and portraits of horses, exhibiting at the Salon from 1880-1911 with gaining several awards. An example of his work is illustrated on p.286.

**TOURNOIS, Joseph (1830-91).** French, born in Chazeuil, died in Paris. Studied in Dijon and later at the Beaux-Arts. His first animal was modelled as a group entitled 'Ulysses Wounded by a Boar' a bas-relief which won the Premier Prix de Rome in 1857. In 1860 he produced his 'Fawn and Kid', a marble copy after the antique.

**TREMONT, Auguste (b.1892).** Belgian. A glazed pottery boar and an earthenware 'Leopard and Serpent' at the Antwerp Zoo. Examples of his work are illustrated on pp.51, 55.

**TRODOUX, Henri Émile Adrien (fl. late 19th century).** A sculptor born in Russia of French parentage. He appears to be exclusively an animalier, concentrating on amusing small table pieces and desk weights. He quite often uses an unsigned rectangular marble self plinth for his bronzes showing Russian influence. Examples of his work are illustrated on pp.87, 88, 233.

**TROMPENEERS, Karel (1891-1947).** Belgian. A very competent sculptor who worked at the Antwerp Zoo and later became inspired to model animals. The results are first class and, although not very original, being a variation on the style of Collin (q.v.), they are very well cast, with excellent patination. He developed a good sense of proportion that is best seen in his 'Okapi' in the Antwerp Zoo collection. He also modelled a lion's head, an ostrich, and a brown bear. Founder: Bartardy of Brussels. Examples of his work are illustrated on pp.53, 54, 59, 61.

**TROUBETZKOY, Prince Paul (1866-1938).** Russian, born and died near Lake Maggiore in Italy. Born of a Russian father and an American mother, he developed a talent and a passion for modelling from a very early age, working in wax from the age of seven, using household pets and domestic animals as his models. He studied and worked in Milan and Paris as well as Russia, with his own studio in Milan. His 'Indian Scout' won a Gold Medal in Rome in 1894, and he spent six years in America from 1914-20 which influenced his models such as 'Cattle Roping' or 'The Wrangler', (1927). He soon developed his own distinctive impressionistic style and was greatly influenced by Rodin and in turn Troubetzkoy influenced Bugatti (q.v.). He worked on a variety of animals, such as dogs and cows a well as portraits. Examples of his work are illustrated on pp.117, 173, 215, 333.

**TROUSSEAU, Madeleine Bastide see BASTIDE-TROUSSEAU, Madeleine**

**TRUFFOT, Émile-Louis (1843-96).** French, born in Valenciennes, died in Paris. After leaving the Beaux-Arts school he won

the Prix de Rome in 1867/8, having exhibited at the Salon from 1863. His Shepherd and Wolf of 1887 was very popular and he modelled a half-breed goat and chamois, shown in plaster at the Salon in the same year. In 1891 he exhibited a plaster animal group entitled 'Chaude Overture' and again in bronze the following year, a fawn in plaster in 1892, and a Poacher and Animals the following year with another animal group in 1894 entitled 'Flagrant délit'. Another model, not recorded in the Salon entires was seen in bronze in a Paris auction 'Fox holding a pheasant in its mouth', 40 x 60cm (15¾ x 23¾ ins.).

**TUAILLON, Louis (1862-1919).** German, born and died in Berlin. Studied and worked in Berlin and Rome. Modelled animals and portrait and classical bronzes. His animals include Hungarian Bull and a Horse in the Kunsthalle, Bremen, 65.5cm (25¾ ins.) high. His style of modelling whilst tending to be rather solid and heavy in a typical late classical Germanic way also has an unusual softness of style and finish. Examples of his work are illustrated on pp.193, 343.

**TURNER, Alfred (1874-1940).** English, born and died in London. Studied in the City and Guilds school and at the Royal Academy winning a travelling scholarsip. His monumental work includes a fine memorial to Delville Wood, inspired by Coustou's Marly Horses. The horse of the 1920s however, is a huge and powerful animal influenced by the German *Jugendstil*, with a powerful restrained suggestion of movement, the animal becoming the principal feature of the sculpture unlike its inspiration of almost three hundred years before.

**VACATKO, Ludwig (b.1873).** Austrian, born in Simmering. A painter and sculptor of nudes, and of horses at Berlin (1906-08) and from 1910 working in Vienna.

**VAINS, H.R. de.** French. Only record to date is a 'Horse racing with jockey up', 41 x 65cm (16 x 25½ ins.).

**VALETTE, Henri (b.1877).** Swiss, born in Basle. Studied and worked in France as an animalier where he also erected monuments.

**VALSUANI, C.** A Paris foundry working in lost-wax from c.1900 to the present day. Cast for Troubetzkoy.

**VALTON, Charles (1851-1918).** French, born in Pau, died in Chinon. Studied under Barye and Frémiet (qq.v.) he exhibited at the Salon regularly between 1868 and 1914. He won several medals and received the Cross of the Légion d'Honneur in 1906. He was Professor of sculpture at the Germain Pilon School from 1883. Many of his models, which number over seventy were purchased for the State and are listed by Lami. Examples of his works are illustrated on pp.19, 86, 121, 126, 139, 159, 230, 237, 260, 295, 346.

**VAN DONGEN, Olivier (b.1924).** Belgian. A gilt-plaster Bison at Antwerp Zoo, illustrated on p.55.

**VAN NOST, Jan see NOST, Jan Van**

**VAN PERCK, Pierre-Henri see PERCK, Pierre Henri van**

**VERBOECKHOVEN, Barthélemy 'Fickaert' (1754-1840).** Belgian, born and died in Brussels. A sculptor of allegorical, religious and animal models such as 'Dog on a Rabbit', 'Dog on a Partridge', 'Boar Hunt' and 'Three Children Playing with a Billy goat'.

**VERBOECKHOVEN, Eugène-Joseph (1798-1881).** Belgian, born in Warneton, died in Brussels. Primarily a painter who made lithographic, etched and sculptural studies on which to base his paintings. Taught by his father (q.v.) he was a natural sculptor and became a popular and prolific painter. His work was very popular in England and America and he spent some time studying animals in the Royal Menagerie, in London. He received numerous awards from various countries during his lifetime. To find an animal sculpture by this artist would be extremely unusual. However he spent his winter evenings modelling, especially during his childhood and youth. It was a habit that he found very satisfying and one that helped his paintings, giving them heightened accuracy and reality. Recorded models include: Recumbent lion, life-size plaster 1863; 'Flemish horse', a life-size head; 'Tigress', life-size, 1863; 'Lioness and cubs', life-size; also numerous small animal figures including, donkeys, horses, dogs, lions, rams, ewes, lambs, bulls, cows, oxen, heifers, goats and wolves. An example of his work is illustrated on p.166.

**VERHAEGHE, Cecile Van Der Beken (1910-73).** Belgian. A highly stylised earthenware 'Yak' at Antwerp Zoo.

**VERLEE, Lucien (b.1939).** Belgian. A modern movement bronze boar at Antwerp Zoo, illustrated on p.56.

**VIDAL, Louis (1831-92).** French, born in Nîmes, and died in Paris. Known as Vidal-Navatel, he studied under Barye and Rouillard (qq.v.), exhibiting at the Salon from 1859 until 1882, having first shown at the 1855 Exposition Universelle. He was helped with his models by Alfred Barye (q.v.), the son of his mentor, and patronised by Princess Mathilde and the Rothschilds. Born blind he was given a pension to study in Paris by his native town and struggled incredibly to model despite his enormous handicap. His models include: 'Crouched Panther', 1855 Exposition, bronze (the plaster is in the Orléans Museum); 'Hind Lying Down', 1859, bronze; 'Goat Suckling her Kid', 1861, plaster; 'Dying Stag', 1863 and at the 1867 Exposition, bronze; 'Wild Horse', 1865, plaster; 'Bull', 1866, bronze; 'Royal Tiger', 1867, plaster; 'Lion', 1870, bas-relief in plaster; 'Greyhound', 1872, plaster; 'Algerian Gazelle', 1879, wax and in bronze the following year; 'English Horse', 1881, bronze and another the following year and 'Anglo-Norman horse', 1891 wax.

**VILLEMINOT, Louis (1826-c.1914).** French, born in Paris. He lived at 4 rue des Chartreux. Exhibiting from 1850-75 and working on decorative sculpture. His bas reliefs include a group of animal studies exhibited at the Salon in stone in 1882 for the façade of the Hôtel de Ville in Paris, modelled as the signs of the Zodiac.

**VINCOTTE, Thomas-Jules, Baron de (1850-1925).** Belgian, born at Borgerhout, died in Brussels. Studied in Brussels, Paris and Italy, becoming Professor of Sculpture at Antwerp and the Brussels Academy. He modelled a wide range of figures and groups, exhibiting in Paris and at the Royal Academy. His 'Goat' is in Antwerp Museum.

**VISSER, Carel Nicolaas (b.1928).** Dutch, born near Rotterdam. Studied in Holland, Britain, Spain and, through a travelling scholarship, in Italy. His animals and birds in galvanised iron have now developed into pure abstract form, making them difficult to class as animalier.

**VISSER, Tijpke (b.1876).** Dutch, born in Workum. Self-taught, he sculpted animal figures and groups including 'Penguin' and 'Penguin and Seagull'.

**VOGT, Adelgunde (1811-92).** Danish, born and died in Copenhagen. An animalier, she specialised in horses.

**VOGT, Gundo Sigfred (1852-1939).** Danish, born in Copenhagen, died at Selchausdal. The son of Adelgunde Vogt, working with her on the same themes.

**VOLMAR, Joseph Simon (1796-1865).** Swiss, born and died in Berne. A painter and sculptor, occasionally modelling animals.

**VON FERNKORN, Anton Dominik Ritter see FERNKORN, Anton Dominik Ritter von**

**VON KOCH, Gottlieb see KOCH, Gottlieb von**

**VON MILLER, F. see MILLER, F. von**

**VON STENGLIN, Ernst Hugo, Baron see STENGLIN, Ernst Hugo, Baron von**

**VORDERMAYER, Ludwig (b.1868).** German, born in Munich. Studied in Berlin and later worked in Italy before returning to Berlin where he worked on models of animals and birds, which can be seen in the Berlin and Hamburg Museums.

**VOROS, Bela (fl. second quarter 20th century).** Hungarian, exhibiting in Paris. An example of his work is illustrated on p.111.

**VREESE, Godefroid de (b.1861).** Belgian, born in Brussels. Pupil of his sculptor father working on various subjects including animals.

**WAAGEN (fl. 1860s).** An animalier with a model in Sheffield Museum of 'Shepherds and their Dog with a dead Mountain-Lion'. His signature is shown below. A fine equestrian group by this little known artist is discussed on p.285.

**WALKER, Arthur George, RA (1861-1931).** English, born in London where he studied at the Royal Academy, exhibiting from 1884. Became an R.A. in 1936.

**WALTERS ART GALLERY.** Formed by William T. Walters in Baltimore in the last century. Exhibits an important and extensive collection of the work of Barye (q.v.) and other animaliers.

**WALTHER, Louis-Clemens-Paul (b.1876).** German, born in Saxony. A self-taught animalier, modelling 'Antelope', 'Crane', 'Deer', 'Heron', 'Magpie', 'Parrots', and 'Pheasants'.

**WARD, Rowland.** A skilled taxidermist who modelled sculpture as a hobby. His life is at present being researched by P. Morris of the Department of Zoology at Royal Holloway College. Examples of his work are illustrated on pp.125, 146.

**WATAGIN, Vassili Alexeivich (b.1884).** Russian, born in Mowcow. A painter, engraver and sculptor of animal figures.

**WAUTERS, Liliane (b.1933).** Belgian. A terracotta shell at Antwerp Zoo.

**WEINMAN, Adolph Alexander (1870-1952).** German, born in Karlsruhe, died Port Chester, New York. Moved with his mother to New York at the age of ten, and at fifteen was apprenticed to a wood and ivory carver. Having worked with many of America's sculptors in his youth, he opened his own studio in 1904, becoming famous for his exhibit at the St. Louis 1904 exhibition 'Destiny of the Red Man'. His neo-renaissance cum-classical style is unusual for either animalier work originating from Paris or for the work of the American Western sculptor. His heavy, almost lumpy 'Bison', c.1922, 30.5cm (12ins.) shows fine attention to detail but in a pose popular in Paris some seventy years before.

**WENTWORTH, Judith Blunt, Baroness (1873-1957).** English, died near Horsham. Her title was inherited from her mother in 1917, after she had become an established authoress and poet, her books concentrating on horses and dogs. She was a leading figure of the Arab Horse Society as well as a breeder. She modelled Arab horses during her forays into sculpture.

**WHEATLEY, Edith Grace (1888-1970).** English, born and died in London. She studied at the Slade School as well as in Paris and lectured at Cape Town University from 1925-37. She was a painter and sculptor working on a selection of bird, animal and figurative works in bronze and terracotta.

**WHEATLEY, Oliver (exh. 1892-1920).** Born in Birmingham but moved to London having studied in Paris under Aman-Jean, an important and progressive painter and engraver. His accomplished sculpture is rare. He exhibited at the R.A.

**WHEATLEY, Penny.** Born in Wendover. A pupil of David Wynne (q.v.). Models horses and otters, notably the Gavin Maxwell memorial, exhibiting R.A. & R.S.A.

**WHEELER, E. Kathleen (b.1884).**
English, born in Reading. Studied at the Slade School, exhibiting at the Salon des Artistes Français from 1906, and the Royal Academy from 1910. Emigrated to America in 1914 where she modelled a series of American thoroughbreds. Another animal group is entitled 'Death Sleep'.

**WHITING, Onslow (fl. 1920-1940).**
English. Working in the 1920s and 1930s in Helston, Cornwall after studying at the Slade School and having exhibited at the Royal Academy and the Paris Salon. An animal and portrait sculptor.

**WILLIAMS, Gertrude Alice Meredith see MEREDITH-WILLIAMS, Gertrude Alice**

**WILLIAMS, Wheeler (1897-1972).**
American, born in Chicago, died in Madison, Connecticut. Produced statuary and portraits as well as animals such as 'Cub Eating a Fish'.

**WINANS, Walter (1852-1920).** Born in Russia but worked in the United States and died in London (England). An example of his work is illustrated on p.311.

**WINDER, Rudolph (b.1842).** Austrian, born in Vienna. Studied at Fernkorn and exhibited at the Vienna Exhibition of 1873. Genre and animal subjects including a stag. An example of his work is illustrated on p.185.

**WOERFFEL, C.F.** German founder working in St. Petersburg, casting Russian bronzes, notably for Gratcheff (q.v.). An example of their signature is shown below.

**WOLF (fl. 1870s).** A specialist bird painter who sculpted a Wild Boar and a Bear in 1876.

**WOLFF, Franz Alexander Friedrich Wilhelm (1816-87).** German, born in Prussia, died in Berlin. Studied in Munich, Paris and in Berlin where he settled. Sculpted portrait busts and animals, especially dogs. Also a cast-iron group of a bitch and her pups, very well cast 18cm (7ins.) long, with a good rich brown patination.

**WUILLEUMIER, Willy (b.1898).** Swiss, born at Châtelaine, near Geneva. Worked in terracotta, and iron as well as bronze on animals and portrait busts.

**WULFF, M.** An example of his work is illustrated on p.383.

**WYGAERDEN, Koenraad (b.1946).**
Belgian. A white marble snail at Antwerp Zoo.

**WYNNE, David (b.1926).** English. Became interested in sculpture whilst at Cambridge and has worked in a wide range of subjects and materials. His 'tug of war' is a familiar logo for the Taylor Woodrow construction company. His animal work is well represented in the United States in an Open Air Exhibition, including his gigantic 'Grizzly Bear' in marble. His work includes birds, horses, dolphins and gorillas in varying styles.

**WYON, Edward William (1811-85).**
English, born and died in London. Studied at the Royal Academy Schools and first exhibited there in 1831. Although a portrait sculptor his state of 'Richard Green with a Newfoundland' is an interesting diversion into animal sculpture.

**YARROW, Annette (b.1932).** English. Brought up on her father's tea estate in the High Range, South India, horses became a part of her life from early youth as they were the main form of transport on the estate. She was champion amateur jockey for three years in succession in South India. Her love of sculpture developed on a wet afternoon when trying to amuse her children, and the resulting head of her youngest son was so realistic that she had it cast in bronze. Aided by technical advice from the Meridian

Bronze Company of London and she painstakingly taught herself the difficult technique of working the intermediate wax stage in great detail. Asprey's of Old Bond Street have been interested patrons since 1977. From her early sculpture she has started to model birds of prey including a 'Golden Eagle' for the Army Air Corps Memorial, and worked on portrait busts. Incredibly, she has received no formal art training at all. Signature, simply 'Annette'. Examples of her work are illustrated on pp.80, 81, 298, 299, 346.

**YOUNG, Mahonri MacIntosh (1877-1957).** American, born in Salt Lake City, died in Norwalk, Connecticut. Son of a wood carver he modelled animals and birds as a child in clay. He paid for his own education at art schools in New York, Paris and Italy. His models include portraits and Western sculpture and, notably 'Sea Gulls' a life-size monument in Temple Square in Salt Lake City. Another endearing model entitled 'Lunch in the Desert', cast by the Roman Bronze Works c.1930 depicts a foal suckling from its mother 20.3cm (8ins.) high.

**ZIMMERMANN, Gabriel-Eugène-Luçien (b.1877).** French, born in Paris. His genre figures include 'The Goose Stealer' in Amiens Museum.

**ZOCCHI, Emilio (1835-1913).** Italian, born and died in Florence. Produced historical portraits and a 'Head of a Horse', in the Museum of Modern Art in Rome.

**ZORACH, William (b.1887).** Born in Lithuania, but moved to Ohio in 1891. Studied in Paris and New York as a painter and started to sculpt in 1917. His sculptural work covers a wide field in mainly wood and stone and includes animal subjects.

**ZÜGEL, Wilhelm (b.1876).** German, born in Munich. Studied painting but became a self-taught sculptor specialising in animals. His bronze casts include 'Condor', 'Eagle', 'Giraffe', 'Playing Bear', 'Pelican Resting', 'Pelican Preening', and 'Rhinoceros'.

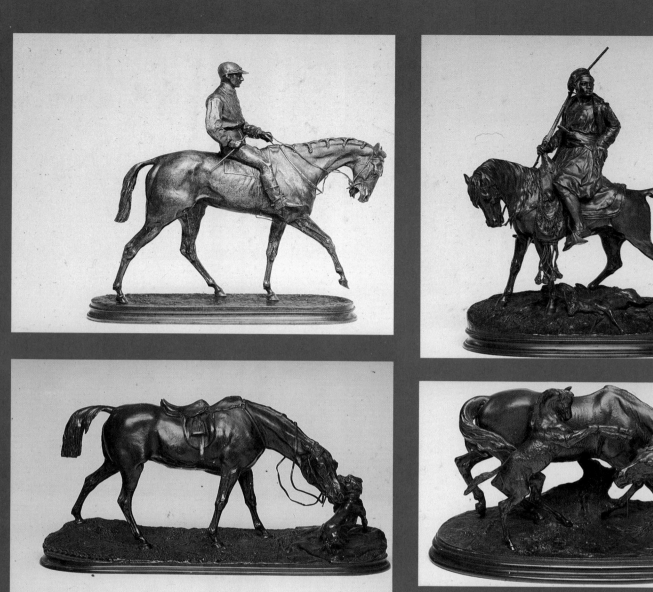
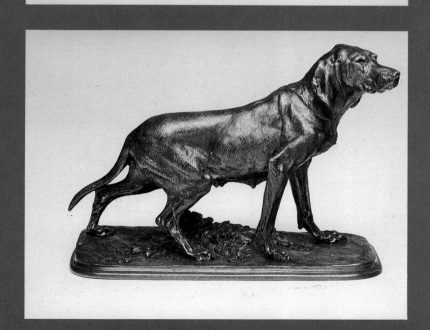
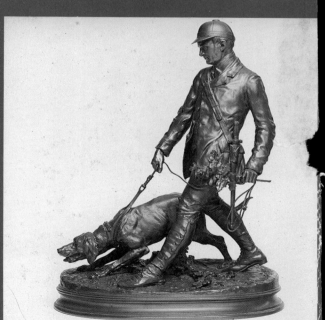